Translating Warhol

Literatures, Cultures, Translation

Literatures, Cultures, Translation presents books that engage central issues in translation studies such as history, politics, and gender in and of literary translation, as well as books that open new avenues for study. Volumes in the series follow two main strands of inquiry: one strand brings a wider context to translation through an interdisciplinary interrogation, while the other hones in on the history and politics of the translation of seminal works in literary and intellectual history.

Series Editors
Brian James Baer, Kent State University, USA
Michelle Woods, The State University of New York, New Paltz, USA

Editorial Board
Paul Bandia, Professeur titulaire, Concordia University, Canada, and Senior Fellow, the W.E.B. Du Bois Institute for African American Research, Harvard University, USA
Susan Bassnett, Professor of Comparative Literature, Warwick University, UK
Leo Tak-hung Chan, Guangxi University, Hong Kong, China
Michael Cronin, Dublin City University, Republic of Ireland
Edwin Gentzler, University of Massachusetts Amherst, USA
Denise Merkle, Moncton University, Canada
Michaela Wolf, University of Graz, Austria

Volumes in the Series
Translation and the Making of Modern Russian Literature
Brian James Baer
Interpreting in Nazi Concentration Camps
Edited by Michaela Wolf
Exorcising Translation: Towards an Intercivilizational Turn
Douglas Robinson

Literary Translation and the Making of Originals
Karen Emmerich
The Translator on Stage
Geraldine Brodie
Transgender, Translation, Translingual Address
Douglas Robinson
Western Theory in East Asian Contexts: Translation and Translingual Writing
Leo Tak-hung Chan
The Translator's Visibility: Scenes from Contemporary Latin American Fiction
Heather Cleary
The Relocation of Culture: Translations, Migrations, Borders
Simona Bertacco and Nicoletta Vallorani
The Art of Translation in Light of Bakhtin's Re-accentuation
Edited by Slav Gratchev and Margarita Marinova
Migration and Mutation: New Perspectives on the Sonnet in Translation
Edited by Carole Birkan-Berz, Oriane Monthéard, and Erin Cunningham
This Is a Classic: Translators on Making Writers Global
Edited by Regina Galasso
Language Smugglers: Postlingual Literatures and Translation within the Canadian Context
Arianne Des Rochers
Translating Warhol
Edited by Reva Wolf

Translating Warhol

Edited by Reva Wolf

BLOOMSBURY ACADEMIC
NEW YORK · LONDON · OXFORD · NEW DELHI · SYDNEY

BLOOMSBURY ACADEMIC

Bloomsbury Publishing Inc, 1359 Broadway, New York, NY 10018, USA
Bloomsbury Publishing Plc, 50 Bedford Square, London, WC1B 3DP, UK
Bloomsbury Publishing Ireland, 29 Earlsfort Terrace, Dublin 2, D02 AY28, Ireland

BLOOMSBURY, BLOOMSBURY ACADEMIC and the Diana logo are
trademarks of Bloomsbury Publishing Plc

First published in the United States of America 2024
Paperback edition published 2026

Copyright © Reva Wolf, 2024

Each chapter © Contributors, 2024

Andy Warhol and Andy Warhol Artworks © 2024 The Andy Warhol Foundation for the Visual Arts,
Inc. / Licensed by Artists Rights Society (ARS), New York.

For legal purposes the List of Figures on pp. viii–xii
constitute an extension of this copyright page.

Cover design by Daniel Benneworth-Gray

All rights reserved. No part of this publication may be: i) reproduced or transmitted in any form, electronic or mechanical, including photocopying, recording or by means of any information storage or retrieval system without prior permission in writing from the publishers; or ii) used or reproduced in any way for the training, development or operation of artificial intelligence (AI) technologies, including generative AI technologies. The rights holders expressly reserve this publication from the text and data mining exception as per Article 4(3) of the Digital Single Market Directive (EU) 2019/790.

Bloomsbury Publishing Inc does not have any control over, or responsibility for, any third-party websites referred to or in this book. All internet addresses given in this book were correct at the time of going to press. The author and publisher regret any inconvenience caused if addresses have changed or sites have ceased to exist, but can accept no responsibility for any such changes.

Whilst every effort has been made to locate copyright holders the publishers would be grateful to hear from any person(s) not here acknowledged.

Library of Congress Cataloging-in-Publication Data
Names: Wolf, Reva, 1956- editor.
Title: Translating Warhol / edited by Reva Wolf.
Description: New York : Bloomsbury Academic, 2024. |
Series: Literatures, cultures, translation ; volume 13 |
Includes bibliographical references and index.
Identifiers: LCCN 2023058313 (print) | LCCN 2023058314 (ebook) |
ISBN 9798765110942 (hardback) | ISBN 9798765110959 (paperback) |
ISBN 9798765110966 (ebook) | ISBN 9798765110973 (pdf)
Subjects: LCSH: Warhol, Andy, 1928-1987–Translations–History and criticism. |
Warhol, Andy, 1928-1987–Criticism and interpretation.
Classification: LCC N6537.W28 T73 2024 (print) | LCC N6537.W28 (ebook) |
DDC 700.92–dc23/eng/20240228
LC record available at https://lccn.loc.gov/2023058313
LC ebook record available at https://lccn.loc.gov/2023058314

ISBN:	HB:	979-8-7651-1094-2
	PB:	979-8-7651-1095-9
	ePDF:	979-8-7651-1097-3
	eBook:	979-8-7651-1096-6

Typeset by Integra Software Services Pvt. Ltd.

For product safety related questions contact productsafety@bloomsbury.com.

To find out more about our authors and books visit www.bloomsbury.com
and sign up for our newsletters.

Contents

List of Figures	viii
Preface	xiii

1. Being, Nothingness, and the Quest to Understand: An Introduction to Warhol in Translation *Reva Wolf* — 1
2. Warhol in French *Jean-Claude Lebensztejn* Translated by Mercedes Rooney — 23
3. *Schnecken, Schlitzmonger*, and *Poltergeist*: Andy Warhol in German—Translations and Cultural Context *Nina Schleif* — 43
4. *La Filosofia di Andy Warhol* and the Turmoil of Art in Italy, 1983 *Francesco Guzzetti* — 71
5. Warhol in Translation, Stockholm 1968: "Many Works and Few Motifs" *Annika Öhrner* — 103
6. Andy and Julia in Rusyn: Warhol's Translation of His Mother in Film and Video *Elaine Rusinko* — 125
7. Translating Warhol for Television: *Andy Warhol's America* *Jean Wainwright* — 161
8. Translating Warhol to India *Deven M. Patel* — 197

Selected Bibliography	212
Notes on Contributors	225
Index	227

Figures

1.1 Andy Warhol, *The Philosophy of Andy Warhol*, Japanese translation by Augustmoon Ochiishi, front cover. Tokyo: Shinchosha, 1998 4

1.2 Andy Warhol and Pat Hackett, *POPism: The Warhol '60s*, Chinese translation by Kou Huaiyu, dust jacket front and spine. Kaifeng: Henan University Press, 2014 8

1.3 Andy Warhol, *La Filosofia di Andy Warhol*, Italian translation by Rino Ponte and Fernando Ferretti, 2nd ed., front cover. Genoa: Costa & Nolan, 1990 10

1.4 *Andy Warhol's America*, BBC Two, directed by Francis Whately, episode three, January 20, 2022, screenshot 12

1.5 "Uttalande av Andy Warhol" [Swedish translation of Gene Swenson, "What Is Pop Art?"], *Bonniers Litterära Magasin* 33, no. 3 (March 1964): 172, detail. Penn Libraries, University of Pennsylvania. Photo: archive of the author 15

1.6 Andy Warhol, *Mi filosofía de A a B y de B a A*, Spanish translation by Marcelo Covián, front cover. Barcelona: Tusquets, 1981 19

2.1 *VH 101* 1 (Spring 1970), front cover. Photo: archive of the editor 24

2.2 Andy Warhol, "Comment devenir un homosexuel professionnel" (excerpts from *a: A Novel*), *VH 101* 1 (Spring 1970): 42–3. Photo: archive of the editor 25

2.3 Andy Warhol, *Blow Job*, 1964, 16 mm black-and-white silent film, 41 minutes at 16 fps, two frames. Photo: archive of the author 31

2.4 *Lucien, de la traduction de N. Perrot, Sr d'Ablancourt* (Paris: Augustin Courbé, 1654), title page. Collection of the University of California, digitized by Google 38

2.5 Andy Warhol, seven *Screen Tests*, mid-1960s, digital transfers, as projected in Times Square, New York, May 2015. Photo: archive of the author 40

3.1 Andy Warhol, *a. Ein Roman*, first German edition (Cologne: KiWi, 1971), dust jacket, designed by Hannes Jähn. Courtesy of Kiepenheuer & Witsch; photo: archive of the author 61

Figures ix

3.2 Andy Warhol, *Blue Movie. Der ungekürzte Dialog mit über 100 Photos*, first German edition (Cologne: KiWi, 1971), cover, designed by Hannes Jähn. Courtesy of Kiepenheuer & Witsch; photo: archive of the author 62

3.3 Andy Warhol, *Die Philosophie des Andy Warhol von A bis B und zurück*, first German edition (Munich: Droemersche Verlagsanstalt Th. Knaur Nachf, 1991), front cover. Photo: archive of the author 65

3.4 Andy Warhol, *POPism. Meine 60er Jahre*, first German edition (Munich: Schirmer/Mosel, 2008), front cover. Courtesy of Schirmer/Mosel München; cover photo © Adelman Images LP 68

4.1 Christopher Makos, photograph of Andy Warhol, 1981, featured on the front cover, Andy Warhol, *La Filosofia di Andy Warhol* (Genoa: Costa & Nolan, 1983). Photo: archive of the author; cover photo © Christopher Makos 72

4.2 Poster advertising the release of the Italian edition of Lucy Lippard's *Pop Art* (Milan: Mazzotta, 1967), featuring Andy Warhol's *Jackie* paintings 74

4.3 Poster advertising the exhibition *Andy Warhol: Ladies and Gentlemen*, Galleria civica d'arte moderna, Ferrara, 1975 81

4.4 Andy Warhol, *Lucio Amelio*, after August 1975, Polacolor Type 108, 4¼ × 3⅜ in. (10.795 × 8.57 cm). The Trout Gallery, Dickinson College, Gift of the Andy Warhol Foundation for the Visual Arts, Inc. 83

4.5 Andy Warhol, *Daniela Morera*, January 1981, Polacolor 2, 4¼ × 3⅜ in. (10.795 × 8.57 cm). Grey Art Gallery, New York University, Gift of the Andy Warhol Foundation for the Visual Arts, Inc. 86

4.6 Andy Warhol, *The Philosophy of Andy Warhol (From A to B and Back Again)* (New York: Harcourt Brace Jovanovich, 1975), dust jacket, design by Herb Lubalin. Photo: archive of the editor 90

4.7 Andy Warhol, *La Filosofia di Andy Warhol* (Genoa: Costa & Nolan, 1983), back flap. Photo: archive of the author 91

4.8 *Warhol verso de Chirico*, front cover (New York: Marisa Del Re Gallery, Inc., 1985). Photo: archive of the author 95

Figures

5.1 Andy Warhol at the Moderna Museet, Stockholm; press photo by Lasse Olsson, February 9, 1968 104
5.2 *Andy Warhol* (Stockholm: Moderna Museet, 1968; 3rd ed., 1970), Warhol quotations with Swedish translations. Photo: archive of the editor 109
5.3 Andy Warhol and Pontus Hultén at the Moderna Museet, Stockholm, 1968. Photo by Nils-Göran Hökby 114
5.4 Installation view of Brillo boxes at the *Andy Warhol* exhibition, Moderna Museet, Stockholm, 1968. Photo by Nils-Göran Hökby 115
5.5 View of the *Multikonst* exhibition, Örebro County Museum, February 1967. Photo: *Örebro Kuriren*, Courtesy of the Archive of Örebro County Museum 121
5.6 View of the *Multikonst* exhibition, Örebro County Museum, February 1967. Photo: *Örebro Kuriren*, Courtesy of the Archive of Örebro County Museum 121
5.7 Poster for the *Multikonst* exhibition, designed by Albert Johansson, 1967. © Albert Johansson/Bildupphovsrätt 2023 122
6.1 Map of Carpathian Rus', 1919–38. Reprinted with permission from Paul Robert Magocsi, *With Their Backs to the Mountains* (Budapest and New York: Central European University Press, 2015) 128
6.2 Andy Warhol, *Factory Diary* ["Julia Warhola in Bed, Talking, Sleeping"], c. 1970–2, ½ in. reel-to-reel videotape, black-and-white, sound, 22:48 minutes. Camera by Andy Warhol. © The Andy Warhol Museum, Pittsburgh, PA, a museum of Carnegie Institute. All rights reserved. Video still courtesy The Andy Warhol Museum 138
6.3 Andy Warhol, *The George Hamilton Story*, 1966, 16 mm film, color, sound, 67 minutes. © The Andy Warhol Museum, Pittsburgh, PA, a museum of Carnegie Institute. All rights reserved. Film still courtesy The Andy Warhol Museum 140
6.4 Signpost at the entrance to the village of Havaj, Slovakia, in Slovak and Rusyn languages. Photograph by Maria Silvestri, 2018 145
6.5 Andy Warhol, *The George Hamilton Story*, 1966, 16 mm film, color, sound, 67 minutes. © The Andy Warhol Museum, Pittsburgh, PA, a museum of Carnegie Institute. All rights reserved. Film still courtesy The Andy Warhol Museum 149

Figures xi

6.6 Film canister containing reel one of *The George Hamilton Story*, labeled in an unknown hand, "MRS WARHOl." The Andy Warhol Museum, Pittsburgh, PA. Photograph © Greg Pierce 154

6.7 Film canister containing reel two of *The George Hamilton Story*, labeled in an unknown hand, "MRS WARHOl." The Andy Warhol Museum, Pittsburgh, PA. Photograph © Greg Pierce 155

7.1 Andy Warhol, *Pink Race Riot [Red Race Riot]*, 1963, silkscreen ink and acrylic on linen, 128¼ × 83 in. (325.8 × 210.8 cm). Museum Ludwig, Cologne. Image and Artwork © The Andy Warhol Foundation for the Visual Arts, Inc./Licensed by ARS 162

7.2 Andy Warhol, *Mustard Race Riot*, 1963, silkscreen ink, acrylic, and pencil on linen, two panels, 114 × 82 in. (289.6 × 208.3 cm) each. Museum Brandhorst, Munich. Image and Artwork © The Andy Warhol Foundation for the Visual Arts, Inc./Licensed by ARS 163

7.3 Andy Warhol, Mechanical ("The Dogs' Attack is Negroes' Reward," *Life* Magazine, May 17, 1963), 1963, newsprint clipping, graphite, tape, and gouache on heavyweight paper, 20 × 22½ in. (50.8 × 57.2 cm). The Andy Warhol Museum, Pittsburgh; Founding Collection, Contribution The Andy Warhol Foundation for the Visual Arts, Inc. Accession Number: 1998.3.4438 178

7.4 Andy Warhol, *The American Indian (Russell Means)*, 1977, acrylic and silkscreen ink on linen, 50 × 42 in. (127 × 106.7 cm). The Andy Warhol Museum, Pittsburgh. Image and Artwork © The Andy Warhol Foundation for the Visual Arts, Inc./Licensed by ARS 184

7.5 Edward S. Curtis (American 1868–1952), *Standing on the Earth–Oto*, 1927, photogravure, 9 × 6½ in. (22.86 × 16.51 cm). Courtesy Charles Deering McCormick Library of Special Collections and University Archives, Northwestern University Libraries 190

8.1 Bhupen Khakhar, *Truth Is Beauty and Beauty Is God*, exhibition catalog/artist book, offset printing on paper, 1972, 7–8. Image courtesy: Chemould Archives, Mumbai, India 203

8.2 Bhupen Khakhar, *Truth Is Beauty and Beauty Is God*, exhibition catalog/artist book, offset printing on paper, 1972, 15–16. Image courtesy: Chemould Archives, Mumbai, India 205

8.3 Bhupen Khakhar, *Truth Is Beauty and Beauty Is God*, exhibition catalog/artist book, offset printing on paper, 1972, 5–6. Image courtesy: Chemould Archives, Mumbai, India 206

8.4 Andy Warhol, *Vote McGovern*, 1972, color screenprint, printed by Jeff Wasserman and published by Gemini G.E.L., $41^{15}/_{16} \times 41^{15}/_{16}$ in. (106.5 × 106.5 cm), image. Whitney Museum of American Art, New York, 78.98, gift of Fred Mueller 207

8.5 Bhupen Khakhar, *Factory Strike*, 1972, oil on canvas, 36 × 36 in. (91.4 × 91.4 cm). Collection Mala Marwah, New Delhi. Image courtesy: Chemould Archives, Mumbai, India 208

Preface

Andy Warhol (1928–87) is one of the most influential artists of the twentieth century. Despite the vast global literature about Warhol and his work, almost nothing has been written about the challenges of translating Warhol or about how the translation of his words contributes to his international reputation. *Translating Warhol* aims to fill this gap. The chapters in this collection develop the topic of translation in multiple directions and across various languages and cultures. The numerous translations of Warhol's writings, words, and ideas offer a fertile case study of how the art of the United States was, and is, viewed from the outside. Within these pages, readers will discover how translation has alternately censored or exposed, or otherwise affected, the presentation of Warhol's political and social positions and attitudes and, in turn, the value we place on his art and person.

Translating Warhol, the first book about the history and broad implications of translating Warhol's work and ideas, offers a fresh approach to understanding Warhol's remarkable global influence, which first emerged in the 1960s and is still palpable today. The chapters in this book, taken together, reveal how the same publications are viewed differently in distinct cultural contexts. And they provide models for exploring the reception of writings by artists. Both historical and theoretical aspects of translation are taken up. Individual chapters cover French, German, Italian, and Swedish translations, and discuss Warhol's translations of his mother's native Rusyn language and culture, the translation of Warhol for documentary television, and the performative translation of Warhol in India.

With its range of topics, *Translating Warhol* contributes to our understanding of Warhol's place in history and enlivens our comprehension of translation theory and intercultural exchange across a broad range of fields: art history, comparative literature, film studies, the history of censorship, philosophy, queer studies, and more. A work of interdisciplinary scholarship, *Translating Warhol* makes a strong case for the benefit of taking translation studies beyond the fields of literature and languages.

From a Book Review to a Translator's Query to *Translating Warhol*

A seed for *Translating Warhol* was planted when in 2006 I received an email from the art historian and cultural critic Jean-Claude Lebensztejn about a review he was then preparing of the French translation of a compendium of

Warhol's interviews for which I had written the introduction. This was the start of a long conversation on Warhol and other topics that continues today. Lebensztejn's review is one of the earliest critical discussions of translating Warhol. In it are the roots of his chapter in this volume, "Warhol in French."

Seven years after Lebensztejn wrote to me, in 2013, I was contacted by Kou Huaiyu, who was completing a translation into Chinese of Warhol and Pat Hackett's book *POPism: The Warhol '60s*. Kou sent me a set of queries regarding hard-to-decipher passages. Only then did I recognize translating Warhol as a subject unto itself. Kou's questions made me aware of a fact that I had not noticed in several previous readings of *POPism*: there were passages I did not understand. This experience made me appreciate the idea, taken up in chapter 1 of *Translating Warhol*, that translation is an "intimate" form of reading.

Eventually, Kou (living in Beijing) and I (residing in the Mid-Hudson Valley of New York State) met and together presented an account of our extensive email discussion about the meanings of various words, idioms, and concepts in *POPism*. This exchange took place at a conference about modernism in China and the United States that was held in spring 2016 at the China Academy of Art, Hangzhou, organized by Zhang Jian in collaboration with Bruce Robertson of the University of California, Santa Barbara, with the support of the Terra Foundation for American Art. The conference papers were published in two editions, both bilingual, in China (2017) and in the United States (2020). This project gave us an opportunity to share some of our email "archive"—pieces of Kou's working material as a translator. It also introduced me to some relevant work within the extensive literature in translation studies, including Martha Cheung's compelling proposal that translation be thought of as "intercultural" rather than "cross-cultural," to represent exchange rather than smooth transfer, in order to "highlight the very special kind of complex communication that translation is."[1]

Thinking about Kou's queries regarding the language of *POPism* made me want to study the history of translations of Warhol's words. It was obvious this would have to be a collaborative enterprise. An early step toward the present publication was to organize a symposium on the subject. At the time, in the late 2010s, I was in discussion with David McKnight, a rare book librarian at the University of Pennsylvania, regarding an exhibition he was putting together, *Out of Sight*, of a series of prints related to a well-known show on

[1] Martha P. Y. Cheung, "Translation as Intercultural Communication: Views from the Chinese Discourse on Translation," in *A Companion to Translation Studies*, eds. Sandra Bermann and Catherine Porter (Chichester: Wiley-Blackwell, 2014), 180.

Warhol held at the Moderna Museet, Stockholm, in 1968 (the Stockholm exhibit is the topic of Annika Öhrner's chapter in the present volume). It seemed like the perfect context for a symposium on translating Warhol. The idea took off, and the symposium was held at the Kislak Center for Special Collections, Rare Books and Manuscripts, University of Pennsylvania, June 23–24, 2022, supported by an Academic Program Grant from the Terra Foundation for American Art. The symposium, along with published versions of the papers in the June 2022 issue of the online *Journal of Art Historiography*, became the foundation for the present volume. *Translating Warhol* has provided the authors an opportunity to revise, extend, and correct, as well as to incorporate feedback from the symposium discussions, strengthening an already excellent series of studies. The first chapter has been extensively revised and expanded, and a thematically organized bibliography has been added to facilitate further research.

Artists' Words and Their Translation

The growing interest in the practice of translating words by artists or about art is reflected in the 2009 founding of the journal *Art in Translation*, which publishes translations of art writings and occasional critical studies of translation. Claudia Hopkins and Iain Boyd Whyte, as co-editors of *Art in Translation*, recently oversaw an extensive two-volume anthology of translations into English of European writings on American art, entitled *Hot Art, Cold War* (2020). *Translating Warhol* extends that publication's exploration of how the art of the United States was understood abroad in the mid to later twentieth century.

Translating Warhol also grows out of innovative work of the last few decades on Warhol's words. Three notable examples are the book that Lebensztejn reviewed the French translation of, Kenneth Goldsmith's edited collection, *I'll Be Your Mirror: The Selected Andy Warhol Interviews* (2004), Nina Schleif's exhibition catalog, *Reading Andy Warhol* (2013), and Lucy Mulroney's *Warhol, Publisher* (2018). *Translating Warhol* amplifies recent discussions of the reception of American art abroad, too, such as, for example: Annika Öhrner, ed., *Art in Transfer in the Era of Pop: Curatorial Practices and Transnational Strategies* (2017), and Liam Considine, *American Pop Art in France: Politics of the Transatlantic Image* (2019). However, almost nothing has been written about the important and complex role of the translation of artists' words, and those of critics. A goal of *Translating Warhol* is to inspire further work along these lines.

Acknowledgments

Translating Warhol is the result of a team effort—the efforts of several teams, really—over the course of many years. Collaboration is what made it not only possible, given the multiple cultures and languages involved, but pleasurable and rewarding, too.

The chapters in this book, as mentioned above, developed out of a symposium on translations of Warhol held at the Kislak Center for Special Collections, Rare Books and Manuscripts, University of Pennsylvania. I am grateful to the Kislak Center staff who supported this symposium, and most especially: David McKnight, who agreed to collaborate with me on it; Eric Dillalogue, who worked with tireless diligence, care, and kindness to ensure everything ran smoothly, from the speakers' travel and accommodations to the technological setup, and much more; former and current directors, William Noel and Sean Quimby; Mary Ellen Burd, Lynne Farrington, Aleta Arthurs, Betsy Deming, Matthew Roberts, and Douglas Smullens; and student assistant Leo Gearin. University of Pennsylvania Professors Kathryn Hellerstein and Ann Moyer participated in the symposium as moderators and added valuable insights from their own respective fields, languages and history. Pierre Von-Ow participated as the reader of the Jean-Claude Lebensztejn's keynote presentation and expertly fielded the questions it provoked. The symposium was planned as programming for the Kislak Center *Out of Sight* exhibition. Thanks go to Gregory McCoy, the collector who lent the work to the exhibition, for his support of the symposium, and to the poet Kenneth Goldsmith and a then-colleague of Kenny's at Penn, Eric Weinstein, for bringing me to the *Out of Sight* project. I was blessed throughout this project by the wonderful collegiality and brilliant sense of humor of Atelier Fine Art Services registrar, Maureen McCormick. I thank the Terra Foundation for American Art for its crucial generous support of the symposium, and in particular, Carrie Haslett, Amy Gunderson, and Francesca Rose. The lively conversations between the symposium speakers and audience members, including the Warhol biographer Blake Gopnik, the archivist at The Andy Warhol Museum, Pittsburgh, Matthew Gray, and the architect Na Wei, have improved the content of this book.

In association with the symposium, I organized a small exhibition of translations of Warhol's writings, also at the Kislak Center. Some of the insights I gained by studying the various book covers and interview translations displayed in the exhibit have been incorporated into my introductory chapter in this volume. I thank Brittany Merriam, Sarah

Reidell, and Lydia Degn-Sutton for their assistance on the installation of this exhibition, and David McKnight for making it happen and for seeing to it that the translations I wanted to feature would be available, which required many new library acquisitions. As a result, the University of Pennsylvania can now boast of having probably the best library collection worldwide of translations of Warhol.

An earlier version of the symposium papers, as noted in the Preface, came out in the June 2022 issue of the *Journal of Art Historiography*. I am grateful to the editor of the journal, Richard Woodfield, for agreeing to publish them. He was initially skeptical but quickly embraced the project with openness and enthusiasm. Working with him was a joy. Thanks also go to the experts who gave generously of their time to review some of the manuscripts and much more, including: Enrico Camporesi, Assistant Curator of Film (Research and Documentation), Centre Pompidou; Gary Comenas, publisher and editor of WarholStars.org; and Neil Printz, co-editor of the *Andy Warhol Catalogue Raisonné*. Without the insights on translation shared with me by Kou Huaiyu, this book would likely not exist. Bruce Robertson and Zhang Jian provided the perfect venue at the 2016 Complementary Modernisms conference in Hangzhou for Kou and I to discuss some of these insights. I thank Augustmoon Ochiishi for sharing with me her thoughts on translating Warhol into Japanese. Mercedes Rooney provided a sensitive and thoughtful translation of Jean-Claude Lebensztejn's chapter. Anat Shiftan translated an article from Hebrew for me. I am grateful to Michelle Woods and Brian James Baer, the Literatures, Cultures, Translation series editors, and to Haaris Naqvi and Hali Han at Bloomsbury Academic, for their support of this book, and also to Mandy Collison and her team at Integra for their careful and responsive management of its production. I thank Michael Hermann and Maria Elena Murguia at the Andy Warhol Foundation, J. R. Pepper at the Artists Rights Society, the photographers Christopher Makos and Bob Adelman, the staff of The Andy Warhol Museum, and everyone else who assisted me and the other contributors to this book with image and text permissions. The Department of Art History and the School of Fine and Performing Arts at the State University of New York at New Paltz contributed crucial publication subvention funds that made it possible to reproduce all the images in color, and the staff of Sojourner Truth Library, especially the skilled Interlibrary Loan staff, provided valued assistance with my research requests. Thanks go to Thomas Kiedrowski for sharing useful video material. I am lucky to have a great editor and loyal fan in my partner, Eugene Heath. A big thank you to all the contributors to *Translating Warhol* for accepting my invitation to pursue the topic, and for the many resulting insights and discoveries, some surprising, that readers will encounter within these pages.

1

Being, Nothingness, and the Quest to Understand: An Introduction to Warhol in Translation

Reva Wolf

In interviews, the artist Ai Weiwei likes to say that the first book he read in English, after arriving in New York City in the early 1980s, was Andy Warhol's *The Philosophy of Andy Warhol (From A to B and Back Again)*, originally published in 1975. The reasons: "It was easy to understand; it was written in Twitter language"; it "was easy to read for a non-English speaker."[1] Nonetheless, residing within the seemingly simple language of Warhol's book are ambiguities, double meanings, and opaque descriptions, rendering the book—like Warhol's other publications—difficult to translate into other languages and sometimes even hard to comprehend for careful readers whose first language is English.

A recent translator of *The Philosophy of Andy Warhol* into Chinese, Kou Huaiyu, sought guidance on the most difficult passages, such as when the dialogue was used to produce a confusion between the literal and the figurative, reality and appearance: was the Swiss actress and model Ursula Andress short or did she *look* short?

[1] Evan Osnos, "It's Not Beautiful: An Artist Takes on the System," *New Yorker*, May 24, 2010; online version, May 17, 2010, https://www.newyorker.com/magazine/2010/05/24/its-not-beautiful; "By the Book: Ai Weiwei," *New York Times Book Review*, January 3, 2021, 6; online version, December 31, 2020, https://www.nytimes.com/2020/12/31/books/review/ai-weiwei-by-the-book-interview.html. Other examples include: Christopher Bollen, "Ai Weiwei," *Interview* magazine, June 28, 2013, https://www.interviewmagazine.com/art/ai-weiwei; Hans Ulrich Obrist, *Ai Weiwei Speaks* (London: Penguin Books, 2016), excerpted in *Artspace*, August 27, 2016, https://www.artspace.com/magazine/interviews_features/book_report/ai-weiwei-hans-ulrich-obrist-interview-54126; and John-Paul Pryor, "The Radical Influence of Drella," *Author*, March 27, 2021, https://authormagazine.com/ai-weiwei-the-radical-influence-of-drella/.

B said, "She looks great. She doesn't look short."
I said, "No. She's very short."
B said, "But she doesn't look short."[2]

Approaches to Translating Warhol

The ambiguities and sometimes deliberate openness to various meanings in Warhol's language can create an immense challenge for the translator. Before exploring some of the particulars, it is important to set out what it means to refer to "Warhol's language" as it appears in publication. His published words, for the purposes of this study, designate a set of collaborative initiatives understood to be "by" Warhol and in his voice. Capturing well this understanding of a collaborative Warhol voice is his query in reply to one of the collaborators on *The Philosophy of Andy Warhol*, Pat Hackett: "Oh, that's great, can you put it in my language?" recorded on one of the tapes created for the purpose of writing the book.[3] But not everyone is convinced. An article of 2004 by Ory Dessau about a then forthcoming translation of the book into Hebrew suggests the impossibility of translating Warhol: since the book is not literally written by Warhol but based on tapes, or "originates in reproduction, translation," it lacks a center, a truth. However, Dessau, in one of the earliest reflections on translating Warhol's books, also notes that the translation constitutes an "important occasion, bringing to light critical questions regarding translation, translation into Hebrew, and Andy Warhol's creative output in writing."[4]

Should the translations be annotated, in order to explain to the reader the range of possible meanings?—an approach called "thick translation" by one of its promoters, Kwame Anthony Appiah.[5] Or should the meaning be left

[2] Kou Huaiyu, email to the author, November 25, 2020; Andy Warhol, *The Philosophy of Andy Warhol* (New York and London: Harcourt Brace Jovanovich, 1975), 170.

[3] See Lucy Mulroney, *Andy Warhol, Publisher* (Chicago and London: University of Chicago Press, 2018), 125. A suitable way to understand Warhol as an author is in terms of the concept of the "author-function" conceived by Michel Foucault in "What Is an Author?" in *Language, Counter-Memory, Practice: Selected Essays and Interviews*, ed. Donald F. Bouchard, trans. Donald F. Bouchard and Sherry Simon (Ithaca, NY: Cornell University Press, 1977), 113–38. On this point, see Douglas Crimp, "*Our Kind of Movie*": *The Films of Andy Warhol* (Cambridge, MA: MIT Press, 2012), 46–66.

[4] Ory Dessau, "מא' עד ז, מז' עד ע'" ["From Aleph to Zein, from Zein to Ein"], סטודי [*Studio: Israeli Art Magazine*] 152 (May–June 2004): 38. I am grateful to Anat Shiftan for helping me locate this article, for translating it, and for discussing its fascinating complexities with me. The translation was published the following year: הפילוסופיה של אנדי וורהול מא לב' זבחורה, trans. Daphna Raz (Tel Aviv: Babel, 2005).

[5] Kwame Anthony Appiah, "Thick Translation," *Callaloo* 16, no. 4 (Autumn 1993): 808–19.

open by the translator, leaving it up to readers to puzzle over? The second option has a certain attraction. As Deven M. Patel points out, Pat Hackett, when editing Warhol's diaries, published in 1989, two years after he died, gave as a reason why she chose not to use a glossary of names, that "it would go against—if not actually betray—the sensibility of what he was about."[6] (Hackett had earlier co-authored Warhol's 1980 book *POPism: The Warhol '60s* and, as just noted, contributed to his *The Philosophy of Andy Warhol*.) Perhaps a hands-off practice has a special resonance, furthermore, for a book of "philosophy," a field built on publications containing language that invites interpretation and debate. Jean-Claude Lebensztejn has proposed, regarding the wide range of translations of Laozi, that translators, almost by necessity, take creative liberty with "the indetermination of meaning resulting from the absence of inflections" in ancient Chinese, the result inevitably being an act of interpretation.[7] Then again, might Appiah's "thick translation" and an openness of meaning operate together? Aarón Lacayo, in a contribution to the growing field of queer translation, contends that if "translation is to be thick, it must preserve the density of unknown, irreducible bodies."[8]

Terms that are highly specific still can contain this type of density. While working on the Japanese translation of *The Philosophy of Andy Warhol*, which appeared in 1998 and is still in print (Figure 1.1), Augustmoon Ochiishi was puzzled by Warhol's statement, "I have to take off my wings."[9] Just about any reader whose first language is English also would be befuddled. Even the "B" to whom Warhol said these words apparently was perplexed: "Say that again."[10] Augustmoon explained how she discovered the meaning of these

[6] Pat Hackett, Introduction to Andy Warhol, *The Andy Warhol Diaries*, ed. Pat Hackett (New York: Warner Books, 1989), xviii. See Deven M. Patel, "Translating Warhol to India," in the present publication. The lack of a glossary in the *Diaries* did not deter translators: a German translation appeared in 1989, the same year as the English first edition, followed by a French version in 1990, and more recently, among others, a Russian (Дневники Энди Уорхола, trans. V. Bolotnikova [Moscow: Ad Marginem, 2015]).

[7] "Le genie des auteurs du *Laozi*—l'un de leur genies—consiste à exploiter les vertus de la langue chinoise ancienne, l'indétermination relative du sens provoque par l'absence de flexions"; Jean-Claude Lebensztejn, "Laozi à la lettre," *Ironie: interrogation critique et ludique* 157 (June 2011): 6.

[8] Aarón Lacayo, "A Queer and Embedded Translation: Ethics of Difference and Erotics of Distance," *Comparative Literature Studies* 51, no. 2 (July 2014): 223. For an overview of the historiography of queer translation, see Brian James Baer and Klaus Kaindl, "Introduction: Queer(ing) Translation," in *Queering Translation, Translating the Queer: Theory, Practice, Activism*, ed. Brian James Baer and Klaus Kaindl (New York and Abingdon: Routledge, 2018), 1–4.

[9] Augustmoon Ochiishi, email to the author, June 26, 2019.

[10] Warhol, *Philosophy*, 6.

Figure 1.1 Andy Warhol, *The Philosophy of Andy Warhol*, Japanese translation by Augustmoon Ochiishi, front cover. Tokyo: Shinchosha, 1998.

"wings" in a poem that embodies the way a word, even when it has a highly precise contextual meaning, evokes other meanings:

> I will tell you my favorite anecdote.
>
> Early on, there's a description of Andy taking off wings, this is his morning ritual.
> What are these wings?
> Called up my friends who were Catholic (gay men) but nobody knew.
>
> But then it fitted my romantic view of a sensitive Andy taking off white wings from his both shoulders in the morning
> (Picture Wim's: wings of desire).
> But he uses 5 of them! Under eyes, around the mouth, one on forehead!
>
> I called around but nobody knew.
> Finally I called Lynne Tillman & told the question & then Callie Angell was introduced.
> She the ultimate uptown girl knew every trick of that by-gone-era trade who said something like
> I'll take you to a cosmetic counter, kind of Band-Aid which stretches wrinkles.
> It's slightly old-fashioned.
>
> Bingo.
>
> So this is my favorite anecdote about wings by Angell.[11]

Evocative. And poignant.[12] The life of words, as they move from their source to another context, is vividly shown in Augustmoon's reminiscence of discovering the meaning of Warhol's wings. The Japanese translation of *The Philosophy of Andy Warhol* has been a big success—it went into its fourteenth printing in 2023[13]—generating new meanings as it reaches a new generation of readers.

[11] Augustmoon Ochiishi, email to the author, June 26, 2019. In transcribing the poem, I have taken the liberty of adjusting the spelling on the few occasions when called for. For a discussion of the ways meanings emerge on the receiving end, see Alan H. Gardiner, *The Theory of Speech and Language* (Oxford: Clarendon Press, 1932), 71–82. I thank Richard Woodfield for leading me to Gardiner.

[12] Callie Angell, who had been working for several years on the catalogue raisonné of Warhol's films, died by suicide in 2010. See Gary Comenas, "Callie Angell Tribute," https://warholstars.org/callie_angell_obituary.html.

[13] Augustmoon Ochiishi, email to the author, August 21, 2023.

In translating the *Philosophy* book into Chinese, Kou raised questions of meaning that put a spotlight on Warhol's penchant for deploying language in the service of paradox, a strategy that is particularly obvious in the discussion of "nothing" and "nothingness." Readers are introduced to this nothing in the opening pages of the book: "... I think about nothing. How it's always in style. Always in good taste. Nothing is perfect—after all, B, it's the opposite of nothing."[14] "In Chinese," Kou explained, "we can only say 'I'm not thinking about anything,' we can't say 'I'm thinking about nothing.'" Kou wondered—as native English readers might—how nothing can also be "the opposite of nothing."[15] The Italian translators, in one of the earliest renderings of Warhol's *Philosophy* into another language, in 1983, apparently likewise wondered how to convey nothing, since they put the Italian equivalent—*niente*—in quotation marks whenever it was used.[16]

The play of ideas, in which nothing becomes a subject, leads us down this rabbit hole of meaning and Warhol clearly loved it. The discussion of nothing resurfaces near the end of *The Philosophy of Andy Warhol*, with a twisting of the expression "to make something out of nothing," followed by this self-ridiculing while also self-promoting piece of advice: "and if you really believe in nothing you can write a book about it."[17]

No doubt, specific cultural references are embedded in this conversation about "nothing." Coming immediately to mind is the composer John Cage's "Lecture on Nothing," published in his book, *Silence: Lectures and Writings* (1961), which has long been seen as an inspiration to Warhol, including for *The Philosophy of Andy Warhol*.[18]

Just as relevant, given that this discussion of nothing comes in a "philosophy" book, is the philosopher Jean-Paul Sartre's 1943 *L'Être et le néant*, translated into English in 1956 as *Being and Nothingness*, which was a mainstay of academic study in the United States at the time of Warhol's publication, in the mid-1970s.[19] "Nothing" even appears as an entry in *The*

[14] Warhol, *Philosophy*, 8.
[15] Kou Huaiyu, email to the author, October 22, 2020, and response of November 23, 2020.
[16] See Francesco Guzzetti, "*La Filosofia di Andy Warhol* and the Turmoil of Art in Italy, 1983" in this volume.
[17] Warhol, *Philosophy*, 183.
[18] See Edward D. Powers, "Attention Must Be Paid: Andy Warhol, John Cage and Gertrude Stein," *European Journal of American Culture* 33, no. 1 (March 2014): 15.
[19] I still have the collection of Sartre's writings, containing extensive passages from *Being and Nothingness*, assigned for a college course on existentialism (note the title!): *The Philosophy of Jean-Paul Sartre*, ed. Robert Denoon Cumming (New York: Vintage Books, 1972). On Sartre's significant influence in the mid-twentieth century in the United States, see Walter Kaufmann, "The Reception of Existentialism in the United States," *Salmagundi*

Encyclopedia of Philosophy, first published in the 1960s and reprinted in the early 1970s, shortly before *The Philosophy of Andy Warhol* came out. The encyclopedia entry contains its own share of fun-making about the apparent paradox of making something from nothing. A few examples: "the narrow path between sense and nonsense on this subject is a difficult one to tread ... the less said of it the better"; "Nothing ... whether or not the being of anything entails it, clearly does not entail that anything should be."[20]

Prior to his translation of *The Philosophy of Andy Warhol*, Kou Huaiyu had translated *POPism* into Chinese (Figure 1.2), and that experience, too, had led him to a wide array of questions on meaning. The translation was published in 2014, not much later than the French version of 2007, with its array of problematic issues (discussed by Jean-Claude Lebensztejn in his chapter, "Warhol in French"), and the more successful German, in 2008 (see Nina Schleif's chapter, "*Schnecken, Schlitzmonger*, and *Poltergeist*"). Kou's questions corroborate a point that Gayatri Chakravorty Spivak likes to make: that translation is "the most intimate act of reading."[21] Elaborating on this point, Spivak has proposed, within a discussion of the hazards and promises of the field of comparative literature, that when reconsidering what she calls "comparativism,"

we think of translation as an active rather than a prosthetic practice. I have often said that translation is the most intimate act of reading. Thus translation comes to inhabit the new politics of comparativism as reading itself, in the broadest possible sense.[22]

10–11 (Fall 1969–Winter 1970): 83–4, where he asserts that the "spell Sartre has cast over generations of American students ... has created an almost unique interest that courses in philosophy, religion, literature departments, and humanities have been designed to satisfy or to exploit. ... That existentialism elicits greater interest in the United States than any previous philosophic movement is almost entirely due to Jean-Paul Sartre." On Sartre's influence more broadly, see Alfred Betschart and Juliane Werner, eds., *Sartre and the International Impact of Existentialism* (Cham, CH: Palgrave Macmillan, 2020).

[20] P. L. Heath, "Nothing," in *The Encyclopedia of Philosophy*, vols. 5 and 6, ed. Paul Edwards (New York: Macmillan Publishing and The Free Press; London: Collier Macmillan, 1967; 1972 reprint edition), 524–5. I am grateful to Eugene Heath (no relation) for calling my attention to this encyclopedia entry.

[21] Gayatri Chakravorty Spivak, quoting herself, from her "Translator's Note" for Aimé Césaire's *Une saison au Congo*, in "Translation as Culture," in Spivak's *An Aesthetic Education in the Era of Globalization* (Cambridge, MA, and London: Harvard University Press, 2012), 255. Previous versions of Spivak's chapter appeared in *Translating Cultures*, ed. Isabel Carrera Suárez, Aurora García Fernández, and M. S. Suárez Lafuente (Oviedo: KRK; Hebden Bridge, UK: Dangaroo Press, 1999), 17–30, and, revised, in *parallax* 6, no. 1 (January–March 2000): 13–24.

[22] Spivak, "Rethinking Comparativism," in *An Aesthetic Education*, 472, and originally published in *New Literary History* 40, no. 3 (Summer 2009): 609–26.

Figure 1.2 Andy Warhol and Pat Hackett, *POPism: The Warhol '60s*, Chinese translation by Kou Huaiyu, dust jacket front and spine. Kaifeng: Henan University Press, 2014.

Translation, then, is a way to gain a closeness through careful reading.[23]

However, as *Translating Warhol* reveals, the kinds of intimate reading Spivak describes can occur only when the translator has the will and the time to get close. And even when conscientious and well-intentioned, it is all-but-impossible not to err somewhere. Especially challenging, but important to a

[23] Kou's interesting questions about how to translate various passages of *POPism* led me to read the book more "intimately" than I had before, and in the process to discover elements that I did not understand. This experience is discussed in Reva Wolf and Kou Huaiyu, "Cosmic Jokes and Tangerine Flake: Translating Andy Warhol's *POPism*" /宇宙的玩笑与橙色亮片漆: 译介安迪・沃霍尔《波普注意》, in *Complementary Modernisms in China and the United States: Art as Life/Art as Idea*, ed. Zhang Jian and Bruce Robertson (Goleta, CA: Punctum Books, 2020), 86, https://www.jstor.org/stable/j.ctv16zk03m.

successful translation, is the ability to capture tone. Jean-Claude Lebensztejn and Francesco Guzzetti both take up this point. Lebensztejn observes: "In the case of artists of Warhol's character, it is the right tone and his deliberate laissez-faire approach that matter." In Guzzetti's discussion of the 1983 Italian translation of *The Philosophy of Andy Warhol*, he likewise notes that a "major challenge was to capture the colloquial, ordinary, sometimes trivial tone and language of the original."[24] The book's parenthetical subtitle, *(From A to B and Back Again)*, was omitted from the Italian version, as Guzzetti points out, and the omission is perhaps indicative of the translator's inability to capture the book's tenor. It's possible there were other reasons for this omission, too. The same year Warhol's book was published in English, a work featuring fictitious interviews with dead historical figures by the writer Giorgio Manganelli was put out by the publisher Rizzoli in Italian with the title *A e B*. Perhaps the publisher of the Italian version of *The Philosophy of Andy Warhol* preferred to avoid the association with *A e B*, however fascinating—and perhaps revealing—the comparison might be.[25]

Before further probing the challenges the subtitle poses, it is helpful to consider, more generally, the significance of the choices made by translators and their publishers regarding outward appearances: book titles and cover images. In the case of the Italian edition of *Philosophy*, Guzzetti highlights the interesting choice to have the book's cover feature a photograph by Christopher Makos showing Warhol wearing a conventionally female-style wig and make up (see Figure 4.1). In Italy this image might have had a particular resonance in connection with Warhol's series of portraits of transvestites and transexuals, *Ladies and Gentlemen* (1975), commissioned by an Italian art dealer and exhibited in Italy. In his nuanced contextual study, Guzzetti proposes that in the early 1980s the image would have been perceived more as emphasizing the interplay of reality and appearance, which is how Warhol's character was perceived in Italy at the time—a perception that also matches up with a recurring theme of *The Philosophy of Andy Warhol* (manifested, for example, in the above mentioned dialogue

[24] The problem of comprehending, or "hearing," tone, understood as emphasis, within a mute text, and its relation to genres of writing, and to the role of implication, is discussed by E. D. Hirsch Jr., in *Validity in Interpretation* (New Haven, CT and London: Yale University Press, 1967), 99–101. I am grateful to Richard Woodfield for suggesting the relevance of Hirsch to this discussion.

[25] On the flourishing of creative uses of the alphabet in the 1970s, see Reva Wolf, "Writing and the Alphabetic Ordering of Culture," in *The Bloomsbury Encyclopedia of Visual Culture*, vol. 1 (*Histories, Theories and Globalities*), ed. Jane Kromm, Michael Gardiner, Julian Haladyn, and Heike Raphael Hernandez (London: Bloomsbury Visual Arts, forthcoming).

about whether Ursula Andress *is* or *appears* short). In the second edition of the Italian translation, from 1990 (three years after Warhol died), the cover image of Warhol "in drag" is replaced by one of his *Dollar Sign* paintings (Figure 1.3), emphasizing a still different facet of Warhol, and one equally connected to the content of the book—especially, the often-quoted passage,

Figure 1.3 Andy Warhol, *La Filosofia di Andy Warhol*, Italian translation by Rino Ponte and Fernando Ferretti, 2nd ed., front cover. Genoa: Costa & Nolan, 1990.

"good business is the best art."[26] The photograph and the *Dollar Sign* painting both were created in 1981, some years after the book itself was first published. These anachronisms were interesting choices, reflecting the basic point that translations are interpretations, and that interpretations change with the times, as reflected even in book cover designs.

In the case of translations of *POPism*, the choices of title and cover image are equally revealing. In her discussion of the German translation of *POPism*, Nina Schleif calls attention to the fact that the title was left in English instead of being switched to the German, *POPismus*. This lack of translation, Schleif notes, along with the cover design's red, white, and blue and picture of Warhol pushing a grocery store shopping cart loaded with merchandise, gives the book a specifically American sound and look (see Figure 3.4). But in the French version, the title was translated—*Popisme*—and the cover design lacks visual signs of Warhol the American; instead, we are presented with a black-and-white photo of Warhol pointing his right index finger to his eye, with the title written in orange (unlike red or blue, a secondary color), perhaps in dialogue with the dust jacket design of the first edition in English, which contains a photo of him with a finger over his mouth against a background of purple (another secondary color). (The fact that the socially coded purple was not selected for the cover of the French version may be understood as reflecting its repressions of allusions in the book to Warhol's sexual identity, discussed at length by Lebensztejn.)

Other cues to meaning, in addition to the visual, are enlisted when the translation is from print to television. In the 2022 BBC Two television documentary *Andy Warhol's America*, the subject of Jean Wainwright's chapter in this volume, we are shown how music and other sounds mix with strategically selected works of art and other visual elements to translate Warhol for TV, casting him as a reflection of the United States. Selected passages from Warhol's books also are enlisted, including the above mentioned line about "business art" (Figure 1.4).

Returning now to the subtitle of the *Philosophy* book, *(From A to B and Back Again)*, it is impossible, without a bit of background knowledge, to grasp what it means. As Kou worked with care on his Chinese translation of the book (unpublished), he asked two questions that provide a glimpse into the difficulties of the translation process: "Does 'From A to B & Back Again' mean phone calls made by A to B again and again? Is the meaning of the title clear to a native speaker or [must] one … read the book before being able to figure out what it means?"[27] (Perhaps these questions were

[26] Warhol, *Philosophy*, 92.
[27] Kou Huaiyu, email to the author, October 22, 2020.

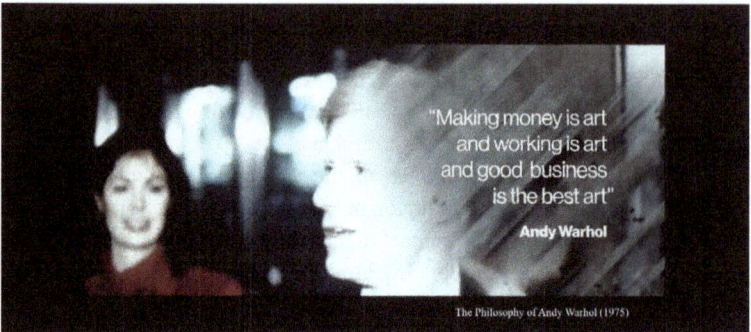

Figure 1.4 *Andy Warhol's America*, BBC Two, directed by Francis Whately, episode three, January 20, 2022, screenshot.

also a reason for the subtitle's omission in the Italian version, although the significance of the alphabet letters would of course be obvious for someone whose first language is Italian.) I responded to Kou's query by trying to provide a sense of the layers of meaning:

> On one level, it refers to Warhol's conversations with Brigid Berlin or Bob Colacello or any "B." But it is meant also to playfully refer to "from A to Z," which is an idiomatic expression, alluding to the English alphabet, that means "everything." In other words, a book containing the "a to z" of philosophy would contain everything; containing "a to b" is very little. … it is as a twist on "from A to Z" that readers would notice first, before understanding any other meaning of the subtitle. The reference to Andy and Brigid (or any other "B") comes only after reading the book and knowing about the people. … There also is an expression in English, "getting from point A to point B," which refers to how we make logical inferences that lead us from one thing to the next.[28]

I also mentioned the potential association of "A to B" with the novel *To the Lighthouse* by Virginia Woolf, in which the husband is a philosopher making his way through the alphabet, each letter representing a concept; he gets to the letter "Q" and gets stuck, failing to complete his life's work.[29]

[28] Email to Kou Huaiyu, November 23, 2020.

[29] Email to Kou Huaiyu, November 23, 2020. On the association of the "A to B" in the subtitle of *The Philosophy of Andy Warhol* with Virginia Woolf's *To the Lighthouse*, see

The German translation of *The Philosophy of Andy Warhol*, published eight years after the Italian, in 1991 (shortly after the fall of the Berlin Wall, probably not by coincidence),[30] and reissued in 2006, *does* include the subtitle—without the parentheses but otherwise rendered literally as *Die Philosophie des Andy Warhol von A nach B und zurück*—although, like the Italian, it was flawed (Schleif considers it to be the "most negligent and faulty" of all the German translations of Warhol's writings). The German *zurück* for "Back Again" adds a nice twist by taking us all the way to "z."

The defects in translation show how Ai Weiwei's assertion that the book is "easy to read" is a bit misleading. Or, put differently, a book can be easy to read but not so easy to understand. Warhol himself even proposed, within the very pages of his philosophy book, that he preferred misunderstandings (and he set up situations for their occurrence):

> If people never misunderstand you, and if they do everything exactly the way you tell them to, they're just transmitters of your ideas, and you get bored with that. But when you work with people who misunderstand you, instead of getting *transmissions* you get *transmutations*, and that's much more interesting in the long run.[31]

Elaine Rusinko highlights this passage in her chapter in this volume, "Andy and Julia in Rusyn," calling attention to potentially problematic questions of human interaction that Warhol's idea of transmutation raises, specifically concerning Warhol's relationship with his mother. Readers of *Translating Warhol* will encounter a smorgasbord of transmutations in the translation of Warhol's words.

Arthur Danto, "The Philosopher as Andy Warhol," in Danto, *Philosophizing Art: Selected Essays* (Berkeley: University of California Press, 1999), 61–2, and Christopher Schmidt, "From A to B and Back Again: Warhol, Recycling, Writing," *Interval(le)s* 2, no. 2–3, no. 1 (Fall 2008–Winter 2009): 797; http://labos.ulg.ac.be/cipa/wp-content/uploads/sites/22/2015/07/72_schmidt.pdf. Schmidt also observed that "A to B" might allude, on another level, to the two sides of a cassette tape, A and B, which is relevant to the fact that tape recordings were used in creating the book (807). Another meaning for "B" is as a sequel, referring back to the "a" in the title of Warhol's previous book, *a: A Novel* (1968) (discussed below); on this association, see, for example, Mulroney, *Andy Warhol, Publisher*, 122.

[30] Other translations of *The Philosophy of Andy Warhol* came out soon after the demise of the Soviet Union, including in Czech, *Od A k B a zase zpět (Filozofie Andyho Warhola)*, trans. Jan Lamper (Zlín: Archa, 1990), and, later, in Russian, *Философия Энди Уорхола (от А к Б и наоборот)*, trans. G. Severskoy (Moscow: Aronov, 2001).

[31] Warhol, *Philosophy*, 99.

Notes toward a History of Translating Warhol

Some of the earliest translations of Warhol's writings into another language are in French. A French version of the *Philosophy* book came out in 1977, just two years after its publication in English. Excerpts of the first chapter appeared still earlier in German, within a 1976 book on Warhol by the art historian Rainer Crone.[32] If these early French and German translations might be expected, an overview of the history of translations of Warhol's writings yields some surprises. Among the earliest translations are renderings of the experimental book, *a: A Novel*, originally published in 1968 by Grove Press. With its fragmented and often disconnected dialogue, which had been loosely transcribed from tape recordings, even Ai Weiwei would not describe this book as easy to read. But its classification as a work of experimental writing led to favorable reviews in Italy in 1969, to excerpts being translated into French in 1970 and 1975 (see Figures 2.1 and 2.2), and, quite remarkably, to a German translation of the entire book in 1971 (and, as Nina Schleif discovered, of excellent quality, standing in sharp contrast to the German rendering of *The Philosophy of Andy Warhol*, despite the latter's seemingly simpler language).[33]

The earliest translations of Warhol's words are from interviews. The often-quoted interview—probably Warhol's most famous—published in 1963 in *ARTnews* magazine,[34] appeared in Swedish already the following year, in *Bonniers Litterära Magasin* (Figure 1.5), then in German in 1965, within a book on Pop art, and soon after, in 1967, in Italian, again in a book on Pop art.[35] When the translation is of excerpts, what is included and what omitted can be revealing, as Schleif observes in comparing the 1965 version of the interview with later ones, of 1970 and 1971. The 1967 Italian translation leaves out this passage:

> When you read Genêt you get all hot, and that makes some people say this is not art. The thing I like about it is that it makes you forget about style and that sort of thing; style isn't really important.[36]

[32] On this translation, see Nina Schleif's chapter in this volume.
[33] Schleif calls attention to how *a: A Novel* fit with the image of the publisher, Kiepenheuer & Witsch (KiWi), as a promoter of avant-garde literature. Among more recent translations of the book is a Czech version, *A: roman*, trans. David Zálesky (Prague: Volvox Globator, 2001).
[34] Gene Swenson, "What Is Pop Art? Answers from 8 Painters, Part I," *ARTnews* 62, no. 7 (November 1963): 26, 60–1.
[35] See the chapters by Öhrner, Schleif, and Guzzetti, respectively, in this volume.
[36] Swenson, "What Is Pop Art?" 61.

> att vara konst. I själva verket var den mycket vacker, kanske litet för bra, eller han känner litet för mycket ansvar för konsten. När man läser Genêt blir man alldeles varm och det får folk att påstå att det inte är konst. Det som jag tycker är bra är att det får en att glömma stil och sånt; stil har egentligen ingen betydelse.

Figure 1.5 "Uttalande av Andy Warhol" [Swedish translation of Gene Swenson, "What Is Pop Art?"], *Bonniers Litterära Magasin* 33, no. 3 (March 1964): 172, detail. Penn Libraries, University of Pennsylvania. Photo: archive of the author.

Whether the choice of the editor, publisher, or translator, the translation's omission of Warhol's response to the homoeroticism of the French writer Jean Genet comes across, from the perspective of today, as a blatant form of censorship. We tend to think of censorship happening in specific places, but the editing that can occur in the process of translation is a reminder that censorship is not necessarily a government-controlled activity.[37] A similar editorial process occurs when Warhol's work and life are translated for television, as Jean Wainwright observes in her chapter on *Andy Warhol's America*: "decisions were made to throw some aspects into sharper focus while leaving out others altogether, either because they were superfluous to the narrative or they did not fit the framework."

Along with publications, the dialogues in Warhol's films have been translated, through the use of dubbing or subtitles, in the form of published scripts, and in the physical transfer from one medium to another. A dubbed version of the sexually explicit and politically charged *Blue Movie*, filmed in 1968 and released in 1969, was screened in West Germany, and the published film script, which came out in the United States in 1970, was published in German just one year later, in 1971.[38] (A published film script is yet another kind of translation.) In "Warhol in French," Jean-Claude Lebensztejn calls attention to the absurdity of using subtitles when the dialogues are often deliberately difficult or impossible to understand in the first place. He

[37] On this point, see Michelle Woods, *Censoring Translation: Censorship, Theatre, and the Politics of Translation* (London: Continuum, 2012), xiv, 3.
[38] See Schleif, "*Schnecken, Schlitzmonger*, and *Poltergeist*" in this volume.

additionally makes note of how the transference of the physical medium of film to video, and, nowadays, to digital, is itself a form of mistranslation in its alteration of the very appearance of the films.

With their sometimes-incomprehensible dialogue, Warhol's films reenact, or perhaps symbolically represent, the gaps in human understanding that occur regularly in the course of human conversation, and, indeed, in translation. This aspect of human coexistence is what Warhol was getting at in *The Philosophy of Andy Warhol* when he claimed to prefer "transmutations" to "transmissions." In "Andy and Julia in Rusyn," Elaine Rusinko associates this statement with Warhol's mother's dialogue in the 1966 film, *The George Hamilton Story* (which was never printed or shown publicly during the artist's lifetime). Rusinko observes that later analyses of the film have made note of Julia Warhola's nearly unintelligible words, and that her conversation with her co-star, Richard Rheem, is "filled with imprecise formulations, misunderstandings, and mispronunciations," and, moreover, that these lacunae are a focus of Warhol's film.

In 1970, Warhol created three video *Factory Diaries* of his mother speaking her native Rusyn. At the time she was quite ill, with few years remaining, as Warhol certainly could see, and the videos gave him a mechanism through which to hold on to and preserve her voice, image, and expression. Rusinko proposes that "Warhol presumably did not anticipate that the tapes would ever be translated. Consequently, they represent private, unmediated interactions between mother and son." The dialogue in these videos, as in *The George Hamilton Story*, takes difficulties of communication as its subject. Rusinko, who is the first person to have translated the language in these videos, points out that in one of them, Julia Warhola frequently asks her son, "do you understand?" (*rozumish?*). In another, she asks, now in English, "What's there, Andy? He understand, Andy? Nobody understand. I not happy, Andy." These words poignantly capture the basic need and desire to be understood and the frustration that results when understanding appears unattainable.

The importance of translation for understanding also concerns the way elements of identity are either revealed or concealed through the choices of translators and publishers. In "Warhol in Translation, Stockholm 1968," Annika Öhrner suggests that Warhol's exploration of gender identity in his films could be discussed more openly in Sweden in the late 1960s than in the United States, an example being a 1968 newspaper article by the artist Öyvind Fahlström. In France, the excerpts of *a: A Novel* that were translated in 1970 appeared with a title and imagery that served to emphasize gay content: "How to Become a Professional Homosexual" ("Comment devenir un homosexuel professionnel") (see Figure 2.2). Around the same time,

in India, the artist Bhupen Khakhar, by imitating Warhol's approach to persona, almost seems to suggest that "how to become" is to perform. This kind of translation-through-doing corresponds with the idea of the poet, literary scholar, and translator A. K. Ramanujan that "only a poem can translate a poem," Deven M. Patel proposes in "Translating Warhol to India" (see Figure 8.3). The cover of the 1983 Italian translation of *The Philosophy of Andy Warhol* (Figure 4.1) might be understood, like the French "Comment devenir un homosexuel professionnel," as foregrounding Warhol's exploration of sexual identity.

These perspectives on Warhol's identity have not always advanced forward in translations of his books, even in the twenty-first century. The 2007 French translation of *POPism* "normalizes" Warhol, as Jean-Claude Lebensztejn puts it, with "queers" becoming "weirdos" (*ces types bizarres*), for example. The idea of "normalizing" is echoed in Nina Schleif's observation that the German edition of *POPism*, coming late in the chronology of Warhol translations, fit into an understanding of Warhol "as mainstream—as history."[39]

Lebensztejn reveals how translation can be akin to censorship, whether conscious or otherwise. This by-product of translation has aptly been called "tacit censorship," whereby, as the German scholar of English-language literature Elisabeth Gibbels observes, "tiny changes … set the tone," in particular when the work in question is positioned "on the boundaries of the sayable."[40] As another literary scholar, Max Kramer states, a "queer projection … is bound to uncover a particularly intense *living-on* of denial and censorship in the translated texts of the modern period."[41] Kramer gives as an example the reference to someone's eyes (*Ses Yeux*) in Arthur Rimbaud's poem "Vowels" ("Voyelles," first published in 1883), translated variously to be the eyes of a woman, a man, God, or a child. When the text in question is less ambiguous, as in Warhol's "queers," the censorship resulting from the mistranslation seems less understandable. Not translating at all is also a form of censorship, of course. In certain times and places, such as Portugal

[39] In a previous work, Lebensztejn observed a similar "effet de normalizer" in the translation of Warhol's interviews: "Zennish (Peel Slowly)," *Les Cahiers du Musée National d'Art Moderne* 97 (Autumn 2006): 21.
[40] Elisabeth Gibbels, "Translators, the Tacit Censors," in *Translation and Censorship: Patterns of Communication and Interference*, ed. Eiléan Ní Chuilleanáin, Cormac Ó Cuilleanáin, and David Parris (Dublin: Four Courts Press, 2009), 61. Gibbels discusses many fascinating examples of the changes in tone produced in four distinct translations from English into German of Mary Wollstonecraft's *A Vindication of the Rights of Woman* (1792).
[41] Max Kramer, "The Problem of Translating Queer Sexual Identity," *Neophilologus* 98, no. 4 (October 2014): 543.

under the dictator António de Oliveira Salazar (r. 1932–68), Warhol's work (and contemporary art from the United States generally) would have been prohibited, and art critics learned about it through travels to France or Italy.⁴² In the Spain of Francisco Franco (r. 1939–75), by the early 1960s, when Pop art emerged in the United States, and as politically motivated cultural exchanges between the two countries were being pursued, news about Warhol's art entered the country.⁴³ A fascinating study of contemporary art by Simón Marchán Fiz, first published in 1972, contains a chapter on Pop art that, interestingly, includes quotations from Gene Swenson's 1963 interview with Warhol (and with other artists), and even the passage on how style is not important (*"el estilo no es realmente importante"*)—omitting the part with Genet's name.⁴⁴ Perhaps revealingly, no images were included in the book.⁴⁵ And *a: A Novel* or *Blue Movie* would have been stopped by the censors.⁴⁶ The earliest one-person show of Warhol's art in Madrid seems to have occurred two years after Franco's death, in 1977 at the Buades gallery.⁴⁷ *The Philosophy of Andy Warhol* was first published in Spain in 1981 (Figure 1.6). The cover featured a dollar bill with Marilyn Monroe's face replacing George Washington's, corresponding with Marchán Fiz's association of what he (and many others at the time) viewed as the impersonal aspect of Pop art with capitalism,⁴⁸ and foreshadowing the design of the 1990 Italian edition (Figure 1.3).

[42] See Pedro Lapa and Sofia Nunes, "A Difficult Gap: The Reception of American Art in Portugal 1945–1990," in *Hot Art, Cold War—Southern and Eastern European Writing on American Art 1940–1990*, ed. Claudia Hopkins and Iain Boyd Whyte (New York and London: Routledge, 2020), 3–11.

[43] Javier Ortiz-Echagüe, "'A Truly Extraordinary Experience of an Unknown World': From American Pop to Neo-Expressionism in Spain 1963–1989," trans. Antonio Romero Limón, in *Hot Art, Cold War—Southern and Eastern European Writing on American Art 1940–1990*, 69–76.

[44] Simón Marchán Fiz, *Del arte objetual al arte de concepto: Las artes plásticas desde 1960* (Madrid: Alberto Corazón, 1972), 40. Marchán Fiz quoted other passages from the Swenson interview to show that Warhol's was an extreme example of the impersonal aspect of Pop, which he proposed was the case in both Warhol's theory and his art (*Del arte objetual*, 52).

[45] A later edition is illustrated but with no Warhol works (6th ed., Madrid: Akal, 1994). In this and other later editions, writings and manifestos were added, including the Swenson interview with Warhol, but the passage about Genet was still left out (*Del arte objetual*, 6th ed., 353–4).

[46] See, for example, chapter 3, "Convulsive Memory: The Spanish Civil War and Post-Franco Spain," in Inez Hedges, *World Cinema and Cultural Memory* (London: Palgrave Macmillan, 2015), 50–64.

[47] According to Ortiz-Echagüe, this show was underfunded and had little impact ("'A Truly Extraordinary Experience,'" 74).

[48] Marchán Fiz, *Del arte objetual*, 52–3.

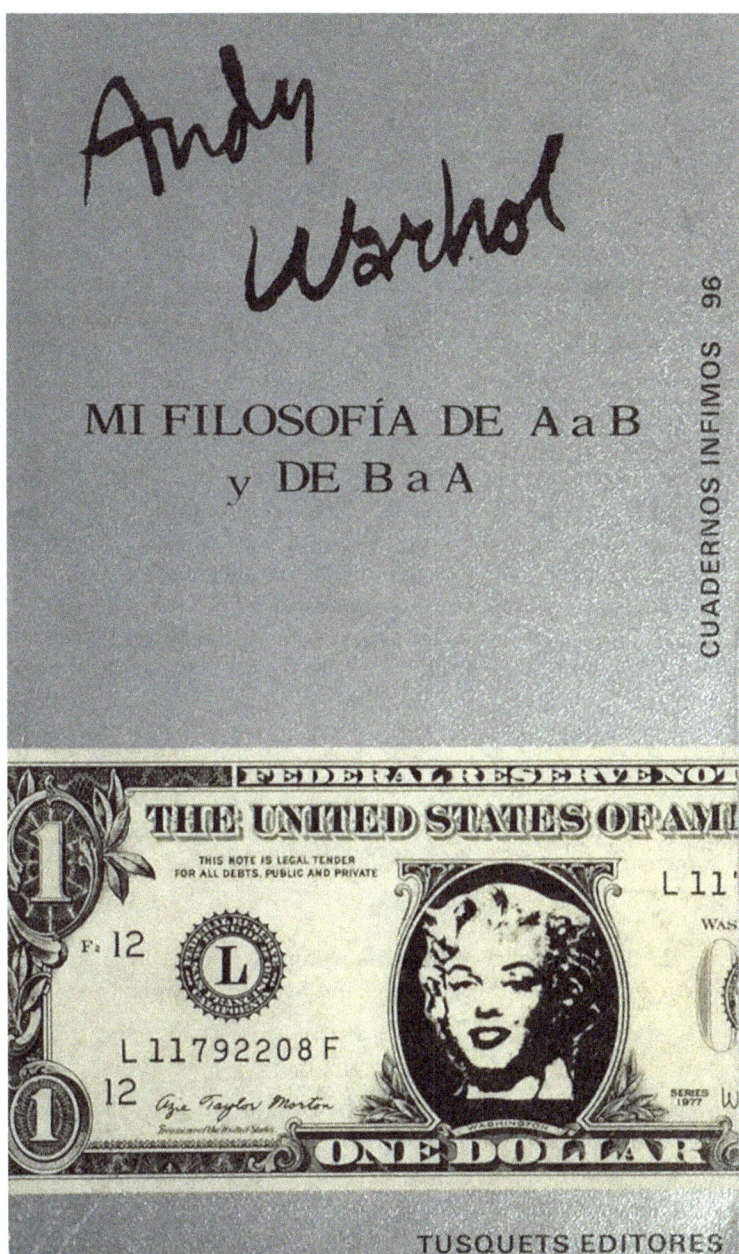

Figure 1.6 Andy Warhol, *Mi filosofía de A a B y de B a A*, Spanish translation by Marcelo Covián, front cover. Barcelona: Tusquets, 1981.

Translation and Understanding

The chapters in this book explore in various ways the significance of the etymology and meaning of "to translate." An early analysis of translation, Leonardo Bruni's *De interpretatione recta* (*On Correct Translation*), written in the 1420s, contains in the title the revealing homonym for "interpretation," and the word *interpretare* at one time referred to translation; Bruni's treatise was innovative, though, in his use and promotion of the term *traducere* instead of *interpretare* and other terms long in use, originating from the word *duco*, meaning to guide or lead.[49] Jean-Claude Lebensztejn points out that in French, in the *Littré* dictionary, the first meaning of *traduire* is "to transfer." To transfer is to move, but its meaning might extend to "transference." Lebensztejn observes, elsewhere in his study: "It is in their lapses and failures that translators insert their own fantasies." Cultural "transfer," understood as a form of translation by the historian Michel Espagne, is the framework within which Annika Öhrner situates her discussion of the 1968 Warhol exhibition in Stockholm. In the same spirit, Deven M. Patel brings to the discussion "transposition," underscoring A. K. Ramanujan's assertion that "translations are never finished, only abandoned."

When Ai Weiwei celebrated the "easy" language in Warhol's *Philosophy* book, he envisioned the writing as symbolic of a particular spirit of democratization that he saw in Warhol:

> I think Warhol would have dreamed to have the Internet. If you study Andy Warhol's philosophy from A to Z and back again, then every sentence is like a Twitter sentence. It's very interesting, light communication; not old democratic, but new democratic. That's very important.[50]

When the first translations of Warhol's writings into other languages were being produced, similar conceptions of him were circulating and these ideas

[49] Belén Bistué, "On the Incorrect Way to Translate: The Absence of Collaborative Translation from Leonardo Bruni's *De interpretatione recta*," in *Collaborative Translation: From the Renaissance to the Digital Age*, ed. Anthony Cordingley and Céline Frigau Manning (London and New York: Bloomsbury Academic, 2017), 34. In discussing the importance of Bruni's use of *traducere*, Bistué draws on the work of Gianfranco Folena, *Volgarizzare e tradurre* (Turin: Einaudi, 1991).

[50] Pryor, "The Radical Influence of Drella." On the correspondences between Warhol and Ai, see *Andy Warhol / Ai Weiwei*, ed. Max Delany and Eric C. Shiner (Melbourne: National Gallery of Victoria; Pittsburgh: Andy Warhol Museum; and New Haven, CT: Yale University Press, 2015).

sometimes affected the results. Nina Schleif observes, in her discussion of early German translations, that the dream of a democratic art partly inspired them. The vison of Warhol as an equalizer resonated with West German audiences because it had an air of familiarity, easily associated with the ideas of the so-called Frankfurt School or with Joseph Beuys's dictum, "everyone is an artist." In Sweden, Annika Öhrner suggests, Warhol was "translated" in the context of a similarly socialist spirit. Öhrner notes that when the 1968 Warhol exhibition opened in Stockholm,

> issues of repetition, of art and democracy, of original and copy, were already cherished themes in the Swedish cultural debate and among artists, as illustrated by *Multikonst*, an exhibition [of 1967] which had an immense impact through the televised circulation of its openings, art, and ideas.

Öhrner explains how the use of reproduction in *Multikonst* was a means by which to create art that would be affordable to all and suggests that this spirit encouraged the focus on repetition in the Warhol show at the Moderna Museet in Stockholm one year later. Alternatively, the shifting winds of culture and politics led to a revised perception, or a "disturbance" (*turbamento*), in the 1980s, whereby in the writings of the art critic Germano Celant, Francesco Guzzetti observes, Warhol becomes the paradoxical "Marx" of Pop art, celebrating the very aspects of capitalism (stars, businessmen, models, boxers, rock singers) that Beuys or the *Multikonst* artists had rejected, at least on the surface.

Perhaps a nagging question has remained in the back of the reader's mind while moving through this discussion: isn't it the case that Warhol didn't actually write "his" books or even utter some of the words in published interviews? Therefore, why bother to study translations of what is not, may not be, or perhaps only partially captures the artist's own voice? The answer to this question, as suggested at the start of this chapter, is that while Warhol's books and interviews are collaborations, in various ways, they are also "by" Warhol, and about him and in his voice (however performative that voice might be). Warhol's books and interviews should not be understood as being either by him, or not, but as something messy, a mixture. Furthermore, the debate about whether the publications should be considered his has continued for some decades; maybe it is ready to be declared exhausted.[51] *Translating*

[51] A recent article to delve into this ongoing conversation is Carmen Merport Quiñones, "Reading Color: Looking through Language in Warhol," *Criticism* 59, no. 4 (Fall 2017): 511–38.

Warhol provides an example of how the conversation might shift direction entirely. Many questions regarding the relationship between Warhol's writings and his visual art remain virtually unexplored, including, until now, the history and significance of the numerous translations of his words. *Translating Warhol* opens the door to this extensive and fascinating field of inquiry and suggests a wide range of possibilities for further exploration. One of these is the consultation of translators' and authors' archives, which can provide great insight into the decisions translators make.[52] What these archives reveal about the collaborative element often involved in the translation process is another promising avenue.[53] The translations of Warhol extend his collaborative approach to crafting language as a way to transmute and yet also to promote the human understanding Julia Warhola pleaded for in the *Factory Diaries*, and that, in the end, we all seek.

[52] On this point, see Woods, *Censoring Translation*, 33.
[53] See Anthony Cordingley and Céline Frigau Manning, "What Is Collaborative Translation?" in *Collaborative Translation*, 1–32.

2

Warhol in French

Jean-Claude Lebensztejn

Translated from French by Mercedes Rooney

A translator is like a violinist. I believe it was the composer Camille Saint-Saëns who said, "All violinists play off-key, but some overdo it." To translate is to play more or less off-key the music of a text. Translating in tune is entirely impossible.

To translate Warhol into French seems easy. His style, polished by the indispensable Pat Hackett, who often worked as his editor, appears to flow naturally, and France—or rather Paris, with its tradition of frivolous luxury—has remained a welcoming ground for his art and his ideas since the famous interview that Gretchen Berg published in 1966 that *Cahiers du cinéma* translated two years later.[1] French editions followed of *The Philosophy* (1977), the *Diaries* (1990), the *Selected Interviews* (2005), and *POPism* (2007).[2] His

A version in French, "Warhol en traduction," is included in Jean-Claude Lebensztejn, *Propos filmiques: En pure perte*, ed. Enrico Camporesi and Pierre Von-Ow (Paris: Éditions Macula, 2021), 181–99.

[1] Andy Warhol, "Rien à perdre," *Cahiers du cinéma* 205 (October 1968): 40–7 (translation anonymous). It is taken as a given that Warhol's published interviews and his other publications are collaborations. See the discussion by Reva Wolf in "Being, Nothingness, and the Quest to Understand: An Introduction to Warhol in Translation," in this volume. Regarding the Gretchen Berg interview, see Matt Wrbican, "The True Story of 'My True Story,'" in *Andy Warhol: A Guide to 706 Items in 2 Hours 56 Minutes, Other Voices, Other Rooms*, ed. Eva Meyer-Hermann (Rotterdam: NAi Publishers, 2007), 00:56:00–00:57:00, and Gary Comenas, https://warholstars.org/Warhol_Danto_2.html. Paris's embrace of Warhol is underlined by Victor Bockris in the opening pages of *Warhol: la biographie*, trans. Emmanuelle and Philippe Aronson (Paris: Globe, 2015), 9–11.

[2] *The Philosophy of Andy Warhol (From A to B and Back Again)* (New York and London: Harcourt Brace Jovanovich, 1975), rendered in French as *Ma philosophie de A à B et vice-versa*, trans. Marianne Véron (Paris: Flammarion, 1977); *The Andy Warhol Diaries*, ed. Pat Hackett (New York: Warner Books, 1989), published in French as *Journal*, trans. Jérôme Jacobs and Jean-Sébastien Stelhi (Paris: Grasset, 1990); *I'll Be Your Mirror: The Selected Andy Warhol Interviews*, ed. Kenneth Goldsmith (New York: Carroll and Graf, 2004), appearing as *Entretiens: 1962-1987*, trans. Alain Cueff (Paris: Grasset, 2005); *POPism: The Warhol '60s* (New York: Harcourt Brace Jovanovich, 1980), published in French as *Popisme: Les années 1960 de Warhol*, trans. Alain Cueff (Paris: Flammarion, 2007).

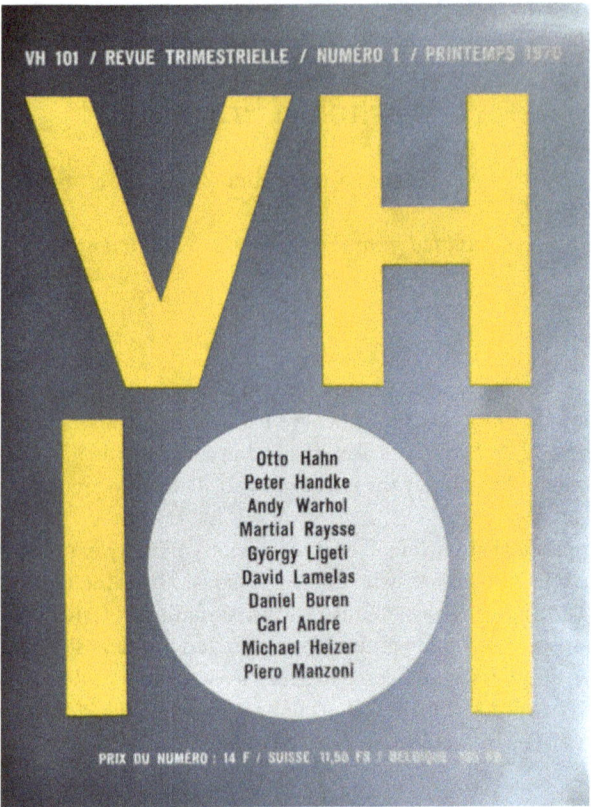

Figure 2.1 *VH 101* 1 (Spring 1970), front cover. Photo: archive of the editor.

novel *a* belongs to the earlier era of the Berg interview, 1965–8, and its soft rumblings fueled by amphetamines are hardly intelligible; nonetheless, excerpts were translated in 1970 in the first issue of the journal *VH 101*, under the direction of the art critic Otto Hahn and Françoise Essellier (Figures 2.1 and 2.2), and in 1975 in *L'Énergumène*, a periodical created by the art historian Gérard-Julien Salvy.[3]

Before looking into particular details of these publications, I would like to consider the translations of Victor Bockris's biography of Warhol,

[3] "Comment devenir un homosexuel professionnel," *VH 101* 1 (Spring 1970): 34–59 (various extracts, illustrated, trans. S. T.-M.); "quelque part dans la 8e rue," *L'Énergumène* 6–7 (June 1975): 45–59 (section 2/2, trans. Zéno Bianu). Many thanks to Hervé Vanel and to Patrick Javault for alerting me to these publications.

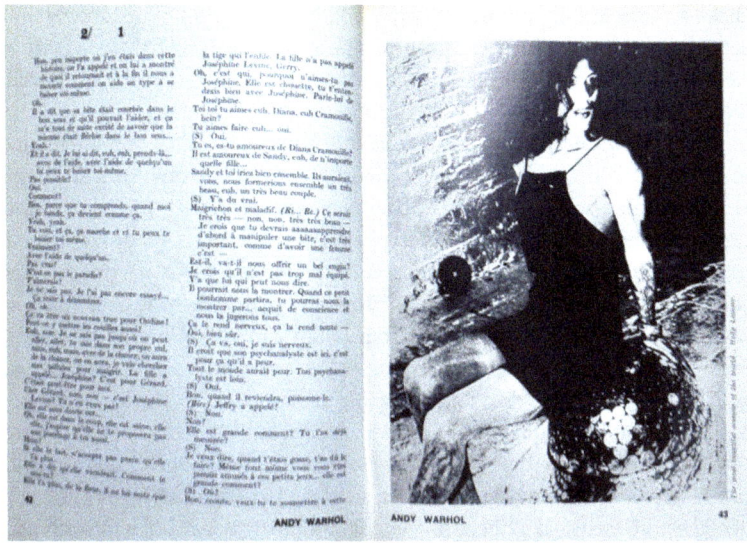

Figure 2.2 Andy Warhol, "Comment devenir un homosexuel professionnel" (excerpts from *a: A Novel*), *VH 101* 1 (Spring 1970): 42–3. Photo: archive of the editor.

originally published in 1989 and released in two different versions, one of them notably abridged.[4] It is clear that the shorter edition, and, in following, the first French translation, excluded a number of testimonies, purging recounted statements, such as of the sodomizing of Warhol by the well-endowed Ed Wallowitch ("Andy took it up the ass a lot"), or his exchange with his friend Brigid Polk after the death of his mother in 1972, a death about which he never spoke with anyone and that took him to the brink of a nervous breakdown: "I change channels in my head, like on TV. I say: 'She went to Bloomingdale's.'"[5] His mourning thus becomes a pop reality TV

[4] Victor Bockris, *Warhol* (London: F. Muller, 1989), 528 pages, and in a paperback edition (London: Penguin Books, 1990), 660 pages; abridged American edition, *The Life and Death of Andy Warhol* (New York: Bantam Books, 1989), 392 pages. The translation by Pascale de Mezamat published by Plon in 1990 (*Andy Warhol*, 374 pages) follows the short version by Bantam, but removes its index. The 2015 translation by Emmanuelle and Philippe Aronson, *Warhol: La biographie*, is based on the complete edition re-released by Da Capo Press in 1997, and contains 592 pages with several deletions and without an index.

[5] Bockris, *Warhol*, Penguin edition, 148–9, 440.

show, an opportunity to put into practice his glorification of distancing and artificiality. Isn't art the ultimate medium to master life? "I think," Warhol said shortly before his death, "an artist is anyone who does something well, like if you cook well."⁶

The first translation of Bockris's biography contains some curious ineptitudes. Warhol claimed that when he arrived in New York in 1949, he had planted some bird seeds (in French, *graines d'oiseau*) in a park and proposed the idea that magazines place advertisements to order a bird. In English, "bird seeds" can mean seeds for feeding birds or, understood with a twist, incorrectly, "seeds" for growing birds (which, it goes without saying, do not exist). The French translation cannot convey this comical ambiguity; in the translation, these seeds became *graines pour les oiseaux*, which made the story incomprehensible.⁷ The art critic David Bourdon's comparison of the full lips featured in Warhol's 1970s portraits to those of Joan Crawford in the 1940s was cited in the full English edition and summarized in the abridged version; in the Plon translation, the full lips become a nonsensical gibberish whereby in the 1940s Warhol had scribbled the lips of the celebrity.⁸ During an interview with his fellow Pop artists Roy Lichtenstein and Claes Oldenburg, recorded in 1964, Warhol answered Bruce Glaser, who was asking him how he had become involved in Pop art imagery, with: "I'm too high right now. Ask somebody else something else." The aristocratic translator, perhaps unfamiliar with the language of recreational drug use, interpreted the first words, "I'm too high right now," as "I'm too high-ranking now" (*Je suis trop haut placé à présent*).⁹ In the translation from 2015, Emmanuelle and Philippe Aronson correct this wording (*Là, je suis trop défoncé*), but still keep the *graines pour les oiseaux*.¹⁰

That is not to say the new translation always sounds accurate. Sometimes, it is just a case of unfamiliarity with the "New York scene," within which Lichtenstein was branded "coy" and "tight," translated into French as *couard* ("cowardly") and *coincé* ("uptight"), but which would be more aptly rendered as *évasif* and *secretive*.¹¹ Other times, it's a matter of disregarding

[6] Paul Taylor, "The Last Interview," *Flash Art* 20, no. 133 (April 1987), in *I'll Be Your Mirror*, 389; *Entretiens*, 392.
[7] Bockris, *Warhol*, Penguin edition, 91; Plon edition, 60.
[8] Bockris, *Warhol*, Penguin edition, 461–2; Bantam edition, 285; Plon edition, 286.
[9] Bockris, *Warhol*, Penguin edition, 91, 199; Plon edition, 60, 131. This four-person interview was broadcast on the radio in 1964 and first published as "Oldenburg, Lichtenstein, Warhol: A Discussion," *Artforum* 4, no. 6 (February 1966): 20–4. It is not included in *I'll Be Your Mirror*.
[10] Bockris, *Warhol*, Globe edition, 188 and 88.
[11] Bockris, *Warhol*, Penguin edition, 197; Globe edition, 186.

the geographic reality of North America to extend the "hundreds of miles" separating Pittsburgh and New York to "thousands of kilometers."[12] And yet, Philippe Aronson is a New York native.

The exhibit of Warhol's work at the Stable Gallery in November 1962, which really launched his career, was accompanied by a press release written by a female student from Bennington College (a women's college until 1969); however, the translation of 2015 changed her into a male student and Leo Castelli's "wolfish smile" was transformed into a "wolf's eye" (*œil de loup*).[13] Max's Kansas City, the artsy nightclub and restaurant on Park Avenue South, changes into "a popular nightclub in Kansas City," but later returns to New York City.[14] The "old queen" in the movie *My Hustler* becomes the *vieille reine* or "elderly queen" instead of *vieille folle*, and the famous "phoney" in the *Chelsea Girls* is converted into *fausset* or "falsetto" (a misprint of *fausseté*— "falsity"?).[15] All this, without even beginning to count the violations of common sense, whether in English or French, such as, *Gerard était la seule face d'une pièce. Billy et moi étions l'autre*, which would translate, literally, "Gerard was the only side of a coin. Billy and I were the other."[16]

Such blunders speak volumes about the backroom of the art publishing world. In France, lacking the luxury of American university presses and an interest beyond a small circle of connoisseurs, well-established publishers mostly release only safe blockbusters, with little concern for the quality of the work as long as the translation job (rather underpaid) is completed at top speed. The other details of production are along the same lines. In the first book by Warhol to be translated into French, *The Philosophy of Andy Warhol (From A to B and Back Again)*, the mere removal of the blank lines separating his various reflections—just as we sometimes get rid of film leaders in three-minute movies—is enough to trivialize the whole project.

When the responsible party is not a professional translator, but rather an art critic or a historian of twentieth-century art, as in the case of Alain Cueff, curator of an exhibition at the Grand Palais of Andy Warhol's portraits and author of the book *Warhol à son image* (2009) containing a thesis on the Christian sources of Warhol, things become interesting. In *POPism*, Warhol declares that when he arrived at a party of mainly Abstract Expressionist painters, "suddenly the noise level dropped," whereas in Cueff's translation, "the noise level picked up" (*le niveau sonore s'éleva*).[17]

[12] Bockris, *Warhol*, Penguin edition, 90; Globe edition, 87.
[13] Bockris, *Warhol*, Penguin edition, 181; Globe edition, 173.
[14] Bockris, *Warhol*, Globe edition, 286 and 308.
[15] Bockris, *Warhol*, Globe edition, 257 and 282–3.
[16] Bockris, *Warhol*, Globe edition, 228.
[17] *POPism*, 34; *Popisme*, 63.

At times, the result betrays a haste or an amnesia that even extends to omitting entire sentences (for example, "'Elliot Pratt is a left-wing liberal who hates McCarthy,' De explained").[18] Lupe Vélez, the "Mexican Spitfire" (whose suicide was memorialized by Kenneth Anger and Andy Warhol), in French becomes *la virago mexicaine* or the "Mexican hag."[19] When Warhol declares, "I was thrilled to finally have a show of my own in New York" in the fall of 1962 (transformed into the winter of 1962 in the French version), Alain Cueff, who knows full well that Warhol is originally from Pittsburgh, confuses "my own" with "show in New York": *j'étais très heureux d'avoir finalement une exposition dans ma propre ville* ("I was thrilled to finally have a show in my home town").[20]

On several occasions, Cueff's translation reveals an infelicitous relationship with what he calls *les gamins*, or "kids." The English designer Nicky Haslam claimed in 1963 that the United States did not really have youngsters: "kids here went from being juveniles straight into 'young adults,' whereas in England the kids eighteen and nineteen were having a ball. Or starting to, anyway—it was a new age classification." In Cueff's translation, *ici les gamins passaient directement de l'adolescence à l'âge adulte, tandis qu'en Angleterre les gamins de dix-huit ou dix-neuf ans baisaient pas mal—ou commençaient, en tout cas* ("kids here went from being juveniles straight into 'young adults,' whereas in England the kids eighteen and nineteen screwed around quite a bit. Or were starting to, anyway").[21] Fucked quite a bit? Doesn't the translator confuse "to have a ball," or to party, with "to ball," or to fuck? Besides, translating "kids" as *gamins* or "street kids" seems restrictive and does not correspond to the Warholian classification.

In his translation of the selected Warhol interviews, Cueff calls "high school student," "high school junior," and "high school graduate," *étudiant* or *diplômé d'une grande école*, confusing the traditional US high schools, or secondary education establishments, with the prestigious university and graduate-level *grandes écoles* in the French educational system (such as the École Normale Supérieure, Polytechnique, and so on), and conversely, the American college with the French *collège*, or middle school.[22] To call a young teenage boy who came to interview the famous

[18] *POPism*, 30.
[19] *POPism*, 127; *Popisme*, 167.
[20] *POPism*, 25; *Popisme*, 51.
[21] *POPism*, 28; *Popisme*, 55.
[22] *I'll Be Your Mirror*, 63, 119, 170; *Entretiens*, 79, 132, 181. See also *POPism*, 218, and *Popisme*, 270: "Fred was in a collegiate outfit"; *Fred portait un costume de collégien* ("Fred was wearing a middle school uniform"). (Yet elsewhere, Cueff correctly translates "high school" as *lycée*; see *Entretiens*, 117.)

artist for a school newspaper "student" certainly changes the situation and the tone of the scene, especially because, on that occasion, Warhol insistently interrogated his interrogator, Joseph Freeman, fourteen at the time of the interview, about the color of his eyes. Freeman–Little Joey–was quickly integrated into the Factory and Warhol included the interview, which first appeared in the Freeman's Brooklyn high school newspaper, in *Andy Warhol's Index (Book)*.[23]

Joey Freeman made several appearances in *POPism*. He ran errands and picked up Warhol at his home at 11:30 a.m. to get him to the Factory. (According to his own testimony, Freeman and a friend used to phone Warhol on Sunday mornings. "He was at home then and he loved talking on the phone. He'd talk for hours. We'd say: 'What are you doing, Andy?' and he'd say: 'Oh, I'm sucking cock.' I mean, we fell about."[24])

Under Alain Cueff's pen, we witness several transformations of Little Joey. On page 170 of *Popisme*, he is introduced as "a brilliant petite female student with a mop-top haircut," but twenty-two pages later, now fifteen years old, Joey becomes "the gofer of the Factory"; he had grown a few inches and lost his baby fat. Freeman recalled that Warhol insisted he call him "mother,"[25] but his real mother was always asking him, "What do you want to hang around with all those queers for?" translated by Cueff as, *C'est quoi l'idée d'être toujours fourré avec ces types bizarres* ("queers" becoming "weirdos").[26]

Here translation becomes a kind of magic operation, a series of unexpected and incoherent metamorphoses, comparable to the tricks the magician dog performs on the opera singer dog in Tex Avery's cartoon *Magical Maestro* (1952). Cueff's magic trick was of relevance at a time when the growing taboo of pedophilia went hand in hand with the acceptance and normalization—at least among liberals—of adult same-sex relationships. But Cueff's taboos go a step further. In Warhol's last interview, the Australian art critic Paul Taylor mentions a novel by Stephen Koch, in which the hero, according to Cueff's translation, is *un type hétérosexuel, genre Rauschenberg dans les années soixante, un artiste charismatique* ("a heterosexual guy, a Rauschenberg type of the sixties, a charismatic artist"), yet, Rauschenberg's homosexuality was notorious in artistic circles (he had previously lived with Jasper Johns), and in fact Paul Taylor describes Koch's hero as "a heterosexual Rauschenberg figure" (in other words, like Rauschenberg, but heterosexual).

[23] *I'll Be Your Mirror*, 118; *Entretiens*, 131.
[24] Stephen Smith, "'He Loved Weightlifting and Buying Jewels': Andy Warhol's Friends Reveal All," *The Guardian*, August 14, 2015.
[25] See Gary Comenas's website: http://www.warholstars.org/andy_warhol_0710.html.
[26] *POPism*, 129, 149, 173, 205; *Popisme*, 170, 192, 218–19, 255.

Elsewhere within the book of interviews, two high school juniors ask Warhol his opinion on prep schools as they prepare their interview for the newspaper of the Gunnery School for Boys, a private institution in Connecticut for children from well-to-do families. Warhol answers, "I think they're really ... ah ... terrific. All the kids are always so pretty," which Cueff translates, *Tous les gamins ont toujours de bonnes têtes* ("Kids that age always look like good people").[27]

I do not want to give the impression that these translations are to be ignored. First of all, they exist. They read easily and give a good sense of the tone of Warhol and his biographer. But their inadequacies are worth noting. It is in their lapses and failures that translators insert their own fantasies ("I'm too high-ranking now"), their own image of Warhol, of contemporary culture, or of the world in general. The case of Alain Cueff is exemplary, and it poses a real problem. Is it due to ignorance, choice, or a strange combination of both that Cueff misses this or that fact in the texts he translates? At times, his ignorance is obvious, as seen in the nonsense he inflicts on the German journalist asking Warhol about the young flocking around him, "This is what interests me and it interests me what it does to you," which Cueff changed to *C'est ce qui m'intéresse et ça m'intéresse ce que vous faites* ("This is what interests me and I am interested in what you do").[28]

Elsewhere, the effort Cueff takes to erase the homosexual factors from the art world is striking, as in the *type hétérosexuel, genre Rauschenberg*. Kenneth Goldsmith, in his introduction to Warhol's last interview, with Paul Taylor, mentions the fact that Taylor died of AIDS at the age of thirty-five; Cueff discloses the death, but not the cause.[29] Above all, describing Little Joey as "a brilliant petite female student," then a gofer at the Factory (at the age of fifteen, having "grown a few inches and lost nine pounds of baby fat"), who does not hang around queers but weirdos, is truly weird.

Alain Cueff's book, *Warhol à son image*, is intent on highlighting Warhol's religious side, even at the expense of the clichés that Warhol himself had embraced. What if Warhol's film *Blow Job* (1964), for example, had nothing to do with oral sex (Figure 2.3)?

> What if nothing was happening in the famous and widely theorized off-screen scene? What if the peculiar off-screen setup was but the space of pure fiction? A perfect absence of action which in fact feeds fiction and

[27] *I'll Be Your Mirror*, 385, 175; *Entretiens*, 388, 186.
[28] *I'll Be Your Mirror*, 124; *Entretiens*, 137.
[29] *I'll Be Your Mirror*, 382; *Entretiens*, 386.

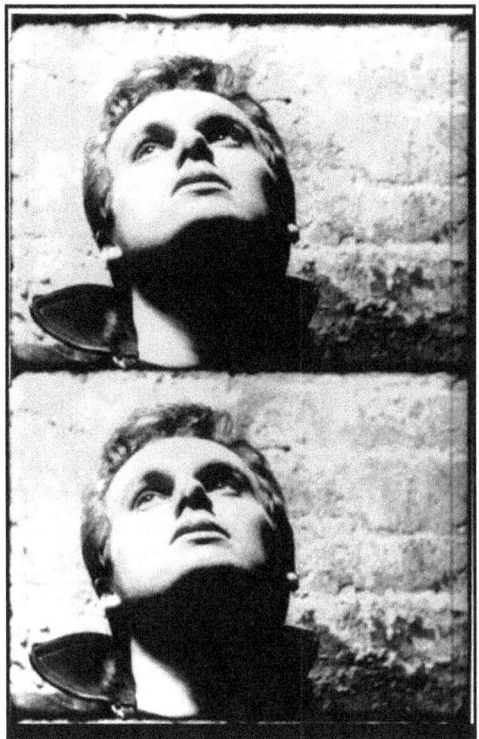

Figure 2.3 Andy Warhol, *Blow Job*, 1964, 16 mm black-and-white silent film, 41 minutes at 16 fps, two frames. Photo: archive of the author.

thought. ... This is clearly not a "pipe."[30] Had it been a "pipe," the movie would never have been conceived or produced.[31]

He points out that the head in the close-up shot belongs to an actor.[32] It does not portray sexual pleasure, he proposes; it implores and agonizes, or rather

[30] In French slang, a blow job is commonly referred to as *une pipe*—literally, "a pipe." Alain Cueff plays on the word "pipe," alluding to the famous *ceci n'est pas une pipe* of René Magritte's painting, *The Treachery of Images* (1929). Translator's note.

[31] Cueff, *Warhol à son image*, 156–7.

[32] The "actor" of *Blow Job*, who had long remained unidentified, was indeed an actor, DeVeren Bookwalter (1939–87). He performed on stage (in Shakespeare, and in *Cyrano de Bergerac*), in movies (*The Omega Man* and *The Enforcer*), and on television. He also appeared in a Warhol screen test film of 1964, reused in *The Thirteen Most Beautiful Boys*; see Callie Angell, *Andy Warhol Screen Tests* (New York: Abrams, in association with the Whitney Museum of American Art, 2006), 38–9, 41, 247.

it interprets agony, with the eyes turned up to heaven, just like Guido Reni's *Saint Sebastian* (1620–5), a painting "with homosexual connotations that did not escape Oscar Wilde."[33]

Cueff is not the only one trying to bring Warhol back into the fold of Christianity. In 2018, the Vatican Museums had scheduled a Warhol exhibition for 2019 to include the *Skulls* (1976) and paintings from *The Last Supper* series (1986). But it was canceled. Earlier, in 2014, an article published in *Aleteia*, a website promoting Catholicism, tried its best to demonstrate the importance of religion in Warhol's life and works, stating: "Widely believed to be homosexual, he remained celibate and was, according to his closest associates, still a virgin at the time of his death."[34] A more nuanced approach to the role of religion in Warhol's life has been taken in other contexts, including recently for the exhibition, *Andy Warhol: Revelation*, which opened at the Warhol Museum in Pittsburgh in 2019, and was on view at the Brooklyn Museum from mid-November 2021 to mid-June 2022.

These new perspectives speak volumes about what Warhol, his image, and his art, have been subjected to through time. Seen as a worthless non-artist and a provocateur at the beginning of the 1960s, he became one of the best-regarded—and most expensive—painters of his time, while the characterization of his personality as satanic was replaced by another as a devout, and sometimes a sexless, Catholic. The complexity of his art and of his personality allowed for these shifts. To be sure, he manipulated his persona as much as those of others, donning various avatars in rapid succession, which prompted numerous speculations. He embraced different positions, all genuine, including his religious standpoint, yet all problematic. Indeed, what are we to make of the religious faith of a man who says he believes in death after death? Does he believe in God? When asked in 1977, "Do you believe in God?" he replied, "I guess I do. I like church. It's empty when I go," and he added that he sneaks in "at funny hours," that he never thinks about God, and that he does not believe in the devil.[35] An odd believer. Personally, I can picture the religious Warhol of the later years as a man caught in Kafka's vise: "God can only be comprehended personally. Each man has his own life and

[33] Cueff, *Warhol à son image*, 156–7. Cueff later (page 170) mentions the "faces without a face" by Kazimir Malevich and says that he painted them at "the end of the 1930s"—that is, after the artist's death.

[34] Kathy Schiffer, "Andy Warhol's Image Belied His Life as a Faithful Catholic: Find Out Why He May Have Been a Better Christian Than You Are," *Aleteia* 5 (November 2014), https://aleteia.org/2014/11/05/andy-warhol-a-celibate-catholic/.

[35] Glenn O'Brien, "Interview: Andy Warhol," *High Times*, August 24, 1977, in *I'll Be Your Mirror*, 253, 258; *Entretiens*, 256, 259–60.

his own God. His protector and judge. Priests and rituals are only crutches for the crippled life of the soul."[36]

Strictly speaking, we have moved beyond the questions of translation, but then again, what does it mean to translate? The first definition of *traduire* that appears in the French dictionary *Littré*, refers to a legal term signifying "to transfer" (a prisoner, a defendant: to prosecute). It is clear that to translate Warhol, and especially to translate him poorly, amounts to having him appear in front of legal religious or cultural authorities that have little to do with him; it means to launch a lawsuit on behalf of normalization, an act which is not without precedent. The operation of expelling a foreign body before absorbing its less toxic form has affected the reputations of many thinkers, writers, and artists, including Charles Baudelaire, who Warhol brings to mind in more than one way; such transmutations are common aspects of the shifting tides in cultural life. As André Gide said of Michel de Montaigne: "The great preoccupation of pedagogues, when they are faced with authors of some boldness, who yet are classics, is to render them inoffensive."[37]

*

Especially difficult to translate are the dialogues of Warhol's sound films. After a series of silent films in 1963 and 1964, Warhol purchased a 16 mm Auricon camera (although the first movie he filmed with it, the eight-hour *Empire*, was silent—"our first 'sound' movie with*out* sound"),[38] and at the end of 1964 he shot a sound movie *with* sound, *Harlot* (with crossdresser Mario Montez). Warhol's subsequent movies, including *Chelsea Girls* of 1966, were all filmed with this equipment.

> The films were shot under the most primitive conditions. The sound was recorded optically, which was inexpensive but often led to garbled, almost inaudible soundtracks. When the soundman on one set protested that the sound was hopelessly unbalanced and the batteries were dying, Andy shot the film regardless.[39]

[36] Gustav Janouch, *Gespräche mit Kafka*, new ed. (Frankfurt: Fischer, 1981), 185; *Kafka m'a dit*, trans. Clara Malraux (Paris: Calmann-Lévy, 1952), 155; *Conversations avec Kafka*, trans. Bernard Lortholary (Paris: Les Lettres nouvelles, 1978), 222.

[37] André Gide, "Montaigne," *Commerce* 18 (Winter 1928), in *Essais critiques* (Bibliothèque de la Pléiade) (Paris: Gallimard, 1999, 684); English translation by Dorothy Bussys, *Yale Review* 28, no. 3 (1939): 93; rpt. *Yale Review*, 89, no. 1 (January 2001): 71.

[38] *POPism*, 90; *Popisme*, 125.

[39] Bockris, *Warhol*, Penguin edition, 304–5; Globe edition, 282.

The unscripted superstars' lines were recorded using this hardly comprehensible medium. The scenes switch from lifeless to hysterical, and grasping their sequence demands intense concentration, difficult to sustain over time even for a native viewer, let alone for someone whose first language is not English. In 1990 a petition was sent to the Centre Pompidou, where a retrospective exhibition of Warhol's work was then on view, requesting subtitles be added to the sound movies, signed by distinguished personalities such as Henri Cueco, Jacques de La Villeglé, Gilles Deleuze, Mikel Dufrenne, Catherine Millet, Dominique Noguez, and Patrick de Haas (who later reconsidered and withdrew his name).[40] It appears the petition was unsuccessful and the movies at the Centre continued to be shown without subtitles. *Chelsea Girls* was later screened with subtitles, specially added for the occasion, at the Cinémathèque française in March 2009 as part of a tribute to Warhol organized by Nicole Brenez.[41] (Previously, in 2003, Raro Video had released a double DVD with closed-captions and subtitles in Italian.)

I guess our film director would have been unmoved by these incidents, but they are not without consequence for the appreciation of the movies. Don't subtitles allow you to hear too much, particularly things normally inaudible? In the absence of subtitles, a French-speaking audience member hears the frequently comical dialogues in varying degrees of garbled utterance based on the abilities and state of mind of each listener, and especially when words are spoken off-screen, as is often the case. Even more than the image, marked by smudges of light and various "accidents," the sound, operating in the interval between noise and meaning, plays on the frustration caused by the resulting gaps in our perception.

The image itself presents its own translation issues. Warhol would insist that his silent films, although shot at 24 frames per second (fps), be projected at the slower speed of 16 frames per second, or "'silent speed.' ... The result is a *ritardando* exerted over all movement and an effect that is extraordinarily alluring. Yet, that allure is faintly paradoxical ..."[42] The speed reduction triggers overlayed textures of the subjects filmed, of the film grain, and of the flicker effect caused by the regular shifts between frame and shutter speed. Yet, at the 2009 screenings of Warhol's films at the Cinémathèque française, both the

[40] On the incident, see *Libération*, June 29, 1990. Many thanks to Patrick de Haas for alerting me to this story.

[41] See Nicolas Villodre, http://www.objectif-cinema.com/spip.php?article5148. I owe this information to Enrico Camporesi.

[42] Stephen Koch, *Stargazer: Andy Warhol's World and Films* (New York and Washington: Praeger, 1973), 43. See also Jonas Mekas, "Revoir les films d'Andy Warhol," in *Andy Warhol, cinéma* (Paris: Carré, in association with Centre Pompidou, 1990), 44–5. (It changes everything, Mekas told Stan Brakhage.)

silent films and the sound movies were projected at the speed of 24 frames per second. The program of April 17, 2009 featured *Blow Job* and the little-known *Eating Too Fast* (aka *Blow Job #2*), ten *Screen Tests* and *Eat*. All these silent films, except *Eating Too Fast*, were projected at 24 frames per second, or "normal speed," as the projectionist put it when I asked him, which decreased the contrast between the two *Blow Jobs*, the first being silent and shot with a Bolex camera with reels two minutes and forty-five seconds long that become four minutes once projected at the slower speed, the second being partly with sound and shot with the Auricon camera with thirty-three-minute reels. "Normal?" The complexity of the textural effects of the silent movies was more or less lost.

The transfer from film to digital format alters not only the visible texture of the film, but also its material basis, substituting the intermittent shift between frame and exposure characteristic of the so-called structural film of Peter Kubelka, Hollis Frampton, or Paul Sharits with another form of discontinuity, somewhat similar to the translation from one language into another. For Kubelka, the difference is crucial, and a digital film is no longer a film, the material itself and its structural basis having disappeared, and it is not even a video. "Those who mimic classical filmmaking with digital technology are mistaken because they sacrifice the possibilities specific to digital media. Playing video games is a thousand times more interesting than watching a movie on a small computer screen."[43]

Patrick de Haas summed up all the arguments against converting film media into a digital format, especially in the case of the experimental films of the 1920s:

> the release of movies in VHS, DVD or Blu-Ray formats reached new audiences. While these "reproductions" are useful, they are also problematic. In the first place, the audience tends to forget that they are watching reproductions, the changes in format, speed, light, and so on resulting in only a pale resemblance to the original work. Indeed, most avant-garde filmmakers of the 1920s devised their works with a specific medium in mind (celluloid film coated with a silver halide emulsion in a sequence of frames), a determined projection technology (reels were cranked at various speeds through sprockets gripping perforations, or sprocket holes, of the reel in a projector equipped with a shutter), and a distinct venue—the movie theater—where individuals collectively watched a work, often silent, projected on a screen of particular size, in the dark. Experimentations, such as the use of negatives or fast cutting

[43] Quentin Papapietro, "Une conversation avec Peter Kubelka," *Cahiers du cinéma* 745 (June 2018): 59.

(sometimes within single frames), only can be fully understood when one considers their connection with the actual materials that generated them. Is it not obvious that these experimentations are ruined when the film is "transferred" to a digital DVD, likely with integrated sound, and viewed on a TV screen sitting on the couch, or glanced at quickly on the wall of a museum in broad daylight? … The switch from celluloid to digital formats also establishes a new relationship to representational images: the substitution of a calculation of individual signs for an indexed luminous photographic impression.[44]

Admittedly, Warhol's "primitive" movies, and particularly his silent movies, avoid a tight editing in favor of a deliberate unedited quality by including the blank film leaders, or "randomly" splicing together three-minute reels end to end, but in their conversion to digital format, what happens to the textural richness of the play between the filmed body and the "body" of the film? As Warhol remarked in 1966, "we're trying to make it so bad but doing it well"; mistakes, scratches, dust, pointless zooms, and so on, were intentionally included, "so that everybody knows that you're watching a film."[45] Four years later, he said, "if you consciously try to do a bad movie, that's like making a *good* bad movie."[46] What was left of that intention after an Italian film editor remastered it?[47] When Paul Morrissey took charge, with Warhol's consent, of the Factory films, Warhol's 1960s movies were removed from distribution in favor of the films with a more conventional narrative that Morrissey directed or co-directed at the end of the 1960s and after 1970. Today, the silent films are mostly screened in museums, often in video format, and when they are shown on reel-to-reel projectors, the projectors are not set to 16 fps but to 18 fps, in order to cut the intermittent strobe lighting effect, even though this effect is part of the structural perception of the work.[48]

[44] Patrick de Haas, *Cinéma absolu. Avant-garde 1920–1930* (Valréas: Mettray éditions, 2018), 9–10.

[45] Lane Slate, "USA Artists: Andy Warhol and Roy Lichtenstein," transcript of a 16 mm film produced by NET (National Educational Television), 1966, in *I'll Be Your Mirror*, 83; *Entretiens*, 96.

[46] Letitia Kent, "Andy Warhol, Movieman: 'It's Hard to Be Your Own Script,'" in *I'll Be Your Mirror*, 189; *Entretiens*, 198. P. Adams Sitney saw in Warhol the "ultimate precursor of structural film"; *Visionary Film: The American Avant-Garde*, 2nd ed. (New York: Oxford University Press, 1979), 371.

[47] *Andy Warhol: 4 Silent Movies (Kiss / Empire / Blow Job / Mario Banana)*, Raro Video, 2005. The eight-hour-long *Empire* is shrunk into 60 minutes, 13 seconds. According to Greg Allen, *Kiss* and *Blow Job* are mastered at a 25 fps instead of 16 fps (https://greg.org/archive/2007/09/14/on-the-mixed-up-films-of-mr-andy-warhola.html). Many thanks to Enrico Camporesi for this reference.

[48] Callie Angell, *The Films of Andy Warhol: Part II* (New York: Whitney Museum of American Art, 1994), 9.

At the time of their production, Warhol's films were mostly shown at the Factory, at Jonas Mekas's Film-Makers' Cinematheque, or at educational institutions that requested them. But in 1966, after it premiered at the Film-Makers' Cinematheque at its location in the West 40s and became a commercial success, *Chelsea Girls* moved to the Cinema Rendezvous on West 57th Street, a shift in distribution that outraged the *New York Times* film critic Bosley Crowther:

> It was all right so long as these adventurers in the realm of independent cinema stayed in Greenwich Village or on the south side of 42nd Street and splattered their naughty-boy pictures on congenial basement screens—or even sent them around to college outlets for the edification of undergraduate voyeurs.
>
> But now that their underground has surfaced on West 57th Street and taken over a theater with carpets, the Cinema Rendezvous, where they have installed Mr. Warhol's most ambitious peep-show put-on, "The Chelsea Girls," it is time for permissive adults to stop winking at their too-precocious pranks.[49]

The issue is the location: this "extensive and pretentious entertainment for voyeurs," as Crowther describes it later in the same article, is reaching affluent neighborhoods; the underground overflows; it no longer maintains itself in the basements that are to contain it. Its rise might well herald the execution after which the dead come back as ghosts to haunt the living. After Andy Warhol's death, his 1963–5 films, having already suffered the purgatory of inaccessibility, resurfaced in the mortuary spaces of museums. The history of Warhol's films is also the history of their multiple translations, the conditions of their reception, and the transmutations that these displacements have brought about.

<p style="text-align:center">*</p>

Translation—moving from one language to another, from one sign system to another, from one state to another—is part of the framework of cultural assimilation. To translate is to make accessible. Errors and deviations are inevitable. To translate means to convey, but to convey what? What does translation filter out of the original language and discourse? The writer

[49] Bosley Crowther, "The Underground Overflows," *The New York Times*, December 11, 1966, excerpted in *POPism*, 185; *Popisme*, 232. Many thanks to Reva Wolf for sending me the complete article. Details can be found at http://www.warholstars.org/chelsea_girls.html and http://www.warholstars.org/andywarhol0409.html.

Pierre de Marivaux (1688–1763) complained about the beautiful infidelities of Nicolas Perrot d'Ablancourt (1606–64), who, in translating Thucydides, explained that a more literal translation would be dull and would not do justice to the ancient Athenian historian:

> In doing so, one could answer, you prejudice the reader who would be enchanted to get to know Thucydides as he was. We imagine we see the Greek author, the ancient author with the thought processes characteristic of his time, and you deform him, wipe out his age; it is no longer Thucydides. He would be dull, you say, if you wouldn't correct him. So what? We would prefer his dullness to your corrections, which we didn't ask for in the first place.[50]

Unfaithful d'Ablancourt was honest enough to warn his readers. When he translated Lucian of Samosata to accommodate modern taste (Figure 2.4), he added notes and comments such as: "I am changing his comparison from

Figure 2.4 *Lucien, de la traduction de N. Perrot, Sr d'Ablancourt* (Paris: Augustin Courbé, 1654), title page. Collection of the University of California, digitized by Google.

[50] Pierre de Marivaux, "Réflexions sur Thucydide" (1744), *Mercure de France*, June 1755, II, 47 and *Journaux et Œuvres diverses*, ed. Frédéric Deloffre and Michel Gilot (Paris: Garnier, 1969), 459.

the Love of Boys, into that of women, which is what I observe everywhere, and also for reasons of public morality, corresponding to his eagerness to please"; "Here is a page of filth removed"; "I do not wish to say another word on the love for boys, nor elaborate on such filth."[51] Cueff does not wish to elaborate either. He avoids the "queers" and "high school juniors," but unlike d'Ablancourt, he keeps it under wraps, as if unaware. We can wonder what he was thinking when he did his translation.

How much emphasis should we place on a few poorly translated words? In the case of artists of Warhol's character, it is the right tone and his deliberate laissez-faire approach that matter. We notice immediately what separates him from those artists who tried to mimic or appropriate his approach, such as Rodney Buice.[52] In Buice's case, it all becomes ordinary and bland, but his slapdash job can serve to satisfy the busy viewer.

In 2003 the Museum of Modern Art presented, at MoMA PS1 in Queens, twenty-eight screen tests transferred from 16 mm to DVD for gallery exhibition, now a common practice in museums and other exhibition venues, even used on Times Square's electronic billboards in May 2015 (Figure 2.5).[53] There is no doubt that Warhol would have welcomed this considerable expansion of the accessibility of his art, its transfer to urban spaces and to the new audiences that it could reach, even at the expense of a significant loss. The issue is not so much the loss but rather the illusion of viewing the same thing, with no significant difference, or with indifference to the differences. We assume we are watching a Warhol movie, just as we assume we are reading his words (already mediatized by the reporters who interviewed him) when we read what translators have transmitted to us. Whether transferred or translated, the flattening out effect is roughly the same. It is the slippery slope of all translations, whatever the language or the medium.

An example: at the start of *POPism*, one reads, in Cueff's translation, "If I'd continued like that and had died ten years ago, I'd probably be a cult figure today" (*Si j'avais continué comme ça et étais mort il y a dix ans, je serais probablement une figure culte aujourd'hui*).[54] Continued like what? Warhol and Hackett open *POPism* with these words: "If I'd gone ahead and died ten years ago, I'd probably be a cult figure today."[55] It would undoubtedly

[51] *Lucien, de la traduction de N. Perrot, Sr d'Ablancourt* (Paris: Augustin Courbé, 1654), I, 648, 633; II, 679.
[52] See the full-page advertisement in *Art in America* 64, no. 3 (May–June 1976), 23.
[53] https://www.moma.org/calendar/exhibitions/142; http://warholstars.org/screen-tests.html#qrrf5.
[54] *Popisme*, 25.
[55] *POPism*, 3.

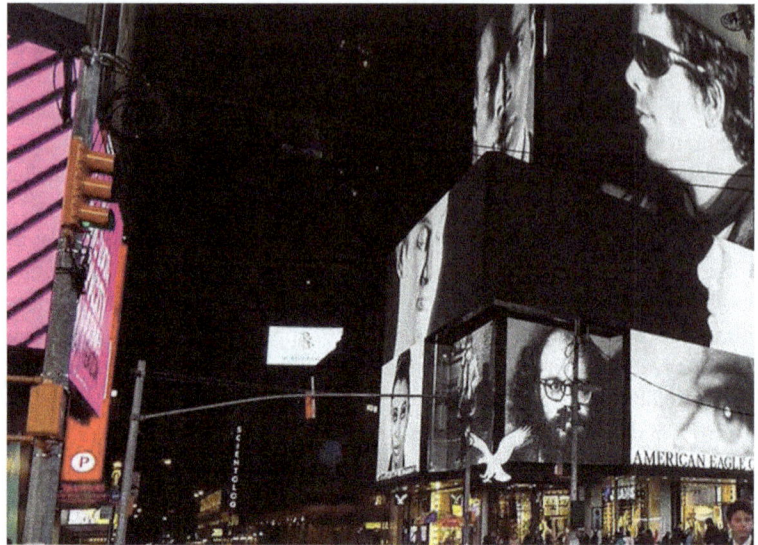

Figure 2.5 Andy Warhol, seven *Screen Tests*, mid-1960s, digital transfers, as projected in Times Square, New York, May 2015. Photo: archive of the author.

be better understood as *Si j'avais continué à être mort* … It is a well-known fact that Warhol was pronounced clinically dead after he was shot by Valerie Solanas on June 3, 1968, until the surgeon performed the open cardiac massage that brought him back to life. This experience (the same one the composer Arnold Schönberg faced twenty-two years earlier) had a profound effect on Warhol. In 1976, the quarterly magazine *Unmuzzled OX* published an interview where this exchange appeared:

> OX: Death was a constant theme in your early works.
> AW: And then, I stopped because I died.
> OX:—because?—
> AW: Then I stopped because I died.[56]

With regard to translating the classics of Chinese thought, the philosopher Feng Youlan (1895–1990) reminded us of this self-evident point:

[56] [Michael Andre], "Andy Warhol's Interview," *Unmuzzled OX* 4, no. 2 (1976): 47. (This interview is not included in *I'll Be Your Mirror*.)

A translation, after all, is only an interpretation. When one translates a sentence from, say, the *Lao-tzu*, one gives one's own interpretation of its meaning. But the translation may convey only one idea, while as a matter of fact, the original may contain many other ideas …
 Kumarajiva, of the fifth century A.D., one of the greatest translators of the Buddhist texts into Chinese, said that the work of translation is just like chewing food that is to be fed to others. If one cannot chew the food oneself, one has to be given food that has already been chewed. After such an operation, however, the food is bound to be poorer in taste and flavor than the original.[57]

Of course, the choice is one of being fed or going hungry. In the case of Laozi as in others, some translations are acceptable to various degrees, and others, appalling; it all depends on the player's abilities and level of commitment to the game. Translation is also an art of connections continually being established between two more or less great distances. For Walter Benjamin,

> It is not the highest praise of a translation, particularly in the age of its origin, to say that it reads as if it had originally been written in that language. Rather, the significance of fidelity as ensured by literalness is that the work reflects the great longing [*die große Sehnsucht*] for linguistic complementation. A real translation is transparent; it does not cover the original, does not block its light, but allows the pure language, as though reinforced by its own medium, to shine upon the original all the more fully.[58]

For his part, Michel Foucault remarked on Pierre Klossowski's overly literal translation of the *Aeneid*:

> The fact is there are two types of translation and they differ in nature and function. Some carry across equivalences of meaning and aesthetic values between languages; it is good when they convey one and the same thing.

[57] Fung Yu-Lan, *A Short History of Chinese Philosophy* (1948), ed. Derk Bodde (New York: The Macmillan Company, 1958), 14–15.

[58] Walter Benjamin, "Die Aufgabe des Übersetzers," 1923; "The Task of the Translator," in *Walter Benjamin, Selected Writings*, vol. 1, *1913–1926*, ed. Marcus Bullock and Michael W. Jennings (Cambridge, MA: The Belknap Press of Harvard University Press, 1996), 260.

Others pitch one language against another, are witness to the collision, take note of the impact, and measure its angle. They consider the source language text as the projectile and the target language text as the bullseye. Their goal is not so much to internalize a foreign meaning but to divert the source language through the target language.[59]

Like all forms of art, all forms of translation should be acknowledged. Languages are marvelous instruments that offer countless ways to perform music, albeit more or less off-key. Therein lies the risk. A translator is the interpreter of a text. We follow along willingly until obvious inadequacies emerge, above all when a lack of linguistic acumen is combined with an unavowed moralism. This is when we are tempted to declare, like Spinoza in his comment about the defenders of the faith, that "the most ignorant are everywhere the most audacious and the most ready to rush into print."[60]

[59] Michel Foucault, "Les mots qui saignent," *L'Express*, August 29, 1964, reprinted in *Dits et écrits I, 1954–1975*, ed. Daniel Defert, François Ewald, and Jacques Lagrange (Paris: Quarto Gallimard, 2001), 453–4.

[60] Baruch Spinoza, letter to Jarig Jelles, June 2, 1674.

3

Schnecken, Schlitzmonger, and *Poltergeist*: Andy Warhol in German—Translations and Cultural Context

Nina Schleif

Judging by the art-historical and art-critical reception in the 1960s, it is fair to say that the West German fascination with Andy Warhol was not solely with his work but also with his persona—by way of his published statements.[1] From the beginning, he was quoted in the West German press and art-historical literature. The German translations of Warhol's texts mirror the evolution of the critical reception he and his art experienced in West Germany over the course of several decades. His most famous interviews did not need to be translated to be understood. His first two books to be rendered in German, on the other hand, posed unique challenges, and were advertised as American avant-garde literature. The titles he is best known for today appeared in translation only after his death.

The way West Germans perceived and discussed contemporary art in the 1960s—the conception even of what qualified as contemporary art—was shaken in its foundations by the appearance of Pop art and, in its wake, of pop culture. From the beginning, Pop art's most controversial American protagonist was Andy Warhol, who divided the West German public on the question of whether his art, films, persona, and statements were critical or affirmative of consumer culture.

The reason why this particular question was so important to Warhol's West German audience can be found in the pervasive ideology of the so-called Frankfurt School of Critical Theory, which paved the way for the

[1] Early drafts of this chapter were kindly read and critiqued by Thomas Seibert, Cornelia Syre, and Reva Wolf. Thanks also to Wiebke Martens who was of great help with my research. The focus of the present text is on the reception of Warhol in West Germany, which reunited with East Germany in 1990. In my research for this text, I did not come across an East German reception of Andy Warhol, which is not to say, however, that there was none.

popularization of Pop art. As neo-Marxist intellectuals (among them Theodor Wiesengrund Adorno, Max Horkheimer, Herbert Marcuse, and Erich Fromm), they developed in their writings and teachings widespread and well-accepted theories of life under capitalism. The School's academic center was the Institute for Social Research (associated before and after World War II with Frankfurt University and located in the years of exile in New York). Critical theory was formative for West German society of the 1950s and 1960s and had a significant impact on the public reception of art as well. This chapter will show that West Germans found the philosophical and sociological reasoning for considering Warhol's art as socially relevant in the teachings of the Frankfurt School. Equally, the why and how of the translations of his writings can only be understood in the context of the cultural discourse initiated by the Frankfurt School. Ultimately, this unique cultural historical nexus is the foundation for the history of Warhol in German translation.

"Pop art," the name coined for the British and American art movement, risked severely hampering its public reception in West Germany.[2] In the early 1960s, the German verb *poppen* was a colloquial term for "having sexual intercourse."[3] While it is an old truism that sex sells and while Pop art in its first decade did sell in West Germany more than elsewhere, the years before the student movement of 1968 and the subsequent sexual liberation were extremely conservative and restrictive in this country regarding any link between art and sexuality. Prior to the late 1960s, art reception and appreciation in West Germany were considered elite, lofty, and intellectual pursuits. The history of the German translations of Warhol's books, then, mirrors a democratization of art criticism and consumption that was initiated by Pop art and that came to benefit subsequent art movements.

[2] Rudolf Zwirner has suggested that it was this idiom that presented the initial challenge to Pop art in West Germany: "In the early 1960s, the German public was very skeptical of it [Pop art]. Abstraction was still considered the gold standard in art whereas the blunt concreteness of Pop art was thought to be vulgar. Especially since in Cologne the word 'poppen' was primarily associated with sex." See Rudolf Zwirner, *Ich wollte immer nur Gegenwart. Rudolf Zwirner Autobiografie*, written by Nicola Kuhn (Cologne: Wienand, 2019), 102. All translations, unless otherwise noted, are by the author.

[3] Elsewhere, Zwirner claimed that the association of "pop" with *poppen* meant that the movement to Germans would be "Fuck art"; Rudolf Zwirner in an interview with Jochen Link, recorded by Link in "Pop Art in Deutschland. Die Rezeption der amerikanischen und englischen Pop Art durch deutsche Museen, Galerien, Sammler und ausgewählte Zeitungen in der Zeit von 1959 bis 1972" (PhD diss., Stuttgart University, 2000), 131. The standard German dictionary *Duden* confirms this colloquial usage of *poppen*; see https://www.duden.de/rechtschreibung/poppen_kopulieren_Geschlechtsverkehr. According to this source, etymologically, the word "probably imitated sounds and movements."

The Reception of Pop Art in Germany

There are no comprehensive studies on either the early art-historical reception of Warhol's art in West Germany or the German translations of his books. However, in recent years a small number of publications have devoted themselves to the reception of Pop art in West Germany, and it is in these studies that Warhol's role in the success story of Pop art in West Germany has been considered by scholars.

In 2000, Jochen Link completed a dissertation at Stuttgart University on the reception of Pop art in West Germany.[4] This study offers a comprehensive overview of Pop art's reception in daily and weekly publications. While intellectuals and critics were skeptical of Pop art at first, it was soon embraced by younger West German audiences who enjoyed the sensibility of Pop not only in art but in their general lifestyle as well. Between 1959 and 1972, Pop art had its internationally strongest market in West Germany.

Link concluded that while Pop art had passed its zenith in the United States by 1965, its popularity peaked in West Germany later. Between Pop art's first appearance and 1972, West Germany saw fifty-seven museum exhibitions devoted solely to Pop art, two of them dedicated exclusively to Andy Warhol.[5] Of the ninety-five Pop art exhibitions staged by galleries, fourteen focused on Warhol's work.[6] Public museums acquired ten of his paintings while twenty-seven Warhol paintings became part of two major private collections, amassed by Peter Ludwig and Karl Ströher, that subsequently went on display in museums.[7] By 1976, according to the catalog of an exhibition held that year at the Nationalgalerie Berlin and the Kunsthalle zu Kiel, there were thirty-eight paintings and 284 works on paper by Warhol in public West German museum collections.[8]

[4] Link, "Pop Art." This dissertation is available in major German libraries as a photocopy but for unknown reasons was not published as is customary in Germany.
[5] Link, "Pop Art," appendix 9.
[6] Link, "Pop Art," appendix 20.
[7] Link, "Pop Art," appendices 12 and 16, respectively. Karl Ströher, in a much-noted private deal, bought the Leo Kraushar collection in 1968. Peter Ludwig acquired Pop art works individually and (through Rudolf Zwirner) at the auction of the Scull collection in 1973. Other German collectors, like Wolfgang Hahn in Cologne or Heinz Beck in Düsseldorf, had less financial power but bought early.
[8] See Dieter Honisch and Jens Christian Jensen, eds., *Amerikanische Kunst von 1945 bis heute. Kunst der USA in europäischen Sammlungen* (exhibition catalog, Nationalgalerie Berlin, Kunsthalle zu Kiel) (Cologne: DuMont, 1976), appendices AI and BI.

The Critical and Public Reception of Warhol's Art and Writings

Reading early West German art criticism of Pop art today, one is struck by the intellectual intensity and gravity of the texts. Pop art was not merely subjected to aesthetic criteria, but to cultural and sometimes political utopian ideas. Pop art's high visibility in West Germany led to discussions among both critics and a wider public over how this new art movement would and should be treated. What should be the theoretical tools for dealing with Pop art? All art-critical writings from that time show that the reception of Warhol's works and persona in West Germany was part of a wider discourse on Pop art and its art-historical and sociological relevance.[9] Any consideration of the translations of Warhol's writings must therefore take into account the context of this discourse, which was initiated by the Frankfurt School.

During World War II, while in exile in New York, Theodor W. Adorno and Max Horkheimer authored the book *Dialectic of Enlightenment*, which was published in 1947 and had a major impact on West German intellectuals in the following decades. Adorno and Horkheimer's study encompassed an art theory that linked aesthetic to social perspectives. From the 1950s through the 1990s, *Dialectic of Enlightenment* was the most influential critical standard text in West German academic discourses on art.[10]

Not just some, but all West German reviews and critical texts in art magazines reflect their authors' familiarity with the ideas of *Dialectic of Enlightenment* in an ongoing and, for a long time, undecided discourse of whether Warhol criticized or celebrated American consumer culture. Adorno and Horkheimer, in their consideration of *Kulturindustrie* (culture industry), condemned tendencies that in the 1960s were being described as central to Warhol's art: the culture industry's proximity to advertising, imitation, repetition, boredom, mechanical reproduction, amusement, film

[9] Catherine Dossin has outlined the cultural and sociological circumstances that promoted the positive reception of Pop art by the German public, among them Germany's moral debt to the United States and its subsequent wish to "escape from Germanness." See Catherine Dossin, "Pop begeistert: American Pop Art and the German People," *American Art* 25, no. 3 (Fall 2011): 109.

[10] For a brief historical assessment of the relevance of *Dialectic of Enlightenment* for post war German intellectual history, see, for example, Christoph Menke, "Theodor Wiesengrund Adorno," in *Ästhetik und Kunstphilosophie. Von der Antike bis zur Gegenwart in Einzeldarstellungen*, ed. Julian Nida-Rümelin and Monika Betzler (Stuttgart: Kröner, 1998), 5–15. When I was a student of art history and American studies at Frankfurt University in the early 1990s, there was an unspoken expectation for all students to be intimately familiar with the writings of the Frankfurt School.

stars that had become brands themselves. Much of what was castigated as "culture industry" was fundamental to ideas associated with Warhol's art, as these two statements from *Dialectic of Enlightenment* suggest: "Beauty is whatever the camera reproduces";

> What is new, however, is that the irreconcilable elements of culture, art, and amusement have been subjected equally to the concept of purpose and thus brought under a single false denominator: the totality of the culture industry. Its element is repetition.[11]

I would like to argue that Adorno and Horkheimer's ideas constituted *the* matrices against which West Germans (whether they were followers or critics of the New Left) listened to Andy Warhol's proclamations and read his books, which in turn they employed to interpret his art. One West German critic, Andreas Huyssen, remarked that "Warhol naively praises the reification of modern life as a virtue."[12] Others would argue an opposing view, which equally was a reaction to Frankfurt School ideas, such as Jürgen Wissmann, who stated:

> Warhol, who believes that "everyone should be a machine," understands the assimilation to his world not as a lamentable subjugation under a dictatorship of civilization. He can even admit that it was precisely objectivity that helped him "to like things (of our world)," thereby opening up the problem of Pop art to becoming a sociological one.[13]

Whichever the stance on Warhol, the criteria to which West German critics subjected his thinking and art were those established by the Frankfurt School.

[11] Max Horkheimer and Theodor W. Adorno, *Dialectic of Enlightenment: Philosophical Fragments*, ed. Gunzelin Schmid Noerr, trans. Edmund Jephcott (Stanford, CA: Stanford University Press, 2002), 119 and 108.

[12] Andreas Huyssen, "The Cultural Politics of Pop: Reception and Critique of US Pop Art in the Federal Republic of Germany," *New German Critique* 4 (Winter 1975): 85. Huyssen early made the case for reading the German reception of Pop art against Marcuse's theory.

[13] "Auch Warhol, der glaubte, 'daß jeder eine Maschine sein sollte,' empfand die Angleichung an seine Welt nicht als beklagenswerte Unterordnung unter eine Diktatur der Zivilisation. Er konnte sogar gestehen, daß gerade die Sachlichkeit ihm dazu verhalf, 'die Dinge [unserer Welt] zu mögen,' womit das Problem der Pop Art sich zu einem soziologischen Thema erweitern könnte"; Jürgen Wissmann, "Pop Art oder die Realität als Kunstwerk," in *Die nicht mehr schönen Künste. Grenzphänomene des Ästhetischen*, ed. Hans Robert Jauß (Munich: W. Fink, 1968), 530.

Rainer Crone, Promoter of Warhol as a Marxist Artist

The most curious offspring of the leftist West German reception of Warhol's work were the neo-Marxist writings of art historian Rainer Crone who in the 1970s and 1980s devoted several monographs as well as a notable exhibition to the American Pop artist.[14] Like most left-wing writers of his time, he sought to bolster his arguments by referencing the writings of the idols of Marxist ideology, among them philosophers Georg Wilhelm Friedrich Hegel, Karl Marx, Friedrich Engels, and Walter Benjamin, playwright Bertolt Brecht, and his contemporary, writer and cultural critic Hans Magnus Enzensberger. Crone argued that because of Warhol's technology-based approach to making art (Crone was referring to silkscreen print and film), Warhol must be considered a Marxist artist. In his 1972 monograph on the artist, Crone included a brief essay titled "Marx und Warhol" by the political activist filmmaker Emile de Antonio, a friend whom Warhol credited with helping him have his artistic breakthrough.[15] In the context of Crone's book, this essay reads like a testimonial from a Warhol intimate confirming Crone's thesis.

Crone understood Warhol to be pursuing in his art a revolutionary aesthetic as propagated by Walter Benjamin and Bertolt Brecht (an approach that for good reasons has not withstood criticism).[16] He proposed: "Within the context of the North-American situation Andy Warhol can be named as one of the authors who represent a conception of a critically and 'politically' potent art."[17] When substantiating this claim proved difficult, Crone resorted

[14] Rainer Crone, *Warhol* (Stuttgart: Hatje, 1970); Rainer Crone and Wilfried Wiegand, *Die revolutionäre Ästhetik Andy Warhol's* [sic] (Darmstadt: Melzer, 1972); Rainer Crone, *Andy Warhol. Das zeichnerische Werk 1942–1975* (exhibition catalog) (Stuttgart: Württembergischer Kunstverein, 1976), and *Das bildnerische Werk Andy Warhols* (Berlin: Wasmuth, 1976).

[15] Emile de Antonio, "Marx und Warhol," in Crone and Wiegand, *Revolutionäre Ästhetik*, 13–15.

[16] For an early criticism of the shortcomings of Crone's methodological approach in his interpretation of Warhol, see Huyssen, "Cultural Politics," 93–4. Huyssen stated Crone's argument in a much more lucid manner than Crone himself: "The technical innovation at the heart of Warhol's work is the use of photography combined with the silk screen technique. Because this technique makes the unlimited distribution of art works possible, it has the potential to assume a political function" (Huyssen, "Cultural Politics," 93). Another criticism of Crone's approach is Siegfried Salzmann, *Kultstar—Warhol—Starkult* (*Kunst und Öffentlichkeit*, 2) (Duisburg: Museumsverein Duisburg, 1972).

[17] "Daher kann im Kontext nordamerikanischer Verhältnisse Andy Warhol als einer jener Autoren angeführt werden, die eine Konzeption einer kritischen und 'politisch' wirksamen Kunst vertreten"; Rainer Crone, "Zur revolutionären Ästhetik Warhols," in Crone and Wiegand, *Revolutionäre Ästhetik*, 11.

to a watered-down line of argument while holding fast to his claim that Warhol's work was the embodiment of Marxist art:

> Whether the artist is aware of this conception nor not, whether it is brought on knowingly or (as bourgeois interpreters would have it) "intuitively" is irrelevant for the meaning and impact of this conception: It is not about the person Warhol but the works he confronts us with.[18]

Disapproval of Crone's approach soon followed. In his sharp and skeptical analysis of "cult star Warhol," museum director Siegfried Salzmann showed himself to be appalled by Crone's methodological deficits and ultimately by the cult he and others were making of Warhol: "Crone isolates artist and work from their reality, the American setting, i.e. from their socio-economic base—an especially problematic undertaking in the case of Pop art."[19] Salzmann's analysis was only one in a group of art historiographic books and articles that started appearing in West Germany almost at the same time that the reception of Warhol and his work set in and that called for a critical analysis of the art and the artist.

As extreme as Crone's hermeneutical approach to Warhol was, even within the West German context, he must nevertheless be credited with publishing some of the earliest monographs on the artist, lavishly illustrated, and with being one of the first art historians to recommend Warhol's early, pre-Pop art oeuvre for serious critical consideration—and not just in his country. Moreover, in his 1976 exhibition catalog devoted to Warhol's drawings, we find the first translation, in excerpts from chapter one, of THE Philosophy of Andy Warhol.[20] A German translation of the entire book was to appear only in 1991, to be discussed below. In Crone's catalog, the passages of the artist reflecting back on his childhood in Pittsburgh and on his early years in New York function as an autobiography of Warhol before he was famous.

[18] "Ob diese Konzeption dem Künstler bewußt oder unbewußt ist, ob sie wissend oder nur 'intuitiv' (wie bürgerliche Interpreten meinen) gebracht wird, bleibt für den Wert und die Wirkung dieser Konzeption unbedeutend: Es geht nicht um die Person Warhol, sondern um die Arbeiten, mit denen Warhol uns konfrontiert"; Crone, "Zur revolutionären Ästhetik Warhols," 11.

[19] "Er isoliert Künstler und Werk aus ihrer Realität, der amerikanischen Umwelt, also von ihrer sozio-ökonomischen Basis, bei Pop-Art ein besonders problematisches Unterfangen"; Salzmann, Kultstar, 9. I understand the extensive art and cultural historical review of the American scene in Crone's 1976 monograph on Warhol, Das zeichnerische Werk, as Crone's direct rebuttal to and defense against Salzmann's criticism.

[20] Andy Warhol, "DIE Philosophie des Andy Warhol," trans. Christa von Goßler, in Crone, Das zeichnerische Werk, 13–14.

Warhol Interviews and Statements in Translation

The first decade of the critical reception of Warhol's art in West Germany was dominated by art-philosophical and art-sociological questions that were ultimately left unresolved. By the early 1970s, the unforeseen art market success of Warhol's work in this country perhaps rendered these questions, if not moot, then at least of little interest any longer except to a few theoreticians. Pop art had conquered West German museums, galleries, and homes.

In this first decade the West German critical reception turned to three sources for quoting Andy Warhol: interviews by Gene Swenson of 1963 and Gretchen Berg of 1966, and the catalog of Warhol's first European museum exhibition, held in Stockholm in 1968. Certainly, the most widely distributed and most often quoted of these texts was what we now know to have been a fully reworked interview, conducted and then heavily edited by critic Gene Swenson with the artist that was first published in the United States in *ARTnews*.[21]

The Swenson and Berg Interviews

The earliest of at least three German translations to appear within the decade of the Swenson interview's publication can be found in Rolf-Gunter Dienst's 1965 monograph *Pop-Art. Eine kritische Information* (A Critical Information).[22] The translator was Marguerite Schlüter (1928–2018), then head of the publisher Limes Verlag that released Dienst's book. She took it upon herself to translate the Swenson interview. A renowned publisher and art lover, she made available German editions of the writings of Truman Capote (a Warhol favorite) and the Beat poets, and even faced pornography

[21] Gene Swenson, "What Is Pop Art? Answers from 8 Painters, Part I," *ARTnews* 62, no. 7 (November 1963): 26, 60–1. For a transcript of part of the tape-recording that was made for this interview, see Jennifer Sichel, "'What Is Pop Art?' A Revised Transcript of Gene Swenson's 1963 Interview with Andy Warhol," *Oxford Art Journal* 41, no. 1 (March 2018): 85–100. See also the chapter by Annika Öhrner in the present volume. For a German translation of Sichel's article and the interview transcript, see Jennifer Sichel, "'Was ist Pop Art?' Überarbeitetes Transkript des Interviews von Gene Swenson mit Andy Warhol aus dem Jahre 1963," in *Andy Warhol Exhibits. A Glittering Alternative*, ed. Marianne Dobner (Cologne: Walther König; Vienna: mumok, Museum moderner Kunst Stiftung Ludwig, 2020), 253–68.

[22] Rolf-Gunter Dienst, *Pop-Art. Eine kritische Information* (Wiesbaden: Limes, 1965), 126–30, translation of the Swenson interview by Marguerite Schlüter. For reasons of economy, I skip discussion of a fourth, the most recent translation, by Magda Moses and Bram Opstelten, offered in *Pop Art*, ed. Marco Livingstone (exhibition catalog, Museum Ludwig, Cologne) (Munich: Prestel, 1992), 56–7.

charges upon publishing William S. Burroughs's *Naked Lunch*, a novel mentioned by Warhol in Swenson's interview. Schlüter won acclaim for her translations from English, French, and Italian.[23] Since she would have had to pay a translator, her decision to translate the Warhol interview herself may have been a way to keep down costs on the production of Dienst's book as well as to ensure the good quality of the translation. Hers became the most often-quoted German translation of the Swenson interview in the years after its publication.

Two passages in Schlüter's translation stand out. The first cannot be anything but a veritable reading mistake: Schlüter translated the quip "I think everybody should like everybody" as "I think everybody should *act* like everybody."[24] What a curious slip! Yet, it is an understandable one, since Schlüter's version was much more in alignment with the thought of the previous sentence, "I think everybody should be a machine," offering an exposition on what Warhol might have meant with this often-quoted sentence. Pop art meant "liking things" (*die Dinge zu mögen*), her translation continued, missing a second chance, provided by a parallel sentence structure, to catch her mistake.

In a passage where Warhol talked about his commercial drawings, Schlüter consciously overstepped her role as translator by interpreting "feeling" ("those commercial drawings would have feelings, they would have a style") as "aesthetic feeling" (*ästhetisches Gefühl*).[25] Here she seems to have been tempted to interpret Warhol's claim, "they would have a style," as explanatory.

In 1970, a German translation of the Swenson interview was commissioned for the catalog of an exhibition of the Ströher collection.[26] Unlike in the Dienst monograph, this time the translators seem not to have been chosen primarily for their literary merits but because they were available locally in Darmstadt where Ströher lived and where the exhibition of his collection was held, at the Landesmuseum Darmstadt. Possibly because of the limited space (the text ran parallel in German and English in the catalog), the interview was shortened in both languages. Cut were the introductory exchange, the commercial-art question and answer, and Warhol's expounding on his "pornographic pictures." While the latter two omissions seem obvious choices because

[23] Carsten Pfeiffer, "In Memoriam Marguerite Schlüter," May 14, 2018, https://buchmarkt.de/menschen/in-memoriam-marguerite-schlueter.

[24] "Ich glaube, daß jeder wie jedermann handeln sollte"; "Andy Warhol," trans. Marguerite Schlüter, in Dienst, *Pop-Art*, 126.

[25] Dienst, *Pop-Art*, 128.

[26] Gerhard Bott, ed., *Bildnerische Ausdrucksformen 1960–1970. Sammlung Karl Ströher im Hessischen Landesmuseum Darmstadt* (Darmstadt: Roether, 1970), 437–9. The interview was translated by Dieter Abel and Ellen Jones.

they constitute digressions in the interview, the first omission discarded two sentences that would have been of interest to West German readers: first, the reference to Bertolt Brecht, the most important German playwright and theater theoretician of the twentieth century and one of the icons of Marxist ideology; second, the quip that Warhol was best known for in West Germany by 1970 and that could be interpreted as a follow-up to his mentioning of Brecht: "I think everybody should be a machine." Since the neo-Marxist school of Pop art interpreters had hinged many of their arguments on these two references, could it be that the capitalist industrialist Ströher was especially keen on eliminating them from the interview, thereby significantly reducing the fodder for such interpreters?

The Darmstadt translation's omission of the Brecht passage is a refusal to interpret Warhol as an artist critical of capitalism. Having the Warhol interview edited to reflect Ströher's anti-Marxist interests makes sense in light of the teachings of the Frankfurt School. In their chapter "Culture Industry," Adorno and Horkheimer had considered the relation of forms of low to high art in capitalist societies and drew a pessimistic picture of what they viewed as the failing Enlightenment agenda to educate the individual. Instead, they observed in various art forms a reification of the individual under late capitalism. In the 1960s, this line of thinking to many West German critics seemed to be confirmed by Pop art. Accordingly, it has recently been argued that it was Adorno's "negative verdict of mass culture [that] structured for decades especially the leftist intellectual objections to dealing with pop as a phenomenon of post-war society in no other manner than by rejecting it."[27] This line of argument explains how industrialist Ströher could stay politically conservative—not in spite of, but by collecting, Pop art.

Only one year after the Ströher catalog, in 1971, art history professor Bernhard Kerber included passages, again in both English and German, from the Swenson interview in a monograph claiming to look at the "theoretical foundations" of American art.[28] Kerber's selection centered on

[27] "strukturiert seine negative Bewertung des Begriffs 'Massenkultur' für Jahrzehnte insbesondere linksintellektuelle Bedenken vor, sich mit Pop als Phänomen der Nachkriegsgesellschaft anders als ablehnend auseinanderzusetzen"; Stefan Greif, "Einleitung. Theodor W. Adorno, Résumé über Kulturindustrie (1963)," in *Texte zur Theorie des Pop*, ed. Charis Goer, Stefan Greif, and Christoph Jacke (Stuttgart: Kröner, 2013), 14.

[28] Bernhard Kerber, *Amerikanische Kunst seit 1945. Ihre theoretischen Grundlagen* (Stuttgart: Reclam, 1971), 213, translator unnamed.

the "I want to be a machine" quip and included the Brecht introductory sentence. Interestingly, Kerber also offered his readers the first (and to my knowledge only) German translation of parts of the Gretchen Berg interview and in addition a passage from Bruce Glaser's interview with Oldenburg, Lichtenstein, and a very reticent Warhol, published in 1966.[29] Kerber's pickings from these texts far exceeded his own comments, which served to highlight Warhol's insistences "I don't want to get too close" and "It's indifference," respectively. Kerber did not explicitly have to cite Bertolt Brecht for Germans to know that he was reading Warhol's art through the playwright's concept of the alienation effect, a central element of Brecht's revolutionary approach to dramaturgy (the so-called epic theater). Brecht used the alienation effect in his plays to break with the mimetic and empathic tradition of theater prevalent since Aristotle and to make the audience critically reflect on the play from an uninvolved and therefore supposedly objective standpoint. This approach is made most evident in the role Kerber assigned Warhol's audience: "The stance of the uninvolved chronicler leaves the verdict up to those who interpret it, thereby reflecting back on them. Not Warhol, but the viewer, is biased. Diametrically opposed positions are possible."[30] The direction Kerber gave his Warhol interpretation, using his selections from the three Warhol interviews as well as his own brief remarks, was intended to position the artist in a neo-Marxist lineage.

Kerber was one of very few West German art history professors at the time to include contemporary art in their curriculum.[31] In his defense, he may have felt justified in instrumentalizing his three source texts if thereby he could argue for a theoretical foundation of the art of his day and justify its relevance and validity for academia.

[29] Kerber, *Amerikanische Kunst*, 214. Like the passages from the Swenson interview, these texts too are presented in both English and German. The Bruce Glaser interview was originally published as "Oldenburg, Lichtenstein, Warhol: A Discussion," *Artforum* 4, no. 6 (February 1966): 20–4.

[30] "Die unbeteiligte Chronistenhaltung überläßt dem Interpreten das Urteil, das auf diesen zurückfällt. Nicht Warhol, sondern der Betrachter ist Partei. Diametrale Positionen bieten sich an"; Kerber, *Amerikanische Kunst*, 128. Kerber, in his own art-historical writing, mirrored this approach, requesting that his readers, too, use their critical faculties to arrive at their own view of the art presented.

[31] For a report on the reception and treatment of Pop art in German art history departments in 1970, see the article by Peter Sager, "Pop-Art oder wie tot muß eine Kunst sein, um Kunstgeschichte zu werden," *Das Kunstwerk* 23, nos. 9–10 (June–July 1970): 37–8. Sager's inquiry revealed that many art history professors considered Pop art to be of relevance foremost to the social sciences, not to art history.

The Stockholm Catalog

For a wider audience it was the Warhol quotations from the catalog *Andy Warhol*, which accompanied the 1968 retrospective at Stockholm's Moderna Museet (see Figure 5.2), that popularized Warhol's thought and ideas in West Germany. West Germans who did not get their hands on one of the thousands of copies printed for Moderna Museet were able to read Warhol's quips in the German exhibition catalog of the underfunded and watered-down version of the Stockholm exhibition that was shown at Berlin's Neue Nationalgalerie in the spring of 1969 in tandem with a show featuring highlights from the Ströher collection (including eighteen Warhol works).[32] The fact that (in contrast to their Swedish colleagues) the West German editors did not bother to translate the English quotes is an indication that they expected readers to be able to understand them or even to be already familiar with them.

Warhol's quips from the Stockholm catalog were quoted by critics but translations seemed unnecessary for this purpose. Siegfried Salzmann's 1972 pamphlet *Kultstar—Warhol—Starkult* is a case in point. The author headed every chapter with a Warhol quote, starting with "Thirty are better than one," which he related to Warhol's use of seriality and that, he lamented, made "the correspondence to consumerism directly visible."[33] The closing paragraph of Salzmann's booklet had the heading, "In the future everybody will be world famous for fifteen minutes," taken from the Stockholm catalog, which he cited to underline his view that Warhol had become the star of the fame he himself had invented.[34]

"*Well, gehn wir" und ich sag*, "All right": Warhol's Books in Translation

West German art historians observed and commented on Warhol's mid-1960s claim that he decided to turn away from painting and to devote himself to film. In West Germany he was perceived as the leading underground

[32] *Andy Warhol. Ausstellung der Deutschen Gesellschaft für Bildende Kunst e. V. (Kunstverein Berlin) und der Nationalgalerie der Staatlichen Museen Preussischer Kulturbesitz in der Neuen Nationalgalerie Berlin, 1. März–14. April 1969* (exhibition catalog, Nationalgalerie Berlin) (Berlin: Deutsche Gesellschaft für Bildende Kunst e. V., 1969).
[33] "macht damit die Korrespondenz zum Konsum unmittelbar sichtbar"; Salzmann, *Kultstar*, 3.
[34] Salzmann, *Kultstar*, 13.

filmmaker of the time. It was noted, too, that with his silver clouds of 1966 and the Brillo boxes of 1964 he had made his mark in sculpture. Therefore, when he turned to books starting in 1967 with the release of *Andy Warhol's Index (Book)*, in West Germany this activity too was considered a serious expansion of his artistic activities.[35] His venture into writing seemed to West German critics and the public to be a consistent next step.

Andy Warhol's Index (Book) was never translated into German (nor has the "German interviewer" who featured in that book been identified), and neither were *Exposures* (1979), *America* (1985), or *Party Book* (1988). The earliest Warhol titles to appear in German editions were *a: A Novel* (1968) and *Blue Movie* (1970).[36] Both were instantly considered works of underground literature in West Germany. Neither book ever became a bestseller, and they are both out of print. However, *a* and *Blue Movie* contributed to Warhol's image in West Germany around 1970 of being an avant-garde artist not only in the fields of painting, sculpture, and film, but also in literature.

The publishing history of Warhol's more mainstream, bestselling titles in German began only after Warhol's death in 1987 when Knaur, a publisher of popular and light literature, issued a German edition of the posthumous *The Andy Warhol Diaries* (1989), *Das Tagebuch*, in 1989, translated by Judith Barkfelt.[37] Two years later, it was also Knaur who commissioned Regine Reimers to undertake the German translation of *THE Philosophy of Andy Warhol (From A to B and Back Again)* (1975): *Die Philosophie des Andy Warhol von A nach B und zurück*. In 2006, on the eve of the twentieth anniversary of Warhol's death in 1987, this translation was licensed—surprisingly, given its multiple errors, without any revisions—to the more prestigious S. Fischer Verlag where it has been in print ever since.[38]

Warhol and Pat Hackett's *POPism: The Warhol '60s* of 1980 was not available in German until 2008 when Nikolaus G. Schneider crafted a worthy translation for art book publisher Schirmer/Mosel: *POPism. Meine*

[35] For an overview of Warhol's pre-1960 book production, see *Reading Andy Warhol. Author, Illustrator, Publisher*, ed. Nina Schleif (exhibition catalog, Museum Brandhorst, Munich) (Ostfildern: Hatje Cantz, 2013).

[36] Andy Warhol, *a. Ein Roman*, trans. Carl Weissner (Cologne: Kiepenheuer & Witsch, 1971); Andy Warhol, *Blue Movie. Der ungekürzte Dialog mit über 100 Photos* (*pocket*, 21), trans. Hans Hermann (Cologne: Kiepenheuer & Witsch, 1971).

[37] Andy Warhol, *Das Tagebuch*, ed. Pat Hackett, trans. Judith Barkfelt (Munich: Droemer Knaur, 1989).

[38] Andy Warhol, *Die Philosophie des Andy Warhol von A nach B und zurück*, trans. Regine Reimers (Munich: Droemer Knaur, 1991); Andy Warhol, *Die Philosophie des Andy Warhol von A nach B und zurück*, trans. Regine Reimers (Frankfurt: S. Fischer, 2006).

*60er Jahre.*³⁹ To this day, *Tagebuch, Philosophie,* and *POPism* are commercial successes in Germany and often can be found in tall stacks at museum bookshops. *a: A Novel* is presently available in English paperback only.

The Avant-Garde Titles

In 1971 the Cologne-based publisher Kiepenheuer & Witsch (KiWi) added both *a. Ein Roman* and *Blue Movie* to its list, which featured, besides socially critical nonfiction and leftist fiction, American avant-garde poetry and literature. A classic among its 1969 titles became the anthology *Silver Screen. Neue amerikanische Lyrik,* edited by the poet and literary editor Rolf Dieter Brinkmann, that comprised poetry by some of North America's underground poets, many of whom were Warhol acquaintances: Robert Sward, Kenward Elmslie, Dick Gallup, Michael McClure, Aram Boyajian, David Ray, Paul Blackburn, Ted Berrigan, Tom Clark, Larry Fagin, Lenore Kandel, Gerard Malanga, John Giorno, Ron Padgett, Frank O'Hara, Anne Waldman, John Perreault, Peter Schjeldahl, Lewis Warsh, Edward Field, Douglas Blazek, and Charles Bukowski.⁴⁰ Their poems were printed both in English and German and were translated by the editor himself as well as the writer and translator Carl Weissner (1940–2012), among others. KiWi also published a tome of poems by Frank O'Hara and, starting in 1971, several titles by William Burroughs.

KiWi viewed Warhol's two titles as fitting for its program of American underground literature. This can be deduced from the fact that they put two expert translators of American literature on the job to translate them: Carl Weissner for *a* and Hans Hermann (1937–2003) for *Blue Movie,* respectively.⁴¹ While the former made his place in literary history with German translations of Charles Bukowski, Allen Ginsberg, and Bob Dylan, the latter translated books by William Burroughs, Jack Kerouac, and Don DeLillo.

[39] Andy Warhol with Pat Hackett, *POPism. Meine 60er Jahre,* trans. Nikolaus G. Schneider (copy-edited by Marion Kagerer) (Munich: Schirmer/Mosel, 2008). In addition to numerous art-historical projects, Schneider is the translator of all titles by Slavoj Žižek for the prestigious publisher Suhrkamp.

[40] On Warhol's connections with underground poets in the 1960s, see Reva Wolf, *Andy Warhol, Poetry, and Gossip in the 1960s* (Chicago and London: University of Chicago Press, 1997).

[41] For biographical information on Weissner, see https://de.wikipedia.org/wiki/Carl_Weissner. His papers are kept at Deutsches Literaturarchiv Marbach; see https://www.dla-marbach.de/find/opac/id/BF00036095/. For biographical information on Hermann, see Helga Pfertsch, "Nachruf: Hans Hermann," *Übersetzen* 1 (2004): 7.

a. Ein Roman 1971

Andy Warhol's book *a: A Novel* was intended as a provocation, from its title down to its format. Drawing on tape recordings he had collected in several encounters with his friend Ondine, the book's drugged protagonist, Warhol turned these tapes into a book with the help of some nonprofessional typists. The result, a mix of often incoherent dialogue and faulty typing, was considered by some as simply trash, but by others (including the West German literature establishment) as the literary equivalent to his underground films. KiWi took *a. Ein Roman* into its program because it regarded the title as a key work of contemporary American literature.

For his translation of *a: A Novel*, Weissner could rely on his familiarity with street slang and colloquial American speech acquired during a two-year fellowship in New York from 1966 to 1968. His use of English filler words in the German translation such as "oh," "aah," "well," and "yeah," while startling at first, clearly was meant to make the setting feel authentically American. Weissner rarely arrived at questionable solutions, but occasionally one slipped in, such as this passage attributed to Sugar Plum Fairy: "*und jemand sagt, 'Well, gehn wir' und ich sag, 'All right,'*" for which he could have found a fully German solution such as: "'*Auf, gehn wir' und ich sag, 'In Ordnung.'*"[42] Actual mistakes are rare, for instance when Weissner translated "campy" as *irre* (crazy), "twinge" as *Knacks* (crack), or "tacky" as *schäbig* (run-down) and *problematisch* (problematic).[43]

In most instances Weissner omitted the typographical errors of the original (of which there are many), but he reproduced capitalizing, even when incorrect. He also kept all names—except for two: The Mayor (Rotten Rita) is referred to as *der Bürgermeister*, and, inexplicably, Sugar Plum Fairy in the German translation figures as *Bonbon-Fee* (Lozenge Fairy). Overall, the text reads well in German and conveys a good idea of the original to readers, which is a remarkable accomplishment, since the multitude of highly unusual spellings and typographical errors, quirky layout, and disjointed language make this book seem virtually impossible to translate.

Some of the funniest dialogues center around the phonetics of the German-sounding words *Schnecken*, *Schlitzmonger*, and *Poltergeist*. The protagonists, high on drugs, come up with endless variations and puns of these words, causing a lot of chuckling among them. These tongue-twisters

[42] Warhol, *a. Ein Roman*, 362.
[43] Warhol, *a. Ein Roman*, 246, 377, 16; Andy Warhol, *a: A Novel* (1968) (London: Virgin Books, 2009), 234, 359, 11.

offer easy entertainment in sound and in print.[44] In the translation, Weissner did not have to trouble himself with the variations; they work just the same in German.

The translator took his greatest freedom with the playful and quirky running headers. Only sometimes did he replicate the ones provided in the original. In many instances he picked them himself and most chapters feature a mix of the original running headers and those chosen by Weissner. In some, however, there is complete congruence, as in chapter 4, section 1, for example; in others, there is not one match, as in chapter 16, section 1:

Everybody's taking off their clothes	sie sehen alle aus wie Atlantic Beach
the tarture of the businessman	Judy de Pasta
on my ass a whole fucking night	den Taxifahrer blasen
"Duchess, goodnight"	Ah, Gott segne Kate Smith
adio mio filio	Wir machen keine unsauberen Sachen

In the latter examples, Weissner endeavored to keep up the wild and intriguing style of selecting the running headers from the text on the double-page where they appear.

The due date for Weissner's manuscript was November 1970, which was barely a half year after he had signed the contract with KiWi in June of that year.[45] According to the contract, Weissner received 10,000 Deutsche Mark for translating *a* inside five months.[46] While this was a nice sum at the time, the honorarium probably took into account the large volume of the book (473 pages), the brief time allotted for the translation, and its avant-garde character.

In Weissner's papers there survives a transcript of a promotional text for Warhol's novel. A West German public radio station, Westdeutscher

[44] The variations of "Schnecken" (which, literally, means "snails" in German) occur throughout chapter 1, section 1. Judging from the context, in which Danish pastry is mentioned, this probably referred to a pastry such as raisin bun (*Rosinenschnecke*) or the like (*Nuss-* or *Mohnschnecke*), a sweet treat based on a yeast dough. The variations of "Schlitzmonger" and "Poltergeist" are to be found in chapter 6, section 2. In the case of the latter, the typing incorrectly introduced the letter "ü," which is not available on American keyboards and therefore must have been added in the editing process. The dialogue even addresses this (false) use of an "umla" (for "Umlaut"; see Warhol, *a: A Novel*, 132).

[45] KiWi had signed the contract on May 15, 1970, Weissner on June 10 of the same year. A copy of the contract is held in the Deutsches Literaturarchiv Marbach, MLA, Weissner, Carl, HS.2013.047, "Übersetzungsvertrag." Cited with kind permission of Mike Rettenberg for the estate of Carl Weissner.

[46] Deutsches Literaturarchiv Marbach, MLA, Weissner, Carl, HS.2013.047, "Übersetzungsvertrag."

Rundfunk, WDR, commissioned it in 1971, the year of *a. Ein Roman*'s release. The publicly funded WDR pursued an ambitious program in support of Pop art for both their radio and TV stations. In 1966 they aired the feature documentary *Pop Art in America*. In 1969, the TV station showed on fifteen Saturday evenings an impressive program of fifty works of underground films, among them Kenneth Anger's *Fireworks* (1947) and Warhol's *Mario Banana* (1964). The person responsible for this programming told a reporter that their American partners "hardly believed that this was possible on German television."[47]

The manuscript is titled "*Vorspann zu*: 'Andy Warhol. A' [sic]," a teaser for a fifty-minute reading by lay actors of excerpts from Warhol's novel.[48] This teaser featured a few prominent characters from the novel: Drella (the Warhol character in the book), Ondine, Roxanne, Billy, and Duchess, who all put in appearances with sappy quips, though not necessarily from *a. Ein Roman*, as well as two speakers who explained the concept and importance of the book as an avant-garde title. Drella's utterances are all from the Stockholm catalog and were translated into German for the occasion.[49]

Speaker 1 starts off: "There is Warhol wallpaper, a Warhol rock 'n' roll group and nightclub show (the Velvet Underground), an Andy Warhol perfume, and now there is also an Andy Warhol novel."[50] Speaker 2 cites John Perreault's favorable review of *a* for the *Village Voice*, thereby implying an American appreciation of Warhol's book. Next follows a German translation of extracts from the American book cover blurb, recited, as the stage direction requests, "luridly with an echo" (*reißerisch mit Hall*). This ends the teaser. The manuscript does not reveal which passages from *a. Ein Roman* followed in the program.

The blurb for the German translation of *a* was identical to the American blurb except for the first few sentences, which clearly sought to market Warhol to the West German audience as an avant-garde author on equal footing with Warhol, the nationally recognized avant-garde filmmaker. The book was a collective work, the text explained. "Warhol's conviction: **People**

[47] Anonymous, "Underground Film. Was alles möglich ist," *Der Spiegel* 40 (1969): 234.
[48] Deutsches Literaturarchiv Marbach, Weissner, Carl, HS.2013.047. The program was scheduled to be broadcast on April 9, 1971. It is uncertain if the program was produced as intended. But if so, it was very likely based on Weissner's translation.
[49] Deutsches Literaturarchiv Marbach, Weissner, Carl, HS.2013.047. The document includes one page, as the headline states, with translations after some of the Warhol quotes in the Stockholm catalog, a selection of which was used in the radio script.
[50] "Es gibt Warhol-Tapeten, eine Warhol-Rock-'n-Roll-Gruppe und Night-Club Show (The Velvet Underground), es gibt ein Andy-Warhol-Parfüm und jetzt gibt es auch einen Andy-Warhol-Roman"; Deutsches Literaturarchiv Marbach, MLA, Weissner, Carl, HS.2013.047, "Übersetzungsvertrag."

are so fantastic, and **Everybody is always being creative** works surprisingly well for **a** as it does for his films."[51] The latter quotation especially would have rung a bell with a West German audience familiar with the art and teachings of Joseph Beuys. "Everyone is an artist" is one of Beuys's most often-cited statements.[52] The analogy was likely intended by KiWi.[53]

In 1973, two years after *a. Ein Roman*'s release, KiWi recognized that Warhol's title would not carry its weight in terms of returns. KiWi licensed the book to Bertelsmann, then a subscription-based publisher who could offer lower prices to a wider audience, reaching book clubs in all the German-speaking countries. To Bertelsmann, it must have been Andy Warhol's by-then household name—not the literary ambitions of his novel—that made the title seem an attractive offer to middle-class subscribers.

By 1973, Warhol's *a. Ein Roman*, had attained the status of an artwork in its own right in West Germany. In the Braunschweig Kunstverein show, *Andy Warhol*, which included paintings, works on paper, and films, the German edition of *a* made the exhibition's checklist (no. 18).[54]

For a dust jacket designer, KiWi used the renowned Hannes Jähn (1934–87).[55] He adapted a big "a" as the page-filler for the front cover and mirrored it on the back and chose black instead of the (not mirrored) red letter in the American edition (Figure 3.1). Also, he found stylish solutions for the placements of "Andy Warhol" and "k&w," the only other elements on the cover.

[51] "Warhols Überzeugung [sic]: **Menschen sind so phantastisch** und **Jeder ist immer kreativ** bewähren sich in **a** genauso überraschend wie in seinen Filmen"; Warhol, *a. Ein Roman*, blurb (bold type in the original). The faulty German grammar is corrected in the above translation.

[52] "Jeder ist ein Künstler"; Joseph Beuys in an interview with Peter Brügge, "Die Mysterien finden im Hauptbahnhof statt," June 3, 1984, http://www.spiegel.de/spiegel/print/d-13508033.html. Beuys had propagated this conviction long before it appeared as a snappy slogan and in print in this 1984 magazine article.

[53] As early as the late 1960s, Warhol and Beuys's art and personae were perceived in Germany as parallel and certainly comparable phenomena. A discussion of this fascinating contemporaneity, however, is beyond the scope of the present chapter. For excellent considerations of the Beuys–Warhol association, see Trevor J. Fairbrother, *Beuys and Warhol: The Artist as Shaman and Star* (Boston: Museum of Fine Arts, 1991); Theodora Vischer, *Joseph Beuys. Die Einheit des Werkes. Zeichnungen, Aktionen, plastische Arbeiten, soziale Skulptur* (Cologne: Walther König, 1991), 50; and Rudolf Zwirner, "Wie Warhol in Europa und Beuys in den USA reüssierten. Ein Beitrag zur händlerischen Rezeptionsgeschichte. Ein Vortrag," *Sediment* 3 (1998): 30–44.

[54] Heinz Holtmann, *Andy Warhol. Bilder, Grafik, Filme* (Braunschweig: Kunstverein Braunschweig, 1973), no. 18. *Andy Warhol's Index (Book)* was also on the checklist (no. 17).

[55] For a synopsis of Jähn's career as a dust jacket designer, see Klaus Detjen, "Fotografisch: Hannes Jähn," *Außenwelten. Zur Formensprache von Buchumschlägen (Ästhetik des Buches*, 9), ed. Klaus Detjen (Göttingen: Wallstein Verlag, 2018), 38–45.

Figure 3.1 Andy Warhol, *a. Ein Roman*, first German edition (Cologne: KiWi, 1971), dust jacket, designed by Hannes Jähn. Courtesy of Kiepenheuer & Witsch; photo: archive of the author.

Blue Movie 1971

Just as he had for *a. Ein Roman*, Jähn provided an attractive design for the German edition of *Blue Movie* (Figure 3.2), the printed dialogue of Warhol's film (1969), which in the United States was censored because it focused on a couple having casual and unstaged sex. Both designs were based on those of the American editions but carried Jähn's mark. *Blue Movie* appeared as a title in KiWi's *Pocket* series, whose overall design was in Jähn's charge. For *Blue Movie*, he used the same, blue-tinted photo as the American edition, but he had it bleed out to the borders, and he also mirrored it on the back cover. The blurb was moved to the inside of the book. In Jähn's cover, the typography is more subdued than in the American edition, having been moved all the way up to the top border and featuring "ANDY WARHOL" right next to "BLUE MOVIE" in black bold capitals in the first line. This design sought to align it with other titles in the *Pocket* series that also made use of photography and were directed at a readership of leftist and provocative titles.

KiWi released the German translation of *Blue Movie* in 1971, the same year as *a. Ein Roman*. The American book launch was in 1970, after the film had provoked a scandal in movie theaters the previous year. By that time, in West Germany Warhol was an established figure of underground film. His films were shown in commercial movie theaters throughout the country and

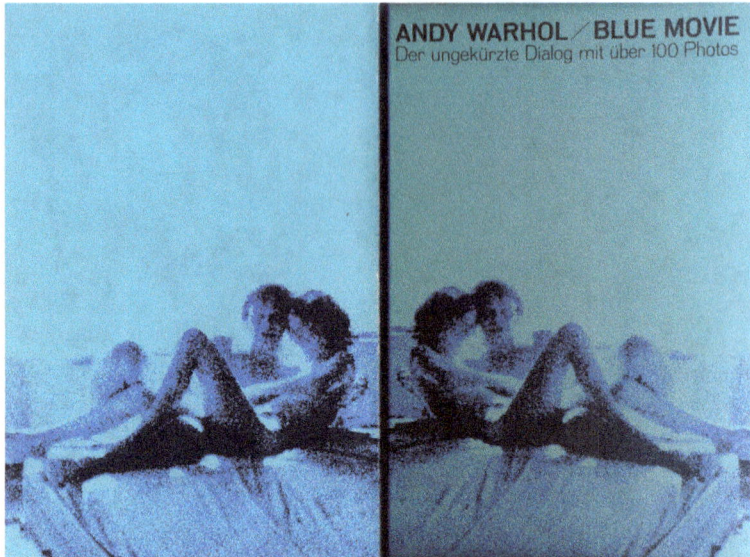

Figure 3.2 Andy Warhol, *Blue Movie. Der ungekürzte Dialog mit über 100 Photos*, first German edition (Cologne: KiWi, 1971), cover, designed by Hannes Jähn. Courtesy of Kiepenheuer & Witsch; photo: archive of the author.

some even on public television. West German movie posters, therefore, could market *Blue Movie* as the latest Warhol "sensation" after *Flesh* (1968) and *Trash* (1970). The West German press had reported on the censorship of the film in New York, which made the marketing of both the film and book all the easier. What the teaser had claimed for *a. Ein Roman*, namely that it was "worse than Henry Miller" (*schlimmer als Henry Miller*),[56] was a sales pitch that would have worked for *Blue Movie* in West Germany as well. In the blurb for the book (inside the front cover), which was in part a rewrite of the one for the English edition, the publisher found yet another, pacifist (and certainly leftist) sales pitch for the volume: "*Blue Movie*, says Andy Warhol, is about the war in Vietnam, and its stars do talk about it. More than that, they lead their lives as an alternative to war."[57] This description seems to be a promotional strategy aimed at an audience familiar with critical theory philosopher Herbert Marcuse's vision of an alternative life of sensual fulfillment.

[56] Deutsches Literaturarchiv Marbach, Weissner, Carl, HS.2013.047.
[57] "*Blue Movie*, sagt Warhol, ist ein Film über den Krieg in Vietnam, Auch [*sic*] darüber reden die beiden Stars. Aber vor allem führen sie ihr Leben als eine Gegenmöglichkeit zum Krieg"; Warhol, *Blue Movie*, blurb, inside jacket.

Marcuse was a key figure of the Frankfurt School (both in West Germany and his country of exile, the United States) who, like Adorno and Horkheimer, gave much consideration to the role of art inside a Marxist reading of history. In his influential book, *Eros and Civilisation* (1955), as Stuart Jeffries explains, Marcuse "advocated play and art as emancipatory activities that could transform human beings and, in particular change their relationship to labour."[58] In Marcuse's opinion such a history would mean as much the end of class struggle as it would the beginning of a non-repressive—that is, among other things, sexually liberated—society. According to Marcuse, human sexuality was a key element of reconnecting man with nature while "advertising, consumerism, mass culture and ideology integrated" people into a peaceful subordination to a bourgeois life.[59] To its West German audience, Warhol's *Blue Movie* then could seem to be a successful realization of Marcuse's utopia of a sexually liberated society free from the constraints of capitalism.

The film was taken up in West Germany by Constantin Film, then a distributor of independent movies to commercial movie theaters. As is still the case with most foreign films in Germany and as was done with the other Warhol films released in this country, *Blue Movie* was dubbed. The script was based not on Hermann's translation but on one crafted by dubbing author Joachim Brinkmann (1928–2015). Constantin Film issued at least three different posters and a set of lobby cards to promote the film throughout West Germany. Due to the scandal at the film's American release and as it was almost censored in the United States, and because in West Germany the film reached a considerable audience, the publisher KiWi was justified in having hopes of high book sales. It was reasonable to expect that the film crowd was also the audience for the book.

The layout of the German edition of *Blue Movie* runs parallel to that of the American edition, with the photographs connecting, in many instances, to the dialogue. To achieve this congruity, the page breaks needed to correspond, and the German text could not be much longer than the original. This consistency was achieved in part by a slightly wider format (approximately one additional centimeter in width) and in part by Hans Hermann's disciplined translation.[60] The page breaks of the English and German editions

[58] Stuart Jeffries, *Grand Hotel Abyss: The Lives of the Frankfurt School* (Frankfurt and New York: Verso, 2016), 289.

[59] Jeffries, *Grand Hotel Abyss*, 284.

[60] In the archive of KiWi, which is today kept at Historisches Archiv der Stadt Köln, there are only two documents (A 680) relating to the contract with Hermann: the publisher's request to Hermann, dated October 9, 1970; and a confirmation of receipt of the translation as well as a copy of the money transfer of the honorarium, 2,500 deutsche marks (however, it is unclear if this is the full amount or only a part of the honorarium), dated November 19, 1970. These documents indicate that Hermann delivered the translation within one month of having received the commission.

are not completely identical but run remarkably close. The German text is a word-for-word translation that nevertheless works for the atmosphere of the dialogue. A mistranslated word is rare (for example, "rooftop apartment" for "loft"),[61] there are a few typos only (such as *Lifeboy-Seife* for "Lifebuoy soap"),[62] and some rare unfortunate choices for interjections (as *ähem* for "uh," throughout). However, the merits of Hermann's translation prevail. A case in point is the solution he found for Viva and Louis Waldon's duet of *In the Mood for Love*, where he managed to keep the meaning of the lines, rhyme, and wit all without exceeding the space available to him.

Die Philosophie 1991

Of all the Warhol titles that became available in German editions, the most negligent and faulty was that of *Philosophy* for Knaur publishers: *Die Philosophie des Andy Warhol von A bis B und zurück* (Figure 3.3). Unfortunately, to this day no other German publisher has seen the need to commission a new translation, one that this great book really deserves. As Patrick S. Smith aptly characterized it, *Philosophy*, based in part on interviews and, like *a*, on tape recordings, is a "careful assemblage of his own 'readymade' and 'found' material" that has been crafted (with the help of those acknowledged in the "Dedication") into a witty and readable collection of thoughts on pop culture.[63]

The trouble with the German translation starts with the title. Apparently, the translator, Regine Reimers, worked after the American paperback edition that omitted the capital *THE* in the title, which was prominent on the title page of the first American hardcover edition and was chosen by Warhol on purpose.[64] Next, a glimpse at the dedication gives a first indication of Reimers's rather loose manner of translating. She writes, for example, "Brigid Polk, my beautiful visavis at the other end of the line" for "to beautiful Brigid Polk, for being on the other end."[65] Beyond finer details that torpedo

[61] Warhol, *Blue Movie. Der*, 10; Andy Warhol, *Blue Movie: The Complete Dialogue with Over 100 Photos* (New York: Grove Press, 1968), 10.

[62] Warhol, *Blue Movie. Der*, 18; Warhol, *Blue Movie: The*, 20.

[63] Patrick S. Smith, *Andy Warhol's Art and Films* (Ann Arbor, MI: UMI Research Press, 1986), 183.

[64] See Lucy Mulroney, *Andy Warhol, Publisher* (Chicago and London: University of Chicago Press, 2018), 114.

[65] "Brigid Polk, meinem schönen Visavis am anderen Ende der Leitung"; Andy Warhol, *Philosophie*, "Widmung." (This and all subsequent citations are to the 2006 S. Fischer edition of *Philosophie*.)

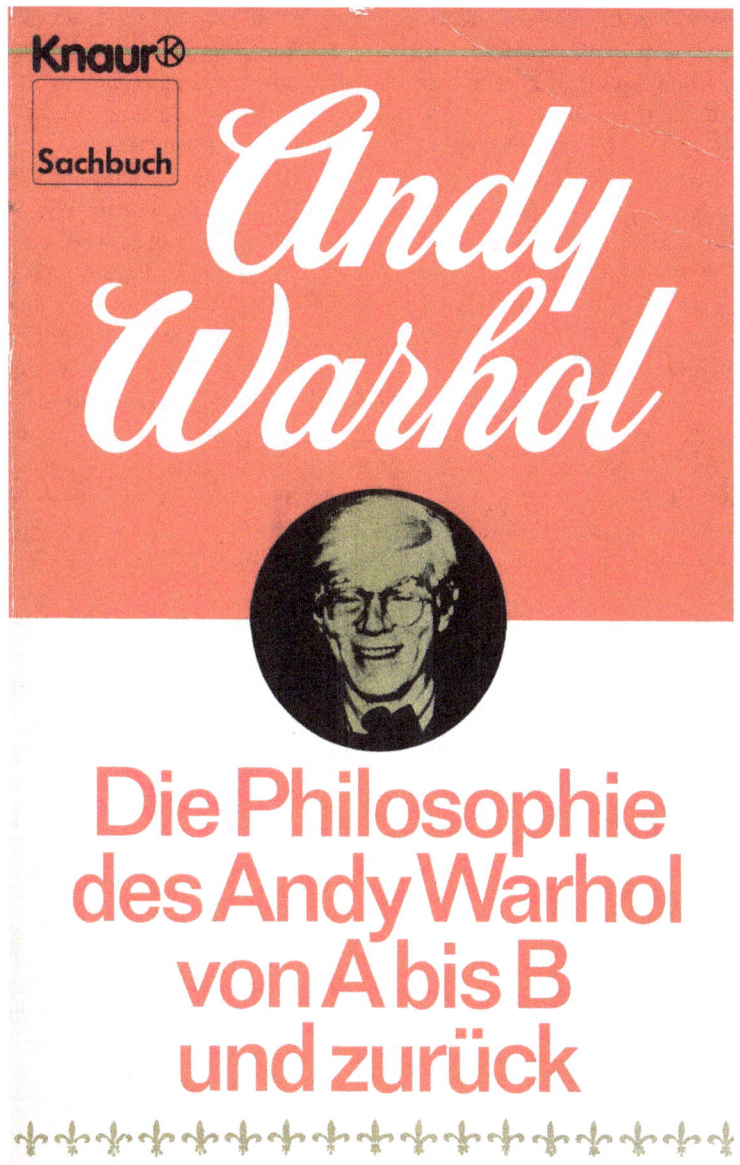

Figure 3.3 Andy Warhol, *Die Philosophie des Andy Warhol von A bis B und zurück*, first German edition (Munich: Droemersche Verlagsanstalt Th. Knaur Nachf, 1991), front cover. Photo: archive of the author.

Warhol's wit, puns, and frequent double entendres, it is the translator's carelessness that most distorts the English original: carelessness in omitting or adding spacing before first lines, in adding or dropping capitalization at will, and in generously using filler words where the original has none.

Readers of the German edition of *Philosophy* unwittingly face distortions to the table of contents, and, as a consequence, to the respective chapters. Why, for instance, change "Andy puts on his Warhol" to "Andy puts on the Warhol" (*den Warhol*)? Why translate "My first scene" as "my first stage appearance" (*erster Auftritt*)? Why not use *Nostalgie* but *wehmütige Erinnerung* (wistful remembrance) for "nostalgia"? Why change "drag queens" to *Transvestiten* (transvestites)? Why garble Warhol's lovingly termed "good plain look" as a "conventional appearance" (*biederes Erscheinungsbild*)? Why are Warhol's "Stars on the Stairs" standing on "marble stairs" (*Marmortreppen*) in the German edition? Why decide on a redundant bilingual solution for the header of the last chapter: "*Unterhosen*—Underwear Power" and not choose one? All these decisions only foreshadow the imprecisions, unfortunate choices, or plain wrong translations that follow in the text itself.

What these infelicities mean for the book can be demonstrated in one of its most fabulous passages, Warhol's verbal self-portrait in chapter one.[66] Here Reimers disfigured "bored languor" as "temperamentless character" (*temperamentloses Wesen*), "enthralling secret knowledge" as "standing grandiosely above things" (*das grandiose Über-den-Dingen-Stehen*), "wispiness" as "those few bushels of hair" (*die paar Haarbüschel*), "the graying lips" as "colorless lips" (*farblose Lippen*), "the cords of the neck standing out around his Adam's apple" as "the hair stubble near the large Adam's apple" (*die Haarstoppeln an dem großen Adamsapfel*). Warhol's memorable concluding sentence, "I'm everything my scrapbook says I am," is distorted into "This is how I am, this is what it says black on white in my scrapbook" (*So bin ich, so hab' ich's schwarz auf weiß in meiner Kritikensammlung stehn*).

For a publisher like Knaur to accept such a flawed translation is one thing. We must suppose that they simply wished to add Warhol's book as a biography of sorts to their series of artists' lives (including, as the ad in the back of *Philosophie* indicates, Zelda Fitzgerald, Juliette Greco, Katherine Mansfield, Nina Kandinsky, Marc Chagall, and Salvador Dalí). Their readership would not have been very discriminate when it came to language. But the prestigious publisher S. Fischer who licensed the title in 2006, fifteen years after is first German release, should have taken the trouble to revise Reimers's work or to do better by Warhol and to commission an entirely new translation.

[66] Andy Warhol, *THE Philosophy of Andy Warhol (From A to B and Back Again)* (New York: Harcourt Brace Jovanovich, 1975), 10; Warhol, *Philosophie*, 18.

POPism 2008

The German translation of *POPism*, first published in English in 1980, appeared in 2008, too late to leave any mark on the early German reception of Warhol and his art. The publisher's blurb advertised *POPism. Meine 60er Jahre* as "*the* authentic artist's autobiography of the late twentieth century—revealing and amusing, vain and intelligent, and, from the first to the last line, POP."[67] The book figured as Warhol's memoir of his first decade as Pop artist and was written by him and his friend Pat Hackett at a time when the historicization of Pop art was a *fait accompli*.

While the German blurb's claims can be dismissed as marketing strategy, the first question that comes to mind in looking at Schirmer/Mosel's German edition is: Why had they decided to go with *POPism* instead of *POPismus*, as the proper German term would be? There is *Impressionismus* and *Expressionismus*, so why not *POPismus*? Was it that they wanted the title to sound not universal but American? As American as Warhol was in the popular imagination? The colors for the text on the cover—blue and red on white—as well as the photo selected for the cover confirm that this was their strategy: A 1964 photograph by Bob Adelman of Warhol pushing a grocery cart through a supermarket aisle (Figure 3.4). The cart is filled with Brillo boxes, Campbell's soup cans, and Coke bottles: Warhol's insignia. Everything—the man, the art, the book—was meant to signal: *Amerika*.[68]

The translator, Nikolaus G. Schneider, did an excellent job with this book. Generally, he dared to be free in his translation rather than going about the task word by word, and that is often to the benefit of the text. In the case of *POPism*, this practice paid off. Unlike Reimers in *Philosophie*, Schneider observed all formal givens (paragraphs, capitalization, and other modes of stressing words, and so on) of the original in his text. What is more, he apparently in collaboration with the copy-editor, Marion Kagerer, endowed it with a flow remarkably close to the English text.[69] Schneider even achieved the unlikely feat, in some instances, of keeping the German shorter than the English. Consider, for example, the opening line of the chapter "1964": *1964 war*

[67] "die authentische Künstlerautobiographie des späten 20. Jahrhunderts—aufschlussreich und amüsant, eitel und intelligent und von der ersten bis zur letzten Zeile POP"; Warhol, *POPism. Meine 60er*, dust jacket blurb.
[68] The credits claim that Adelman's photo dates to 1962 but this is too early since Warhol first showed the *Brillo* series in 1964.
[69] In the colophon, Marion Kagerer is listed as "Bearbeiter." She stated that she copy-edited Schneider's translation for "content and tone" in an email to the author of July 13, 2023. Schneider found out about these changes only later, he noted in an oral communication to the author of August 1, 2023.

Figure 3.4 Andy Warhol, *POPism. Meine 60er Jahre*, first German edition (Munich: Schirmer/Mosel, 2008), front cover. Courtesy of Schirmer/Mosel München; cover photo © Adelman Images LP.

Jugend angesagt for "Everything went young in '64."⁷⁰ Or: *Man lernt was, wenn man über sein Leben schreibt* for "One of the things that happens when you write about your life is that you educate yourself."⁷¹ Schirmer/Mosel's *POPism* is a superior kind of non-verbatim translation, one that would be becoming to *Philosophie* as well.

Evidently, what was marketed with the German edition of *POPism* was no longer the avant-garde or underground artist Warhol whom KiWi had tried to push with its early 1970s releases of *a. Ein Roman* and *Blue Movie*. *POPism*, the most polished and artistically least unconventional of Warhol's books, was to present him to a German audience twenty-eight years after its first release as mainstream—as history. With its German edition, Schirmer/Mosel advertised Warhol in 2008 as an embodiment of Pop art, as a desirable commodity, as something universally recognizable and likable, as a personification of America.

In Conclusion

Whereas *a* and *Blue Movie* had been considered literary projects and were treated as such by West German publishers, Warhol's later books held an interest for a wider audience, possibly because they promised to reveal something about the man, Andy Warhol. Even though the English originals of *Philosophie*, *Tagebuch*, and *POPism* were easier reads than *a* and *Blue Movie*, the change in audience led to the creation of German translations of these more mainstream publications. The fact that it was Knaur and not a more ambitious publisher who took up Warhol's *Philosophie* and *Tagebuch* and that they did so in 1991 and 1989 (the release dates of the English editions having been 1975 and 1989, respectively), when the influence of the Frankfurt School was waning, is an indication that the German neo-Marxist ideas were losing their hold on the general reception of Warhol. The intended and actual audiences for Warhol's titles had changed significantly since the early 1970s. While it was initially intellectuals (art historians, art critics, academics, gallerists, and others), the audience later widened to encompass all those who enjoyed art as a mere leisure activity or as—*horribile dictu* to Adorno and Horkheimer—entertainment. Consequently, the general conception of Warhol's writings had shifted as well: from avant-garde literature to a popular read.

⁷⁰ Warhol, *POPism. Meine 60er*, 113; Andy Warhol and Pat Hackett, *POPism: The Warhol '60s* (New York: Harcourt Brace Jovanovich, 1980), 87.

⁷¹ Warhol, *POPism. Meine 60er*, 81; Warhol and Hackett, *POPism: The Warhol '60s*, 59.

By 1996 the standard German dictionary *Duden Deutsches Universalwörterbuch* explained that the term "pop art" derived from "popular art = *volkstümliche Kunst*" (folksy art).[72] No mention was made of its early association in the West German reception with the verb *poppen*. In a way, this translation of "popular" as "folksy" blends out the historical dilemma posed by the initial appearance of Pop art in West Germany. *Volkstümlich* entails "well-liked," the other meaning of *populär*; but it certainly does not suggest a relation to things sexual. This link—and with it that to the critical theory of the Frankfurt School—today is no longer part of either the critical or popular perspective in Germany on either Warhol or the historical movement called "Pop art." The shift over time in both the choice of Warhol books to translate and the meaning of "pop" echo the move away from critical theory as the prevailing ideology behind the German reception of Warhol's art.

[72] "Pop-Art," *Duden. Deutsches Universalwörterbuch*, 3rd rev. edn. (Mannheim, Leipzig, Vienna, Zürich: Dudenverlag, 1996), 1166.

4

La Filosofia di Andy Warhol and the Turmoil of Art in Italy, 1983

Francesco Guzzetti

Titled *La Filosofia di Andy Warhol*, the Italian translation of *The Philosophy of Andy Warhol (From A to B and Back Again)* was published in 1983 by Costa & Nolan, a publishing house founded in Genoa in 1981 (Figure 4.1). The company name combines the last name of Carla Costa with the nickname of the cofounder, Eugenio Bonaccorsi, who used to sign his theater reviews as "Nolan."[1] The American edition of the book had appeared eight years earlier, in 1975. It was the Genoese critic and curator Germano Celant who suggested the publication of the book in Italy. Celant collaborated with Costa & Nolan and was the editor of a collection of books titled *I turbamenti dell'arte*, which translates as *The Turmoils of Art*. *La Filosofia di Andy Warhol* inaugurated the series, for which the graphic design was elaborated by the architect and designer Pierluigi Cerri, who was a friend of Celant and collaborated with him on several of his exhibition and publication projects beginning with the seminal show *Ambiente arte* at the Venice Biennale of 1976.

In order to properly frame the release and reception of the book, the history of the relationship between Warhol and Italy up to then should be first briefly surveyed. While some moments have been already studied, the whole evolution of the Italian reception of the artist has yet to be fully analyzed.

I wish to thank Neil Printz and Reva Wolf for their invaluable help and insights, and Enrico Camporesi for his careful review of the manuscript and excellent suggestions. Translations and transcriptions are mine, unless stated otherwise.

[1] Unfortunately, not much information about the publishing house is available. Owners varied, the company moved to Milan in 1997, and it apparently ceased publications in 2010. In the early 2000s, Fondazione Arnoldo e Alberto Mondadori in Milan, a foundation specializing in preserving and studying the legacy of Italian publishers, commissioned a survey of all the publishing houses based in Lombardy. It was a long-term project, in which Costa & Nolan was included, resulting in the creation of a database of the archives of each publisher. With regards to Costa & Nolan, contact details have never been updated since the end of the project, and it has been impossible to locate the archive so far (see https://lombardiarchivi.servizirl.it/fonds/1205).

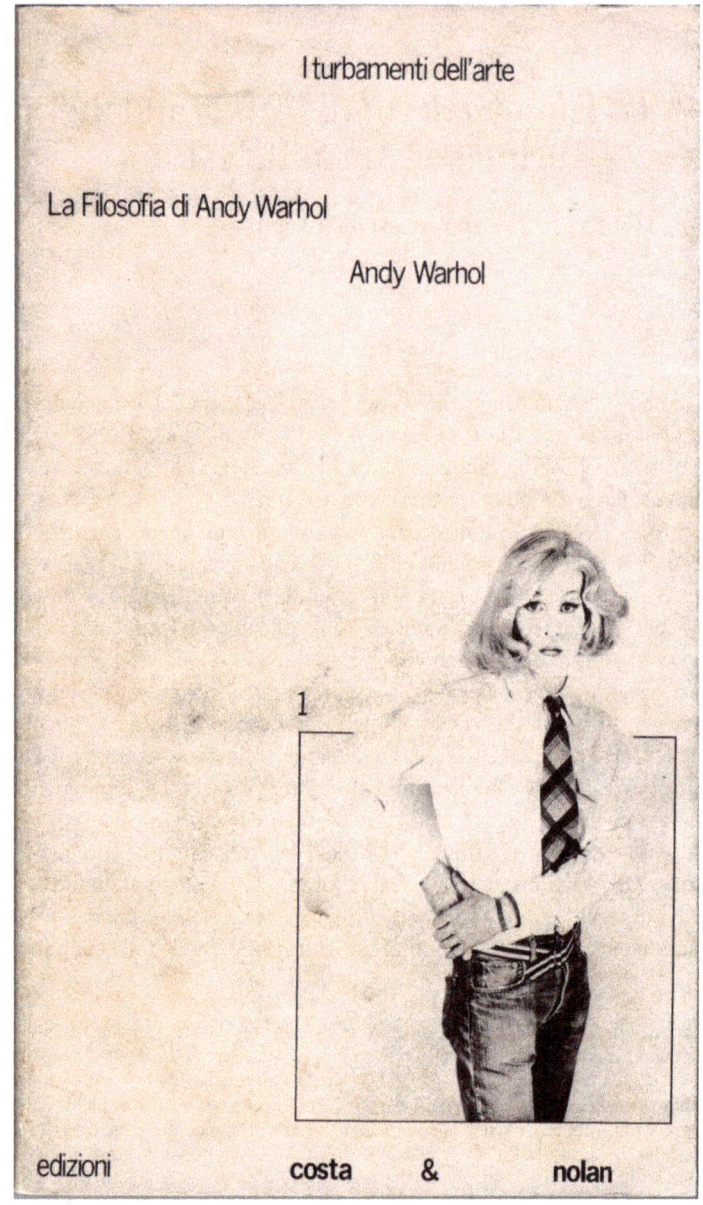

Figure 4.1 Christopher Makos, photograph of Andy Warhol, 1981, featured on the front cover, Andy Warhol, *La Filosofia di Andy Warhol* (Genoa: Costa & Nolan, 1983). Photo: archive of the author; cover photo © Christopher Makos.

The Context

The name of Warhol first circulated in Italy within the exposure to Neo-Dada and Pop art in the 1960s, concurrently with the seminal exhibitions of Pop artists organized by dealers such as Gian Enzo Sperone. Before opening his own gallery, Sperone worked as the director of Galleria Il Punto in Turin, where he organized a pivotal solo show of Roy Lichtenstein, opening on December 23, 1963, thus anticipating the interest in American art, consecrated during the famous edition of 1964 of the Venice Biennale, in which Robert Rauschenberg was awarded the International Grand Prize in Painting.[2]

In conjunction with such initiatives, a few critics investigated the effort of Neo-Dada and Pop artists to reassess the tenets of the representation of reality in art. Contributions authored by Maurizio Calvesi and Alberto Boatto paved the way to the interpretation of Pop art as the epitome of the newly raised awareness of the modification of individual and social life habits induced by the increasing circulation of mass-produced objects and mediatized images.[3] The ideas of Calvesi and Boatto would resonate with those expressed in a book edited by the American art critic Lucy Lippard, published in Italy by Mazzotta in 1967 (Figure 4.2).[4] Compared to other Pop artists, Warhol looked like an artist with a limited expressive range, yet of undeniable quality (*artista limitato ma sicuro*),[5] who undertook a deliberate revision of the status of the image, midway between the repetitiveness of mechanical reproduction and the aesthetics of pure painting. His distinctive technique combining silkscreen and paint was analyzed as a critique of the proliferation of replicated images and the consumerist nature of the society of mass media. The practice of the artist was compared to the work of sociologists and ethnographers, as providing a comprehensive report on social structures and collective habits.[6] In the mid-1960s, early insights on Warhol, mainly borrowed

[2] *Lichtenstein* (Turin: Il Punto arte moderna, 1963).
[3] See the three-part essay, "Un pensiero concreto," which translates as "A Concrete Thinking," by Maurizio Calvesi: "Un pensiero concreto (1°)," *Collage* 3–4 (December 1964): 65–70; "Un pensiero concreto II," *Marcatrè* 3, nos. 16–18 (July 1965): 241–51; "Un pensiero concreto parte terza," *Marcatrè* 4, nos. 23–25 (June 1966): 92–100. After traveling to New York in fall 1964, Alberto Boatto published a book that radically redefined the terms of the reception of Pop art in Italy: *Pop Art in U.S.A.* (Milan: Lerici, 1967).
[4] Lucy Lippard, ed., *Pop Art* (Milan: Mazzotta, 1967). Lippard's anthology had just been published in the United States the year before, 1966, by Praeger Publishers, also as *Pop Art*.
[5] Calvesi, "Un pensiero concreto parte terza," 94.
[6] Boatto, *Pop Art in U.S.A.*, 214–15.

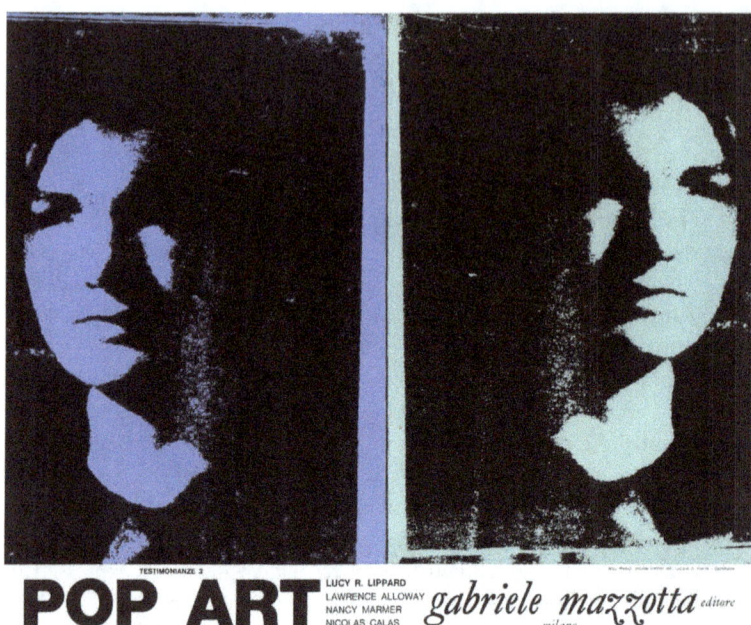

Figure 4.2 Poster advertising the release of the Italian edition of Lucy Lippard's *Pop Art* (Milan: Mazzotta, 1967), featuring Andy Warhol's *Jackie* paintings.

from American criticism, started to circulate, such as the profile by Gene R. Swenson following the exhibition of *Brillo Boxes* at Stable Gallery in spring 1964 and published in the magazine *Collage* at the end of the year.[7] Some of the photographs of the artist at the Factory taken by the Italian painter Mario Schifano during his stay in New York in 1964 illustrated the article.[8]

The general popularity of the figure of Andy Warhol gradually complemented and overshadowed the appreciation of his work, especially when the artist started to travel to Italy in the 1970s.[9] Until then, the voice of the artist was relatively unknown in Italy, with a few exceptions, such as the interview of 1963 with Gene Swenson for *ARTnews*, which was translated in

[7] Gene Robert Swenson, "The Darker Ariel: Random Notes on Andy Warhol / annotazioni casuali su Andy Warhol," *Collage* 3–4 (December 1964): 102–6.

[8] Francesco Guzzetti, ed., *Facing America: Mario Schifano 1960–1965* (New York: Center for Italian Modern Art, 2021), 7–8.

[9] In this respect, see Einav Zamir, "Lucio Amelio and Two Unidentified Men," in *Andy Warhol: Private and Public in 151 Photographs*, ed. Reva Wolf (New Paltz, NY: The Samuel Dorsky Museum of Art, 2010), 98–101.

Boatto's 1967 book on Pop art.[10] The dismissal of a conventional approach to the interview, which would soon mark any conversation with the artist, was especially challenging and would soon be considered as a substantial component of his self-constructed narrative. A rare interview published in Italy in 1966 attested to this approach: "Do I still paint? I wanted to stop … I can't: how can I find the money to make films otherwise?" the artist said to Juditte Sarkany-Perret in the interview, produced for a news story on underground cinema in New York that included Warhol among other filmmakers, such as Jonas Mekas, Harry Smith, Gregory Markopoulos, Stan Vanderbeek, and Stan Brakhage, published in the Italian magazine *Marcatrè* in 1966.[11] Rendering ordinary life in an objective and detached style, the films of Warhol aimed to raise in the viewer "the awareness of things as things, of moments as moments,"[12] as Gerard Malanga said in the same interview.

The interview with Sarkany-Perret was seminal insofar as it signaled the importance of filmmaking in the art of Andy Warhol and introduced the idea that objectivity was distinctive to his vision. In this respect, the article was similar to another publication that marked a turning point toward the broader acknowledgment of Warhol's body of work, and of Warhol as a public personality in Italy: *New York: Arte e persone* (1967), which was simultaneously published in the United States in English,[13] and consisted of a collection of stories on the New York art scene, featuring pictures shot by the Italian photographer Ugo Mulas during trips to the city in 1964, 1965, and 1967. The pictures were accompanied by the insightful commentary of Alan Solomon, who introduced Mulas to artists, collectors, and other major figures of the New York art world. Mulas captured Warhol surrounded by his friends and assistants at the Factory, his canvases and *Brillo Boxes* piled along the walls. Only one photograph captures the artist in the process of silk-screening. The majority of the pictures refer to his use of the movie camera and his production of films. According to the text by Solomon, his paintings and films "anticipated much of the present spirit of detachment in American art."[14] Solomon provided a comprehensive portrait of the artist and his life,

[10] Boatto, *Pop Art in U.S.A.*, 275–6.
[11] "Se dipingo ancora? Volevo smettere … non posso: i soldi per i film dove li trovo altrimenti?" Juditte Sarkany-Perret, "U.S.A.—Cinema a New York," *Marcatrè* 4, nos. 19–22 (April 1966): 90.
[12] "la consapevolezza delle cose come cose, dei momenti come momenti"; Sarkany-Perret, "U.S.A.—Cinema a New York," 90.
[13] Ugo Mulas and Alan Solomon, *New York: arte e persone* (Milan: Longanesi, 1967), and *New York: The New Art Scene* (New York: Holt, Rinehart and Winston, 1967).
[14] Mulas and Solomon, *New York: The New Art Scene*, 306.

introducing aspects that would become distinctive of the public recognition of Warhol in the 1970s:

> the Factory also doubles as a film studio and an exhibition hall for miscellaneous eccentrics, many of whom appear at all hours, uninvited ... Life in the Factory picks up in the late afternoon. Later Andy goes out with an entourage of his latest super-stars and various attendants. The group is a familiar sight in the parts of the city where the scene night life [*sic*] goes on.[15]

Mulas's photographs and Solomon's text emphasized the objectivity of the artist's practice as well as the context of his intense social life and his eccentric entourage of assistants and superstars. Solomon's words resonated with the interview given to Sarkany-Perret, but also prefigured major aspects of the discussion about the artist, such as the assessment by Maurizio Fagiolo dell'Arco of 1968, in which the critic focused on the coolness and presumed superficiality through which Warhol treated reality in his work and by means of which he frustrated any attempts of interpretation.[16]

By the early 1970s, in Italy Warhol's experimentations in film fashioned the debates on his work, due to the circulation of the New American Cinema, championed by intellectuals and artists such as Piero Gilardi and Fernanda Pivano, associations including Club Nuovo Teatro in Milan, Unione Culturale in Turin, and Filmstudio in Rome, theater and film magazines like *Sipario*, the third edition of the festival of experimental cinema in Pesaro in 1967, and the program of screenings organized by Jonas Mekas at the Galleria Civica d'Arte Moderna e Contemporanea in Turin from May 13 to 21, 1967.[17] As a result of such initiatives, Warhol was regarded as a

[15] Mulas and Solomon, *New York: The New Art Scene*, 306.
[16] Maurizio Fagiolo dell'Arco, "Warhol: The American Way of Dying," *Metro* 8, no. 14 (June 1968): 72–9.
[17] For Gilardi's analysis, see Piero Gilardi, "Lettera da New York," *Ombre elettriche* (December 1967): 23–5 [*Ombre elettriche* is an alternative magazine, with no volume or issue nos.]. The following writings by Fernanda Pivano are relevant: "Manovelle fuori canale: i filmatori italiani da underground a indipendenti a collettivi," *Domus* 477 (August 1969): 42–9; and "Obiettivo nell'occhio/coscienza: i filmatori USA dal cinema sperimentale all'underground," *Domus* 490 (September 1970): 51–8. Club Nuovo Teatro was a film club founded by Franco Quadri in 1967; see Renata M. Molinari, ed., *Franco Quadri* (*Panta* 31) (Milan: Bompiani, 2014). Filmstudio, a film club in Rome, regularly screened Warhol's films starting from 1968, often for the first time in Italy; see Adriano Aprà and Enzo Ungari, *Il cinema di Andy Warhol* (Rome: Arcana Editrice, 1971), 4. The program of the festival in Pesaro was self-printed by the festival organizers and few copies of it still exist; see *NC New American Cinema. Terza mostra internazionale del nuovo cinema. Quattro programmi selezionati da Jonas Mekas* (Pesaro, 1967). On the screenings

major figure among underground filmmakers. Germano Celant, too, first acknowledged the artist's pioneering role as a filmmaker rather than a Pop artist, as he noted in one of the earliest essays on the new artistic avant-garde of Arte Povera, in which he highlighted the liberating power of the artlessness distinguishing the adherence to life in the films of Warhol.[18]

The film *Chelsea Girls* (1966) in particular aroused the interest of leading Italian intellectuals and writers, including Alberto Arbasino and Alberto Moravia. Both had traveled to New York, where they were informed firsthand on the latest tendencies and wrote extensively on Warhol's films, acknowledging their novelty in the structure and visual vocabulary of filmmaking beyond the provocative, sometimes disturbing, imagery. The reception of the artist's underground films was countered by the early accounts on his public figure and the entourage around him. In the eyes of the commentators, the provocation of the films overlapped with the artist's construction of his identity. Critics would ultimately put an emphasis on cinema, more than painting, as the medium resonating the most with the artist's negotiation of his life vis-à-vis his public persona. In the same article in which he reported on the 1968 attempt on Warhol's life, Moravia reviewed *Chelsea Girls* by defining the specific authenticity of the cinema of Warhol as the technique "of the unpredictable of the ordinary."[19] After seeing the film and visiting the artist at the Factory, Arbasino collapsed the analysis of Warhol's art and the person of Warhol, concluding: "Finally, not only because *Chelsea Girls* is the most extraordinary success of the season (and it cost so little), the 'extraordinary' film character is currently Andy Warhol."[20] Arbasino described the main physical traits of Warhol—the hair, the nose, the way of speaking, the indefinable age—and the flawless continuity between artistic creation and ordinary life, setting the tone of later assessments of the artist.

organized by Mekas in Turin in 1967, see the local newspaper review, R. Gi., "Il 'nuovo cinema' americano alla Galleria di Arte moderna," *La Stampa* 112 (May 13, 1967): 4. In 2017, Fondazione Prada in Milan replicated the film program as a celebration of its fiftieth anniversary; see https://www.fondazioneprada.org/project/the-new-american-cinema-torino-1967/?lang=en.

[18] Germano Celant, "Arte povera," in *La povertà dell'arte*, vol. 1, ed. Pietro Bonfiglioli, (Bologna: Quaderni de' Foscherari, 1968), n.p.; rpt., Germano Celant, *Precronistoria 1966–69* (Florence: Centro Di, 1976), 66.

[19] *L'imprevisto del normale*; Alberto Moravia, "A mezzanotte con l'ape regina," *L'Espresso* 14, no. 25 (June 23, 1968): 23. Moravia would later expand on the film practice of Warhol in his book *Al cinema. Centoquarantotto film d'autore* (Milan: Bompiani, 1975), 211–12, 255–7.

[20] "Finalmente non soltanto perché *Chelsea Girls* è il successo più straordinario della stagione (ed era costato pochissimo) il personaggio cinematografico 'straordinario' è attualmente Andy Warhol"; Alberto Arbasino, *Off-off* (Milan: Feltrinelli, 1968), 183–4.

According to these analyses, the films of the artist conveyed no less of a blatant sense of detachment than his person, and this quality inspired untraditional formats to communicate it. Gathering texts and statements to compose a survey on the New American Cinema published in *Sipario* in 1969, Aldo Rostagno and Nuccio Lodato employed a collage technique to present Warhol. The investigation of his work was interspersed with quotations from a diverse range of sources, collapsing notes on ordinary events, references to the scars on his body, and insights into a practice that embraced the use of recording systems as the ultimate form of realism.[21] The article diverged from previous attempts to explain Warhol by virtue of its proximity to the "matter-of-factness" of his statements and works, even while drawing on earlier appraisals of him. It contained a translation of parts of a story written by John Leonard for *New York Times Magazine* on the occasion of the publication of *a: A Novel* in 1968, for which he interviewed superstars and assistants of Warhol at the Factory.[22]

A book published in 1971 marked the transition toward a more original approach to the personality of the artist with a comprehensive survey of Warhol's experimental cinema. It was edited by the critics Adriano Aprà and Enzo Ungari and republished in an updated version in 1978. The book was meant to be a catalog of all the films directed and produced by Warhol, enriched by the editors' commentaries. They defined his cinema as a "cinema-limit," in which all the conventions of making and judging films are at stake:

> Not only the notions of "realism," "verisimilitude," and "statement" are lacking and inadequate. The concepts of "work," "author," and "discourse," too, are turned upside down and reassessed by films which identify with their process of production and turn this relationship into a theoretical thinking, thus producing knowledge and setting a new field of inquiry (whose effects require tools which old-fashioned critics lack).[23]

[21] Aldo Rostagno and Nuccio Lodato, "Collage per Andy Warhol," *Sipario* 274 (February 1969): 65–6. The article is followed by the partial translation of a review of *Chelsea Girls* by Toby Mussman, "The Chelsea Girls," *Film Culture* 45 (1967): 41–5.

[22] John Leonard, "The Return of Andy Warhol," *New York Times Magazine*, November 10, 1968, 32–3, 142–51.

[23] "In questo senso si può parlare di cinema-limite: non sono solo le nozioni di 'realismo,' 'verosimile,' 'enunciato' a risultare insufficienti o spurie; sono le stesse nozioni di 'opera,' 'autore,' 'discorso' ad essere stravolte e ripostulate da film che, identificandosi con il loro processo di produzione e facendo di questa relazione una riflessione teorica, producono un sapere e stabiliscono il campo di una problematica nuova (i cui effetti chiamano in causa strumenti di cui la vecchia critica è sprovvista)"; Aprà and Ungari, *Il cinema di Andy Warhol*, 4.

Aprà and Ungari's anthology on the artist's films included a translation of what became one of Warhol's most famous interviews, with Gretchen Berg, published in *The East Village Other* in 1966, which they probably knew through a version that appeared the following year in *Cahiers du Cinema*.[24] The translation of an interview reflects a broader trend of the time.

The same year when the book by Aprà and Ungari was published, an interview that Warhol had given to Joseph Gelmis in 1969 was translated for an issue of *Sipario*.[25] Gelmis had published this conversation in his book, *The Film Director as Superstar*, in which he gathered interviews with several emerging filmmakers.[26] The interview reinforced the view that Warhol decided to abandon painting to concentrate on film and that he embraced chance and banality by refusing specific involvement as a director.

All the interviews published throughout the years in Italy prefigured the effect of the publication of the Italian edition of *The Philosophy of Andy Warhol*. Affirming the control exerted by the interviewee on the final result of the interview, the artist at times blatantly reversed the format of the interview, undermined its presumptive objectivity, and resorted to banality as a creative means of collaboration with the interviewer. As Reva Wolf explained,

> With his seemingly banal answers, Warhol constructed space for the creativity of the interviewer. He further encouraged such creativity through reversing and otherwise confusing the roles of interviewer and interviewee.
>
> … [P]recisely when the idea of giving the interviewee more control over the content of interviews was embraced, and just as the seemingly objective question-and-answer format gained wide acceptance within the realm of serious journalism, Warhol, through his apparent evasiveness, showed that its claims to documentary objectivity were trickery. After all, interviews nearly always are rehearsed, edited, or

[24] Gretchen Berg, "Andy Warhol: My True Story," *The East Village Other* 1, no. 23 (November 1–15, 1966): 9–10, and "Nothing to Lose, Interview by Gretchen Berg," *Cahiers du Cinema in English* 10 (May 1967): 38–43, published in Italian in Aprà and Ungari, *Il cinema di Andy Warhol*, 21–6. On the creation of this interview, see Matt Wrbican, ed., *A Is for Archive: Warhol's World from A to Z* (New Haven, CT: Yale University Press, 2019), 106–11 (also see the references in Jean-Claude Lebensztejn, "Warhol in French," note 1, in the present volume).

[25] Joseph Gelmis, "I veri film li fanno a Hollywood: Andy Warhol si confessa," *Sipario* 299 (March–April 1971): 24–8.

[26] Joseph Gelmis, *The Film Director as Superstar* (Garden City: Doubleday & Company, 1970), 65–73.

otherwise manipulated, and are not the spontaneous conversations that the question-and-answer format would suggest.[27]

Up until the early 1970s, the reception of Warhol in Italy was largely based on the integration of interviews and articles published abroad. Publications generated in Italy about the artist began to proliferate with his increasing presence in the country during this decade. In 1972, Warhol was invited by Incontri Internazionali d'Arte in Rome—an association championing international avant-garde, founded by Graziella Lonardi Buontempo in collaboration with Achille Bonito Oliva—to present his latest films (collaborations with Paul Morrissey), *Women in Revolt* and *L'Amour*, and participate in a public debate with critics and intellectuals.[28] The program took place on April 10–11, 1972, and was widely reviewed. The public dialogue with the artist confirmed the impressions produced by the previously translated interviews. Surrounded by his assistants, Warhol acted as an ageless and inscrutable "wax mask."[29] He said little and avoided answers, these strategies serving to reaffirm his superficiality and indifference to any debates, while he meanwhile obsessively recorded the proceedings with his Polaroid camera and tape recorder.[30]

Later, other events brought the artist back to Italy and increased his popularity. An exhibition at Palazzo dei Diamanti in Ferrara from October to December 1975, in which his *Ladies and Gentlemen* series of painted portraits of transvestites was presented in Italy for the first time, stands out in this respect (Figure 4.3). Organized by the director of the museum, Franco Farina, and promoted by Luciano Anselmino, a dealer based in Turin who was championing the art of Warhol at the time, the exhibition was introduced by a roundtable with the artist, whose visit to Italy was documented by the

[27] Reva Wolf, "Introduction: Through the Looking-Glass," in *I'll Be Your Mirror: The Selected Andy Warhol Interviews, 1962–1987*, ed. Kenneth Goldsmith (New York: Carroll & Graf Publishers, 2004), xvii, xxi. Wolf has recently expanded this contextualization of Warhol's approach to interviews within the broader history and problem of the artist interview as a genre; see Reva Wolf, "The Artist Interview: An Elusive History," *Journal of Art Historiography* 23 (December 2020): 21–3.

[28] A full record of the roundtable is provided in Bruno Corà, ed., *Incontri 1972. Quaderni del Centro di Informazione Alternativa*, vol. 3 (Rome: Incontri internazionali d'arte, 1979), 8–25. On the question of the authorship of the early 1970s films involving Morrissey, see the discussions cited in Jean Wainwright's contribution to the present publication, note 34.

[29] See Franco Quadri, "Warhol la maschera di cera," *Sipario* 313 (June 1972): 14–16.

[30] Luca Patella and Rosa Patella, "Films e disattenzione selettiva di Warhol," *Data* 2, no. 4 (May 1972): 69.

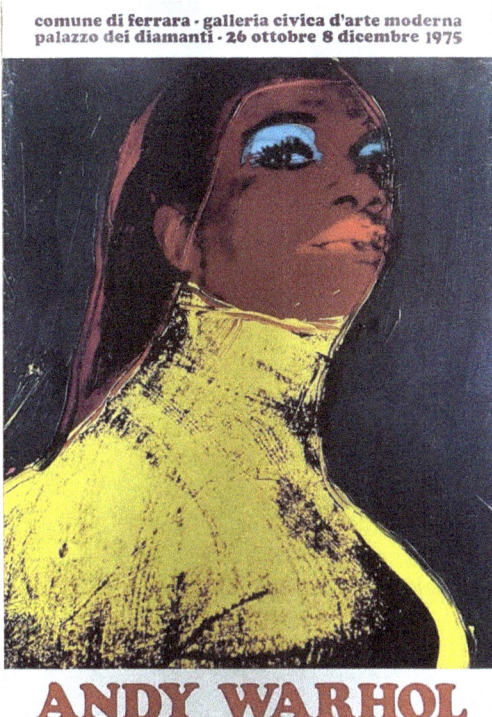

Figure 4.3 Poster advertising the exhibition *Andy Warhol: Ladies and Gentlemen*, Galleria civica d'arte moderna, Ferrara, 1975.

photographer Dino Pedriali.[31] As usual, Warhol was reportedly evasive in the roundtable, and his assistant Bob Colacello protected him by answering the majority of the questions on his behalf.[32] The exhibition was accompanied by a catalog edited by the art critic Janus, who was based in Turin and collaborated frequently with Anselmino.[33] Janus interpreted

[31] Maria Luisa Pacelli, "*Ladies and Gentlemen* at the Palazzo dei Diamanti in Ferrara, October 1975: An Interview with Franco Farina," trans. Ulrich Birkmaier, in *Warhol & Mapplethorpe: Guise & Dolls*, ed. Patricia Hickson (Hartford: Wadsworth Atheneum, in association with Yale University Press, 2015), 43–7. Publications in which the photographs by Pedriali are reproduced include: Gianni Mercurio and Mirella Panepinto, eds., *Andy Warhol. Viaggio in Italia* (Milan: Mazzotta, 1997), 181–200; and Claudio Spadoni and Estemio Serri, eds., *Andy Warhol* (Bologna: Edizioni Cinquantesi, 2006).

[32] Pacelli, "*Ladies and Gentlemen*," 45.

[33] Janus, ed., *Andy Warhol. Ladies and Gentlemen* (Milan: Mazzotta, 1975).

Warhol's portraits of transvestites from a political perspective, in light of the ongoing race problem in the United States.[34]

The *Ladies and Gentlemen* exhibition coincided with a moment of intense political debate in Italy, a context that contributed to diverse interpretations of the work. Anselmino asked Pier Paolo Pasolini, who was one of the most prominent intellectuals in Italy at that time, for an essay on it. The essay was written in October 1975 and published in the catalog of an exhibition of a small selection of the *Ladies and Gentlemen* paintings held at Anselmino's gallery in Milan in May 1976, soon after the author's death.[35] An intellectual deeply rooted in European culture, Pasolini held a distinctive, yet problematic, conservative worldview, which extended also to his own homosexuality. In the essay, he interpreted the *Ladies and Gentlemen* series as the representation of the homogeneity of the American view of humankind, in which diversity is absorbed within

> a sclerotic unity of the universe, in which the only freedom is that of the artist, who, essentially despising it, plays with it. The representation of the world excludes any possible dialectic. It is, at the same time, violently aggressive and desperately impotent. There is, therefore, in its perversity of cruel, cunning and insolent "game," a substantial and incredible innocence.[36]

Another major connection with Italy in the 1970s revolved around the long-lasting relationship between Warhol and Lucio Amelio, a dealer based in Naples who invited Warhol to the city for the first time in 1976 (Figure 4.4).[37]

[34] On the exhibition, the catalog, and Warhol's visit to Italy on that occasion, see Neil Printz, "Ladies and Gentlemen," in *The Andy Warhol Catalogue Raisonné*, vol. 4: *Paintings and Sculpture Late 1974–1976*, ed. Neil Printz and Sally King-Nero (London: Phaidon, 2014), 59–60.

[35] See Alessandro Del Puppo, *Pasolini Warhol 1975* (Milan and Udine: Mimesis Edizioni, 2019), 11–112. Pasolini's essay has often, even recently, mistakenly been thought to have written for the catalog of the exhibition in Ferrara, as Del Puppo observes.

[36] "una unità sclerotica dell'universo, in cui l'unica libertà è quella dell'artista, che, sostanzialmente disprezzandolo, gioca con esso. La rappresentazione del mondo esclude ogni possibile dialettica. È, al tempo stesso, violentemente aggressiva e disperatamente impotente. C'è dunque, nella sua perversità di 'gioco' crudele, astuto e insolente, una sostanziale e incredibile innocenza"; Pier Paolo Pasolini, *Andy Warhol. Ladies and Gentlemen* (Milan: Luciano Anselmino, 1976), n.p., and republished in Del Puppo, *Pasolini Warhol 1975*, 112.

[37] On the collaboration between Warhol and Amelio, see Angela Tecce, "Warhol e Napoli," in *Andy Warhol. Viaggio in Italia*, ed. Gianni Mercurio and Mirella Panepinto (Milan: Mazzotta, 1997), 21–6; Michele Bonuomo, ed., *Warhol, Beuys: Omaggio a Lucio Amelio* (Milan: Mazzotta, 2007); Zamir, "Lucio Amelio and Two Unidentified Men," 98–101; and Francesca Franco, "Diario napoletano e altro," in *Andy Warhol Vetrine*, ed. Achille Bonito Oliva (Cinisello Balsamo: Silvana Editoriale, 2014), 17–20.

La Filosofia di Andy Warhol *and the Turmoil of Art in Italy, 1983* 83

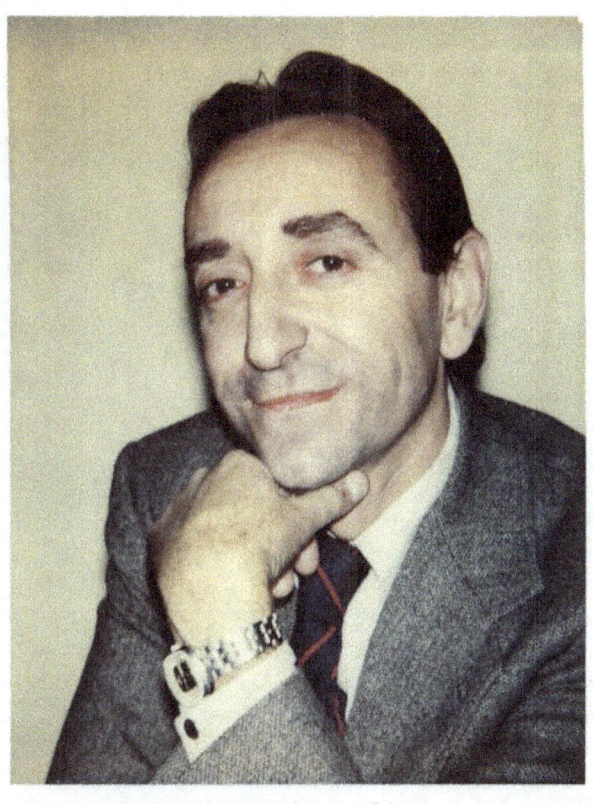

Figure 4.4 Andy Warhol, *Lucio Amelio*, after August 1975, Polacolor Type 108, 4¼ × 3⅜ in. (10.795 × 8.57 cm). The Trout Gallery, Dickinson College, Gift of the Andy Warhol Foundation for the Visual Arts, Inc.

This association resulted in important projects, culminating in a group of portraits by Warhol of Joseph Beuys. Amelio held an exhibition of these portraits, in conjunction with which he organized a public meeting between the two artists, which took place on April 1, 1980. Reporting on the event, commentators couldn't help but notice the diverging attitudes of the two artists, which were seen as representative of a perceived opposition between the utopianism of European art and the superficiality of American art. One writer described the two as, "the ideological project-making European artist, and the American artist as distant and objective as his mythical camera, his

inseparable companion."[38] The journalist Michele Bonuomo dedicated a page of *Il Mattino*, the daily newspaper of Naples, to both artists. The section on Warhol included a collection of excerpts translated from *POPism*, Warhol's memoir on Pop art, which he had just co-authored with Pat Hackett,[39] and a poem on Naples. Despite a misleading translation of a portion of it, which appeared in *Domus* in 1980,[40] the poem was apparently originally published solely in Italian:

> I love Naples because it reminds me of New York,
> especially due to the many transvestites and the garbage by the street.
> Like New York, it's a city
> that falls apart, and regardless the people are
> happy as people in New York.
> What I love the most to do in Naples is visiting
> all the old families in their old palaces, that seem to be standing held
> together by a rope, almost giving the impression of falling into the
> sea at any moment.
> The best seafood is in Naples, too,
> the best pasta
> and the best wine.
> What else could I add?[41]

Published at the end of a decade of increasing presence of the artist, the poem encapsulates the defining traits of his attitude. The prose-like style of the

[38] Angelo Trimarco, "Warhol e Beuys," *Domus* 607 (June 1980): 56. On the comparison of Warhol and Beuys, see also Nina Schleif's chapter on German translations of Warhol in the present volume, note 53.

[39] Andy Warhol, "Amo New York, cioè Napoli," *Il Mattino* 84 (April 1, 1980): 5. The article translates a few paragraphs from the first pages of Andy Warhol and Pat Hackett, *POPism: The Warhol '60s* (New York: Harcourt Brace Jovanovich, 1980), 3, 5–6, 16–17, 20, 22, 34–5. The Italian text sometimes diverges from the source, and the last sentence, which reads as "time has passed, by now I can get to any parties all over the world" (*Il tempo è passato, ormai riesco ad entrare nei salotti di tutto il mondo*), doesn't correspond to any passage of the book.

[40] Trimarco, "Warhol e Beuys," 56.

[41] The original text reads as follows: "Amo Napoli perché mi ricorda New York, / specialmente per i tanti travestiti e per i rifiuti per strada. Come New York, è una città / che cade a pezzi, e nonostante tutto la gente è / felice come quella di New York. / Quello che preferisco di più a Napoli è visitare / tutte le vecchie famiglie nei loro vecchi palazzi che sembrano stare in piedi tenuti insieme da una corda, dando quasi l'impressione di voler cadere in mare da un momento all'altro. / A Napoli c'è anche il pesce migliore / la migliore pastasciutta / ed il vino migliore. / Cos'altro potrei aggiungere?"; "Una poesia per 'Il Mattino,'" *Il Mattino* 84 (April 1, 1980): 5.

verses resonates with the artist's love for references to prosaic, ordinary reality. Despite the ingenuous question in the final line, Warhol totally overlooked the most remarkable aspects of the city, which often recur in literature as a celebration of Naples, such as the breathtaking seascapes, the astonishing light, the pleasant weather, the sense of greatness of the illustrious past, or the beauty permeating its art. The artist focused instead on images of degradation and stereotypes about Italian food. The poem conveys the sense that a literary construction lies behind the ingenuity of the words, as the dullness expressed by the artist's inscrutable expressions concealed the construction of a public persona. Such a disorienting feeling of the artist's double personality, split between banality and awareness, would culminate a few years later, when the Italian edition of his *Philosophy* was released.

The Book

The Philosophy of Andy Warhol was published in early September 1975, not long before the exhibition of *Ladies and Gentlemen* opened in Ferrara. Eight years later, by the time the book appeared in Italian translation, Warhol had achieved a solid popularity in Italy, where he was mostly known for his look and his elusive attitude in public situations. His "mask-like" face had already attracted diverse interpretations and his obsession for recording reality had been noticed.

The spirit of the book, however, resonated with news stories about Warhol's social life or his extravagant presentations in fashion magazines, rather than with his apparent evasiveness. The Italian edition of *Vogue* had already introduced the artist as early as 1970. A column titled "*Se ne parla*"—which translates as "Talked about"—included a full-page illustration of a photograph by Cecil Beaton depicting Warhol with Jay Johnson, who was the twin brother of his then boyfriend, and Candy Darling, a well-known transgender actor in his movies, accompanied by a short caption describing him as "the most famous artist of America ... Someone says that the masterpiece of Andy Warhol is Andy Warhol."[42] Significantly, the brief note mentioned that the artist was working on his second novel, which might be the novel titled *b*, never completed, for which Warhol had begun making tape recordings in 1969.[43]

[42] "Andy Warhol è tuttora l'artista più famoso d'America"; "Se ne parla: Andy Warhol," *Vogue Italia* 224 (April 1970): 140–1.

[43] Lucy Mulroney, "I'd Recognize Your Voice Anywhere: THE Philosophy of Andy Warhol (From A to B and Back Again)," in *Reading Andy Warhol*, ed. Nina Schleif (Ostfildern: Hatje Cantz, in association with Museum Brandhorst, Munich, 2013), 281; see also Lucy Mulroney, *Andy Warhol, Publisher* (Chicago and London: University of Chicago Press, 2018), 122.

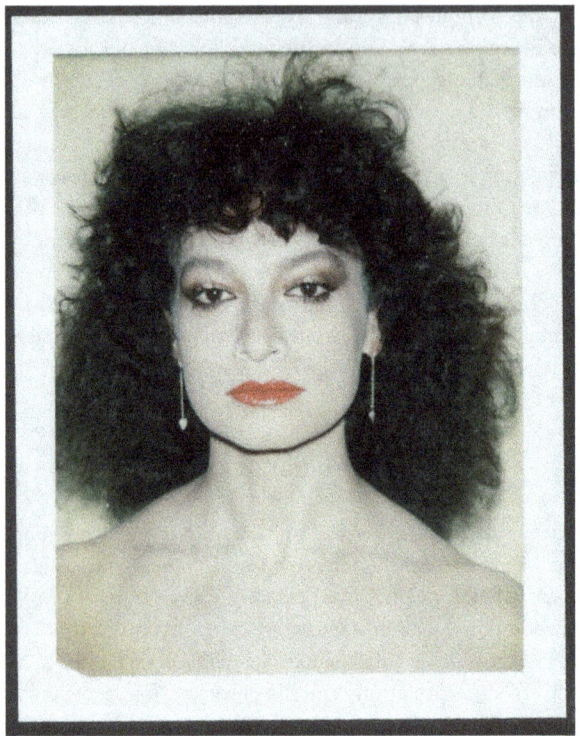

Figure 4.5 Andy Warhol, *Daniela Morera*, January 1981, Polacolor 2, 4¼ × 3⅜ in. (10.795 × 8.57 cm). Grey Art Gallery, New York University, Gift of the Andy Warhol Foundation for the Visual Arts, Inc.

At the outset of the 1980s, stories on Warhol and his life in the Italian edition of *Vogue* resonated with the artist's own way of presenting himself and contributed to his appreciation by the general public. This vision was distinct from attempts made in the previous decade to give his work a political or intellectual interpretation. Daniela Morera, a New York correspondent for *Vogue Italia* and the European editor of Warhol's magazine, *Interview*,[44] was a dear friend of the artist and authored insightful articles about him (Figure 4.5). In 1980, she described him as follows:

> Vague? For sure, to the fool's eye. Instead, he has been collecting and cataloguing everything for years: recordings, photographs, videotapes,

[44] Pat Hackett, ed., *The Andy Warhol Diaries* (New York: Warner Books, 1989), 3.

furniture. … Inattentive? But how could he be, if he's the first to catch the new waves, to acknowledge, simplify, manipulate, multiply them.[45]

Ending with an excerpt of a recorded conversation,[46] not unlike some of the dialogues in *The Philosophy of Andy Warhol*, the article is illustrated by photographs of Warhol at the Factory, surrounded by paintings and copies of *Interview*, and having meetings, thus providing the perfect visual counterpart to the notion of "business art" that the artist articulated in his philosophy book.

Two years later, Warhol posed as a model for a fashion shoot on the looks of 1982, embodying transformation as a sign of the culture of his time. Acting as a mannequin, the artist wore four outfits.[47] According to the accompanying caption, in the first photograph he presented "how he would be for the whole of 1982."[48] He wore his signature ruffled wig and his own clothes—a travel jacket, a vest, a shirt, a bow tie, and blue jeans—and held a camera. In the vein of the process of self-construction undertaken in his philosophy, he impersonated himself, posing as the "wax mask" that one writer had described some ten years earlier. This and the previous article by Morera in *Vogue Italia* shed light on the process of self-construction by means of which Warhol built up the public understanding of his personality by fusing ordinary life and the blatant construction of a public persona.

Retrospectively, it makes sense that *The Philosophy of Andy Warhol* was published in Italian only in the early 1980s. Compared to the efforts of Janus or Pasolini to provide a political or intellectual reading of *Ladies and Gentlemen* in the mid-1970s, just after the book was first published in English and at a time when social upheavals and political violence were spreading in Italy and impacting cultural life at large, the atmosphere at the start of the 1980s, which historians have characterized as the *riflusso nel privato*, meaning the return to a focus on private affairs after the crisis of the utopian ideals of revolution, could resonate with the artist's attitude. With his typical nonchalance, the artist could combine references to the latest social situation in Italy and stereotypical ideas about Italians, asking Morera in 1980: "Do they still pinch your butt and kidnap people in Italy?"[49] In 1983,

[45] "Vago? All'occhio dello stolto, sì certo. Invece raccoglie e cataloga tutto, da anni: registrazioni, fotografie, video-tapes, mobili. … Disattento? Ma se è proprio lui che capta per primo le nuove ondate, le recepisce, le semplifica, le manipola, le moltiplica"; Daniela Morera, "Andy Warhol," *Vogue Italia* 356 (March 15, 1980): 538.

[46] Morera, "Andy Warhol," 540–1.

[47] Daniela Morera, "Andy Beauty," *Vogue Italia* 385 (February 1982): 316–19, 372.

[48] Morera, "Andy Beauty," 316.

[49] "Ma in Italia continuano a pizzicarti il sedere e a fare rapimenti?"; Morera, "Andy Warhol," 540.

when *The Philosophy of Andy Warhol* came out, it was the first of his books to be translated into Italian (*POPism* had already been published in English by then). The book was mostly presented as a means of self-publicity for the artist. Back in 1975,

> the publicity materials circulated by Harcourt Brace Jovanovich [the publishing house of *The Philosophy* book] play on the reader's desire to get the *real* Warhol. The spring catalog copy reflects Jovanovich's first impression, contending that the book is not only "an incredible potpourri: astonishing, delighting, puzzling, funny" but also, "above all, true." The brochure for the book, crafted to generate advance purchases from booksellers, went even further: "This surprisingly candid self-portrait reveals a shy, sensible, provocative, and often endearing personality for perhaps the first time ever."[50]

While the jacket of the 1975 book includes a frontal portrait of the artist shot by Philippe Halsman in 1968 (Figure 4.6), the cover of the Italian edition shows one of the photographs taken by Christopher Makos in 1981 depicting Warhol in drag (see Figure 4.1). His severe expression in the picture by Halsman resonates with the presumed seriousness of the book, which the emphatic presentation of the book's truth in the front flap and the publicity materials emphasized.

On the contrary, the image printed on the cover of the Italian edition showed the artist as an impersonator, thus alluding to the process of construction laying underneath the transcription of real-life recordings on which the book is partly based. Consistent with the aim to reveal the intent of the artist within a mediatized society, the back flap contains a still from the cable TV show *Andy Warhol's T.V.*, which ran from 1980 to 1983 (Figure 4.7). The Italian edition pointed plainly to the literary process by virtue of which Warhol elaborated his persona. These photographs resonate with aspects of the somewhat obscure description printed on the front flap of the book, which reads as follows:

> Employing the cynicism and aggressiveness typical of the most vulgar commerce, and unusual, maybe, to aesthetic research, Warhol treats art

[50] Mulroney, "I'd Recognize Your Voice Anywhere," 276–7, and *Andy Warhol, Publisher*, 117. The quote from the press release of the publisher provided by Mulroney resonates with the text written in the front flap of the edition of 1975, which reads as follows: "The Philosophy of Andy Warhol is an incredible potpourri: sublimely irreverent, unfailingly funny—above all, true."

according to his monstrosity and success. He dives into the standardized totality of the consumer, and shamelessly seeks for survival in what is reproduced. He pushes the pedal of super-consumerism to the metal and circulates symbols and signs which help define the impermanence of an epoch. The ultra-American (but of Czechoslovak descent) Andy directed his attention to the cadaveric celebrity of "stars," thus moving in the world of industrial stardom, in which the protagonists are food, sport, death, politics, sex, leftovers, and spectacular flesh. Each of his works has the image of a tombstone, planted with no dignity along the street where the market is located, where the avalanche of images and people symbolize the futility of any life conditions and the cancellation of any values. Even his "Philosophy" is configured as a still life. It buries art and Warhol himself under a mountain of ash (the color of his hair and skin), so as to shatter the ultimate resistance of the aristocratic artist. If in fact death besieges art, then art kills itself. It builds an aesthetic and theoretical catafalque, which is a capital to be exhibited all over the world: a philosophical and sepulchral monument, rewarded for the sensation it causes.[51]

This description no doubt was written by the editor of the book series, Germano Celant. Passages in the text had been already employed in an essay on Pop art authored by Celant in the catalog of an exhibition organized by the dealer and collector Attilio Codognato at Palazzo Grassi in Venice in 1980.[52] The interpretation provided in the essay is twofold. On one hand,

[51] "Con un cinismo e un'aggressività tipici del più volgare commercio e atipici, forse, della ricerca estetica, Warhol tratta l'arte in funzione della sua mostruosità e del suo successo. Si immerge nella totalità standardizzata del consumatore e, senza vergogna, cerca una sopravvivenza nel riprodotto; schiaccia il pedale del superconsumismo e fa circolare i simboli e i segni che servono a misurare un'epoca come transitoria. Avendo orientato la sua attenzione verso la celebrità cadaverica delle 'stars,' l'arciamericano (ma di famiglia cecoslovacca) Andy si agita nel mondo del divismo industriale, dove protagonisti sono i cibi, lo sport, la morte, la politica, il sesso, i rifiuti e la carne spettacolare. Ogni suo lavoro tende ad assumere l'effige di una lapide, piantata nella strada—senza dignità— del mercato, dove la valanga delle immagini e delle persone ricorda l'inutilità di ogni condizione e l'azzeramento di qualsiasi valore. Anche la sua 'Filosofia' configura una natura morta. Essa seppellisce l'arte e Warhol stesso sotto una montagna di cenere (il colore dei suoi capelli e della sua pelle), così da frantumare le ultime resistenze dell'artista aristocratico. Se infatti la morte assedia l'arte, l'arte si dà la morte. Si costruisce un catafalco estetico e teorico, che è un capitale da esporre in tutto il mondo: un'arca filosofica e sepolcrale, retribuita per la sua spettacolarità"; Andy Warhol, *La Filosofia di Andy Warhol* (Genoa: Costa & Nolan, 1983), front book jacket flap.

[52] Germano Celant, "Il congelatore pop, memento mori dell'avanguardia," in *Pop Art: evoluzione di una generazione*, ed. Attilio Codognato (Milan: Electa Editrice, 1980), 24, 25, 27, 28.

Figure 4.6 Andy Warhol, *The Philosophy of Andy Warhol (From A to B and Back Again)* (New York: Harcourt Brace Jovanovich, 1975), dust jacket, design by Herb Lubalin. Photo: archive of the editor.

La Filosofia di Andy Warhol *and the Turmoil of Art in Italy, 1983* 91

Figure 4.7 Andy Warhol, *La Filosofia di Andy Warhol* (Genoa: Costa & Nolan, 1983), back flap. Photo: archive of the author.

Celant addressed Pop art as an already historicized movement, within the broader history of the avant-garde tendencies emerging in American art in the post war years. On the other hand, he identified Pop art with the end of the utopias of the modernist avant-garde, thus suggesting a connection with the contemporary moment. Embracing the crisis was part of the inherently artistic value of artists like Warhol, whose "necrophilia," as Celant called it, responded to the end of individuality and the rise of standardization within an increasingly industrial and consumerist society.[53] At the turning point between a *memento mori* of the avant-garde and the avant-garde of *memento mori*,[54] Pop art resonated with the dissolution of 1960s utopias as envisioned by artists emerging in the 1980s. Celant considered it as the most deliberate act of survival of art, incorporating the sense of death implied by the endless consumption of a society devouring humanistic values (or even the images of them) at the fast pace of communication systems and industrial production.

The front cover flap of the Italian edition of *The Philosophy of Andy Warhol* articulated this same vision. Celant expanded the notion of the monstrosity of society, which Pop art represented from within, and applied it to the process of making art and building narratives developed by Warhol through his strategies of self-publicity. The notion of still life, which Celant identified the book with, resonates with the perceived stillness and lifelessness of the practice of the artist.

La Filosofia di Andy Warhol inaugurated a book series that eschewed literary genres and spanned a diverse range of subjects. The notion embedded in the name of the series, *I turbamenti dell'arte*, was broad enough to apply to publications addressing the social and cultural crisis through perspectives that hardly fit within traditional methodological categories. The Italian *turbamento* can be translated into English in various ways. The 1986 edition of the English–Italian dictionary compiled by Robert C. Melzi in 1976 listed the following translations under the entry for *turbamento*: "commotion, perturbation, disturbance, breach (*of laws and order*)."[55] Its meaning encompasses the crisis's sense of collective turmoil and private disquiet and unease. Significantly, Celant had already used the word with regard to Warhol in the essay published in 1980, in which he defined the artist as the "Marx" of Pop art, "who celebrates the lame character, the wheeler-dealer, the star, the businessman, the model, the boxer, the rock singer and introduces the

[53] Celant, "Il congelatore pop," 22.
[54] Celant, "Il congelatore pop," 26.
[55] Robert C. Melzi, *The Bantam New College Italian & English Dictionary* (Toronto, New York, London, Sydney, Auckland: Bantam Books, 1986), 349.

disturbance [*turbamento*] of disengagement and glamour into the politically correct system of art."[56]

The books that followed *La Filosofia di Andy Warhol* in the *I turbamenti dell'arte* series include a socio cultural study of subculture by Dick Hebdige, an alternative reading of the infrastructural environment of Los Angeles by Reyner Banham, and an analysis of modernist avant-garde film and painting by the experimental filmmaker and scholar Standish D. Lawder.[57] The series attests to Celant's variety of interests at that time, reflected in his aim to compose a scattered panorama of fragmented insights, resonating with the sense of lost unity of a moment of transition in Italian culture around 1980. The name of Warhol resurfaced in the fifth book of the collection, titled *Vite d'avanguardia* (*Avant-Garde Life*), by the art critic Calvin Tomkins, which was released in 1983 as well. In the book, Celant gathered translations of interviews by Tomkins with six protagonists of the New York art scene, published between 1964 and 1980, including a conversation with Warhol that was first published in 1970.[58] Since the early 1970s, Celant envisioned the role of the art critic as a means to support and be sympathetic with contemporary artists, rather than being a distant and normative interpreter of their work.[59] The format of Tomkins's long interviews resonated with Celant's approach. In the introduction to the collection of interviews, he stated explicitly his desire to reassert the centrality of the life experience of the artist and the interconnectedness between art and biography in the spirit of the tradition of Giorgio Vasari, as opposed to the

[56] "esalta il personaggio laido, l'affarista, il divo, il businessman, l'indossatore, il pugile, il rock singer ed immette nel sistema benpensante dell'arte il turbamento del disimpegno e del glamour"; Celant, "Il congelatore pop," 22.

[57] Dick Hebdige, *Sottocultura: Il fascino di uno stile* (Genoa: Costa & Nolan, 1983), originally published as *Subculture: The Meaning of Style* (London: Methuen & Co., 1979); Reyner Banham, *Los Angeles: l'architettura di quattro ecologie* (Genoa: Costa & Nolan, 1983), originally published as *Los Angeles: The Architecture of Four Ecologies* (London: Allen Lane, 1971); Standish Lawder, *Il cinema cubista* (Genoa: Costa & Nolan, 1983), originally published as *The Cubist Cinema* (New York: New York University Press, 1975).

[58] Calvin Tomkins, *Vite d'avanguardia: John Cage, Leo Castelli, Christo, Merce Cunningham, Philip Johnson, Andy Warhol* (Genoa: Costa & Nolan, 1983), 229–49; the profile on Warhol in *Vite d'avanguardia* was originally published as "Raggedy Andy" in *Andy Warhol*, ed. John Coplans (Greenwich: New York Graphic Society, 1970), 8–14, and reprinted in Calvin Tomkins, *The Scene: Reports on Post-Modern Art* (New York: Viking Press, 1976), 35–53.

[59] Two examples of this approach are a monograph on Giulio Paolini, which incorporates a long conversation between the artist and the critic (Germano Celant, *Giulio Paolini* [New York: Sonnabend Press, 1972]), and the catalog of a retrospective of Mario Merz organized at the Guggenheim Museum in New York, in which Celant gathered four major interviews that the artist gave to him at different times (Germano Celant, ed., *Mario Merz* [New York: The Solomon R. Guggenheim Museum Foundation, 1989], 45–55, 104–10, 178–82, 228–30).

latest formalist tendencies in Italian art history and criticism of separating the analysis of art from the biography of its creator.[60] Celant found in Tomkins's interviews an embodiment of his own goals as a critic.

La Filosofia di Andy Warhol was presented as the culmination of the process of identifying the work with the biography of an artist. In this respect, the omission of the English subtitle, *(From A to B and Back Again)*, in the Italian edition might be interpreted as a "betrayal" of the original intentions of the author and the American publisher, in the resulting focus on the individuality of the artist rather than on the conversation between two people, "A" and "B," through which the artist articulated his philosophy.[61] Far from being an assertion of superficiality, the translation of "Nothingness Himself" as *Nulla in Persona* turned the self-presentation in the first chapter of the book into a statement resonating with the present condition, undermining the very essence of the notion of nothingness applied to the figure of the artist in general, midway between the feeling of a broader crisis of the artist's social role and the ultimate attempt to survive as an individual by impersonating a character.[62]

Warhol underscored the interconnectedness of art and life, on which his vision was based, by articulating the notion of repetitiveness vis-à-vis the seriality of the paintings of Giorgio de Chirico. Interviewed in 1982 by Achille Bonito Oliva for an exhibition at Campidoglio, the Rome city hall, of his paintings after de Chirico, which also were shown in New York in 1985 (Figure 4.8), the artist stated:

> I love his art, and then the idea he repeated the same paintings over and over again. I like that idea a lot, so I thought it would be great to do it. … Most artists repeat themselves throughout their lives. Isn't life a repetition of events. … Isn't life a series of images that change as they repeat themselves?[63]

[60] Tomkins, *Vite d'avanguardia*, 1983, front book jacket flap. On the lineage of the artist interview from previous writings on art, including Vasari's biographies of artists, see Wolf, "The Artist Interview: An Elusive History," 15–16, 20. Wolf also refers to the study of the interconnectedness between the artist's work and life, relevant here, in Gabriele Guercio, *Art as Existence: The Artist's Monograph and Its Project* (Cambridge, MA and London: MIT Press, 2006).
[61] Mulroney, "I'd Recognize Your Voice Anywhere," 278; *Andy Warhol, Publisher*, 119.
[62] Warhol, *La Filosofia di Andy Warhol*, 13–14. The original reads as follows: "Some critic called me the Nothingness Himself and that didn't help my sense of existence any. Then I realized that existence itself is nothing and I felt better. But I'm still obsessed with the idea of looking into the mirror and seeing no one, nothing"; Warhol, *The Philosophy of Andy Warhol*, 7.
[63] Achille Bonito Oliva, "Industrial Metaphysics: Interview with Andy Warhol," *Warhol verso de Chirico* (New York: Marisa Del Rey Gallery, 1985), 49, 52, 53. The interview was originally published in Italian as "Una metafisica industrial. Intervista di Achille Bonito Oliva a Andy Warhol," in *Warhol verso de Chirico* (Milan: Electa, 1982), 55, 58, 59.

La Filosofia di Andy Warhol *and the Turmoil of Art in Italy, 1983* 95

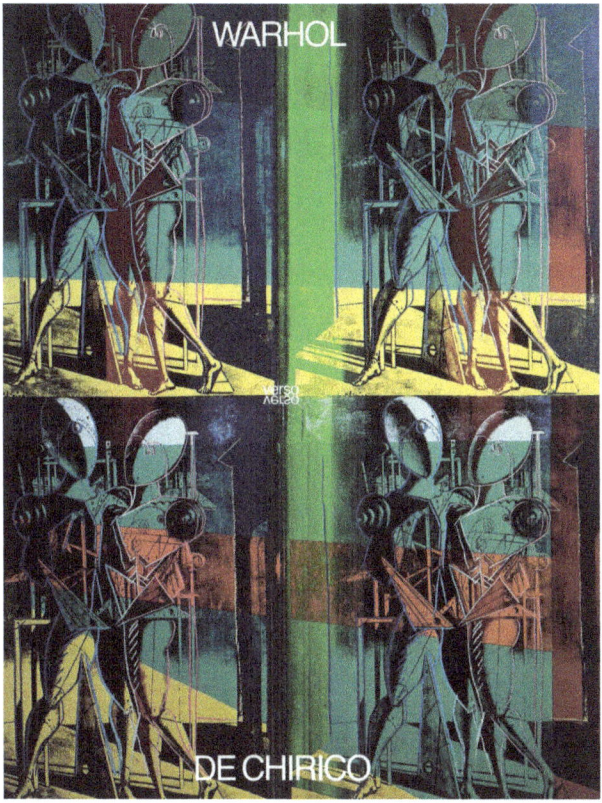

Figure 4.8 *Warhol verso de Chirico*, front cover (New York: Marisa Del Re Gallery, Inc., 1985). Photo: archive of the author.

The admiration for de Chirico, whom the artist had met in New York in 1972, is a main chapter in the story of the connections between Warhol and Italy.[64]

Indeed, Italy holds a special place in *The Philosophy of Andy Warhol*, more than other foreign countries. Sometimes the artist made humorous remarks

[64] The two artists most likely met for the first time at the opening of de Chirico's retrospective at the New York Cultural Center, on January 9, 1972. The circumstances were recalled by the painter Gerard Tempest, who studied with de Chirico in Rome; see Michael Taylor, "A Conversation with Gerard Tempest," *Giorgio de Chirico and the Myth of Ariadne* (London: Merrell; Philadelphia: Philadelphia Museum of Art, 2002), 185. On the encounter between Warhol and de Chirico and how the latter inspired Warhol's art, see the video of the lecture on the subject given by Neil Printz at the Center for Italian Modern Art on June 21, 2017, https://vimeo.com/251394588.

on the personality and habits of the Italians.⁶⁵ Elsewhere, he recounted memories of experiences he had in Italy: he recalled feeling small before the huge statues of the Mussolini Stadium (which the Italian translators opted to translate innocuously as *Foro Italico*);⁶⁶ an anecdote from his stay in the town of Boissano in Liguria was a sign of his popularity in the country;⁶⁷ the entire eleventh chapter is devoted to memories of his stay in Rome while he was playing a cameo as a British aristocrat alongside Liz Taylor in the film *The Driver's Seat* (known in Italian as *Identikit*), realized in 1974 by the director Giuseppe Patroni Griffi;⁶⁸ he discussed his stay in Turin, upon the invitation of Luciano Anselmino, probably in August 1974, when he was asked to sign portraits of Man Ray and started to think about *Ladies and Gentlemen*.⁶⁹

No information is available concerning the translators of the book, Rino Ponte and Fernando Ferretti, who apparently did not go on to translate other books. The major challenge was to capture the colloquial, ordinary, sometimes trivial tone and language of the original. The result was less than successful in conveying this voice. It is not necessarily the fault of the translators. Some expressions are impossible to render in Italian: for instance, "young-and-with-it" and "butterboy" (being a mama's boy) were transformed into the more generic *giovane-e-moderna* and *patata molla*;⁷⁰ the assonance of "either partridge or porridge" could not be kept by translating the words as *pernici* and *polenta*, which sounds like a rather odd combination in Italian.⁷¹ A few words and phrases were misinterpreted, including Philly (taken as a name of a person instead of a nickname for the city of Philadelphia),⁷² vulgar slang, such as "blow-job," translated as *un lavoro del cazzo*,⁷³ the sentence "I want

[65] Warhol, *La Filosofia di Andy Warhol*, 45, 127–8; *The Philosophy of Andy Warhol*, 50, 157.
[66] Warhol, *La Filosofia di Andy Warhol*, 55; *The Philosophy of Andy Warhol*, 63.
[67] Warhol, *The Philosophy of Andy Warhol*, 79–80. In the summer of 1974, the artist was a guest of the dealer Marie Louise Jeanneret, who ran a gallery in Boissano. On that occasion, Jeanneret convinced the collector and artist Guglielmo Achille Cavellini to pose for a portrait; Guglielmo Achille Cavellini, *1946–1976: incontri/scontri nella giungla dell'arte* (Brescia: Shakespeare, 1977), 167.
[68] Warhol, *La Filosofia di Andy Warhol*, 97, 133–40; see *The Philosophy of Andy Warhol*, 115, 165–72.
[69] Warhol, *La Filosofia di Andy Warhol*, 151–8; see *The Philosophy of Andy Warhol*, 189–96.
[70] Warhol, *La Filosofia di Andy Warhol*, 27, 93; *The Philosophy of Andy Warhol*, 25, 111.
[71] Warhol, *La Filosofia di Andy Warhol*, 87; see *The Philosophy of Andy Warhol*, 101.
[72] Warhol, *La Filosofia di Andy Warhol*, 32; see *The Philosophy of Andy Warhol*, 34.
[73] Warhol, *La Filosofia di Andy Warhol*, 50; see *The Philosophy of Andy Warhol*, 55.

my machinery to disappear,"[74] the word "comedians,"[75] and the name of the fashion designer Halston, made plural to designate a couple.[76]

Sometimes, adjustments were necessary due to differences in grammatical construction between English and Italian. For instance, the ambiguity of the construction of a negative sentence in Italian, which often implies a double negation, especially in spoken language, resulted in bracketing in single inverted commas the word *niente*, the translation for nothing, in the exhortation to think about nothing which A gives to B, while no such punctuation was needed in the original version.[77] Elsewhere, the gender neutral of English words couldn't be kept in Italian, so the word "date" was translated as *compagno*, thus specifying the male gender.

A few major edits betrayed the spirit of the original book. The book alludes to the power of the media to transcend the physical limits of space with this remark: "People, I think, are the only things that know how to take up more space than the space they're actually in."[78] The translators omitted the association of people and things and just kept the reference to people, thus humanizing the indifference expressed by the artist: *Gli uomini credo siano gli unici che sanno come prendersi più spazio di quello che occupano.*[79] In another passage, the description of the loneliness of living in the city, split between sitting alone in big rooms and squeezed in crowded subway cars or elevators, is oversimplified in the translation, which entirely omits the contrast of big empty rooms to small crowded spaces.[80]

The major misinterpretation concerns the presence of the tape recorder in the narration. The tape recorder is notoriously presented as Warhol's "wife" near the beginning of the book.[81] However, a few references to this "wife" were omitted by the translators, who thus failed to recognize the importance of

[74] Translated as if the author looked for a machine to disappear; Warhol, *La Filosofia di Andy Warhol*, 95; *The Philosophy of Andy Warhol*, 113.
[75] In Warhol, *La Filosofia di Andy Warhol*, 96, the word is intended as a generic reference to people of show business attending night-clubs, instead of the professionals entertaining onstage the attendees of night-clubs to whom Warhol referred in the original version; *The Philosophy of Andy Warhol*, 114.
[76] Warhol, *La Filosofia di Andy Warhol*, 141; see *The Philosophy of Andy Warhol*, 177.
[77] "La cosa importante è pensare a 'niente', B. Guarda, 'niente' è eccitante, 'niente' è sexy, 'niente' non è imbarazzante" (Warhol, *La Filosofia di Andy Warhol*, 15); "The thing is to think of nothing, B. Look, nothing is exciting, nothing is sexy, nothing is not embarrassing" (*The Philosophy of Andy Warhol*, 9).
[78] Warhol, *The Philosophy of Andy Warhol*, 146.
[79] Warhol, *La Filosofia di Andy Warhol*, 116.
[80] Warhol, *La Filosofia di Andy Warhol*, 124–5; see *The Philosophy of Andy Warhol*, 154.
[81] Warhol, *The Philosophy of Andy Warhol*, 26–7.

the tape recorder in Warhol's art, life, and self-fashioning.⁸² The employment of the tape recorder was definitely unclear to the translators, even though the artist recounted in detail the story of the use of it to create his novel, *a*, within the sixth chapter of *The Philosophy of Andy Warhol*.⁸³ For instance, the sentence, "I was organizing some transcripts," which surfaces in a passage of the book describing an ordinary moment of life and work, is rendered as *stavo progettando delle riproduzioni* in the Italian edition, meaning "I was planning some reproductions."⁸⁴

Such a misleading interpretation might be attributed to the inexperience of the translators rather than a general lack of familiarity in Italy with Warhol's process of making books. In fact, his books were reviewed in Italy almost concurrently as in the United States. The critic Tommaso Trini wrote an extensive review of *a: A Novel* for the art and architecture magazine *Domus* in 1969, the year after the book was published. He praised it as the ultimate version of a nonfiction novel and as a quintessential example of underground experimentation. Acknowledging that Warhol didn't simply use the tape recorder, but turned it into the protagonist of the narration, Trini concluded as follows:

> Today, as is well-known, a novel can't help but be the story of its own making. And Warhol provides us with a novel which makes itself. If a product of nonfiction-novel ever existed, this is it. One more truth is added, though: reality can be stimulated, after all, and life fabricated at the very moment.⁸⁵

Trini aligned film, art, and literature as three means of expression equally defining Warhol's practice. In this respect, the sense of indifference emanating from his look was interpreted as the result of the objectivity through which the artist reasserted the centrality of media and mediation in his vision of the world and "identified art, the product of art, with the techniques of mediation and the methods of instrumentalization."⁸⁶ Trini disputed that

⁸² See, for instance, the end of the episode in Rome in the eleventh chapter, where it's written that "My wife was running low and I was tired"; Warhol, *The Philosophy of Andy Warhol*, 172. The translators identified the wife with B; Warhol, *La Filosofia di Andy Warhol*, 140.
⁸³ Warhol, *The Philosophy of Andy Warhol*, 94–5.
⁸⁴ Warhol, *La Filosofia di Andy Warhol*, 141; *The Philosophy of Andy Warhol*, 177.
⁸⁵ "Oggi, si sa, un romanzo non può essere che la storia del suo farsi. E Warhol ci dà un romanzo che si fa. Se mai si è avuto un prodotto della letteratura-verità, questo è uno. Ma con una verità in più: che la realtà può essere stimolata, dopo tutto, e la vita fabbricata sul momento"; Tommaso Trini, "Deus ex recording," *Domus* 476 (July 1969): 49.
⁸⁶ "identificare l'arte, il prodotto d'arte, con le tecniche di mediazione e i metodi di strumentalizzazione"; Trini, "Deus ex recording," 50.

the book could be included in the genre of autobiography, the patent sense of real life of recording and transcribing being a self-reflective act of mediation, by virtue of which the character of Ondine "becomes the Leopold Bloom 'tape recorder-sized' in this *Ulysses* of American paranoia."[87]

This interpretation was likewise applied to *The Philosophy of Andy Warhol*, which also was reviewed in Italy soon after the American edition was published. The art critic Gregory Battcock reviewed it as the New York correspondent for *Domus*.[88] He presented it as the most accomplished product of the art of Warhol, in which he articulated his interest in trivia to the fullest extent, thus subverting conventions, as he had already done in painting and film. The fragmentary associations on which the book is based "is deliberate, calculated anti-literary tampering with the principles of formal narration, stream-of-consciousness abstraction and conventional data distribution."[89] In this respect, Battcock dismissed the association made by Trini, regarding *a: A Novel*, with the literature of stream-of-consciousness. According to Battcock, one would expect a thorough and serious investigation of trivia from a book that includes the word "philosophy" in the title, as opposed to the term "novel" appearing in the title of *a*:

> If Warhol were more serious, more careful, more deliberate, his efforts to enhance the trivial would be more effective. Within a context of seriousness, even fake seriousness or pomposity or self-righteousness or self-deprecation, the search for trivia would result in more amusing, lively, less obvious and predictable, results.[90]

The final doubt expressed by Battcock, concerning a lack of the seriousness that one might expect from a book of philosophy, and the resulting sense of disorientation and discomfort in reading it, could probably be listed among the reasons why the Italian translation of *The Philosophy of Andy Warhol* apparently received almost no reviews. The reception of the original edition of the book also disappointed Warhol for being less substantial than he had expected, according to the artist's diaries.[91] With regard to the reception in Italy, one might argue that the artist was already so famous by 1983, that the book would not have made an impact on his popularity there in any case.

[87] "diventa il Leopold Bloom formato magnetofono di questo *Ulysses* della paranoia americana"; Trini, "Deus ex recording," 50.
[88] Gregory Battcock, "Warhol: un libro. À la recherche du temps trivial, the philosophy of Andy Warhol," *Domus* 553 (December 1975): 52.
[89] Battcock, "Warhol: un libro," 52.
[90] Battcock, "Warhol: un libro," 52.
[91] Hackett, *The Andy Warhol Diaries*, 223.

Nonetheless, the context of the publication of the *Philosophy* book in Italian might have impacted its reception too. As the review in *Domus* attests, the original book circulated at the time of its release, thanks to several tours undertaken by the artist in the following months, which also led him to Italy for the *Ladies and Gentlemen* exhibition in Ferrara. In fact, the book was already quoted in reviews of this exhibition.[92] Perhaps since the original version already was familiar to critics and readers, the release of the Italian edition would have seemed unnoteworthy. In addition, the book was published by a relatively new publishing house and was included within a miscellaneous series. Despite Germano Celant's likely intent to introduce alternative methods of cultural inquiry in Italy, his book series probably did not facilitate the circulation of the book, which was written up briefly in the above mentioned column of book and music reviews in *Domus*, and apparently nothing more.[93] However, even if it was not widely acclaimed at the moment of its release, the book reinvigorated the reception of the artist in Italy. It was regularly mentioned as a fixture, as attested by the news story on the presence of Warhol in Milan in conjunction with an exhibition of his portraits of Italian fashion designers at Galleria Rizzardi in October 1983, which was published in *Vogue Italia*.[94]

The figure and art of Warhol have always generated diverging and controversial reactions in Italy—as elsewhere—and this was also the case with the *Philosophy* book, whose long-term reception was not entirely positive.[95] In 1990, three years after Warhol's death, a major traveling retrospective organized by Kynaston McShine landed at Palazzo Grassi in Venice. A majority of the reviews were positive, yet for different and often problematic reasons, a few were negative.[96] Among the latter, the negative assessment by the artist Enrico Baj, which included a pronouncement on *The Philosophy of Andy Warhol*, stood out for its harsh tone.

[92] Flavio Caroli, "Il cinico Andy Warhol da Marilyn ai travestiti. Dollari come arte," *Corriere della sera*, October 26, 1975, 16.

[93] Nives Ciardi, review in "Libri e dischi," *Domus* 641 (July 1983): 81.

[94] Silvana Bernasconi, "Andy Warhol il grande replicante," *Vogue Italia* 406 (January 1984): 338.

[95] On divergent opinions of Warhol in Germany, as rooted in the ideas of the Frankfurt School, see the study by Nina Schleif in this volume.

[96] Among the positive reviews, see Fabrizio d'Amico, "Non è Warhol senza Warhol," *La Repubblica*, February 24, 1990, 32; Dario Micacchi, "Al Circo Warhol," *L'Unità* 67, no. 46 (February 24, 1990): 17; Claudio Savonuzzi, "Andy Warhol a Venezia il grande travestito in 280 opere," *La Stampa Tuttolibri* 15, no. 692 (February 24, 1990): 9; Lea Vergine, "Andy Warhol, angelo della morte," *Corriere della Sera*, February 24, 1990, 3. The positive note in the report on the Biennale by the dealer Lucio Amelio is noteworthy too: Lucio Amelio, "La Biennale di Venezia 1990," *Domus* 718 (July 1990): 66.

Baj's review appeared in the political and cultural magazine *MicroMega*, which was founded in 1986 to give voice to debates among leftist intellectuals. Baj was four years older than Warhol and had been a protagonist in Italian art since the post war years. A commitment to social issues and politically engaged themes often characterized his practice and informed his view of Warhol. Baj's review was nothing less than an attack on the entire body of Warhol's work and the system of economic and cultural promotion surrounding him. In the title, Warhol was defined as "bidone," meaning a scam, a fraud.[97] The review shows how a part of the leftist side of Italian culture found the sense of disengagement that the artist deliberately embodied throughout all his life to be unacceptable. Baj couldn't help but read *The Philosophy of Andy Warhol* as the manifesto of this attitude and dismiss it as "a compendium and a compilation of cretinism."[98]

Baj's article should be considered as the expression of a cultural and intellectual niche rather than a veritable representation of the general debates on Warhol and his problematic legacy in the 1980s, a subject that is tied to the translation of his words into Italian and could extend further beyond the scope of the present chapter. In any case, despite the lack of reviews of *La Filosofia di Andy Warhol*, the book definitely penetrated into the multifaceted reception of the artist and was well-known by a broad range of commentators, from the most prominent critics of the new avant-garde to the journalists reporting on social life. It confirmed the perceived contradictions surrounding Warhol's art and life, as the diverse references to the book within the discussions of the artist's work throughout the years attested. The errors in translating what was meant to be a very basic English language, and the rather obscure interpretation of the twofold status of Pop art and Warhol's role provided by Celant in relation to the book, somehow confirm the sense of disorientation that has often imbued the reception of the book. The ambiguous status of the book, midway between the merely autobiographical record of moments in the artist's life and the literary construction of a new genre of memoir, in which identities and roles mingle and overlap, resonated with and corroborated the general perception of the ambiguity and elusiveness of Warhol, the artist hiding behind a "wax mask."

[97] Enrico Baj, "Un bidone chiamato Warhol," *MicroMega. Le ragioni della sinistra* 2 (1990): 65–76.
[98] "Un compendio e un concentrato di cretineria"; Baj, "Un bidone chiamato Warhol," 67.

5

Warhol in Translation, Stockholm 1968: "Many Works and Few Motifs"

Annika Öhrner

In the cold Stockholm winter of 1968, Moderna Museet presented the first major retrospective of Andy Warhol outside the United States. Showcasing Warhol's screen-printed Flower and Electric Chair paintings, Marilyn prints, film projections of *Chelsea Girls* (1966), and a mountain of 500 Brillo boxes (Figure 5.1), the exhibition received intense attention. The exterior of the museum building, ornamented with patterns of the artist's Cow Wallpaper, evoked the show's fundamental rhetoric and translation of Warhol's work: repetition. A selection of statements by Warhol, in both English and translated into Swedish, was printed in the first fourteen pages of the exhibition catalog, as the publication's only text (see Figure 5.2). The catalog, brilliantly designed, featuring a Warhol Flower painting on the cover repeated in four rows of three, contained black-and-white photos of Warhol and his associates, and was (and still is) considered by many to be an art object in itself.

The Moderna Museet exhibition echoes in the art world still today. It has been claimed, incorrectly, that the show flopped in Sweden due to a politicized climate, which supposedly created a lack of space for a "more complex view on Warhol's relation to consumption."[1] Furthermore, the

I would like to thank Reva Wolf for her invitation to write this chapter, and for her editorial guidance. Anna Tellgren, Moderna Museet, and my colleagues in the Higher seminar of Art History at Södertörn University read and made valuable comments to the text. John Peter Nilsson, Moderna Museet, contributed with crucial facts. I also would like to thank Neil Printz for his generous reading of and comments on the manuscript, which were most helpful.

[1] Quoted from Willem de Rooij, "Willem de Rooij on Andy Warhol," https://www.modernamuseet.se/stockholm/en/exhibitions/andy-warhol-other-voices-other-rooms/willem-de-rooij-on-the-andy-wa/, republished from *Andy Warhol: A Guide to 706 items in 2 Hours 56 Minutes, Other Voices, Other Rooms*, ed. Eva Meyer-Hermann (Rotterdam: NAi Publishers, 2007), 02:31:00.

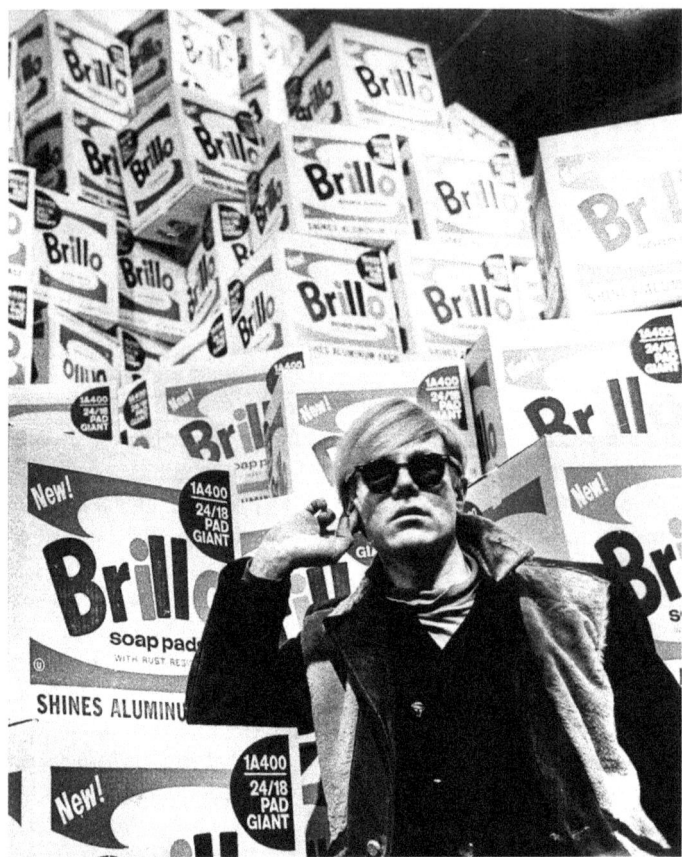

Figure 5.1 Andy Warhol at the Moderna Museet, Stockholm; press photo by Lasse Olsson, February 9, 1968.

exhibition is part of a long-standing narrative of an American soft invasion of Europe, presumably creating a moral shock and controversy through a blunt presentation of Pop art imagery.[2] This chapter, drawing upon the conceptualization of translation connected to ideas of cultural transfer, shows, on the contrary, that the show deeply resonated in its local cultural and political context. It is additionally clear that it was embraced, and a hot topic, within the young intellectual and artistic scene of Stockholm. A dimension of this cultural transfer, besides the notable structure of

[2] The narrative reoccurs even as late as in Claes Britton, *Pontus Hultén. Den moderna konstens anförare. En biografi* (Stockholm: Albert Bonniers förlag, 2022), 258.

repetition and ideas of democracy, was that queer aspects of Warhol's films and personal appearance were the topic of open discussion.

French historian Michel Espagne, with his research group, developed the concept of cultural transfer, with the fundamental view that the original context is lost when a cultural object is transferred. Espagne sees cultural transfer as translation in that it relates to a "passage from a code to new code."[3] Clearly, an exhibition is a cultural object that can be viewed as translated, coded, and therefore in need to be studied from the point of its destination; it is not simply just transferred from the departure point to any other cultural position in an untouched, original guise. To grasp the complex relations that are at play, it is necessary to combine an understanding of global structures of art in transfer with attention to local circumstances, to follow Polish art historian Piotr Piotrowski.[4] In the case of the presentation of Warhol at Moderna Museet in 1968, verbal as well visual "texts" were translated. Viewing the exhibition with a departure point in Espagne's concept of translation as coded allows us to see beyond its more obvious content of American popular and underground culture, allegedly rejected by the Stockholm art scene.

Pop art is maybe the most obvious subject for discussions of cultural transfer from the United States to Europe during the post war era, as it often was seen as exporting American culture and imagery per se—for good or for bad, depending on the context. Espagne's call for the need to acknowledge several spaces of meaning simultaneously leads to looking at the actual choices of foci, in this case, of the North European pole of this transmission. This approach will help distinguish the curatorial program from the reception, the historiography from the actors' statements, and thereby open up a reading of this exhibition as a situation where some aspects of Warhol's art and ideas were translated and coded in ways that resonated with structures already activated in Sweden.

Late 1960s Stockholm was a particular space of meaning. When investigating the Warhol exhibition in Stockholm, a consideration of how it was translated to and coded in the local context provides a fresh understanding of its reception. In this essay, *Multikonst*, of 1967, one of the largest art and media projects in Sweden and maybe in Europe of the time, is

[3] "Un transfer culturel est une sorte de traduction puisqu'il correspond au passage d'un code á nouveau code"; Michel Espagne, *Les transferts culturels franco-allemands* (Paris: Presses Universitaires de France, 1999), 8.
[4] Piotr Piotrowski, "On the Spatial Turn, or Horizontal Art History," *Umění* 56, no. 5 (2008): 378–83. For further discussion and cases of how this dual approach can be productive, see Annika Öhrner, ed., *Art in Transfer in the Era of Pop* (Stockholm: Södertörn Academic Studies, 2017).

the context within which the reception of some fundamental aspects of Andy Warhol's work is understood. Coming just after *Multikonst*, the Warhol show in fact resonated in an already well-funded and ongoing cultural practice about media, repetition, democracy, and art reproduction.

Moderna Museet opened in 1958. Even though the museum presented a well-balanced mix of European high modernism and Swedish early avant-garde and contemporary art, the American-related exhibitions shown during the first ten years, such as *Movement in Art* (1961), *American Pop Art: 106 Forms of Love and Despair* (1964), and *Claes Oldenburg: Sculptures and Drawings* (1966), marked its reputation.[5] *American Pop Art* was a cultural event in Stockholm, which was reported in international journals such as *Art International* while also exposing the Swedish audience to the new American movement. It was, however, an exhibition that partly showcased aspects already visible in art produced by Swedish artists, such as the imagery of comics.[6] The work of Andy Warhol was included in the show, as was that of Roy Lichtenstein, Claes Oldenburg, James Rosenquist, George Segal, and Tom Wesselmann.

Before the museum was established, some of the group shows of American art sent to Europe to impose a "soft power" had been presented in Sweden.[7] Moderna Museet did not, however, work directly with the Museum of Modern Art in New York, and other official US bodies, in producing exhibitions. Instead, two factors, in addition to the museum's orientation and ambitions for a position within the European art scene, coincided with and served to realize its exhibition projects.[8] First of all, key figures in the art market had a strategy to develop among European collectors an interest in Pop art, and by supporting shows in museums such as Moderna Museet,

[5] On Moderna Museet's exhibition history, see Anna Tellgren, ed., *The History Book: On Moderna Museet 1958–2008* (Stockholm: Moderna Museet; Göttingen: Steidl, 2008); Anna Tellgren, ed., *Pontus Hultén and Moderna Museet. The Formative Years* (Stockholm: Moderna Museet; London: Koenig Books, 2017); and Annika Öhrner, "On the Construction of Pop Art. When American Pop Arrived in Stockholm in 1964," in *Art in Transfer*, 127–61.

[6] On early Swedish "pre-American" Pop art, see Annika Öhrner, "Hillersberg i tiden," in *Lars Hillersberg. Entreprenör och provokaatör*, ed. Andreas Berg (Stockholm: Ordfront, 2013), 104–24. Examples of Öyvind Fahlström (1928–76), Lars Hillersberg (1937–2004), Berndt Pettersson (1930–2002), and others using comics in their work are found from at least the late 1950s.

[7] Examples are *12 Contemporary Painters and Sculptors* (1953), and *American Primitive Painting* (1955), both shown at Liljevalchs konsthall, Stockholm. For a full account of American exhibitions in Sweden in the 1950s and 1960s, see Öhrner, "On the Construction of Pop Art," 162–3.

[8] Serge Guilbaut, *How New York Stole the Idea of Modern Art: Abstract Expressionism, Freedom, and the Cold War* (Chicago and London: University of Chicago Press, 1983).

helped to legitimize the art for collectors. Pontus Hultén worked closely with the Sonnabend, Castelli, and Green galleries as well as with collectors who already were acquiring Pop art.[9]

Secondly, as so often, networking, support, and loyalty between artists played a role in realizing complex transatlantic art projects such as these shows. Two Swedish artists, Öyvind Fahlström and P. O. Ultvedt, participated in the pivotal *New Realists* exhibition at the Sidney Janis Gallery in New York in 1962. Fahlström and the painter Barbro Östlihn, his wife, were among the few European artists who, as early as 1961, had settled in Manhattan. Ultvedt, on the other hand, was a more temporary visitor. Having made friends with Robert Rauschenberg during his visit to Stockholm for the *Movement in Art* exhibition in 1961, Fahlström and Östlihn moved in his circle and were offered use of his Front Street studio. Claes and Pat Oldenburg as well as James Rosenquist were also their friends. Oldenburg was a native Swede and Rosenquist was of Swedish descent. Another Swede, Billy Klüver, an engineer and researcher at Bell Laboratories, played an important role in the connections between Moderna Museet and the Manhattan scene. As the museum's point person in Manhattan, he, among other things, recruited the Americans to participate in the *Movement in Art* exhibition. He also worked closely with Andy Warhol, Jean Tinguely, and other artists to find technical solutions to their art. On top of that, he was a cofounder in 1967 of Experiments in Art and Technology (E.A.T.). Catherine Dossin, in her quantitative study of the presence of American art in Europe, has claimed that it was not just the result of single actions or a few gallerists' strategies but of "the strategic imperatives of the general apparatus of Europe's 'urgent need' for recognition."[10]

"Many Works and Few Motifs"

How was the object of translation—the 1968 Warhol show with its exhibits, catalog, and graphic design—curatorially coded at the space of its destination? The young art historian Olle Granath, who acted as the local curator, working together with is team members—in addition to Warhol himself, Pontus Hultén, Billy Klüver, and Kasper König—later described its fundamental curatorial guideline: "One of the basic themes was repetition; there were to be many works

[9] Öhrner, "On the Construction of Pop Art," 127–61.
[10] Catherine Dossin, *The Rise and Fall of American Art, 1940s–1980s: A Geopolitics of Western Art Worlds* (New York: Ashgate, 2015), 10.

and few motifs."[11] Thus, repetition was the concept within which the coding of the translation was performed, as we shall see. Moderna Museet, situated on the island of Skeppsholmen in the middle of Stockholm, faces the Royal Palace on the other side of the inner bay of the Baltic known as Strömmen. When approaching the museum, the visitor was greeted by Warhol's Cow Wallpaper, a repeating motif of a bright pink cow on a yellow ground covering the west-facing façade of the building, a former navy drill hall. Before following the visitor into the exhibition room itself, we turn to the catalog.

What struck any reader of the Warhol catalog of 1968 was the highlighting of translation through twenty-seven quotations of Warhol (which have since become emblematic), each followed by its Swedish version (Figure 5.2). Filling the catalog's first fourteen pages, the quotations formed the first section and the only verbal content. They were followed by three chapters of illustrations, the first one featuring Warhol's work, meant to serve as what Granath would describe as the exhibition's "retrospective content." Here the presentation of the works emphasized repetition, a feature of both the artworks themselves and of the manner in which they were reproduced, with some works repeated on several pages. This section was followed by photos by Billy Name and Stephen Shore of life at the Factory. Name's were more informal snapshots, whereas Shore's were more formally arranged. These photos depicted a space of gay desire, young men, and a few iconic blonde females. The repetitive flow of imagery in the catalog was in line with what Granath said was the curatorial statement for the show, to create a sense of "many works and few motifs."[12]

[11] My description of the 1968 Warhol show at Moderna Museet relies on the following publications: Olle Granath, "With Andy Warhol 1968," in *Andy Warhol: A Guide to 706 Items in 2 Hours 56 Minutes*, 00:10:00–00:13:00, https://www.modernamuseet.se/stockholm/en/exhibitions/andy-warhol-other-voices-other-rooms/with-andy-warhol-1968-text-ol/; "Essay by John Peter Nilsson, Curator," https://www.modernamuseet.se/malmo/en/exhibitions/warhol-1968/essa-av-curator-john-peter-nilsson/ (Nilsson was the curator of the exhibition *Warhol 1968* held at Moderna Museet in 2018–19, itself a kind of translation of the 1968 show); and Natalie Musteata, "Odd Walls, Even Pages: Andy Warhol as Curator and Editor," in *Andy Warhol Exhibits. A Glittering Alternative*, ed. Marianne Dobner (Cologne: Walther König; Vienna: mumok, Museum moderner Kunst Stiftung Ludwig, 2020), 109–40, as well as documentary photographs from the Moderna Museet archive and reviews in the daily press. Olle Granath was later to become the museum's director.

[12] Granath, "With Andy Warhol 1968," 00:11:00. It has also been mentioned that an early idea, suggested by Billy Klüver already in early 1966, was to create a show in which Warhol's paintings and films were shown together, in Georg Frei and Neil Printz, eds., *The Andy Warhol Catalogue Raisonné*, vol. 2: *Paintings and Sculpture 1964–1969* (London: Phaidon Press, 2004), 345. That premise does not reappear in texts framing the exhibition opening itself.

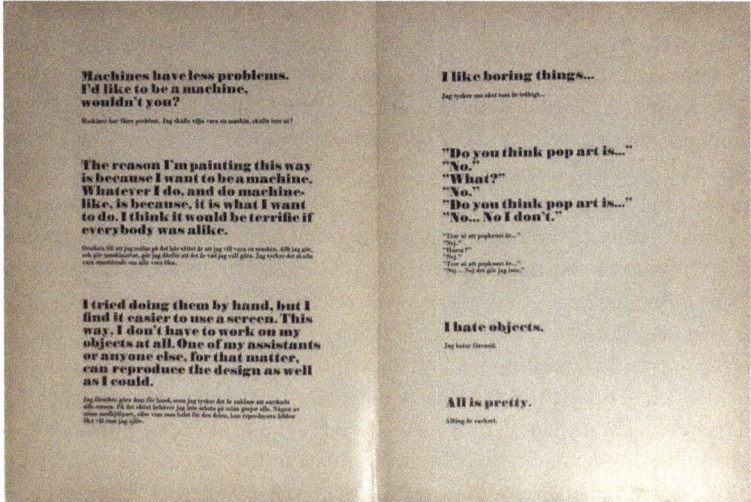

Figure 5.2 *Andy Warhol* (Stockholm: Moderna Museet, 1968; 3rd ed., 1970), Warhol quotations with Swedish translations. Photo: archive of the editor.

Seven of the Warhol sentences in the catalog were picked for exhibition posters, printed just in English in black on white paper.[13] They were followed by the name of the museum and its location, "Stockholm, Sweden," with the exhibition title and dates all given the same space and font. The art director John Melin (1921–92), who had designed a number of the museum's exhibition posters and catalogs, had, along with Gösta Svensson, produced the typography and graphic design. The publication was printed at the printing offices of the southern Swedish daily newspaper *Sydsvenska Dagbladet*, using the same thin paper.[14] By repeating the same graphic expression in the poster, the museum itself was highlighted and equated with Warhol's now-famous sentences, written in bold lettering: it became associated with something new, fresh, and important—with a media event. In this respect, it had similarities with the poster made by Melin for the *American Pop Art* show of 1964, for which he had chosen a provocative and

[13] Around ten posters were made, according to Granath, "With Andy Warhol 1968," 00:11:00. John Peter Nilsson confirmed that the number existing in the archive of Moderna Museet is seven; email to the author, October 12, 2021.

[14] *Andy Warhol* (Stockholm: Moderna Museet, 1968), colophon page. On the design of the catalogs at Moderna Museet by Melin and others, see Martin Sundberg, "Between Experiment and Everyday Life: The Exhibition Catalogues of Moderna Museet," in *The History Book*, 297–328.

exhorting visual statement, namely Roy Lichtenstein's *Pistol* (appropriated from a US Army recruitment poster), in which the barrel of a gun faces directly out at the viewer in a confrontational and attention-getting gesture. This design packaged and translated Pop art as a big event that the Swedish audience needed to take as an important, new, and vital fact, as I have explored in detail elsewhere.[15] Altogether, the catalog and the posters for the Warhol show of 1968 served as the ingenious expression of a bold artist and of a museum with confidence and ambitions. Four of the posters are still reproduced and sold at the Moderna Museet, thereby continuing to add value to the museum's trademark, while referring to its historical past.

The selection of which phrases to be translated in the catalog was done in an open process. The museum director, Pontus Hultén, had handed over a box to Granath of texts on Warhol that was kept in the museum's office, and asked him to suggest passages from these texts for the exhibition's publication.[16] The sentences that Granath chose to translate in the Stockholm catalog can be loosely grouped around two related themes: they were expressing aspects of Warhol's detached persona or they circled around the idea of the artist as a machine. The two last phrases, placed as setting the tone before the images section started, are examples of the detached persona theme. The first of these passages reads:

[26] I'd prefer to remain a mystery; I never like to give my background and, anyway, I make it all different all the time I'm asked. It's not just that it's part of my image not to tell everything, it's just that I forget what I said the day before and I have to make it all up over again. I don't think I have an image, anyway, favourable or unfavourable.[17]

It was translated as:

Jag föredrar att förbli ett mysterium, jag tycker aldrig om att redogöra för min bakgrund och, i vilket fall som helst, gör jag det på olika sätt varje gång jag tillfrågas. Det är inte bara att det hör till min image att inte berätta allting, utan jag glömmer vad jag sagt föregående dag och så måste jag göra alltihop från början igen.
Jag tror i varje fall inte att jag har någon image, varken fördelaktig eller ofördelaktig.

[15] Öhrner, "On the Construction of Pop Art."
[16] Granath, "With Andy Warhol 1968," 00:13:00.
[17] The statements are here numbered in the order they appear in the catalog, which is unpaged.

The second, and final, phrase, reads:

[27] If you want to know all about Andy Warhol, just look at the surface of my paintings and films and me, and there I am. There's nothing behind it.

It was translated into Swedish as:

Om ni vill veta allt om Andy Warhol, se bara på ytan av mina målningar och filmer och mig. Det finns inget bakom detta.

These two phrases were both quotations from Gretchen Berg's interview with the artist published in the *Los Angeles Free Press* the previous year.[18] The translations are generally as straightforward as the original lines, while the word "image"—in the sense of the appearance of a person—had been imported directly from English to Swedish in a way that was fresh and gave the text a modern impression.

The second category of phrases concerned the notion of the artist as a machine, producing art while staying detached from the process. Already on the second page [quotation 5], the reader learns that the artist doesn't "like to touch things, that is why my work is so distant from myself," and then, on the third [7], "Machines have less problems. I'd like to be a machine, wouldn't you?"

From Gene Swenson's interview in *ARTnews* in 1963, Granath had picked up the following lines:

[8] The reason I'm painting this way is because I want to be a machine. Whatever I do, and do machine-like, is because, it is what I want to do. I think it would be terrific if everybody was alike.[19]

The Swedish reads:

Orsaken till att jag målar på det här sättet är att jag vill vara en maskin. Allt jag gör, och gör maskinartat, gör jag därför att det är vad jag *vill* göra. Jag tycker de skulle vara enastående om alla vore lika.

[18] Gretchen Berg, "Andy, My True Story," *Los Angeles Free Press*, March 17, 1967, 3. On other versions of the Berg interview, see the essays by Francesco Guzzetti, Jean-Claude Lebensztejn, and Nina Schleif in this volume.

[19] Andy Warhol interviewed by Gene Swenson in "What Is Pop Art? Answers from Eight Painters, Part 1," *ARTnews* 62 no. 7 (November 1963): 26, 60–1.

These sentences give an apology to any artist looking for new production forms and modes to make art—an apology, however, that does take its departure point in the subjective perspective of the artist. These phrases, which in different ways put the artistic production in relation to the notion of the machine, as chosen by Granath, were relevant among a large group of artists in Sweden, as we shall see.

Thus, it was not so much about how these phrases were translated, but rather, the selection of phrases that was chosen for the audience—the target and destination for the whole exhibition project. Warhol's ideas were not new to the Swedish reader. In 1964, not only had his art been presented in the *American Pop Art* show at Moderna Museet, but a translation of Gene Swenson's 1963 interview with Warhol was published in *Bonniers Litterära Magasin* (*BLM*), a distinguished literary journal covering art theory as well, and put out by Sweden's largest publishing house, Bonniers bokförlag.[20] The phrase [8] in the catalog, "The reason I'm painting this way ...," is translated somewhat differently in the *BLM* version of the Swenson interview, binding the two sentences together in one, apparently to produce a more fluid reading: "Orsaken till att jag målar på det sättet är att jag vill vara en maskin, och jag känner det som att allt jag gör och gör som en maskin, är det som jag vill göra."

This variation in the translation proves that Granath's source was not the *BLM* translation as such, although one can be certain that he, as any member of the young intellectual circles in Stockholm at the time, had read it. One can assume that the selection of texts in the box Granath was working with were from recently published international art journals. The museum had, as already mentioned, established its own, direct connections within the art networks of Manhattan, and the staff was well oriented in what was published in New York.

Finally, the famous line [12] "In the future everybody will be world famous for fifteen minutes," translated as "I framtiden kommer var och en vara världsberömd i femton minuter," a promise to anyone who felt a temptation for Warhol's lifestyle, apparently was printed in the Stockholm catalog for the first time. Hultén, according to Granath, although happy with his selection of Warhol's phrases, concluded:

"but there is a quotation missing." "Which one?" I said. "In the future, everyone will be world-famous for 15 minutes," Pontus replied. "If it is in the material, I would have spotted it," I told him. The line went quiet for

[20] Gene Swenson, "Andy Warhol," *Bonniers Litterära Magasin* 3, no. 33 (1964): 171–3.

a moment, and then I heard Pontus say, "If he didn't say it, he could very well have said it. Let's put it in." So we did, and thus Warhol's perhaps most famous quotation became a fact.[21]

Whether this version of how the famous quotation came about, as more or less directly from Pontus Hultén, who knew Warhol personally, is factual or not is not our topic here, but the story exemplifies the open approach to artistic authorship that seems to have been typical of the project.[22] From there on, effectively transmitted and mediated, it became one of the pronouncements most often associated with Warhol, and, contributing to its circulation, it was chosen for one of the museum posters advertising the exhibition. Not surprisingly, it is one of those still reprinted today.

As we now turn from verbal statements to aspects of translation within the visual presentation of the show, we can see how certain features within the chosen phrases, those that regarded art production and the idea of the artist as a machine, following the curatorial imperative of "many works and few motifs," were repeated.

After passing the exterior wall of Cow Wallpaper, entering the south section of the first gallery, the visitor met ten large Flower paintings hung on the walls, and in the north section, Warhol's Electric Chair paintings (Figure 5.3).[23] Visitors could only approach them by circumventing large plastic sacks filled with air. On a small, movable screen hung a number of Marilyn prints, which visually echoed the repetitive structure of the cows on the façade of the building. Films were shown in looped projections in the same space, although not actual films by Warhol as the plan had been. The most interesting and creative solution to problems of budget and short production time, however, was to display authentic Brillo boxes ordered directly from the New York Brillo company. These boxes differed from those Warhol had created in 1964, which were made of synthetic polymer paint and silkscreen ink on wood. A large pile of some 500 actual Brillo boxes formed

[21] Granath, "With Andy Warhol 1968," 00:13:00.
[22] According to the photographer Nat Finkelstein, the source of the "world famous for fifteen minutes" quip is a photo-session with Warhol for a proposed book. When a crowd gathered and tried to get into the picture, Warhol is supposed to have remarked that everybody wants to be famous. Finkelstein was to have replied, "Yeah, for about fifteen minutes, Andy"; see in Jeff Guinn and Douglas Perry, *The Sixteenth Minute: Life in the Aftermath of Fame* (New York: Jeremy F. Tarcher/Penguin, 2005), 364–5.
[23] Warhol made two new bodies of work directly for this show, based on the earlier series of *Electric Chairs* and *Flowers*, but now in larger versions. See *Andy Warhol Catalogue Raisonné*, vol. 2, 345–65, cat. nos. 2030–55.

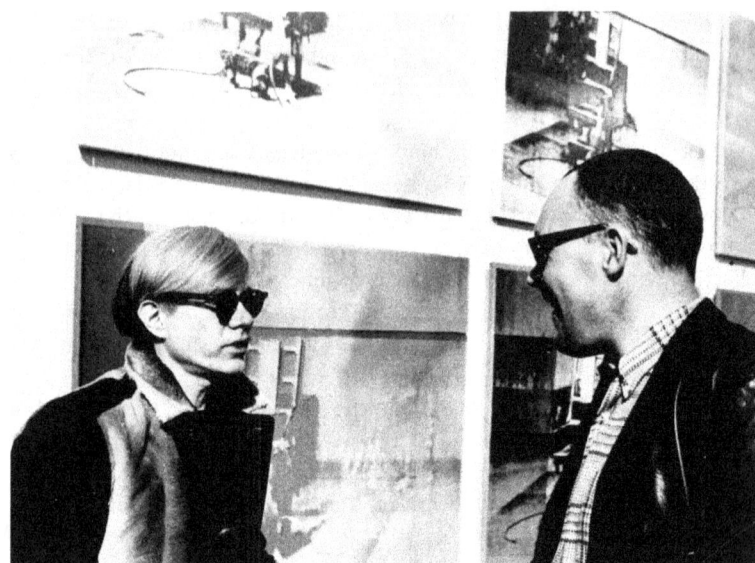

Figure 5.3 Andy Warhol and Pontus Hultén at the Moderna Museet, Stockholm, 1968. Photo by Nils-Göran Hökby.

an impressive mountain in the second space (Figure 5.4). While several of the show's elements are in fact traceable to previous exhibitions by Warhol, this was the first time that the Brillo boxes had been presented in such an impressive quantity. As Natalie Musteata has remarked, the fact that real objects replaced the artist's critical and/or Duchampian representations of the same consumer objects can be understood as short-circuiting the meaning.[24] While it remains unclear whether the audience actually knew much about or reflected greatly on the museum's curatorial efforts and creative production modes, the open approach to the binary original/copy as well as the idea of repetition for this exhibition, so brilliantly expressed through the pile of Brillo boxes, certainly got across to them. Contrary to the bold, in-your-face texts on the posters distributed throughout Stockholm, which equally put forward imperatives of an artistic position such as Warhol's, and the ambition of the museum, it was not the motifs, or the content, that resonated the most. Instead, it was the structure of repetition that was, to again recall Espagne's terminology, translated and "coded" in a manner that would resonate within the cultural situation in Stockholm, as we shall see.

[24] Musteata, "Odd Walls, Even Pages," 110.

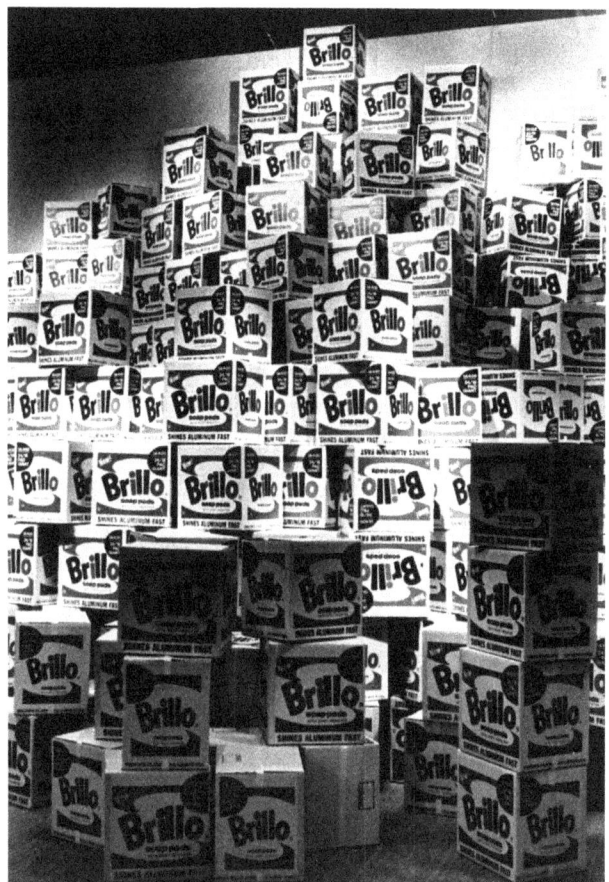

Figure 5.4 Installation view of Brillo boxes at the *Andy Warhol* exhibition, Moderna Museet, Stockholm, 1968. Photo by Nils-Göran Hökby.

Hultén's life companion at the time, Anna-Lena Wibom, who worked at the Swedish Film Institute, helped to arrange a substitute to the lost Warhol films, namely, loops with archival material containing an elephant that had just stepped on a drum. Having studied in New York in 1953, Wibom was one of the first in the future circle around Moderna Museet to learn about American film and meet Jonas Mekas and Andy Warhol.[25] The Swedish Film Institute was also presenting screenings of New American Cinema films

[25] Annika Öhrner, *Barbro Östlihn och New York. Konstens rum och möjligheter*, PhD diss., Uppsala University, 2010 (Gothenburg and Stockholm: Makadam, 2010), 168.

made by, for instance, Shirley Clarke, Gregory Markopoulos, Jonas Mekas, Andy Warhol, Stan Brakhage, Jack Smith, and Robert Breer, during the exhibition period.[26] And already in 1965, the audience had been prepared for Warhol's films with screenings in Gothenburg and Stockholm of films such as *Eat* (1963), distributed by the New American Cinema Group.[27]

Turning to how the Warhol show of 1968 resonated within the Swedish art scene, as has already been noted, it was far from a critical failure.[28] Reviews were generally engaged, well-informed, and passionate. Öyvind Fahlström, who had personally followed Warhol in New York, wrote an interesting introduction to his work, titled "Andy Warhol: Pop Artist with No Inhibitions—'Everybody Should Be Machines,'" published in the largest Swedish daily, *Dagens Nyheter*.[29] As the title reveals, the Swedish audience again was presented with Warhol's words through phrases from Gene Swenson's interview.[30] The review also gave a rather thorough introduction to the conceptual background to Warhol, emphasizing

> that the most impersonal method of reproduction, the photographic silk screen ... *per se* was a challenge to the fundamental rule of visual art: the unique, permanent original. Warhol's next move is to produce a large number of wooden copies of product boxes, bulk packs of soap, and tomato cans.[31]

Interestingly, in Fahlström's article, even though he drew upon the interview as published, the Swedish reader did not have to miss out a certain dimension

[26] Advertisement in *Svenska Dagbladet*, February 28, 1968.
[27] A collection of American films from New American Cinema Group, including Warhol's *Eat*, had been screened in Göteborgs konsthall (Kunsthalle of Gothenburg municipality) in February 1965 (Ulla Swedberg, "Rått, opolerad och levande paroll för nya USA-filmare," *Göteborgs-Tidningen*, February 14, 1965). Warhol's *Kiss* was screened in the theater of Nationalmuseum, by Moderna Museet's film studio in cooperation with the American film group, on January 30, 1965 (Carl Henrik Svenstedt, "Filmkrönika: Hjärntvätt på Nationalmuseum," *Svenska Dagbladet*, February 1, 1965). Svenska Filminstitutets filmklubb [the film club of the Swedish Film Institute] presented a collection of American films on January 30, 1968, including work by Shirley Clarke, Gregory Markopoulos, Andy Warhol, Stan Brakhage, Jack Smith, Robert Breer, and others (advertisement in *Dagens Nyheter*, January 28, 1968).
[28] See "Essay by John Peter Nilsson, Curator."
[29] Öyvind Fahlström, "Andy Warhol: Popkonstnär utan hämningar—'Alla Borde Vara Maskiner,'" *Dagens Nyheter*, February 4, 1968; quoted from the English translation by Donald S. MacQueen in *Hot Art, Cold War—Western and Northern European Writing on American Art 1945–1990*, ed. Claudia Hopkins and Iain Boyd Whyte (New York and London: Routledge, 2020), 461–5.
[30] Fahlström, "Andy Warhol: Popkonstnär utan hämningar," 461.
[31] Fahlström, "Andy Warhol: Popkonstnär utan hämningar," 462–3.

of Warhol's work. Fahlström, who knew Warhol's art and thinking firsthand, described how the remediating of films with different narratives are masked, featuring among other things, the transvestite trying out alternative gender roles.

Recent research has discovered that the interview Swenson published with Warhol in 1963 was in fact a heavily edited version of the recorded one, where particularly references to queer sexuality were omitted.[32] This is another aspect of translation as coded; a theme that was so loaded as to be subject to self-censorship within the American context—that is, at the point of departure—could easily be brought to attention in the most read daily newspaper in Sweden at the time. The exhibition was coded in new ways.

The photography critic Kurt Bergengren, from his side, declared in the evening paper *Aftonbladet* that Warhol's film *Chelsea Girls*, together with the exhibition catalog, represented something completely new in photography: an authenticity in images where the actors are filmed and photographed in a lived situation, but with a consciousness of the mediation taking place.[33] Finally, Ulf Linde, a leading art critic closely allied with the museum, wrote a brilliant analysis of Warhol's work. He took as his starting point the Marxist concept of alienation and went on to declare that he found Warhol disgusting, before closing the long article with the statement that one should maybe not take the artist that seriously: "Marilyn Monroe is painted in an original way—and the suggestion is that Warhol is much more interesting than that, after all."[34] Thus, the overall impression of the reviews is of highly informed critical discussions on, among other things, Warhol's relation to society's consumer culture. The Stockholm audience was not that provoked by the themes of the exhibition—the already familiar motifs and Pop art vocabulary—or, it seems, so much by Warhol's persona or queer lifestyle. Finally, it was the underlying structure of repetition, which was curatorially emphasized in the visual and verbal translation of Warhol's art, that most resonated with the Swedish audience.

[32] Jennifer Sichel, "What is Pop Art? A Revised Transcript of Gene Swenson's 1963 Interview with Any Warhol," *Oxford Art Journal* 41, no. 1 (March 2018): 85–100. For an alternative interpretation of the edited version of Swenson's interview, see Reva Wolf, "The Artist Interview: An Elusive History," *Journal of Art Historiography* 23 (December 2020): 22–3, https://arthistoriography.files.wordpress.com/2020/11/wolf.pdf.
[33] Kurt Bergengren, "Bilden," *Aftonbladet*, February 18, 1968.
[34] Ulf Linde, "U.P.A," *Dagens Nyheter*, February 10, 1968. For an overview of press reactions to the 1968 show, see "Essay by John Peter Nilsson, Curator," where he states that even the Marxist art critic Beng Olvång of *Aftonbladet* accepts Warhol as a disillusioned searcher of truth.

Distributive Democracy

In his 1989 essay on Andy Warhol, Benjamin Buchloh refers to Theodor Adorno's approach to modernist art as paradoxically having a history "while under the spell of the eternal repetition of mass production."[35] To Buchloh, Warhol embodied this dialectic as he had emerged from the collective disposition toward material objects that had formed two distinct consumer styles by the end of the nineteenth century, one elitist and one democratic. Warhol transformed himself from a "commercial artist" into a "fine artist" around 1960. Buchloh points out that Warhol had early on fraudulently claimed fine art successes and to have been exhibited at museums in 1955, long before this had actually happened. Naturally, the prospect of actually exhibiting in a European museum when first invited to Moderna Museet in 1964 must have appeared attractive to him. Buchloh also highlights Warhol's early motivations for egalitarian and democratic credos, which continued past this turning point, as exemplified by this 1966 statement:

> Factory is as good a name as any. A factory is where you build things. This is where I make or *build* my work. In my art work, hand painting would take much too long and anyway that's not the age we live in. Mechanical means are today, and using them I can get more art to more people. *Art should be for everyone* [my italics].[36]

While Warhol in this statement directly connects mechanically produced artworks to art distribution, Buchloh also points to him saying, in 1967, "Pop art is for everyone. I don't think art should be only for the select few, I think it should be for the mass of American people and they usually accept art anyway."[37] Buchloh also refers to a 1971 interview in which Warhol stated that in the past he had felt that "if everyone couldn't afford a painting, the printed poster would be available."[38]

[35] Benjamin Buchloh, "Andy Warhol's One-Dimensional Art: 1956–1966," in *Andy Warhol: A Retrospective* (New York: Museum of Modern Art, 1989), 39–61; reprinted in *Andy Warhol* (October Files 2), ed. Annette Michelson (Cambridge, MA: MIT Press, 2001), 1–46. All citations are to the October Files reprint.

[36] Andy Warhol, "Underground Films: Art or Naughty Movies," interview by Douglas Arango, *Movie TV Secrets*, June 1966, as cited in Buchloh, "Andy Warhol's One-Dimensional Art," 5.

[37] Andy Warhol, "Nothing to Lose," interview by Gretchen Berg, *Cahiers du Cinema in English* 10 (May 1967): 39–43, as cited in Buchloh, "Andy Warhol's One-Dimensional Art," 5.

[38] "A Conversation with Andy Warhol," interview with Gerard Malanga, *Print Collector's Newsletter* 1, no. 6 (January–February 1971): 125–7, cited in Buchloh, "Andy Warhol's One-Dimensional Art," 8, note 14.

More or less one year before the Warhol exhibition's vernissage at Moderna Museet, *Multikonst* ("*Multi-Art*"), large in scale and with considerable media attention, was launched at venues all over Sweden in no less than 100 exhibitions presenting identical sets of editions of sixty-five artworks created by sixty-eight Swedish artists.[39] *Multikonst* provides a specific context for the translation of Warhol in Sweden. The original Swedish title *Multikonst* will be used throughout this chapter. Interestingly, the word was invented by the organizers and very quickly transformed into the common Swedish term for art in editions.[40] The artists were well-known names and representatives of both the established, modernist generation, such as Sven X:et Erixson and Siri Derkert, and a younger, emerging one, for example Einar Höste, Lennart Rodhe, Sivert Lindblom, Albert Johansson, and Berndt Pettersson. Of interest to our context is the fact that John Melin, one of the two graphic designers who worked on the Warhol catalog, participated in the show. He created with Anders Österlin, another artist and graphic designer, a work entitled *Tallriken* ("*The Plate*"), of 1966, which represented a white, broken dinner plate in high plastic relief.

The artworks were listed as printed art (lithographs and woodcuts) or sculpture. The latter included both traditional materials and more modern ones, such as plexiglass and plastic. These two groups of works are related to two different legacies, sculpture and object-art. Limited editions of colored lithographs, signed by the artist, had already previously been used as a vehicle for the democratization of art in Sweden, especially after the 1939–45 war. One such example is the exhibition *God konst i hem och samlingslokaler* ("*High-Quality Art in Homes and Public Spaces*"), which opened at Nationalmuseum in 1945 and then toured the country. The idea was to expand the audience for art, to reach a public that "is largely to be found in the parts of the country that are culturally starved."[41] An important part of *Multikonst* was the editions of lithographs produced by well-established artists, as a continuation of this tradition. These were part of the show and sold to the audience at affordable prices. The other group of works, the sculptures and objects, were a direct consequence of the organizers inviting artists to take part and encouraging them to experiment and use new materials and techniques. This initiative

[39] My description of the *Multikonst* project owes much to David Rynell Åhlén, *Samtida konst på bästa sändningstid: Konst i svensk television 1956–1969 (Contemporary Art on Prime Time: Arts Programming on Swedish Television 1956–1969)*, PhD diss., Stockholm University, 2016 (Lund: Mediehistoriskt arkiv, 2016).

[40] See Kristian Romare, "Multikonst—ett ord, en företeelse," in *Multikonst: En bok om 66 konstverk, 100 utställningar, 350 000 besökare*, ed. Ragnar Edenman et al. (Stockholm: Sveriges radios förlag, Statens försöksverksamhet med riksutställningar, 1967), 16.

[41] This statement is from the compendium that was distributed to the local organizers of *Multikonst*, as quoted in Rynell Åhlén, *Samtida konst på bästa sändningstid*, 182.

resulted in some interesting new works. While Melin and Österlin's piece was Pop related, others were geometric sculptures, such as Einar Höste's *Varierad kub* ("Varied cube"). Organized by bodies like the initiating Folkrörelsernas Konstfrämjandet ("People's Movements for Art Promotion"; for short, Konstfrämjandet), as well as the temporary, then later permanent, government agency Riksutställningar ("Swedish Traveling Exhibitions"), and Swedish Radio, this show emerged from the young social welfare state.[42] That the state and the Social Democratic government supported the project was no secret, with the inaugural speech by the Minister of Education and Cultural Affairs, Ragnar Edenman, broadcast on Swedish Television on February 11, 1967, at the same time as the actual openings were being staged in 100 Swedish towns. In the minister's inaugural speech, artists were presented as producers, their artworks as goods or products, and the viewers as consumers.[43] The television set was seen to be presented on exhibition walls side by side with the artworks themselves. Thus, *Multikonst* was received not just as a modern art project as such, as showing new art, but also in its manner to use the modern media to communicate widely. It was driven by the idea not only to let art be visible in smaller venues in the nation's periphery but also to let art be affordable, a kind of distributive democracy (Figures 5.5 and 5.6). In *Multikonst*, therefore, each edition of the artwork was supposed to be regarded as original despite not being unique.[44]

However, the project was not understood to be associated with Warhol or American Pop art per se. On the other hand, the organizers' narrative made references to having been inspired by Daniel Spoerri's Edition MAT, for which, beginning in 1959, artists such as Alexander Calder, Josef Albers, Jean Tinguely, and Man Ray produced objects in series.[45] In an article published in the journal *Konstfrämjandets tidskrift*, Åke Meyerson even contrasts *Multikonst* with the work of American Pop artists in that the former conceals a distributive strategy—not an aesthetic one—and another of the organizers of *Multikonst* called it, in contrast to the American version, "real pop art."[46] Association with the Pop art discourse can also be found in the poster and cover of the book *Multikonst: En bok om 66 konstverk, 100 utställningar, 350 000 besökare*, which came out after the exhibition and were designed by Albert Johansson, one of the participating artists (Figure 5.7). In this design,

[42] Rynell Åhlén, *Samtida konst på bästa sändningstid*, 178–220.
[43] Rynell Åhlén, *Samtida konst på bästa sändningstid*, 183.
[44] Rynell Åhlén, *Samtida konst på bästa sändningstid*, 178–220.
[45] Romare, "Multikonst—ett ord, en företeelse," 16.
[46] Matts Rying, "Konst över landet," *Röster i Radio-TV* 5 (1967): 18–19, as quoted in Rynell Åhlén, *Samtida konst på bästa sändningstid*, 186.

Figure 5.5 View of the *Multikonst* exhibition, Örebro County Museum, February 1967. Photo: *Örebro Kuriren*, Courtesy of the Archive of Örebro County Museum.

Figure 5.6 View of the *Multikonst* exhibition, Örebro County Museum, February 1967. Photo: *Örebro Kuriren*, Courtesy of the Archive of Örebro County Museum.

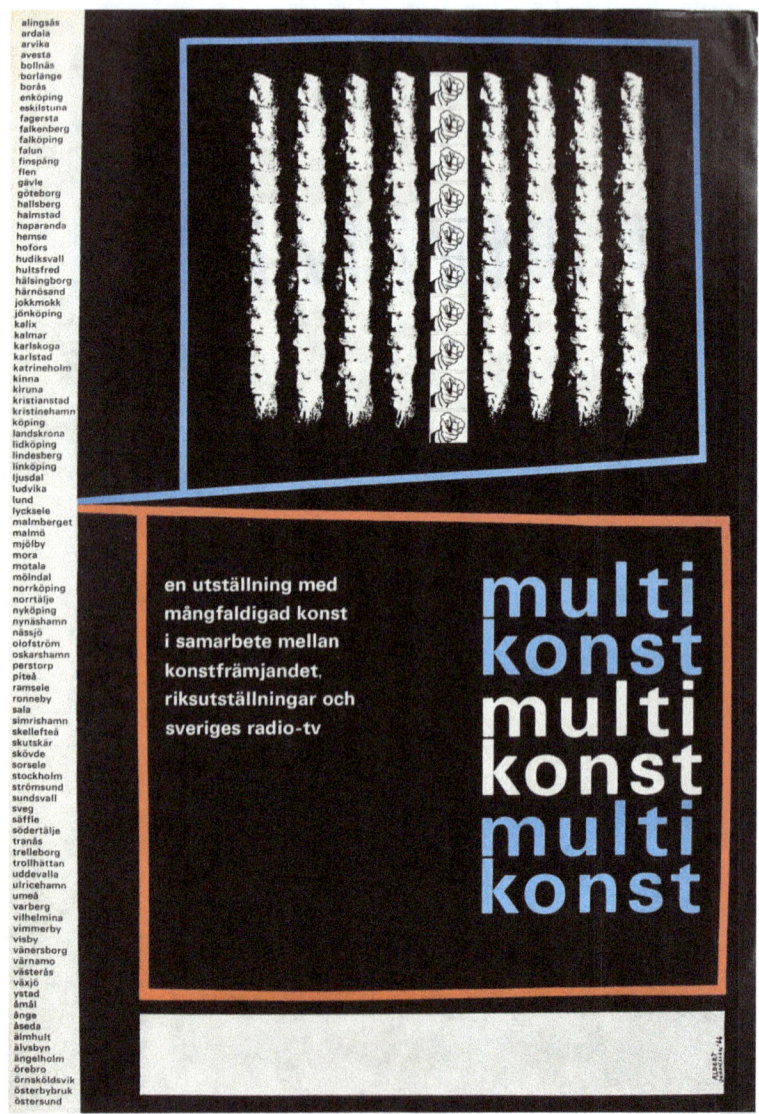

Figure 5.7 Poster for the *Multikonst* exhibition, designed by Albert Johansson, 1967. © Albert Johansson/Bildupphovsrätt 2023.

Johansson made reference to an image from the front cover of the catalog and the poster of the American Pop art exhibition of 1964, namely, Lichtenstein's pointing gun, in the form of a pointing finger, and, importantly, *in repetition*. It was set alongside an illustration of Johansson's own work for the show, which was composed of repetitive face masks.

Thus, when the Warhol exhibition opened in 1968, issues of repetition, of art and democracy, of original and copy, were already cherished themes in the Swedish cultural debate and among artists, as illustrated by *Multikonst*, an exhibition that had an immense impact through the televised circulation of its openings, art, and ideas. *Multikonst* and the Warhol show were representations of two poles within the Western art world at the time: the core of Manhattan art life and the political initiatives of the Swedish welfare state. However, when looking more closely, concrete entanglements between these two poles are to be found. Already in September 1967, Konstfrämjandet had advertised that American—and Polish—posters were for sale in the organization's Stockholm gallery and mentioned Warhol as one of the authors.[47] And maybe surprisingly to some readers, Swedish Traveling Exhibitions included works by Warhol in its 1967 exhibition titled *Kvinnan* ("*The Woman*"), which presented the topic with works by, for example, Honoré Daumier, Henri de Toulouse-Lautrec, and Tom Wesselmann. The catalog lists a silkscreen, *Jacqueline Kennedy*, by Warhol.[48] The Swedish cultural institutions saw the potential in Warhol's work to help them achieve their distributive ambitions.

On arriving late for the opening of his own show at Moderna Museet, Warhol went straight to a press conference. There he was interviewed by a journalist from a Swedish west coast paper, presenting yet another idea of the affordable multiple artworks, by proposing the following: "It does not matter if a work is original or not. If you desire anything here in the exhibition, just make a photo of it and bring it home."[49]

The Friends of Moderna Museet newsletter, edited by two students at Stockholm University's Department of Art History, featured the Warhol show. And here is where Warhol is directly connected to the concept of *multikonst*.

[47] Advertisement by Konstfrämjandet, *Dagens Nyheter*, September 20, 1967, 5.
[48] *Kvinnan* (Stockholm: Riksutställningar, 1967). *Svenska Dagbladet*, January 15, 1968, advertised an opening of the art exhibition in Kalmar, Sweden.
[49] "Det spelar ingen roll om en sak är originell eller inte. Vill ni ha någonting här på utställningen så fotografera det och ta med er hem, sade den amerikanske popkonstnären Andy Warhol då han på fredagen besökte Moderna Museet där man just nu har en Warhol-utställning. Warhol är numera formskapare och gör långrandiga filmer. Han vill vara en maskin utan kontakt med människan. Det skapar bara problem, menar han"; *Arbetet, västsvenska editionen*, February 10, 1968.

The exhibition was taken as the starting point for a survey of some artists on more general aspects of reproduction and repetition, with the first of eight questions being: "Do you believe a unique (two- or three-dimensional) artwork has any important qualities missing in a reproduced one?"[50] Most of the nineteen artists surveyed were favorable to artwork in multiples provided that the material was suitable for such a procedure. The questions were posed in general terms; however, the article was illustrated with works by Warhol. Not all the artists commented on the democratic distributive aspect. One who did was Sten Dunér, who stated that it would be terrific to spread one's work and thereby cheat the market. Karl-Olov Björk, a young conceptual artist, felt it would be really nice to create artworks in multiples, in editions; however, he concluded: "unfortunately, for my sculptures, this possibility does not exist. But a reproduction factory handling this would be splendid."[51] The reference to Warhol's art production was clear.

Warhol's statements and art, as translated into the presentation that became the exhibition at Moderna Museet in spring 1968, were curatorially coded, to follow Espagne, in a way that underlined the quality of repetition. That quality appeared in his images, but even more so in the way they were arranged in the exhibition space, and in the content that his sentences in the catalog carried. While the notion of repetition in Warhol's work had been under discussion in the United States, in Sweden repetition had its own focus within artistic and cultural practice, which made his show resonate well there. In the context of Stockholm and the Swedish welfare state, the notion was understood and used in connection to ideas of democratization of art, that was in fact not that far from points Warhol occasionally had made. Before anything else, what appeared deeply relevant as it was translated and coded into the Swedish scene was the curatorial concept "many works and few motifs"—of repetition.

[50] "Konstnärer om multikonst," *Meddelande från Moderna Museet till Moderna Museets vänner*, 1968, 27–8.
[51] "För mina skulpturer finns tyvärr inte den möjligheten. Men en reproduktionsfabrik som tog hand om den saken vore smaskens," "Konstnärer om multikonst."

6

Andy and Julia in Rusyn: Warhol's Translation of His Mother in Film and Video

Elaine Rusinko

Mothers

In November 1966, an article in *Esquire* featured interviews with the mothers of four prominent names in the news: White House Press Secretary Bill Moyers, Green Bay Packers running back Paul Hornung, comedian Jonathan Winters, and artist and filmmaker Andy Warhol.[1] The article, entitled "Mothers," included full-page photographs of the women, each holding a framed picture of her famous son. The women tell their own stories, revealing diverse backgrounds and distinctive personalities. Mrs. Moyers, a "sedate, impeccably coiffed" working woman, shares her parenting philosophy and shows the interviewer complimentary letters about her son from President Johnson. Jonathan Winters's mother is a natural comedienne, who, during the interview, smokes ("Don't worry. It's not marijuana") and quaffs bourbon ("Let's live it up"). Mrs. Hornung, "her reddish hair ... piled high atop her head," is a government worker who shows off the color television her son bought her and her spacious, "spotless" apartment. Mrs. Warhola is last in the sequence, and in her photograph as well as her story, she stands out markedly from the others. The interviewer describes her as "a slight grey-haired woman who speaks with animation, throws her hands excitedly in the air, weeps easily." Her photograph shows a stolid elderly woman in what must be her Sunday-best hat and flowered dress, her veined, gnarled hand resting on her chin in a similar pose to the one in the portrait of her son that she holds in her lap.

The interviewer, Bernard Weinraub, asked each of the mothers the same basic questions, encouraged them to talk freely, and then presented their words as a free-flowing discourse in their own idiosyncratic speech styles.

[1] Bernard Weinraub, "Mothers," *Esquire*, November 1966, 96–101, 155–8.

Each woman talks about herself and her background, her son's childhood, achievements, relationships, and their own mother-son bond. Julia's portion of the article is less comprehensive than the others, which is not surprising, considering the communication difficulties that occurred. But this interview is significant, because it is the only firsthand account of Julia's history, and as such, it is cited in all the Warhol biographies.

In contrast to the interviews with the "elegantly coiffed" and "impeccably dressed" mothers, Julia's account contains no political views, cultural critique, or explicit child-rearing methods—concepts that she would probably not have understood and could not articulate. While the other women compare indulgent and authoritative parenting styles, Julia says simply, "I raise my children okay. Oh, Andy a good boy." Like Jonathan Winters's mother, a frustrated actress, Julia talks more about herself than her son. She indulges in fond memories of her wedding, grieves her baby daughter's death, and laments the pain of war. According to Weinraub, it was a stream-of-consciousness style of narration.

> The most frustrating thing was her inability to express herself in English. She had a very thick accent, and sometimes broke into another language. I didn't ask about her wedding, but she brought it up. She was sort of in charge of the interview.[2]

Misunderstanding some of her speech, Weinraub got a few details wrong, but overall, he managed to elicit valuable, verifiable information.

When the *Esquire* article appeared, it caused consternation in the Warhola family. Julia's son John complained that his mother's way of speaking English "was made to appear ridiculous in a national magazine." Allegedly, "Andy had asked beforehand that Julia's conversation be edited for publication—but the magazine decided to emphasize her broken English. Andy was embarrassed and upset by this manipulation of his mother."[3] The Pittsburgh Warhola brothers may well have been offended, since their working-class Carpatho-Rusyn background made them sensitive to the "broken English" of their parents, which carried shame for many American-born children of immigrants. But according to Weinraub, there was no request to standardize Julia's English. In the context of the *Esquire* article, in which Mrs. Moyers speaks in a Texas twang ("Fine, just fine. Honey … we have some talkin' to

[2] Bernard Weinraub, interview with the author, February 25, 2020.
[3] R. Jay Gangewere, "Ten Years Later—What Would Andy Say?" *Carnegie Magazine* 63, no. 9 (May/June 1997), https://carnegiemuseums.org/magazine-archive/1997/mayjun/feat4.htm.

do"), and Jonathan Winters's mother hams it up in a simulated southern accent ("I'm gonna have me some Suthun Frahd Cheeken"), Mrs. Warhola's authentic expression highlights her endearing old-world qualities and contributes to her likability. There is no indication that Julia's interview brought any embarrassment to Andy, who would later (through his ghost-writers) refer to his mother's "thick Czechoslovakian accent."[4] In fact, the publication of the *Esquire* article may have alerted him to the creative potential of Julia's speech style. Shortly after the appearance of the article, Warhol cast his mother in his film, *The George Hamilton Story* (commonly known as "Mrs. Warhol").[5] Susan Pile, who was sound tech for the film, wrote to a friend in November 1966, "I was at Andy's house this week (a truly rare privilege …). He filmed the George Hamilton story with his mother as star—her screen debut." Pile goes on to recommend Julia's interview: "See *Esquire* this month for an interview with Mrs. Warhola, who speaks to Andy in Czechoslovakian and can only rattle off to others a garbled English. She's a very sweet old lady."[6]

The Trouble with Rusyn

In the past, there was much confusion about the Warholas' ethnicity and language.[7] Mrs. Warhola did not speak "Czechoslovakian," which is neither a language nor an ethnicity. Julia was a Carpatho-Rusyn from what was, for most of the time she lived there, northern Hungary, and became part of Czechoslovakia in 1918. Her ancestral village, Miková, is located in what is today northeastern Slovakia, which was under Soviet domination from 1945 to 1989. For their own political and strategic purposes, the

[4] *The Philosophy of Andy Warhol (From A to B and Back Again)* (1975; Orlando: Harcourt, 2006), 21.
[5] Greg Pierce, director of film and video at The Andy Warhol Museum, devised a standardized titling system for Warhol's films. Titles given to films by Warhol, used for screenings, and printed in publications, are indicated by italics. Films entitled according to information found on the box, can, or reel are denoted in quotation marks. Hence, *The George Hamilton Story* and its more commonly known title, "Mrs. Warhol." See "Notes on Titling," in *Andy Warhol's* The Chelsea Girls, ed. Geralyn Huxley and Greg Pierce (Pittsburgh: The Andy Warhol Museum, 2018), 318. The disparate titles will be discussed later in this chapter.
[6] As cited in Gary Comenas, "Mrs. Warhol," https://www.warholstars.org/andy_warhol_films.html, accessed April 26, 2021.
[7] For more on this point, see Elaine Rusinko, "'We Are All Warhol's Children': Andy and the Rusyns," *The Carl Beck Papers in Russian and East European Studies* 2204 (2012): 9–21, http://carlbeckpapers.pitt.edu/ojs/index.php/cbp/article/view/190.

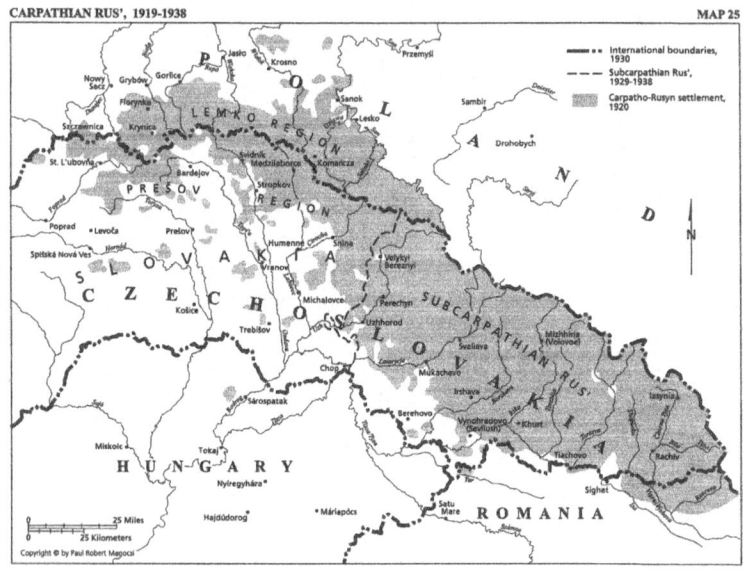

Figure 6.1 Map of Carpathian Rus', 1919–38. Reprinted with permission from Paul Robert Magocsi, *With Their Backs to the Mountains* (Budapest and New York: Central European University Press, 2015). Miková is located eight miles northwest of Medzilaborce.

Soviets rejected the very concept of a Carpatho-Rusyn ethnicity or identity. Carpatho-Rusyns were declared to be Ukrainian, and the Rusyn language was proscribed in education, publication, and official documents. In a move of passive resistance, large numbers of Rusyns in Slovakia chose to identify as Slovak rather than Ukrainian, which partly accounts for the muddle of language and identity among Rusyns in the American immigration.[8] Miková was located in an ethnolinguistic borderland, and the vernacular language had admixtures of West Slavic languages (Slovak and Polish), numerous loan words from a Finno-Ugric language (Hungarian), and several borrowings from German and Romanian (Figure 6.1). In the early twentieth century,

[8] The term "Rusyn" was historically applied also to Ukrainians and Belorusians. When used here for convenience, it refers specifically to Carpatho-Rusyns. Their homeland, Carpathian Rus', straddles the borders of Poland, Slovakia, Ukraine, and Romania. It has never existed as a distinct administrative entity. The name of the language is "Rusyn." Rusyn words from the Warholas' correspondence are rendered as written. References to the spoken Rusyn language are given in a simplified version of the Library of Congress transliteration system for Rusyn.

Rusyns in the United States would have said they spoke *po-nashomu* (in our way), without, perhaps, even recognizing their speech as a distinct language. After the collapse of Soviet control, the proscription against all things Rusyn was lifted, and the language was formally codified in Slovakia and Poland in the 1990s. Today Rusyn is acknowledged by an increasing number of international linguists as a distinct East Slavic language.

When Carpatho-Rusyn immigrants came to America, lexical borrowings from English infiltrated the language, especially for concepts that had not existed in the Old Country. Phrases like *rent platit* (pay the rent), *lem pyat minute ride* (just a five-minute ride), and *James dostal cara* (James got a car) are convenient mixed phrases that appear in Julia's correspondence and would be understood by bilingual speakers. English verbs were transformed by adding Rusyn morphological endings: *mam klinuvati apartment* (I have to clean the apartment), *vi ne feelujete dobri* (you do not feel well). As a result, the peculiar mixed Rusyn language was a source of embarrassment and inferiority in America, just as it had been in the homeland, where the prestige language was first Hungarian, then Slovak.

The natural alphabet of Rusyn was Cyrillic, but because their homeland was historically part of the Hungarian Kingdom, Warhol's parents were educated in schools that transcribed Rusyn in the Latin alphabet, using an unwieldy Hungarian system of transliteration. None of the immigrant generation of the Warhola-Zavacky family had more than a few years of elementary education, and they had little awareness of spelling or grammar in any language. Julia and her relatives wrote as they spoke, phonetically, not recognizing lexical segments or sentence boundaries, interspersing English words, and forgoing capitalization and punctuation entirely. For example, Julia's husband Andrii writes *nakari*, misspelling the English word for "car" and combining it with a Rusyn preposition and case ending to mean "in a car." *Taustinema sto take pisati* is "and I have nothing more to write to you" (*ta už ti ne mam što tak pisati*). Deciphering their correspondence is challenging even for native speakers of Rusyn.

A recognition of Julia's linguistic limitations casts new light on the calligraphy she did for Warhol's early artist books. Semiliterate in her own language and totally unschooled in English, she approached copying text as a work of art, focusing on the shape of the letters rather than the meaning of the words. Occasional misspellings and omitted letters were to be expected, as in *25 Cats Name Sam and One Blue Pussy* of the mid-1950s, where Julia dropped the "d" on "named." But for the most part, as in *Wild Raspberries*, 1959, a sendup of a gourmet cookbook on which Warhol collaborated with Suzie Frankfurt, she carefully reproduced the original text, with little

comprehension of its meaning.⁹ A related drawing, which was not included in the book, is *Tranches de Truite à la Jeanne d'Arc*, for which Julia transcribed a fifteen-line text completely in French.¹⁰

The Warholas retained the Rusyn language longer than many Rusyn-American families. Julia spoke Rusyn with her children and relatives all her life. Her older sons, Paul and John, were able to communicate easily with Carpatho-Rusyn kin in Slovakia when they visited in the early 1990s, and they even gave radio interviews in Rusyn. As a child, Andy spoke Rusyn until he went to school. A cousin wrote to him in 1965,

> You know Andy, I remember an amusing thing about you when you were about four years old. Your mother asked you what you're going to be when you grow up and you answered, "*Ya budu bom, ya vas zastreliu.*" Oh, how we all laughed.¹¹

That is, in a comment that is of interest for more than just its language, at around four years of age, Andy told his family, "I'm going to be a bum, and I'll shoot you all."¹² In Carpatho-Rusyn immigrant culture, the term "bum" had a sinister meaning that was stronger than the standard American connotation of tramp or vagrant. Akin to a menacing bogeyman, a "bum" was an ominous malefactor, a rogue scoundrel, or a vague, ever-present specter to induce good behavior in children. The sense and implication of Andy's childish threat is a topic for another discussion, but the inverted word order and his grammar, the use of a perfective future verb form, are quite correct.

Since there was no name for their *po-nashomu* speech style, Julia and her older sons often told uninformed Americans that they spoke Slovak. Because his mother emigrated from Czechoslovakia, Andy assumed he was speaking Czech with her, and he identified his ethnicity as "Czechoslovakian." In July 1967, the Lincoln Center's film festival featured Czech cinema of the New Wave movement. The *New Yorker*'s reviewer described the films as

⁹ Susan M. Rossi-Wilcox, who examined the typed sheets for *Wild Raspberries*, concluded, "Mrs. Warhola faithfully copied the text. The typos, corrections, hyphenations, and duplications are in the original"; "Social Satire in the Guise of a Cookbook: Warhol's *Wild Raspberries*," in *Reading Andy Warhol*, ed. Nina Schleif (Ostfildern: Hatje Cantz, in association with Museum Brandhorst, Munich, 2013), 158.

¹⁰ Andy Warhol Museum Archives (hereafter, AWMA).

¹¹ Mary (Sally) Zymboly, letter to Andy Warhol, January 9, 1965; AWMA.

¹² It is uncertain precisely to whom this threat was directed. The pronoun is the formal "you," which children used to address a parent in some traditional Carpatho-Rusyn families. It could also be a plural "you." The context here seems to suggest that the entire family was Warhol's audience.

"amazing and unforgettable."¹³ Noted for their rejection of conventional film forms, their mix of documentary and fiction, their nonprofessional actors and improvised dialogue, the avant-garde Czech films would naturally have attracted Warhol's attention. But he was also intrigued by the visiting delegation of Czech directors. He socialized with them at an organized get-together, and later, the Czechs attended a party at his studio, the Factory. Czech film director Jaromil Jireš recalled that Warhol "said something to me that was sort of like Czech, but I couldn't understand it. Then he denied that he spoke Czech at all."¹⁴ In 1969, Woody Vasulka, a Czech video artist originally from Brno, who knew Warhol from Max's Kansas City and the Factory, tried to converse with him. Warhol refused to respond in Czech, but Vasulka believed he understood it.¹⁵ Since there is some mutual intelligibility between one Slavic language and another, Warhol probably would have been able to pick up a word here and there or the general sense of a conversation. But his half-hearted efforts to communicate with Czechs in their language were futile, leading to embarrassment when his own language proved to be not up to par. Finally, near the end of his life, Warhol came to question his life long ethnic identification. In 1986, he met the Czech model Paulina Porizkova and her mother. He commented in his diary, "I guess maybe I'm not really Czech, because I didn't understand it when they were talking."¹⁶

There is video evidence that, as an adult, Warhol understood his mother's language perfectly and responded appropriately, although mostly in English, as was typical for children of immigrants. When Julia's sister visited from Miková in 1967, she reported that he seldom spoke to her, but he prayed together with her and his mother in Church Slavonic, the Rusyn liturgical language.¹⁷ His expressive ability in conversational Rusyn seemed limited to discrete lexical items, which he sometimes interspersed in his English-language discourse when speaking with his mother. That is, he knew individual words for everyday use, but not how to link them in grammatically correct syntax. Although there are few documented examples of his spoken Rusyn—precisely four short sentence fragments in one video—it is probably accurate to say that his pidgin Rusyn was on a lower level than Julia's pidgin English.

[13] Penelope Gilliatt, "The Current Cinema: Czech Wave in New York," *The New Yorker*, July 1, 1967, 54.
[14] Jaromil Jireš, in Rudo Prekop and Mihal Cihlář, *Andy Warhol a Československo* [Andy Warhol and Czechoslovakia] (Řevnice [Czechia]: Arbor Vitae, 2011), 215.
[15] Woody Vasulka, in *Andy Warhol a Československo*, 218.
[16] Andy Warhol, *The Andy Warhol Diaries*, ed. Pat Hackett (1989; New York: Warner Books, 1991), 744.
[17] Eva Bezekova, in Michal Bycko, *Nočné dialógy s Andym* [Nocturnal Dialogues with Andy] (Prešov [Slovakia]: CUPER, 1996), 82.

"Lay Down, Mom"

In 1965, Warhol told *Tape Recording* magazine, "The tape machine is so easy to use. Anyone can do it."[18] In 1970, when he purchased a Sony Portapak, he began to experiment with video in earnest. With his assistants, Vincent Fremont and Michael Netter, he documented the goings-on in his studio on tapes that became known as *Factory Diaries*, uninterrupted and unedited footage of people talking or performing everyday activities. As "easy to use" as the video camera may have been, before he focused it on friends and visitors, Warhol performed test-runs, with his mother as subject. Three videos, labeled by the Andy Warhol Museum "Julia Warhola in Bed, Talking," "Julia Warhola in T-shirt, Sick," and "Julia Warhola in Bed, Talking, Sleeping," were shot in Mrs. Warhola's apartment on the lower level of her son's Lexington Avenue townhouse.[19] They were never shown in public, and until now, they were never screened by anyone who understood the Rusyn language. Julia, who does almost all the talking in the videos, is performing for an audience of one, her son. Since Rusyn, at the time, was confined to church and family, Warhol presumably did not anticipate that the tapes would ever be translated. Consequently, they represent private, unmediated interactions between mother and son and a window into their personal relationship. It is uncertain exactly when he acquired his video equipment, but Julia refers to it as "brand new" in "Julia Warhola in Bed, Talking," and internal evidence dates the videos to late summer or early fall 1970. Julia had been hospitalized for a week in January, perhaps for a stroke, and she was being treated throughout the summer by doctors, caregivers, and visiting nurses. In all three videos, she is ill and visibly uncomfortable, but she valiantly follows Warhol's directions and plays her role as test subject.

In "Julia Warhola in Bed, Talking," Warhol has settled his mother in the camera frame, lying in bed on her right side against an exposed-brick wall. While Andy fiddles with the camera, Julia talks—and talks—in Rusyn.[20] Her monologue is at times rambling, but she is articulate and coherent. Her

[18] Richard Ekstract, "Pop Goes the Videotape: An Underground Interview with Andy Warhol," *Tape Recording* 12, no. 5 (September–October 1965), as reprinted in *I'll Be Your Mirror: The Selected Andy Warhol Interviews: 1962–1987*, ed. Kenneth Goldsmith (New York: Carroll and Graf, 2004), 75.

[19] "Julia Warhola in Bed, Talking," VR.00.0025; "Julia Warhola in T-shirt, Sick," VR.30.0024; and "Julia Warhola in Bed, Talking, Sleeping," VR.30.0015. A fourth video, "Julia Warhola Watching Television," is just under a minute of footage at the beginning of Warhol's *Factory Diary* "Whitney Museum Retrospective," VE.30.0004; AWMA.

[20] Darina Protivnak, a native speaker of Rusyn, assisted with the translation of Julia Warhola's language in these videos.

Rusyn, intermixed with occasional English, is emotional and expressive. She speaks to Warhol as to a child, in endearing terminology and diminutives. *Tvoia koshul'ka tu brudna Andik*, shirt*ka brudna* (Your shirt is dirty here, Andik), using a childish diminutive for the Rusyn word "shirt" (*koshul'ka*) and then adding a diminutive Rusyn ending (*-ka*) to the English translation "shirt." Her monologue is laced generously with terms of endearment—Andik (pronounced Andeek), Andriiko, *synok* (little son), *synochko* (a more tender version of "little son"), *syne mi zlaty* (my golden son). However, she also uses these affectionate diminutives in reproaches about his indifference and neglect. As he prepares for a trip to Europe, she complains, her voice full of fear and distrust,

> *Hospodi* [Lord], who will be here with me, *synok*? Will you lock up the house? They would steal everything from you, *synok*. If somebody would find out that Andy Warhola is not here, you would have nothing to come back to. During the day is one thing, but at night I'm afraid to sleep here by myself. *Understand* [English], Andy?

Then, sarcastically, she scolds in Rusyn, "But why would you care about that?"

While his mother desperately tries to evoke a response from him, Warhol is largely silent behind the camera. We first hear his voice when she complains that her side hurts and she tries to get up, moving out of the camera frame. "Lay down, lay down, mom, lay down," he repeats, even as she responds in discomfort, "Yoi, Andik." At one point, the phone rings and Warhol carries on a conversation in another room, while Julia obediently remains in place. After another attempt to get up, protesting, "My hip hurts, my side is hurting when I breathe," countered by the same "Lay down, mom," she asks, like an eager-to-please child, "So how is it, Andy? How I'm laying down? Is it all right?" To this question, there is no verbal response. Finally, after a long pause, during which she seems silently distressed, Warhol addresses her in a tender voice with the classic Rusyn expression of affection, an offer of food, using the Rusyn verb "to eat": "You want something to eat, mom? eat? *isty*? What *isty* you want?" In English, Warhol offers a sandwich, "good sandwich," but Julia refuses, answering in Rusyn, "I don't want to eat. Leave it, give me peace, Andy." Mournfully, she sighs, "If only I didn't have stomach problems, if only I could get over this somehow. But I don't think I will be around for very long, because my breath gets stuck here."

For all her affection and distress, in the same thirty-minute video, Julia also reveals a spirited, feisty, and fiery personality that contrasts with the "naïve and childlike" image often attributed to her. "Everybody looks out for themselves," she complains cynically. Speaking about an acquaintance, she

carps, "For the whole world, she won't buy anything for herself. That's how [tightly] she holds onto money. She thinks she can eat it. And then she comes here and she's hungry." Finally, Julia goes off on a serio-comic riff in Rusyn about a beauty salon on Lexington Avenue where she got a perm.

> I don't know why I have a scab on my head. I don't know why I have peeled skin on my head. I don't know who gave that to me. And it's hurting me a lot. Is it because they burned my scalp when they were curling my hair? That damn medicine burned my skin. That old lady [pejorative]. It's the fault of that old *boss woman*, she burned my hair. For my *twenty-five dollars*, she burned my head with that strong evil stuff. I could have her arrested for what she did to my head. ... She burned my head. *With poison.* ... The old devil, she burned my head herself. The young ones wouldn't do that. ... She's not that old, but I'm calling her that because I'm angry with her. If it were just my hair, it would be nothing, but it's my skin. She boiled it.[21]

Gifted with a theatrical personality, Julia developed a natural talent for performance as she practiced the folkways of her native culture. From weddings to religious liturgies, from St. John's Eve festivities to Bethlehem plays, Carpatho-Rusyn peasant culture was replete with ritual and tradition, and multiple versions of folk theater were performed expertly by unsophisticated, barely literate peasants. Evgenii Nedziel'skii, a Russian ethnographic historian of Carpatho-Rusyn drama, compared the peasants' theatricalization of everyday life to the elaborate court ceremony of English royalty: "The theatrical ceremony of the royal court pales by comparison to the traditional, ritualistic, and superstitious aspect of everyday Carpatho-Rusyn peasant life."[22] Performance, in the sense that the term is used in performance studies—"a certain type of particularly involved and dramatized oral

[21] Italicized words in this passage indicate phrases that Julia Warhola spoke using English. In his biography of Warhol, Blake Gopnik referred to this passage, citing me and Darina Protivnak as translators; *Warhol* (New York: Ecco/HarperCollins, 2020), 739. However, Gopnik changed "old devil" to "old bitch," replacing the mild insult, an inoffensive expression of frustration, with a word that, in Rusyn, conveys malice and vulgarity. My translation with Protivnak, a native speaker of Rusyn from a village near Miková, was done with Julia Warhola's socio cultural orientation in mind. Altering it misrepresents our translation, distorting Julia's tone, thought, and character.
[22] Evgenii Nedziel'skii, *Ugro-russkii teatr* [Subcarpathian Rusyn theatre], Uzhhorod (in present-day Ukraine), 1941. It is noteworthy that the "theatricalization of experience" was also part of the camp sensibility, as described by Susan Sontag in "Notes on Camp," *Partisan Review* 31, no. 4 (1964): 515–30.

narrative"[23]—was an integral part of Julia's communicative style throughout her life. From her earliest performances in Miková to the stories she told her children and recorded on tape, to her relationships with Warhol's New York friends and her appearances in his film and video, performativity was basic to Julia Warhola's personality.

Performance and performativity entail a purposeful projection of the self. Julia's outburst in the video magnifies her persona in a performative assertion of identity in a world where social constraints and language insufficiency restricted her self-expression. In this private session before Warhol's camera, she can transgress social and cultural norms, using a pejorative Rusyn term for an old woman, a folk expletive for "devil," and finally, in a theatrical flourish, threatening to have the "devil" arrested. The repeated phrase "I don't know why …" serves to position her as a character as well as a narrator in her story and emphasizes its poetic and expressive features.[24] The performance nature of her monologue is exposed when she reveals that her word choice was evaluative, rather than referential, since the "old devil" was actually "not that old." Code-switching from Rusyn to English, she isolates and sets apart the terms "boss woman," "twenty-five dollars," and "poison" to emphasize their importance. And with her final formulation of the damage to her hair and her skin—"she boiled it"—Julia reaches a dramatic catharsis. After the energetic monologue, delivered in a lively intonation, she becomes silent and pensive. A lengthy pause follows before she changes the subject.

"I Just Make Her Take the Pills"

In an interview with Warhol for the South African publication *Scope*, published in March 1973, interviewer George Gruskin was particularly interested in Warhol's mother, and the artist was loath to talk about her. Gruskin asks, "You used to live with your mother, didn't you?" Warhol answers, "Oh yes, she is around somewhere." In fact, Julia had returned to Pittsburgh in 1971 and died November 22, 1972. Apropos of nothing, Warhol tells Gruskin that he regularly hurries home to give his mother her pills. When asked what language he speaks with her, he responds, "I don't talk to her

[23] Kristin M. Langellier, "Personal Narrative, Performance, Performativity: Two or Three Things I Know for Sure," *Text and Performance Quarterly* 19, no. 2 (1999): 127.
[24] See Kristin M. Langellier and Eric E. Peterson, *Storytelling in Daily Life: Performing Narrative* (Philadelphia: Temple University Press, 2004), loc. 344–5, Kindle Edition.

much. I just make her take the pills."²⁵ One of Warhol's videos, "Julia Warhola in T-shirt, Sick," cinematizes this difficult procedure. Julia speaks entirely in Rusyn with Andy and her nurse, who respond in English. The camera focuses on Julia, who sits on her bed. She is posing for the camera, and she flaunts her familiarity with the procedure, snapping, "Don't touch anything, Nancy. He wants to do something with me." She scolds Nancy: "You'll break it. What do you know about it? ... I don't want you here. Go to the kitchen." When Nancy returns and tries to give Julia her pills, she resists, concealing them in her hand. Nancy warns, "No, no, you're going to lose them that way. Put them in the cap." Julia responds irritably, "Don't worry, do you think I'm stupid? I'm not crazy. Just go away. I'll give them to Andy." Then she turns to her son, and her tone shifts markedly. "Andrii, *synok* (little son), *syne mi zlaty* (my golden son), I can't eat now. I'll just have coffee." Warhol patiently doles out her pills. "All these, Andy?" she asks tremulously. She swallows the pills slowly, with great difficulty. "It won't go down. For all the world, it doesn't want to go down, Andy. The pills are stuck in my throat." Julia complains that her ears are ringing, but her son is concerned with the pills, and urges her in Rusyn: "*No perulky neber do ruku? ... No na druhu ruku?*" ("But didn't you put the pills in your hand? In the other hand?") This awkward utterance is the only known audio record of Warhol's Rusyn-language speech. Julia does not immediately understand Warhol's question, because of the clumsy phrasing. "I don't have them," she says, and then asks, "In which hand?" Unsure of his grammar, Warhol changes the case ending: "*Na druhyi ruky*. No?" ("In your other hand?")²⁶

Julia goes on to insist, in Rusyn, that she has only a piece of paper in her hand, and she asks for water to swallow the pills. "*Rozumish, Andriik, chto perulky v hyrtani? Tot paperik ne* good" ("Do you understand, Andriik, that the pills are in my throat? This tissue is no good"). Julia frequently asks "*rozumish?*" ("do you understand?") to check the communicative channel, to confirm the continued attention of her son, and to elicit a response. Warhol does not react, thwarting sustained dialogue. As he told Gruskin, "I just make her take the pills." After crossing herself three times and saying a prayer, Julia manages to swallow, or *eatuvati* (English "eat" with a Rusyn verbal ending), a handful of pills and the lunch that Andy brings her. As breadcrumbs fall on her nightgown, she fears ants will feed on them, and momentarily she

[25] "Who Is This Man Andy Warhol?" *Scope*, March 16, 1973, as reprinted in *I'll Be Your Mirror*, 207–8.

[26] It is difficult to translate Warhol's utterance exactly. It may be an imperative: "Don't take the pills in your hand." In addition, he seems to be improvising the inflectional endings. My translation here, and probably Julia's understanding, comes from context.

returns in her mind to a traumatic experience of the 1914–18 war, saying, "The Germans will come and eat all this." A cat meows in the background.

"Julia Warhola in Bed, Talking, Sleeping" is the only one of the "Julia videos" that has been shown in public at museums and film festivals. It seems to portray a peacefully sleeping Julia Warhola, but for the first time in these test-videos, she participates unwillingly. "Andy, don't bother with me, I sleep." Her mixed Rusyn-English monologue is disjointed and querulous. Again, she has trouble eating ("Maybe I'll choke, Andy"), laments that she does not have a daughter, and complains about "Jed *paskudnyi*" (disgusting Jed),[27] who seemed to be burning something in the kitchen. In English, she asks, "What's there, Andy? He understand, Andy? Nobody understand. I not happy, Andy." In both Rusyn and English, Julia repeatedly asks for confirmation that she has been understood, but her concern is only partly about language comprehension. She is asking to be heard and acknowledged, but she does not receive that concession from her son. Finally, she tells Warhol she is not up to performing for him, and concludes, "If I could only take some pills so I could sleep. My head is burning, my eyes too, that's how much I want to sleep." Mercifully, she falls asleep, with her glasses and kerchief on, and she sleeps until the tape runs out (Figure 6.2).

Bringing Back Old People

In a press conference covered in the *New York Times* on November 11, 1966, Warhol refers to a movie he made "yesterday afternoon": "It starred my mother, who played an aging peroxide movie star with a lot of husbands. We're trying to bring back old people."[28] This was Warhol's nonchalant announcement of Julia Warhola's screen debut in *The George Hamilton Story*.

This is not the place for a lengthy discussion of Warhol's film technique, but it is important to note the most significant features—his disdain for plot, scripts, and technical matters. "I never liked the idea of picking out certain scenes and pieces of time and putting them together, because then it ends up

[27] Jed Johnson worked at Warhol's studio, took care of Andy after his shooting in June 1968, and helped with Julia as her health declined. He moved in with Andy in early fall 1968. Although he continued to help with housekeeping and took Julia to doctor's appointments, Julia never liked him. Paul Warhola shared her opinion. See Victor Bockris, *Warhol: The Biography* (New York: Da Capo Press, 2003), 310. Johnson's relationship with Warhol lasted twelve years.

[28] "The Painting on the Dress Said 'Fragile,'" *The New York Times*, November 11, 1966; AWMA. The reporter comments that Warhol made the remark about old people "a little sadly."

Figure 6.2 Andy Warhol, *Factory Diary* ["Julia Warhola in Bed, Talking, Sleeping"], c. 1970–2, ½ in. reel-to-reel videotape, black-and-white, sound, 22:48 minutes. Camera by Andy Warhol. © The Andy Warhol Museum, Pittsburgh, PA, a museum of Carnegie Institute. All rights reserved. Video still courtesy the Andy Warhol Museum.

being different from what really happened—it's just not like life."[29] Most of his films are improvisations organized around a sketchy narrative plotline, which is constantly transgressed when the actors respond to off-screen comments or play to the camera. Warhol insisted that professional actors "are all wrong for my movies."[30] He preferred amateur performers who were spontaneous and capricious: "What I like are things that are different every time. That's why I like amateur performers and bad performers—you can never tell what they'll do next."[31] His favorite amateurs had strong personalities: "Somehow, we attract people who can turn themselves on in front of the camera. In this sense, they're *really* superstars."[32] In 1966, Julia Warhola, who had honed her

[29] Andy Warhol and Pat Hackett, *POPism: The Warhol '60s* (New York: Harcourt Brace Jovanovich, 1980), 110.
[30] David Bourdon, "Warhol as Filmmaker," *Art in America* 59, no. 3 (May–June 1971): 51.
[31] Warhol, *Philosophy*, 82.
[32] Letitia Kent, "Andy Warhol Movieman: 'It's Hard to Be Your Own Script,'" *Vogue*, March 1, 1970, as reprinted in *I'll Be Your Mirror*, 187.

acting skills in Miková folk dramas, became a Warhol superstar. Her tenuous command of English added an unpredictable creative dimension to her performance.

The George Hamilton Story, which consists of two 33-minute reels, was never printed or screened publicly during Warhol's lifetime. Shot in Julia's ground floor apartment in Warhol's Lexington Avenue townhouse, it features Julia with her co-star Richard Rheem, Warhol's then boyfriend who lived with him for about six weeks during the winter of 1966.[33] Also present offscreen, and occasionally heard on the soundtrack, are Paul Morrissey and Susan Pile. Pile described Julia as "gracious and nice, albeit unintelligible."[34] Most reviewers of the film have commented on her "almost unintelligible, heavy Czech accent."[35] However, for viewers who are familiar with Julia's speech style and knowledgeable about the Carpatho-Rusyn context, her comedic talent steals the show, and her self-revelatory performance discloses private thoughts, feelings, and memories. The resulting cinematic portrait differs substantially from the standard description of her in film festival promos as "Warhol's delightfully oddball mother."[36]

The film, shot five years before the Factory Diaries, shows Julia at her best. The opening image is a close-up of the almost 75-year-old Julia, wearing glasses, a pink flowered-print blouse and a black-and-white checked dirndl skirt. Her permed gray-blonde hair is covered with a loose net that ties under her chin, an American version of the cap or kerchief worn by married Carpatho-Rusyn women in the Old Country (Figure 6.3).[37] J. J. Murphy, an American scholar of Warhol's films, says, "She looks very much like an Eastern European peasant."[38] But the Slovak screenwriter and film theorist Ivan Stadtrucker, who is undoubtedly more familiar with East European peasants, has a different opinion.

[33] See Bockris, *Warhol: The Biography*, 263.
[34] Email from Susan Pile, July 25, 2015.
[35] Douglas Crimp remarks that the film narrative is comprehensible only from Richard Rheem's part of the dialogue, in his book "*Our Kind of Movie*": *The Films of Andy Warhol* (Cambridge, MA: The MIT Press, 2012), 123.
[36] Harvard Film Archive, Film Series, February 8, 2004, https://harvardfilmarchive.org/calendar/four-of-andy-warhols-most-beautiful-women-2004-02, accessed May 3, 2021.
[37] Ara Osterweil repeats the "nearly unintelligible Ruthenian accent" commonplace, but her description of Julia as "puttering around the kitchen in housecoat and babushka" is unaccountable. "Sons, Mothers, and Lovers: Ara Osterweil on Andy Warhol's and Rainer Werner Fassbinder's Queer Home Movies," *Artforum* 55, no. 9 (May 2017), https://www.artforum.com/print/201705/ara-osterweil-on-andy-warhol-s-and-rainer-werner-fassbinder-s-queer-home-movies-67936, accessed May 14, 2021.
[38] J. J. Murphy, *The Black Hole of the Camera*: *The Films of Andy Warhol* (Berkeley: University of California Press, 2012), 147.

Figure 6.3 Andy Warhol, *The George Hamilton Story*, 1966, 16 mm film, color, sound, 67 minutes. © The Andy Warhol Museum, Pittsburgh, PA, a museum of Carnegie Institute. All rights reserved. Film still courtesy The Andy Warhol Museum.

> Based on this film, the viewer gets to know Mrs. Julia Warhola as a gentle, intelligent woman who, in her appearance and her psychology, is reminiscent of an elementary school teacher. Her personality differs from that of the primitive, rural woman described in [some] memoirs.[39]

In fact, while Julia's language and mannerisms have much in common with Rusyn peasant women, her animated personality and her genteel appearance would set her apart dramatically from her peers in Europe, as becomes clear when her sister visits from Miková the following summer.

Richard Rheem was a darkly handsome twenty-year-old in 1966. Julia affectionately calls him "Richik" (pronounced Reecheek, with a trilled *R*), "Richko," and in a double diminutive, "Richichko." In characteristic Rusyn speech style, his name, in one version or another, peppers almost every sentence. The relationship between Julia and "Richik" is close and playful. She strokes his hair and touches his face, they tickle one another, and in the

[39] Ivan Stadtrucker, "Andy Warhol a Júlia," *Literárny týždenník* [Bratislava: Literary Weekly] 23, nos. 39–40 (November 18, 2010): 16. Stadtrucker refers specifically to memoirs by Ultra Violet and Viva Hoffman.

course of the film, they refer to secrets and shared activities, whispering with furtive smiles about shopping together for whiskey. Their dialogue, filled with imprecise formulations, misunderstandings, and mispronunciations, is the focus of Warhol's film. When the conversation flags, Julia prods Rheem, "Wake up. C'mon, talk something." Nonstop chatter was routine for Julia, whether or not she had a willing interlocutor. Her urging of Rheem to "talk something" echoes curator Henry Geldzahler's recollection of a phone call from Warhol at 2:00 a.m., asking him to meet for an important talk. "For a minute or two there was silence while I waited for him to broach the subject. Finally, I asked him why he had gotten me out of bed. Andy said, 'We've got to talk … say something.'"[40] Andy's love for "talkers" ("I really don't care that much about 'Beauties.' What I really like are Talkers")[41] started with his Rusyn-speaking mother.

Word Games

The George Hamilton Story opens with what seems to be an impromptu conversation between Julia and Richard Rheem. On closer analysis, it becomes apparent that it is a vetted interview, in which Rheem asks pointed questions meant to elicit predetermined stories and linguistic peculiarities. In the opening shot, Julia nods to the camera and addresses Rheem: "What we gonna talk now, Rich?" Rheem responds, "Tell the story about the wedding," a favorite topic of Julia's that Rheem would have known from the *Esquire* interview that had been published just days earlier, and probably from previous conversations. But Julia resists. "Oh no, that not … when me was little girl, Rich … no, I gonna talk something else for you, Richik." Julia interrupts the presumedly planned narrative and, probably on cue, she redirects the conversation, asking Rheem how old he is. Rheem answers facetiously that he will be seventy-five on November 20. In fact, it is Julia who will turn seventy-five, a fact that Rheem clearly knew.

Rheem had met Andy Warhol a few months earlier in San Francisco at a party to celebrate an appearance of the Exploding Plastic Inevitable, Warhol's multimedia production in which Factory regulars danced to the music of the Velvet Underground against the background of Warhol's films. In a letter from July 27, he reminds Warhol of their meeting, telling him that he was

[40] Henry Geldzahler, "Andy Warhol: A Memoir," in Geldzahler, *Making It New: Essays, Interviews, and Talks* (New York: Turtle Point Press, 1994), 44.
[41] Warhol, *Philosophy*, 62.

"turned on by the Warhol scene" and especially interested in Warhol's offer to be in his films. "I would like to get this film deal over with one way or the other ... So if you still want me for your films—I'm yours, for your films."[42] Rheem appeared in four screen tests and a few other Warhol films. According to Victor Bockris, he "fit the profile of the shy, egoless young man on whom Warhol could assert his will. Sometimes he took a small part in a movie but his personality did not lend itself to the kind of dramatic self-expression Andy's movies required."[43] This film with Warhol's mother may have been a kind of audition. According to Gerard Malanga, while Rheem lived with Warhol, he spent little time at the Factory.[44] He seems to have socialized mostly with Julia. From their conversations, it is clear that he knows about her background and her family, even down to one "cousin Johnny" who was a friend of Julia's son John. As they banter back and forth, Rheem scrambles to direct, and sometimes to keep up with, Julia's performance, which is grounded largely in verbal play.

Their conversation touches on food, language, cats, the Greek Catholic priesthood, and Julia's childhood task of tending cows. Rheem steers the conversation to Julia and her son's previous residence in New York, which he refers to several times as "a junk house," exploiting for comic purposes Julia's idiosyncratic characterization of their notoriously messy apartment at 242 Lexington Avenue. When she says, "We move here 1960," Rheem states, simultaneously, "1960," adding "I'm so telepathic, aren't I?" Clearly not understanding "telepathic," but showing an intellectual quickness, Julia responds, "You remember everything." Similar manipulative techniques lead to conversations about her family and her cats—Hester ("She was really good, she was smart") and the "black bum," who keeps her up at night with his meow. The crew laughs at some of Julia's old-world word choices and nonstandard usages like "bum" and "bogeyman," as well as her faulty pronunciation. Rheem plays with her as one would with a child to have her repeat *yogo* (her word for yogurt), chuckling each time she says it, to Julia's amused perplexity. The effect is to draw attention to Julia's eccentricity and the peculiarities of her nonstandard English, playing on the style of the *Esquire* interview that Andy was said to abhor. Mrs. Warhola's unintelligibility and her innocent participation in the verbal buffoonery is a primary source of the film's humor.

[42] Richard Rheem, letter to Andy Warhol, August 18, 1966; AWMA.
[43] Bockris, *Warhol: The Biography*, 263. For unknown reasons, Bockris changed Rheem's name to Green. Details of his life after his connection with Warhol are unknown. He died in California in 2012 at age sixty-six. On Rheem, see also Gopnik, *Warhol*, 516–17.
[44] Gerard Malanga, interview by the author, March 2, 2016.

Warhol used language differences for creative confusion in other films made around the same time as *The George Hamilton Story*—mangled Spanish in *The Life of Juanita Castro* (1965), German in *Beauty #2* (1965), and French in *Ari and Mario* (1966). But random words in those relatively common languages are nothing compared to the comic muddle that is created by Julia's garbled English.[45]

> Julia Warhola: I don't know talk English.
> Richard Rheem: Yes, you do.
> JW: Oh Richik, talk little bit, see?
> RR: What about the first time you came to New York? […]
> JW: When me come from Europe, you know, when me come from Europe, I don't know nothing talk. This time you know, I want, ask some lady how name boy, you know, boy. One lady come from Europe, fat lady, and she say, Europe. [Pause.] I say, I know how talk English. I know what mean carrot.
> RR: You can say carrot.
> JW: Carrot.
> RR: The vegetable?
> JW: Carrot.
> RR: You can say carrots.
> JW: Carrot, carrot.
> RR: Carrot. [Simultaneously.]
> JW: Oh, carrot.
> RR: Fourteen carat?
> JW: No, no fourteen carat, vegetable.
> RR: Oh, the vegetable, the food.

The ethnolinguistic borderland where Julia lived in Europe nurtured metalinguistic awareness even in uneducated peasants. Referring to the "fat lady" from Europe, Julia goes on to instruct her young American interlocutor.

> JW: She say she know talk, what mean bread.
> RR: Bread.
> JW: Bread. You know, for Jewish peoples, name *broyt*.
> RR: *Broyt*?

[45] Rendering spoken language in written form, especially nonstandard dialects, may seem to imply inferiority or a negative stereotype. Here and throughout, I intend no pejorative attitude in my presentation of Julia Warhola's oral performance in her own voice. Rather, I consider Julia's accent and vernacular language to be integral elements of her verbal art.

> JW: English—bread.
> RR: Bread.
> JW: A Czechoslovak-a—*khlib*. You understand?
> RR: *Khlib*.
> JW: *Khlib*. I don't know what talk with you. Ask Andy something ...

Rheem changes the subject.

In a lecture about *The George Hamilton Story* at the German Film Institute and Museum, media and cultural studies professor Brigitte Weingart argued that the wordplay mix-up of "carrots" and "carats" encapsulates the blending of reality and fantasy, private life and performance, and the ironic contrast between fictional, glamorous Hollywood stars and the artless, real-life Julia Warhola.[46] This assessment is certainly an improvement over the "delightfully oddball mother" cliché, but lacking the Rusyn language and context, Weingart's analysis misses the private subtexts and ironic contrasts encapsulated in Julia's multilingual monologues.

After another discussion of pussycats, Julia tries to introduce her own topic. Once again, she announces a performance narrative, with "when me was little girl."

> JW: You know Richik, when me was little girl, I was stuck, hurting. [With emotion.] I go to ... my post office was far away from farm, named Havaj [pronounced Havai]—this post office.
> RR: Hawaii? You went to Hawaii?

Struggling to make herself understood, Julia is delighted at what seems to be Rheem's grasp of her story, and she responds eagerly:

> JW: Yeah, Havaj ... was Havaj name, this post office. You know this post office was named Havaj.[47]

Viewers familiar with the Carpatho-Rusyn context would know that Havaj is a village near Miková that served as the postal center (Figure 6.4). Julia goes on, mixing Rusyn conjunctions into her English-language narrative.

[46] Brigitte Weingart, "*Carrots/carats*: Die doppelte Erscheinung der '*Mother of Pop Art*' in *Mrs. Warhol*," lecture, German Film Institute and Museum, Frankfurt, January 16, 2014, https://www.youtube.com/watch?v=tKMUO1KF8ao, accessed May 3, 2021.

[47] The Slovak and the Rusyn words for "Hawaii" are, in fact, the same as the name of the village.

Andy and Julia in Rusyn 145

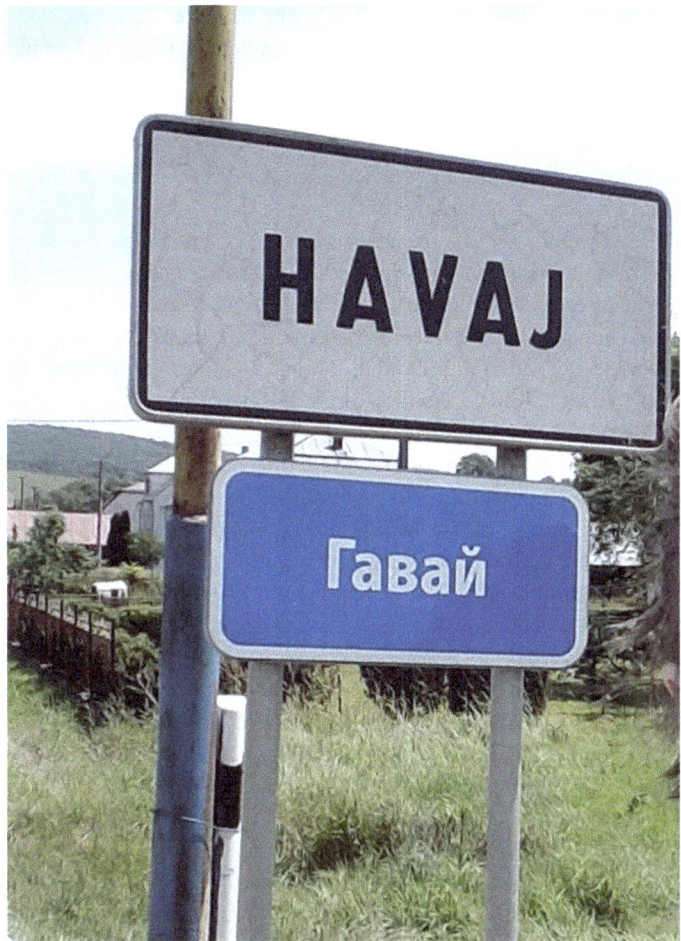

Figure 6.4 Signpost at the entrance to the village of Havaj, Slovakia, in Slovak and Rusyn languages. Photograph by Maria Silvestri, 2018.

 JW: And you know what? Next door living priest *i* [and] … wife, *i* four children. He always call me … Julia, go to the Havaj, bring me a letter. You know letter? I don't know how say English.
 RR: Letter? [Rheem picks up a piece of paper to show what he means.]
 JW: Yes, here this letter. You know what, Richik, I go. Was big woods. Maybe two mile. I no running, I flying. [With animation.] I come back, bring letter to for priest, he say, you no was not post office Havaj.

> I say yeah I was. I give you letter, you know, too many letter, you know for people. ... He say oh, how you flying. I'm flying, Richik. I was really hurting. I was, maybe I was thirteen years old. [Distressed, tearful.] Always I go help, priest children, you know, priest children.

Julia is then sidetracked onto a discussion of married priests in the Greek Catholic Church.

The full import of Julia's narrative is uncertain, since we do not have the statement in the original Rusyn. But it seems clear that she struggled to "fly" to please the priest, and she smarted from his distrust. At this point in the story, her distress is apparent, her voice reveals genuine agitation, and she is almost in tears. Today, the road from Miková to Havaj is 3.6 miles, although Julia would have taken a back way through the forest. In mountainous terrain—Miková is 1,362 feet and Havaj, 906 feet above sea level—before paved roads, in bad weather, one can imagine that the trip from Miková to Havaj was no easy task, and it seems she was called on to perform it frequently, with no thanks from the priest. In the film shoot, Julia gets no sympathy from her interlocutor, her audience, or her son behind the camera, who surely had heard the story before and knew the facts. In making the film, Warhol may have been more interested in the fortuitous semantic shift that placed his immigrant mother on a beach in Hawaii, a phenomenon that he later called "transmutation."

> Something that I look for in an associate is a certain amount of misunderstanding of what I'm trying to do. Not a fundamental misunderstanding; just minor misunderstandings here and there. When someone doesn't quite completely understand what you want from them, or when they didn't quite hear what you told them to do, or when the tape is bad, or when their own fantasies start coming through, I often wind up liking what comes out of it all better than I liked my original idea. ... If people never misunderstand you, and if they do everything exactly the way you tell them to, they're just transmitters of your ideas, and you get bored with that. But when you work with people who misunderstand you, instead of getting transmission you get transmutation, and that's much more interesting in the long run.[48]

In this respect, Julia is a perfect associate for Warhol, for try as she might, she cannot follow directions, and the inadvertent misunderstandings she generates are artistically productive.

[48] Warhol, *Philosophy*, 99. Weingart also refers to Warhol's concept of transmutation in relation to Julia's performance.

The irony and the art of this "Havaj" sequence is in the fact that Warhol was the only one present—as well as the only one in most subsequent screenings—who "got" the joke. In her study of Warhol's home movies, Ara Osterweil notes that in *The George Hamilton Story*, as in many of Warhol's films, "fiction dissolves into documentary."[49] In fact, the opposite takes place in this sequence. If Warhol had filmed a documentary, the full story of Julia's travails just hinted at here might be told—taking the cows to pasture, surviving the war, and working for the priest's family. These were real aspects of her life, and today the lack of information in this potentially revealing firsthand narrative is regrettable. But for Warhol, it is not the factual, documentary details that matter, but the creative "psychodrama" that emerges when Julia's memory intrudes into present-day life. In the words of Richard Whitehall,

> Warhol is a camera with the shutter open. He records, quite coldly, that moment when fantasy clashes with reality and out of the dissonance come glimpses of pain, loneliness, fear, too close to the soul to be simulated. When his actors, despite themselves, seem to stumble over truths they'd rather not face. For improvisation and psychodrama are the heartbeat of these movies.[50]

Chekai, Dear Husband ...

In the second reel of the film, Julia plays an aging Hollywood star who has poisoned her previous fifteen husbands and is now married to the young, attractive Rheem. *The George Hamilton Story* is thematically related to Warhol's "Hollywood trilogy," *Hedy*, *Lupe*, and *More Milk, Yvette*, a series filmed in 1965 and 1966 devoted to Hollywood actresses from the 1930s and 1940s who were known for glamor, scandal, and defiance of moral conventions.[51] In terms of narrative, *The George Hamilton Story* derives most closely from *Hedy*. Hedy Lamarr, billed as the world's most beautiful woman, was notorious for her controversial role in the Czech film *Ecstasy* (1933), where she appeared in the nude. But what attracted Warhol's attention was Lamarr's arrest in January 1966 for shoplifting $86 of merchandise, followed by a sensational six-day trial, in which she attributed her crime to the failure

[49] Osterweil, "Sons, Mothers, and Lovers."
[50] Richard Whitehall, "Andiflix II: The Home Movie as Art Form," *Coast FM and Fine Arts*, September 1969, 24, https://warholfilmads.files.wordpress.com/2015/02/war-coast-12.jpg, accessed May 3, 2021.
[51] See Murphy, *The Black Hole of the Camera*, 86–92, 160–5.

of her sixth marriage.⁵² Warhol's *Hedy* includes factual episodes from this then well-known story, as well as references to Lamarr's role in the film *White Cargo* (1942), where she played an African seductress who poisons her lover. Adding ironic distance, in Warhol's film Hedy was played by the transvestite Mario Montez.

This is the context in which the naive Julia Warhola is figuratively translated as "an aging peroxide movie star with a lot of husbands." The ironic incongruity between Hedy Lamarr and the elderly Carpatho-Rusyn immigrant is inescapable, except perhaps to Julia herself, who was most likely not familiar with the Hollywood legend. As with his casting of Mario Montez in *Hedy*, Warhol sets up his mother to subvert Hollywood standards of glamor and cinematic conventions.

Julia opens the second reel of the film by calling to Rheem: "Richik, you ready? Come, I show you how I do for you. Eat scrambled eggs. Maybe I give it for you, for you girlfriend, Susie" [Susan Pile].

> RR: I don't have a girlfriend. You're my wife.
> JW: That's what everyone tell me.
> RR: What do I need a girlfriend for, when I have a wife like you?
> JW: I'm too old for you, too old for you. You just keeping me for cook.
> RR: That's not true.
> JW: You need sweetheart, for date, for love. ... If you be good husband, I always be making for you scrambled eggs. ... Everyday. You be so big, you can't eat no more.

Julia makes scrambled eggs and coffee for the crew, while teasing Rheem and chatting continuously (Figure 6.5). As she focuses on feeding her guests, she forgets the role she is supposed to be playing and asks the off-screen observers if they want sugar, pepper, or more coffee, moving out of camera range to serve them. Rheem repeatedly tries to bring her back to the premise of the plot by insisting that she is poisoning his food and making him her next victim. There is a good bit of playful banter, in which Julia gives as good as she gets, interspersing Rusyn words within her heavily accented English.

> JW: OK mister [prounounced "meester"], my dear husband. ... *Chekai* [wait], I give you coffee. *Chekai, chekai,* dear husband, you such a big one, you very big one. ... Husband, you too big. You leg too big.

⁵² On this story, see "1940s Star Also Tried for Theft: Shoplifting Charges Against Sultry Hedy Lamarr Drew Courtroom Crowds," https://www.recordnet.com/article/20021110/a_news/311109938, accessed May 15, 2021.

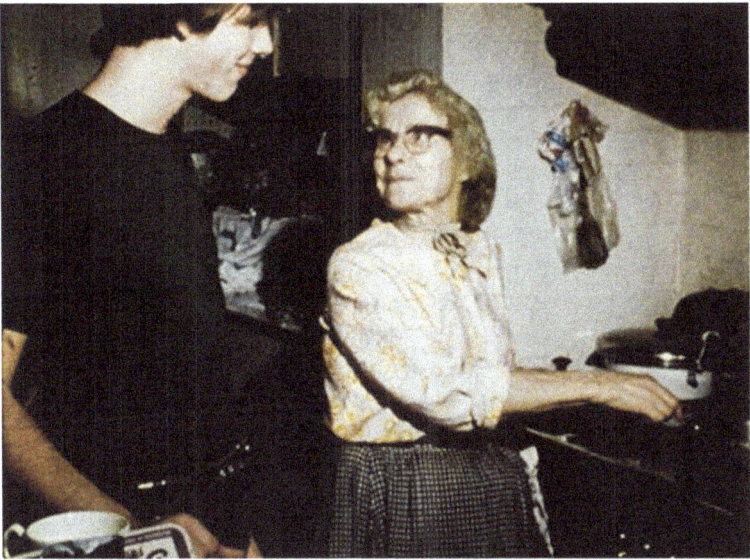

Figure 6.5 Andy Warhol, *The George Hamilton Story*, 1966, 16 mm film, color, sound, 67 minutes. © The Andy Warhol Museum, Pittsburgh, PA, a museum of Carnegie Institute. All rights reserved. Film still courtesy The Andy Warhol Museum.

> RR: You don't like me now. I'm too big.
> JW: I like you sometime, when you sleep.
> RR: You're gonna get rid of me now, because I'm too big?
> JW: I think so. I be looking for 'nother one. With one leg.
> RR: With what?
> JW: With one leg. So he can't beat me.

The off-screen observers laugh.

As the action proceeds, Julia becomes visibly tired of play-acting, and she tries to tell her own story. In the words of cinema professor David James, the

> drama of the Warhol narratives … resides in the interplay between the different levels of artifice in any one actor/character as much as it does in the interaction between the separate characters. … The primary interest lies in people assuming roles; after that point … in people falling out of them.[53]

[53] David James, "The Producer as Author," in *Andy Warhol: Film Factory*, ed. Michael O'Pray (London: British Film Institute, 1989), 136.

In the process of "falling out" of her role, Julia Warhola emerges from the fictional construct of *The George Hamilton Story* into her own personal performance.

> RR: For what movie did you win your academy award?
> JW: Oh Richik, no movie. This time there was war. You know? You see, about war ...

But before Julia can describe her wartime hardships, Rheem interrupts, dismissing her real-life story and returning to the fictitious Academy Award: "A war movie? ... *Combat*?" Rheem had fortuitously transmuted Havaj to Hawaii, but his effort now to place Julia in *Combat!*, a popular television series in 1966, fails. Disappointed at being rebuffed in her effort to convey her horrific wartime experience, Julia deflects his question, returning to her guests: "I put in pepper for Paul. *Chekai*, Paul—I talk to you, I talk to you Slovak." She chuckles at her own vacillation between English and Rusyn, which contributes to the fluctuation between reality and illusion—at least for those who understand it. Rheem continues to push the premise of the plot, and Julia plays along.

> JW: I put poison in that black pepper. [Laughter from crew.] I always poison with black pepper.
> RR: Why don't we have a party and poison everybody with black pepper.
> JW: I won't poison nobody, only old men.
> RR: Just old men?
> JW: Old men, who want marry me.

She tells Rheem she can't remember how many husbands she has poisoned, but, she says, "I'm gonna keep you for rest of you life." Richik responds with feeling, "You really like me." But to Rheem's gesture, she replies, "You want kiss, I no kiss you. [Shakes head.] No, I kiss nobody."[54]

As she tires noticeably, the comedy turns to pathos. Julia refuses to play along with Rich's party-planning, and says, "Nothing to do then. Sleep, go sleep, Richik. ... You be nice boy, but nobody wants you, me no want you. Susie no want you." Although she chuckles as she says it, Rheem looks sad, then smiles uneasily and says with emotion, "It's not funny when nobody

[54] In tone and phrase, Julia's ripostes call to mind Carpatho-Rusyn women's lyrical folksongs, which she continued to sing and record in her sixties. See Elaine Rusinko, *Andy Warhol's Mother: Julia Warhola and the Carpatho-Rusyn Immigrant Experience* (Pittsburgh: University of Pittsburgh Press, forthcoming).

wants you." Finally, Julia looks directly into the camera, to Warhol, and says, "Already finished, no? Andy, nothing to do, put away." Warhol does not comply, and the camera continues to roll. Then with determination in her voice, she again starts her own story, announcing a performance for the third time, with "When me was little girl."

> JW: You know Richik.
> RR: What?
> JW: When me was little girl, was always working *na* [on] farm. Always go to shepherd, grass for cow.

Misunderstanding her, Rheem asks, "You chopped grass for cows?" Happy to think she's been understood, Julia agrees:

> Cows, yes. Yes, I chop it. ... In Europe you want milk from cow, you have to get something for cow. You know I a farmer, ten cow my mama and *didi* [grandfather] have ... maybe nine year old I was. I chopped wheat, *toto* [that is] grass, you know, grass? I say wheat, I know grass. Green grass, nice, grass for cow eating. ... [Proudly] Czechoslovak-a. Was my Europe, long time ago.

Ignoring her interjection and bringing her back to the narrative line, Rheem asks: "How many husbands did you have in Czechoslovakia?" In a tone that expresses weariness and surrender, Julia answers, "I don't know, seven-eight-nine. I don't know." And then, Rheem asks,

> RR: Did you ever marry a cow?
> JW: A cow? Cow?

And the reel ends just when the treatment of Julia begins to take what might be interpreted as a sadistic turn.

Lost in Translation

Through a process of creative misunderstanding, the film fortuitously provides insight into the authentic, unstudied Carpatho-Rusyn immigrant woman, for whom the pathos of a childhood burdened by tending cows contends with pride in the number of cows she had to tend. The film also generates in the audience a certain degree of sympathy for her perplexed discomfiture. In

Warhol's films of this period, the end of the reel usually determined the end of the scene, and performers are often cut off in midsentence. By chance, this reel, the second and final reel of the film, ends with an effective rejoinder from Julia. Her incredulous repetition of the question "A cow?" hangs in the air, a potent retort to the mortification that she is scarcely conscious of.

Warhol film scholars have debated whether in his movies cruel manipulation occurs in what may seem to be objective, documentary-like treatments. Warhol said, "I only wanted to find great people and let them be themselves and talk about what they usually talked about and I'd film them for a certain length of time and that would be the movie."[55] In *The George Hamilton Story*, Warhol sets up a situation that plays on his mother's humble background and her lack of English proficiency. Richard Rheem and the crew members tease Julia, mostly in good fun, although not without knowing mockery. Artful and quick-witted, she responds like the improvisational actress she learned to be in Miková. Most viewers of the film are charmed by Mrs. Warhola's sunny personality, affectionate gestures, and quirky eccentricity, even as they founder in the flow of her unintelligible chatter. According to Ara Osterweil, "In spite of its ironic conceit, *Mrs. Warhol* is one of the most touching and least sadistic cinematic portraits Warhol ever made."[56]

In the words of scholar Brian Schiff, "Narrating is an expressive act in which life experiences and understanding of life are articulated and made meaningful through their declaration in our present circumstances and in collaboration with co-actors."[57] Julia's narrative performance of her childhood experiences in Miková achieved Warhol's desired "psychodrama," as his mother confronted past fear and painful truths. But her own goal of self-presentation through narrative performance is ultimately unsuccessful. Language insufficiency prevented her from bridging the gap between her experience and her storytelling, and, faced with a blank camera instead of an attentive audience, she is blocked and frustrated. Ultimately her pain and fear become a trigger for comedy. On the surface level, she wins over the audience with her sincerity and good-natured humor. But viewers who understand the multiple levels of meaning in her exposition feel her distress and isolation.[58]

[55] Warhol and Hackett, *POPism*, 110.
[56] Osterweil, "Sons, Mothers, and Lovers."
[57] Brian Schiff, "The Function of Narrative: Toward a Narrative Psychology of Meaning," *Narrative Works: Issues, Investigations and Interventions* 2, no. 1 (2012): 37–8.
[58] A written transcript or description of the film cannot convey the actor's intonation, facial expressions, gestures, and other nonverbal cues that amplify the substance of her utterance.

During the film shoot, the only onlooker who understood Julia's language and her stories was her son, the man behind the camera. One gets the impression that many of Julia's domestic performances began with "When me was little girl." Warhol had probably heard the stories about the war, the cows, and Havaj past the point of boredom. In his film, the seemingly impatient camera, which zooms in to a cup of whisked eggs Julia had prepared to scramble, a bag of A&P coffee, and a Tem Tee hot chili peppers jar, might be interpreted as Warhol's bored dismissal of familiar tales. But Rheem, the unaware interlocutor, perceives her stories from a naive viewpoint, revitalizing them and generating a new vision of old trivialities. For Warhol, this is the very definition of art, even if, in this case, he is the only one to appreciate it. The creative defamiliarization of Julia's stories through her interaction with Richard Rheem transformed them into cinematic art, even as it denied Julia—and future generations of viewers—documentary truth. Weingart says, "Even more than in other Warhol films in which the actors fall out of their roles, 'Mrs. Warhol' gets its momentum from the private persona insistently attracting attention to itself." A more complete understanding of the language and context of the interaction enhances the dramatic tension between the artifice of the screen-star persona and the truth of Julia Warhola, ultimately producing as much pathos as comedy.

Mommy Issues

Most commentators on *The George Hamilton Story* have focused on the mother-son relationship, rather than the depiction of Julia Warhola. J. J. Murphy calls the film "a highly convoluted Oedipal fantasy," and he refers to the title as "incestuous."[59] According to Weingart, since a person of this name does not exist outside the film, the character of "Mrs. Warhol" was a fictional construct who might signify Andy's wife or his female alter ego.[60] In Ara Osterweil's interpretation, the film's (unofficial) title—"Mrs. Warhol" rather than "Mrs. Warhola"—suggests that Julia was essentially her son's wife rather than the wife of her late husband, who, following the premise of the plot, was presumably one of the twenty-five that she had killed. "Thus, in a film that initially seems to be yet another 16-mm bagatelle, Warhol manages to unite himself, his mother, and his lover in a scene of patricidal queer intimacy that lauds the death of the hetero-normative family."[61] As

[59] Murphy, *The Black Hole of the Camera*, 151, 146.
[60] Weingart, "*Carrots/carats*."
[61] Osterweil, "Sons, Mothers, and Lovers."

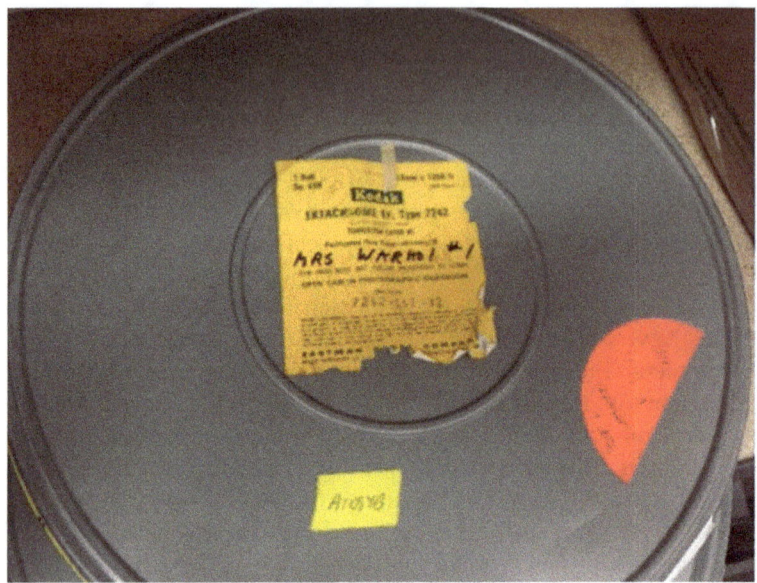

Figure 6.6 Film canister containing reel one of *The George Hamilton Story*, labeled in an unknown hand, "MRS WARHOl." The Andy Warhol Museum, Pittsburgh, PA. Photograph © Greg Pierce.

intriguing as such speculation may be, in this case, Warhol's meaning is, in fact, "on the surface," in the film's title.

From Susan Pile's comments, it is clear that the film's intended title during shooting was *The George Hamilton Story*. That title has been largely lost in the literature and catalogs. Never printed or released, the raw footage exists only as original camera negative, and is preserved in the Andy Warhol Museum Archives in two canisters labeled in an unknown hand, "MRS WARHOl," most likely by someone who simply used Andy's last name to designate Julia Warhola, the focal point of the film (Figures 6.6 and 6.7). According to Greg Pierce, director of film and video at The Andy Warhol Museum, the popular title "Mrs. Warhol" was not assigned by the filmmaker but was derived from what was found on the can.[62] Searching for any deeper meaning Warhol may have intended by the phrase "Mrs. Warhol," then, is a diverting, but baseless, exercise.

Nonetheless, the suggestions of Oedipal fantasy cannot be neglected, as they underlie several relationships touched on in the film. In the first reel,

[62] Greg Pierce, personal communication, April 2, 2018.

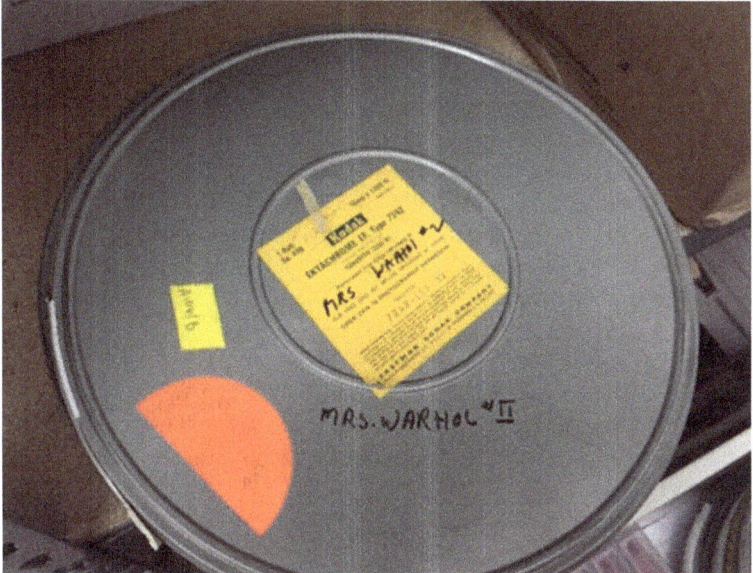

Figure 6.7 Film canister containing reel two of *The George Hamilton Story*, labeled in an unknown hand, "MRS WARHOl." The Andy Warhol Museum, Pittsburgh, PA. Photograph © Greg Pierce.

when Julia finally runs out of conversation topics, she asks, "What else?" and takes a furtive look into the camera, at her son. According to Susan Pile, Warhol was standing just out of frame, feeding her lines, topics, and directions. In response, Julia jumps up and says, "I be pressing already. C'mon, Richik. I iron you shirt," apparently a pre-planned activity. After setting up an ironing board and fumbling energetically for an extension cord, she unexpectedly deviates from the plan and picks up some laundry. "I be pressing for you. I be pressing for you *gachi*. Rich, you don't know pressing? Rich, c'mon, I be pressing for you underwear. Underwear is *gachi*, Rich. I be pressing for you *gachi*." The word *gachi*, used by Rusyn-Americans as a kind of inside joke, has a funny and slightly naughty connotation. Julia irons a pair of men's jockey briefs, then lifts and shakes them out, to the laughter of Rheem and the crew. The effect achieved by her unforeseen turn to *gachi* shows Julia's flair for comedy and is, as Warhol described "transmutation," better than his original idea.

After folding underwear and socks in accordance with Julia's directions, Rheem returns to the script and asks her to iron his shirt, saying "I'll take it off." Julia objects: "No, no, no. Take jersey. Somebody see you ... somebody

see you in window." He takes off his long-sleeved green shirt, stands shirtless for a moment, smiling knowingly and seductively into the camera, and then puts on the black T-shirt that Julia hands him.[63] Julia begins to teach him how to iron a shirt, chattering constantly: "I be your boss teacher ... do it like this ... do it nice straight ... always pull more straight ... you don't have to squeeze, take it easy ... you good boy, Richik." Her use of the popular idiomatic English phrase "Take it easy," in an artificial, stylized intonation and a not entirely appropriate context, exposes an ingenuous attempt to sound modishly American.[64] The implicitly maternal role Julia has been playing in relation to Rheem becomes explicit:

> JW: I bet your mama no teach you.
> RR: No, she no teach me.
> JW: You be good boy, your mama no teach you. Be good for your wife if you know pressing. Richik. Fix it nice, like this. Fix it like this.

Warhol's camera lingers lovingly on Rheem's handsome face as he and Julia talk, joke, and tease one another playfully and flirtatiously. Julia picks hair from Richard's shirt, they look closely into one another's eyes, and Julia pats his cheeks, as if he were a child.

Richard Rheem came from a prominent but emotionally cold upper-class California family. In letters to Warhol, he described his own mother as depressing, and his stepmother as "wicked." "I have to shut [mother] out when she goes on & on about nothing. You may wonder why I visit her. She is more loving & enjoyable then [sic] Dad & stepmother."[65] Given the bleak relationship with his mother figures, it is no wonder that "Richik" appreciated Julia Warhola's down-to-earth motherly warmth. (However, given his conversations with Julia, there is an amusing irony in his statement about "shutting out" his mother "when she goes on and on about nothing.")

[63] The change of shirt is a key to the proper order of the film reels, which are often reversed. In the kitchen scene, Rheem is wearing the black T-shirt given him by Julia in the ironing sequence, indicating that ironing (roll 1) preceded scrambled eggs (roll 2).

[64] The expression "take it easy" was popularized in ads for Coca-Cola, Kellogg's, Gimbels, and numerous department stores. According to Newspapers.com, in a select number of Pittsburgh newspapers from the 1940s, the phrase appeared in 3,531 articles and images—in the Joe Palooka comic strip, in descriptions of wartime bombing runs and patriotic army shows, on the sports pages, in advice columns, and as the official 1946 Pittsburgh traffic slogan. Julia used the phrase also in one of the self-composed stories she told her young sons and recorded on tape in English, as a divine personage tells a lowly hobo, "Good-bye. God bless you. Take it easy"; tape recording, John Warhola family collection.

[65] Richard Rheem, letter to Andy Warhol, September 4, 1966; AWMA.

Another mother-son relationship is hinted at in Warhol's original title of the film, *The George Hamilton Story*. At a moment in the film, when the crew is busy eating scrambled eggs, the conversation flags, and off-screen whispers can be heard prompting, "George?" Paul Morrissey says, "I'll ask it." He then questions Julia, "Do you like that one that's marrying the president's daughter?" An exchange of overlapping voices follows, and the vague reference to the actor George Hamilton is lost. In 1966, Hamilton was in the news for his romantic relationship with Lynda Bird Johnson. But his relevance to Warhol's film is his close relationship with his mother, Anne Stevens, a glamorous socialite, who had four failed marriages and numerous affairs with high-profile movie stars. In Hollywood, Hamilton was viewed as a privileged, sensitive "mama's boy." As he described her, "My mother ... was incredibly beautiful, a real charmer, the ultimate Southern belle, irresistible to men, and able to pull rabbits out of hats."[66] The film presents an ironic portrayal of the parallels between Hamilton and Warhol, their mothers, and their respective mother-son relationships. In terms of glamor, Warhol was no George Hamilton, and Julia was no Anne Stevens.

In the biographical literature, it is often suggested that Warhol was ashamed of his mother. As an early friend and associate Ted Carey noted, "She had a very strong accent, and Andy, I think, would have liked to have thought of his mother was [sic] very glamorous. And Mrs. Warhola was not glamorous, and I think he felt a little bit ashamed of her."[67] If so, it did not prevent Andy from introducing Julia to Carey and his affluent, upscale parents, who were prominent in Philadelphia society. In a letter on monogrammed stationery, dated November 1, 1961, Carey's mother wrote,

> We are so happy that we had the opportunity to meet you last Sunday afternoon. We enjoyed ourselves so much and want to thank you for your kind hospitality and also the many kindnesses you have extended to Teddy over the last few years. He has spoken of you often, so we really felt we know you."[68]

[66] George Hamilton, *Don't Mind If I Do* (New York: Touchstone, 2009), 17.
[67] Ted Carey, interview by Patrick S. Smith, October 16, 1978, in Patrick S. Smith, *Andy Warhol's Art and Films* (Ann Arbor, MI: UMI Research Press, 1986), 252.
[68] Correspondence shows a continuing personal connection between Mrs. Carey and Mrs. Warhola. In December 1964, Mrs. Carey writes in a tone of friendly familiarity, "Ted was home for the weekend and told us that you had been hospitalized and quite ill. ... Do hope you continue to make progress and will be able to enjoy the holidays." Letter from Ruth Carey to "Mrs. Warhol," November 1, 1961; AWMA. A Christmas card from Ted Carey, postmarked December 20, 1965, is addressed to "Mrs. Julia Warhol and her son Andy." Julia noted on the outside of the envelope, "From Dear Ted." Carey's New York address is found in Julia's address book; AWMA.

What Carey must have told his parents can be found in another interview: "Mrs. Warhola was very lovely … We would just talk. … And she would laugh. She had a wonderful sense of humor."[69]

For Carey, as for many of Warhol's friends, Julia's down-home, childlike charm must have prevailed over her lack of traditional glamor. As Weingart points out, "'Mrs. Warhol' demonstrates the error in the judgment that Julia lacked glamor." Just as Warhol raises banal objects to the level of artistic fantasy in his art, his camera expands the spectrum of normative glamor to include Julia's simple charm, a foil to the screen glamor of Hollywood and the high-class allure of George Hamilton's mother. Like many Rusyn-American children of immigrants, Warhol may well have wished for a more sophisticated, fashionable mother, but in *The George Hamilton Story*, he, perhaps unwittingly, valorizes the unpretentious beauty of his simple, loving parent.

Warhol exploited the simple directness of the immigrant Carpatho-Rusyn woman by juxtaposing her with the sophisticated but emotionally vulnerable "Richik." Rheem revels in Julia's open affection and responds accordingly. In fact, his fondness for Julia must have outweighed his attachment to Andy. In the second week of December, when Warhol encountered Rheem on the street with another young Factory regular, he jumped to the baseless conclusion that they were lovers, turned Rheem out of the house and changed the locks. It is unknown whether Julia received an explanation for the disappearance of her dear "Richik" from Andy's life, or how she reacted to losing her confidante and shopping partner. Rheem, however, did not forget her. In a blank envelope marked "To Andy Warhol's Mother," a note in Rheem's hand reads, "Dearest Julia, God Bless you and Andy. I love and pray for you both. Always, Richard Rheem. June 6, 1968."[70] That was three days after Andy was shot.

Julia Warhola, Superstar

The George Hamilton Story showcases Julia's natural tendency to performance. Along with her co-star, she revels in her muddled language, even as she apologizes for it. Andy, who embraced his mother's textual errors in his artist books, now relishes her verbal blunders, and integrates them

[69] Ted Carey, interview by Patrick S. Smith, in *Warhol: Conversations about the Artist* (Ann Arbor, MI: UMI Research Press, 1988), 94.

[70] Letter from Richard Rheem to Julia Warhola; AWMA.

into his cinematic art. He listens as she tells Rheem about her seminarian-grandson, who was "teaching self for priest." "Priest-*y* [Rusyn plural ending] now 'posed to know how talk Russia, write Russia, *i* [and] Jewish, *i* Latin … He have to know. Big, big hard time for priest-*y*. You understand? Me no talk good English." In the same style, she praises her sons. "My boys-*y* [Rusyn plural ending] all very good. Paul, John, Andy good … never no tell me bad things." Even after she tires of role-playing and asks Warhol to stop the camera, she rallies to Rheem's attention, pats his cheeks, and launches an improvisational comedy sketch.

> RR: You're so beautiful, I can't believe you.
> JW: Oh, Richik, you want a dollar?

They act out a scenario describing Julia's cynical view that a compliment is given only in the hope of monetary return.

> JW: Say, you look nice, hat *na* [on] you perfect, say take dollar, *na!* [there!]
> RR: *Na!* Two dollars, three dollars …
> JW [To Susan]: You understand? Maybe Susie don't understand. [Clearly, Julia and Rheem had been through this game before.] …
> JW: [To Susan]: Person say you look nice, you hat look perfect. [Acts out with intonation and gestures.]
> RR: [To Susan]: Doesn't she [inaudible compliment on Julia's acting.] Don't you love it?

The *Factory Diary* videos, partially translated from Rusyn here for the first time, and *The George Hamilton Story*, from which Julia's pidgin English is decoded to reveal newly accessible meaning, paint a portrait of Julia Warhola that addresses the deficiencies in the conflicting facts and opinions offered by Warhol's associates. In *The George Hamilton Story*, she is a bubbly, playful woman who enjoys socializing, teasing, and flirting with the young people who surround her son. As she aged and her health declined, Warhol's camera captured her melancholy isolation and petulant irritability in the private *Factory Diaries*. Both film and video demonstrate her efforts to articulate the worth and meaning of her life experience and to have it validated by her son. In both cases, she is thwarted by Warhol's dispassionate reaction to her emotional discourse. In the videos, he is largely unresponsive to her Rusyn-language monologues, and in *The George Hamilton Story*, he transmutes her "broken English" as comedic art.

Julia was Andy Warhol's first art teacher and studio assistant in his childhood sickroom. When she joined her son in New York, she actively collaborated on his drawings and promotional books. Into her seventies, she continued as Andy's associate, participating in test-videos and enthusiastically taking on the role of "an aging peroxide movie star with a lot of husbands." However, much of Andy Warhol's mother is lost in translation, and the authentic Julia Warhola transcends her cinematic portrayal. For viewers who understand her language and the Carpatho-Rusyn context, there are hints of an interesting and complex woman, who is no less intriguing than her artist son.

7

Translating Warhol for Television: *Andy Warhol's America*

Jean Wainwright

This chapter addresses the challenges inherent in translating Andy Warhol's art for a contemporary television audience, and what lies beyond the storytelling, the selected key artworks, the interviews, the archival footage, and the choice of evocative music. Whose story is it, how is it edited and adapted, and what are the influences and decisions that affect the narrative? It will be argued that the medium specificity of television inevitably alters how some of the historical intricacies, political imperatives, and art-historical debates are received when translated into moving-image sequences and the translation itself is subject to numerous medium-specific constraints. Questions that arise in relation to the dynamics of translating historical narratives and facts about Warhol and his artworks for a television audience will be explored, and the potential to distort, fragment, or expand the experience of artworks through the editing and cinematic devices which are fundamental to television filmmaking will be discussed.

To develop the argument, this chapter will examine the translation of two bodies of Warhol's work for a television audience in the recent British TV documentary *Andy Warhol's America* (2022), a three-episode program for BBC Two. Each of the three episodes has a subtitle that suggests its content: *Living the Dream* (aired on January 6), *The American Nightmare* (aired on January 13), and *Life after Death* (aired on January 20). The works featured in the program that are the focus of this study are *Pink Race Riot* [*Red Race Riot*] (1963) and *Mustard Race Riot* (1963), presented in an eight-and-a-half-minute segment of the second episode, and *The American Indian (Russell Means)* (1976–7), explored in a segment six minutes long in the third (Figures 7.1, 7.2, and 7.4). As series consultant (art-historical advisor) to this documentary, I had a unique insight into the translation process from

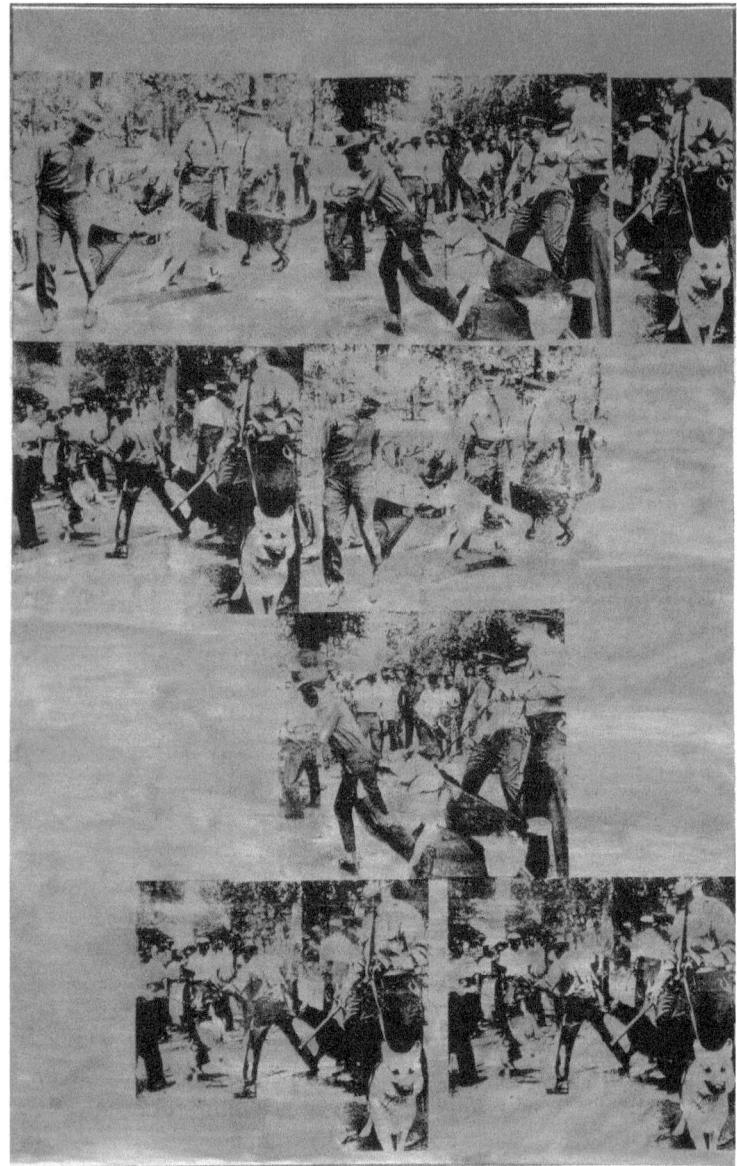

Figure 7.1 Andy Warhol, *Pink Race Riot* [*Red Race Riot*], 1963, silkscreen ink and acrylic on linen, 128¼ × 83 in. (325.8 × 210.8 cm). Museum Ludwig, Cologne. Image and Artwork © The Andy Warhol Foundation for the Visual Arts, Inc./Licensed by ARS.

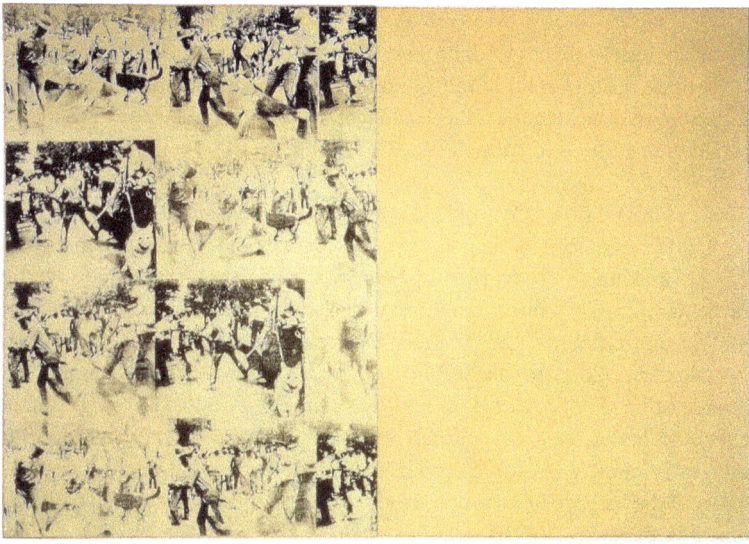

Figure 7.2 Andy Warhol, *Mustard Race Riot*, 1963, silkscreen ink, acrylic, and pencil on linen, two panels, 114 × 82 in. (289.6 × 208.3 cm) each. Museum Brandhorst, Munich. Image and Artwork © The Andy Warhol Foundation for the Visual Arts, Inc./Licensed by ARS.

inception to broadcast,[1] my firsthand observations enhanced by interviews conducted with the director and series producer Francis Whately and producer Phil Cairney after the program was completed.[2] It is important to note, however, that although I advised and made suggestions about content, I had no influence over which material was included, or its treatment, and had no editorial control.

Before discussing the process of translating the *Race Riot* and *The American Indian (Russell Means)* paintings to the medium of television, it is necessary to examine the specific prism through which Warhol is viewed in the program. As Francis Whately explained,

> What television hasn't done before, is to put Warhol in a cultural, political, historical framework, and so therefore we could see a different way of approaching the subject, and that was to look at American history through the eyes of Warhol.[3]

This was the version of Warhol's story that was to be translated.

It is also important to consider the context and practical constraints on the making of *Andy Warhol's America*, since these inevitably overtly or subconsciously impacted editorial decisions and hence the translation of Warhol's art. First, the program was funded and made by the British Broadcasting Corporation (BBC), which is a national (non-commercial) broadcasting service funded principally by the British public through annual television license fees.[4] Accountability to the British public tends to lead to budgetary constraints for program makers, and careful thought has to be given to the balance between judicious spending and fulfilling the program's objectives.

[1] The role of series consultant included consultation on and fact-checking of some of the scripts, archival research, and attendance at weekly team meetings throughout the production process. I also watched the rushes and gained insight into offline edits.

[2] Jean Wainwright, interview with Francis Whately, December 20, 2021, and with producer Phil Cairney, December 30, 2021, and January 10, 2022. Whately is a freelance director and producer who started his career in 1998. Other programs he has produced include *David Bowie: Finding Fame* (2019), *David Bowie: The Last Five Years* (2017), *Rock 'n' Roll Guns for Hire: The Story of the Sidemen* (2017), *Judi Dench: All the World's Her Stage* (2016), *Kim Philby—His Most Intimate Betrayal* (2014), and *David Bowie: Five Years* (2013). Cairney has worked on numerous projects as producer and director, including previous documentaries on subjects as varied as Ludwig van Beethoven, David Bomberg, Walter Sickert, Edward Burra, Giorgio Vasari, and twentieth-century Spanish art.

[3] Frances Whately, interview with Jean Wainwright, December 20, 2021.

[4] TV license fees (£159 in 2023) are required by law to be paid in the UK by anyone owning a TV or who downloads or watches BBC programs on BBC iPlayer.

The program was also made during 2020 and 2021 against a backdrop of the global COVID-19 pandemic, with consequent restrictions in face-to-face contact, travel, and access to certain archives and materials. One area where this limitation had a potential major impact was on the contemporary interview material—which played a key narrative role in the documentary—not least because most of the interviewees were US-based. A solution was found that involved UK-based Whately and Cairney conducting the majority of the interviews via internet video conferencing (Zoom), with a US film crew simultaneously filming the interviewees at each location as they responded. Furthermore, some people were unavailable for interview because they were engaged with other productions, and some were unable to appear in the program because they wanted to have their COVID vaccination before being filmed, with time constraints playing a role.

Also, prominently in the background when production started on *Andy Warhol's America* were the protests and civil unrest against police brutality and racism sparked by the death of American citizen George Floyd in May 2020, support and outrage reverberating around the world under the #BlackLivesMatter banner. This situation likely inspired and added poignancy and immediacy to the inclusion of Warhol's *Race Riot* and *The American Indian (Russell Means)* in the program, undoubtedly impacting viewers' perceptions of these works, and hence on the translation process.

Given the documentary's underlying premise, editorial decision-making involved highlighting certain bodies of Warhol's work while discarding others that were initially considered primarily because they did not specifically fit the profile of Warhol as bellwether for the "America story." The series format of three hour-long episodes also placed limitations on how the narrative was shaped, and on which artworks and aspects of Warhol's work to focus. *Andy Warhol's America* was also filmed at a time when the entire media sector was undergoing shifts, as audiences embraced new and multiplying digital viewing platforms, inevitably raising questions about choice and competition in terms of what the viewing public chooses to watch.[5] Whately suggested that this issue was an important factor when scripting the Warhol series:

> There is reworking and rewriting the drafts for each program. The difference between making a film contemporaneously and a film series

[5] As a publicly funded institution, the BBC was during filming under intense scrutiny. See, for example, Emily Bell, "The BBC Faces Major Challenges from the Government to Its Independence," *The Guardian*, July 20, 2021, https://www.theguardian.com/commentisfree/2021/jul/20/the-bbc-faces-major-challenges-from-the-government-to-its-independence. The government is moving toward abolishing the license fee by 2027.

about an artist from the past is that there is now greater desire not just to record what happened, and when it happened, but to also have more in terms of drama. And you have to make the audience want to watch the next episode.[6]

In other words, even though this was a factual documentary, "good TV" in contemporary terms meant that the script had to contain "drama" to entice the viewer to choose this program over others—and to keep watching.

Furthermore, while providing contemporary currency, the retelling of the Warhol story for a twenty-first-century audience required sensitivity to current sociopolitical sensibilities. For example, language and behaviors relating to race and gender that might have been considered socially "acceptable" in Warhol's time would now be considered shockingly unacceptable, and such social transformations had to be carefully negotiated while remaining true to the historical narrative. Given these challenges and constraints (or even without them), the question is raised of whether an authentic translation of the story of Warhol's life and art for a contemporary TV audience is possible.

The framing device selected by Whately is a chronological timeline, each episode moving through different stages of Warhol's life and art and its reflection in American cultural history. The grouping into three overarching themes suggested by the episodes' subtitles, *Living the Dream*, *The American Nightmare*, and *Life after Death*, hints at the storyline even before the viewer starts watching. Title sequences repeated at the start of each episode, following the cold open, embed the concept of Warhol distilling American culture in his art and films through his own particular lens through carefully edited statements about Warhol spoken directly to camera by interviewees.[7] These statements are juxtaposed with a collaged visual synopsis of art and scenes from the programs, and all to a soundtrack of the song "Planet Claire"

[6] Whately, interview with Jean Wainwright, December 20, 2021. For further discussion of the contemporary need for "drama" in the making of factual TV programs, see Richard W. Kilborn, *Staging the Real: Factual TV Programming in the Age of Big Brother* (Manchester: Manchester University Press, 2003), or Hannah Andrews, *Biographical Television Drama* (Basingstoke: Palgrave Macmillan, 2022), especially 185–210. TV ratings themselves are compiled daily by the Broadcasters' Audience Research Board (BARB).

[7] A cold open (also called a teaser sequence) is a narrative technique used in television and films. This is the practice of jumping directly into a story at the beginning of the show before the title sequence or opening credits are shown. Whately made the editorial decision to film all the interviews against a screen to reference Warhol's film portraits, *Screen Tests* (1964–6), though in color, with colored backgrounds. The aim was to produce a Warholian "levelling effect," with everyone portrayed in the same aesthetic. It was also to remove visual distraction from any background contextual interference, such as people's houses or hired studios, to allow the viewer to focus on what is being said.

by the B52s (1979).⁸ The scene is set, and the viewer is subtly led into the narrative underpinning the translation of Warhol as someone slightly on the outside, able to step back and see the reality of America, unafraid in his art to highlight its darker side while simultaneously celebrating the "wow" of it. For example, James Warhola, son of Warhol's oldest brother, Paul, is shown explaining, "My uncle was the first generation of immigrant parents. He looked at America with those fresh eyes, seeing some things that were different and unique, that maybe most people took for granted."⁹ Bob Colacello, an associate of Warhol in the 1970s, then suggests that "Andy was both glorifying and critiquing the whole American system."¹⁰ The model Jerry Hall, who became friends with the artist during the same decade, hyperbolically states, "Someone once said if a bomb went off and everything was destroyed except Andy's work, you would still have a very good idea of America. Yes, I think that is true, I think you would get a good idea."¹¹ As Whately commented, one of the challenges of documentary-making is that "you try as hard as you can not to lead, and allow the stories to lead themselves … inevitably, you will [though] because you need someone to agree with someone else to make a story. There is no such thing as an 'impartial history.'"¹²

From the documentary's inception, Whately, as director and producer, needed to make decisions about how Warhol was to be translated for television while accommodating all the constraints and limitations. He described how

8 The decision to use this song is not explored in this chapter, but a survey of Warhol documentaries, including *Andy Warhol: The Complete Picture*, directed by Sarah Mortimer and Chris Rodney for Channel 4, UK, 2001, and the two-part *Andy Warhol: A Documentary Film*, directed by Ric Burns, Steeplechase Films, WNET New York, 2006, would reveal how the different musical choices in each documentary aurally inform the viewer. The musical choices in *Andy Warhol's America* were a matter of debate between the two producers, highlighted in the author's conversations with Phil Cairney, December 30, 2021, and January 10, 2022, and with Francis Whately, December 20, 2021. On the role of music in documentaries, see Holly Rogers, *Music and Sound in Documentary Film* (New York: Routledge, 2014).
9 James Warhola was interviewed in the family home in South Oakland, Pittsburgh, which he now owns, and where Warhol grew up (Warhol moved there when he was six).
10 In 1970 Bob Colacello wrote a review of Andy Warhol's film *Trash* that caught the attention of Warhol and Paul Morrissey. Colacello was approached to write for Warhol's *Interview* magazine and became editor after six months, remaining in the post for twelve years, during which he was directly involved with Warhol's business and social life. Colacello wrote the book *Holy Terror: Andy Warhol Close Up* (New York: HarperCollins, 1990), about his years with Warhol.
11 Jerry Hall met Warhol in Paris in 1973. She sat for her portrait and Warhol took numerous Polaroids of her. They remained close friends until his death. She would go with him to the New York club, Studio 54, which she talks about in program three of *Andy Warhol's America*. See also the interview for *The Times*, Arts section, January 6, 2022, 4–5.
12 Whately, interview with Jean Wainwright, December 20, 2021.

the making of the program was an extremely nuanced process and how the direction of the series formed a subtle and challenging series of interlocking tasks, months of intense preparation and scrutiny of material, finding the interviewees and linking the stories to name but a few. What emerged was a program which interspersed archival footage with new interviews to provide new and convincing arguments to support the premise that Warhol's art was more than just the art, that it encapsulated the events and values of modern-day America, using dramatic filming techniques and evocative background music to add an extra dimension to the narrative.

As the program developed, scenes and scenarios changed organically, with different emphases. Inevitably there was a filtering of Warhol's work and life story as decisions were made to throw some aspects into sharper focus while leaving out others altogether, either because they were superfluous to the narrative or they did not fit the framework.[13] In one of his introductory emails to the production team, Whately listed some of the key ideas for the program:

> Each story must be telling a different story. So artworks that are all saying the same thing about celebrity or brands or death or whatever, can be put together even if they are not historically all together. Each story must have one genuine wow moment. For example, we interview someone who was at the riots in Alabama and we find out the very real and personal consequence of that day/moment for them. Each story feeds into the overall theme of the film it is included in and increases our understanding of that theme. For example, the *Electric Chair* [painting] is in the Death and Religion programme and tells us about Warhol's and America's view of that theme.[14]

We can see from this early email that storylines developed or changed focus. For example, the title of the second episode was subsequently changed from *Death and Religion* to *The American Nightmare*, indicating a change of storyline to that of "bursting the bubble" of the "American Dream" referred to by the title of episode one (*Living the Dream*).[15]

[13] Sometimes sections were shot that did not make the cut. Cairney, for example, would have liked to have included Warhol's *Shadow* paintings and "fought for them" but it was decided that they did not contribute to the overarching narrative. Cairney, interview with Jean Wainwright, December 30, 2021.

[14] Whately, email to *Andy Warhol's America* production team, October 1, 2020.

[15] The focus on Warhol's shooting was also a reference back to the John F. Kennedy assassination on November 22, 1963, which is also shown in program two, *The American Nightmare*, which "burst the bubble" and which for Warhol was both experienced by the American population and also was personally responded to by him.

Perhaps mindful of the need to draw viewers into the program, the opening and closing sequences of the series highlight Warhol's relevance for a contemporary audience and his perceived influence on contemporary culture. As mentioned above, this is an important parallel agenda to the art-historical one, which must be prominent in the translation to TV in a way that it might not be in a pure art-historical context. The need for a contemporary audience to feel that a program is relevant enough to invest time watching it has to be acknowledged and embraced, because otherwise the viewer might switch channels to a program that perhaps provides more instant gratification. The cold open to episode one shows TV footage from the Super Bowl LIII game of 2019, with its advertisement for Burger King and the #Eat like Andy Warhol campaign, which used forty-five seconds of Jørgen Leth's 1982 film *66 Scenes from America* of Warhol sitting eating a burger.[16] The decision to start *Andy Warhol's America* with this segment aimed to make this program about Warhol appear instantly relevant, since the match had occurred only three years previously, watched by a worldwide TV audience of 98.2 million viewers.[17] The sequence had perhaps even more impact when interwoven with a clip of a well-known American football commentator on British TV, Jason Bell (perhaps even more well known as a contestant in the popular *Strictly Come Dancing* show in 2020), conveying the message that although the program is documenting history, Warhol and his art are relevant to contemporary life.

The Super Bowl introduction dovetails with the conclusion of the series, which highlights already commonly held views on not only how relevant, but also how prescient and ahead of his time Warhol was in terms of popular culture, through an ending sequence scrolling through key moments and soundbites from the program coupled with a kaleidoscope of collaged events considered "Warholian," underpinned by a soundbite from Blake Gopnik, author of a recent extensive biography of Warhol,[18] that Warhol "didn't die" but was resurrected in our popular culture. These images include footage of

[16] Marcelo Pascoa, the then head of Global Brand Marketing at Burger King, had seen Leth's film, prompting the advertising idea. The cold open sequence at the beginning of the first episode includes interviews.
[17] "Super Bowl LIII Draws 98.2 Million TV Viewers, 32.3 Million Social Media Interactions," *Nielsen*, February 4, 2019, https://www.nielsen.com/insights/2019/super-bowl-liii-draws-98-2-million-tv-viewers-32-3-million-social-media-interactions/#%3A~%3Atext%3DSuper%20Bowl%20LIII%20Draws%2098.2%2CMillion%20Social%20Media%20Interactions%20%E2%80%93%20Nielsen.
[18] Blake Gopnik, *Warhol* (London: Penguin/Random House, 2020).

reality TV star Jade Goody in the *Big Brother* house,[19] celebrities such as Paris Hilton, Kim Kardashian, and Kanye West, President Trump, artists such as Jeff Koons and Damien Hirst, record auction prices for Warhol, and the Twitter symbol, all played out to the soundtrack of "The Rockafeller Skank" by Fatboy Slim (2003).

The scripting of a program is the heart of its translation, as are decisions made in the early weeks of production that shape a series. For example, Whately decided that, because the most traumatic moment in Warhol's life was his attempted assassination, he would use that event as a framework device to create a dramatic moment for both the second and third episodes. Cairney points to the "non-submersible units"[20] that "drifted between episodes" but were "robust and coherent" on their own[21] and the narrative behind them, such as a film segment on Warhol's *Electric Chair* paintings of 1963–5, which was moved around during the editing process until the best place for it was found in terms of the overall narrative (in the second episode).

A decision that shaped the whole translation was to have the documentary storyline told to camera by the interviewees instead of an unseen narrator, both linking and creating key dramatic moments. Whately explained that he wanted to resist the "dictatorial voice telling you what to think."[22] Cairney described how they always questioned who was relating the commentary: "Who is telling me this? Is this the filmmaker, is it a book … where is this voice coming from?"[23] Whately noted that for the last five years the BBC has been trying to get away from the "man in a field telling us how things were," that "BBC voice of God."[24] The "job of television people," as Whately explained, is to rely on the experts for the factual content and then "to make a story out of the experts' opinions of those people who were there. So our job is really

[19] *Big Brother*, one of the first reality TV shows on British TV, premiered on Channel 4 on July 18, 2000, and was a ratings hit. Jade Goody, who died in 2009 aged twenty-seven, has been described as the "ultimate *Big Brother* contestant" (*Big Brother 19*, September 14–November 5, 2018) and "the reality star who changed Britain" (*Jade: The Reality Star Who Changed Britain*, three episodes, August 7, 14, and 21, 2019, Channel 4).

[20] A non-submersible unit, a term coined by Stanley Kubrick, is understood as a story sequence where all the non-essential elements have been stripped away. These units are generally so robustly compelling that they would, by themselves, be able to keep the viewer interested, containing only what is absolutely necessary for the storyline. For an analysis of "non-submersible units," see Robert P. Kolker and Nathan Abrams, "Non-Submersible Units: An Analysis of Key Scenes in Stanley Kubrick and the Making of his Final Film," in *Eyes Wide Shut: Stanley Kubrick and the Making of his Final Film* (Oxford: Oxford University Press, 2019), chapter 7.

[21] Cairney, interview with Jean Wainwright, December 30, 2021.

[22] Whately, interview with Jean Wainwright, December 20, 2021.

[23] Cairney, interview with Jean Wainwright, December 30, 2021.

[24] Whately, interview with Jean Wainwright, December 20, 2021.

as a storyteller."²⁵ The interviewees then become the heart of the translation as they comment on and interpret history. Scripts would be annotated with comments such as "Who could say this?" and at times two people might make the same point, but one might say it in a more dynamic way, which then became the segment the editors decided would "make the cut."

For the contemporary interview extracts which were to drive the narrative, the decision was made that, with the exception of Blake Gopnik, everyone interviewed should have a personal connection to Warhol. They were his friends and relatives. They had been participants in the activities of his studio, the Factory. They had been involved in his business. They had sat for portraits. They had been a witness to events that he featured in his art (or were a close relative of a witness). Interviewees provided the program's narration from the perspective of someone who had firsthand knowledge either of him or of the events he portrayed in his works. This gave the documentary a sense of oral history, bringing Warhol's art alive in an entirely different way than, for example, a program narrated exclusively by art historians might have done, which would have been a different translation. Initially the program's executive producer, Janet Lee, was inclined not to include any historians or biographers, but this vision was later revised to include Gopnik.²⁶ Amy Taubin, a critic, and Donna De Salvo, a curator, were included in a dual role, as people who knew Warhol personally (for example, Taubin had sat for one of his *Screen Tests*). What guided the selection of interview extracts was how well-expressed and relevant they were in terms of the underlying narrative, a process that, as series consultant, the author had insight into as she witnessed not only the way the scripts were altered as the programs progressed, but also how selective editing can create, suggest, and imply, while maintaining the integrity of what the interviewees expressed.

An academic text is a filtering and editing process by the author and editor or editors. Television filmmaking is similar but typically more collaborative; there is a production team, and many different audio visual contributions are brought together. The producer and director (often the same thing in television) bring to the program their own interests and background in the subject, which then informs the translation of the subject matter as it is filtered through their own lens as well as those of the selected interviewees. Whately and Cairney had both been aware of Warhol since they were children. Whately recalled visiting the *Andy Warhol* exhibition at the Tate Gallery, London in 1971, aged six: Although "I do not remember

²⁵ Whately, interview with Jean Wainwright, December 20, 2021. The BBC also has an inclusion and diversity plan 2021–3 available online: https://www.bbc.com/diversity/documents/bbc-diversity-and-inclusion-plan20-23.pdf.
²⁶ Cairney reported that both he and Whately had read Blake Gopnik's biography of Warhol before they began production and Cairney had wanted to include him from the beginning of scripting; Cairney, interview with Jean Wainwright, December 30, 2021.

how much I took in … [Warhol] has been a part of my consciousness, if not my reading, for a long time."[27] He emphasizes that it is not necessary to be an expert in a topic to make a program about it: "That is what the people you interview bring to the program; often people making the programs are not."[28] In contrast, Cairney recollected that Warhol was:

> always in the air that I breathe. There was never a time that I wasn't aware of him. But it was the *Love Boat* Andy rather than the Pop Andy; the sell-out, the omnipresent artist-cum-capitalist. Even when I was small, I was aware of Warhol being everywhere in the culture; that he was, kind of, America.[29]

Later, becoming interested in the more theoretical, philosophical side of Warhol's work, Cairney found himself drawn to Walter Benjamin's essay "The Work of Art in the Age of Mechanical Reproduction" and began questioning what repetition does "to the image … to the referent, to the original subject," a questioning he brought to the program (a point returned to later, in the context of translating the *Race Riot* images to television).[30] Yet he countered that:

> In some ways knowing so much from books and philosophical interests is perhaps a hinderance, as I had to unlearn what I loved and unwrite and undo a lot of my thinking … and come at [Warhol] from a very different angle …. There was a kind of parallax involved in making [the program]. It was perhaps because I came in from this very overly intellectualized angle.[31]

[27] Whately, interview with Jean Wainwright, December 20, 2021. Whately would have seen many of the works that he later felt drawn to in the program. The selection of artworks in the Tate exhibition was very specific and the catalog included an explanation by the director, Norman Reid: "At the request of the artist the exhibition omits all works earlier than 1962 and several developments of the last eight years, and is restricted to the soup cans, disasters, portraits, flowers and Brillo Boxes." Norman Reid, Foreword, in Richard Morphet, *Andy Warhol* (London: Tate Publishing, 1971), 5. More recently, Whately visited the 2019 Whitney Museum of American Art Warhol exhibition, organized by Donna De Salvo, while it was on view in San Francisco and before he took on the BBC project. The book produced to accompany this exhibition, *Andy Warhol: From A to B and Back Again* (New York: Whitney Museum of American Art, 2018), was one of the publications used by Whately to obtain background information for the program.

[28] Whately, interview with Jean Wainwright, December 20, 2021.

[29] Cairney, interview with Jean Wainwright, December 30, 2021.

[30] Cairney, interview with Jean Wainwright, December 30, 2021.

[31] Cairney, interview with Jean Wainwright, December 30, 2021.

This is in contrast to the writing of an academic study, where depth of knowledge is a prerequisite. At the heart of translating for the television is a different set of parameters governing what is included to make compelling viewing.

Two storylines within *Andy Warhol's America* will serve as cases in point for this translation and are discussed in terms of what underpins the final footage shown on the screen—not only what is omitted or sacrificed for the sake of expediency or the narrative, but what is gained. The two storylines, as noted in the introduction to this chapter, revolve around Warhol's paintings *Pink Race Riot [Red Race Riot]* and *Mustard Race Riot* from the Race Riot series, and *The American Indian (Russell Means)*. Each image has a complex backstory with both cultural and political implications. Although there were other controversial bodies of work included in *Andy Warhol's America*, most notably the *Thirteen Most Wanted Men* (1964) in the first episode, the earliest of the *Electric Chair* paintings (1963–5) in the second, the *Race Riot* and *The American Indian (Russell Means)* works have not featured in other documentaries on Warhol and seem particularly relevant in the current sociopolitical climate.[32]

One of the challenges of translating Warhol and his art to a mainstream television documentary for a wide-ranging audience is that Warhol, as the art historian Thomas Crow asserts, was not one, but a minimum of three persons, and that, "The second was the passions that are actually figured in paint on canvas."[33] How could these complexities be communicated by the television program? Before discussing this question, a detailed description of what the audience sees on the screen is first needed. In episode two of *Andy Warhol's America, The American Nightmare*, the title sequence fleetingly shows both Warhol's *Little Race Riots* (1964) and the *Mustard Race Riot* (1963), while Jefferson Drew, an interviewee who was an eyewitness to the Birmingham, Alabama protest, comments that "He [Warhol] shows the violence and utter distain for human life in America." Directly preceding the eight-and-a-half-minute sequence on the Birmingham civil unrest is a storyline on Warhol's *Electric Chair* paintings. We are given a teaser by Bianca Jagger, a close friend of Warhol, asserting that "I don't see it as Andy trying to shock the world,

[32] *Andy Warhol: The Complete Picture*, which aired in 2001 on Channel 4 did not feature either series; neither did *Andy Warhol*, in the Modern Masters series for the BBC, of 2010, or Ric Burns' *Andy Warhol: A Documentary Film* for PBS American Masters, of 2006.

[33] Thomas Crow, "Saturday Disasters: Trace and Reference in Early Warhol," *Art in America* 75, no. 5 (May 1987), as reprinted in *On & By Andy Warhol*, ed. Gilda Williams (London: Whitechapel Gallery; Cambridge, MA: MIT Press, 2016), 135. Several other writers also have suggested how complex Warhol was in his work and life.

it was Andy trying to show us the world as he saw it, and the America as he saw it." The performance artist, writer, and poet Penny Arcade, who, at age nineteen featured in Paul Morrissey's film *Women in Revolt* (1971),[34] then introduces a powerfully montaged sequence with her passionate, direct address to the viewer:

> The sixties was not a time of freedom People tell me, "Oh you grew up in the sixties it was so optimistic," and I'm like, "are you kidding me?" The sixties were a nightmare, it was a time of complete violence.[35]

The subsequent footage includes archival film clips from the 1960s of the Ku Klux Klan, women's liberation, and civil rights marches (demanding the end of police brutality), and climaxing on an image of a nuclear mushroom cloud (a subject of one of Warhol's mid-1960s paintings),[36] all choreographed to the soundtrack of "Pissing in a River" by Patti Smith (1976). For Whately, this combination of images and sounds was a bridging device to show that the popular image of the 1960s

> needed to be pricked, this time of freedom and love, and sexuality. ... whereas all those things, as we know, were probably a slightly minority sport for most of America, who were still very much based in 1950s values. And a lot of those thoughts didn't really come through until the 1970s. The dramatic montage also prepares us for the next sequence with its challenging subject matter.[37]

[34] There have been various arguments as to who produced *Women in Revolt*. Gary Comenas on his extensive website Warholstars.org (https://warholstars.org/women-in-revolt.html) states that "Warhol is not credited as the producer in the on-screen credits of the version released by First Independent, but IMDB currently lists him as producer along with Jed Johnson as associate producer and Paul Morrissey as executive producer." Maurice Yacowar, in *The Films of Paul Morrissey* (Cambridge: Cambridge University Press, 1993),136–7, lists Warhol as producer with Paul Morrissey as director and executive editor and Warhol and Jed Johnson as the camera operators.

[35] Penny Arcade was interviewed by Cairney for *Andy Warhol's America*. In the program she states that "the sixties were not a time of freedom. I mean homosexuality was illegal, women's rights not even talked about really ... The sixties were a nightmare, it was a time of complete violence." Her interview with Cairney was preceded by five hours of conversation where they established a strong rapport in preparation for her filmed interview.

[36] Warhol made *Red Explosion (Atomic Bomb)* in early to mid-1963, after the *Car Crash* and *Electric Chair* paintings, according to Neil Printz in *The Andy Warhol Catalogue Raisonné*, vol. 1: *Paintings and Sculptures 1961–1963*, ed. Georg Frei and Neil Printz (London: Phaidon, 2002), 331. The BBC Warhol program maintains this timeline.

[37] Whately, interview with Jean Wainwright, December 20, 2021.

There are various visual tropes that the program utilizes to visually and aurally translate live archival footage from the 1963 violence against the civil rights protesters into contextualizing stills of Warhol's *Pink Race Riot* [*Red Race Riot*] and *Mustard Race Riot* paintings (Figures 7.1 and 7.2).[38] The viewer is led through fast edits of archival footage, overlaid with dramatic music, witness testimony, and conflicting opinions, which build up to the reveal of Warhol's two canvases. The specific seven-and-a-half-minute segment on the Birmingham, Alabama protests is introduced by Victor Bockris, Warhol's associate and later biographer, who suggested that "Andy used what was happening in society,"[39] followed by a rousing extract from a speech by Martin Luther King on segregation. Each interview and image is juxtaposed to build a story that highlights black-and-white images by the photographer Charles Moore of peaceful Black marchers being attacked by white policemen with dogs. These photographs, used by Warhol as source material for his *Race Riot* images, were taken on May 3, 1963 in Birmingham, and published in *Life* magazine two weeks later.[40]

Whately's translating of the sequence of events brings the riots alive and into our contemporary psyche. We see the peaceful marchers violently assaulted by fire hoses and flung to the ground by the force of the water. Eyewitnesses, such as Jefferson Drew, who observed the hosing of protesters and the dog attacks, and Denise Barefield-Pendleton, a Black doctor from Alabama, give the contextual observations on Eugene (Bull) Connor, Birmingham's Commissioner for Public Safety,[41] with his staunch racism and

[38] The titles of the works are themselves inaccurate, as the marches for Civil Rights Movement: Project C, better known as The Birmingham Campaign, were peaceful and it was the actions of the police and fire department that were violent.

[39] Victor Bockris published many pieces in Warhol's magazine *Interview*. Warhol wrote that "Victor Bockris is a brilliant young writer who only writes about three people: William Burroughs, Muhammad Ali and me. Victor Bockris has more energy than any person I know. He types like Van Cliburn plays the piano. He's always tape-recording and taking pictures. I can't keep up with him"; *Andy Warhol's Exposures* (New York: Andy Warhol Books/Grosset & Dunlap, 1979), 210. After Warhol died, Bockris published the biography *Warhol* (London: Frederick Muller, 1989). On the various editions of this book, and its translation into French, see Jean-Claude Lebensztejn's chapter, "Warhol in French," in this volume.

[40] Charles Moore was a staff photographer for the *Birmingham Advertiser*. For a reading of Charles Moore's photographs, see the chapter "Skin Problems" in Jonathan Flatley, *Like Andy Warhol* (Chicago and London: University of Chicago Press, 2017), 185–210. See also *Andy Warhol Catalogue Raisonné*, vol. 1, 380–4, and Okwui Enwezor, "Andy Warhol and the Painting of Catastrophe," in *Andy Warhol: From A to B and Back Again*, 34–41.

[41] Theophilus Eugene "Bull" Connor (July 11, 1897–March 10, 1973) was a white supremacist and politician who served as Commissioner of Public Safety in Birmingham, Alabama, for more than twenty years. He strongly opposed the Civil Rights Movement in the 1960s. He had responsibility for administrative oversight of the Birmingham fire

use of attack dogs on the peaceful marchers. Their testimonies are preceded by the inflammatory archival television footage from 1963 of Connor, who, when asked if he can still keep Birmingham segregated, retorts that he "may not be able to, but [he'll] die trying." Connor had directed the police and fire departments to halt the demonstration and Drew's chilling account in the program of a racist police officer and his German Shepherd dog is given extra impact as the camera pans from a close-up detail of Moore's image of a dog tearing at a Black protester's trousers to a slow reveal of the entire photograph, where we are left staring directly into the muzzle of a German Shepherd that has us in its sights—we are now in the frame. The art dealer and curator Jeffrey Deitch claims to camera that Warhol was sympathetic to the Civil Rights Movement, and that he had the "genius" to, out of the hundreds of images, "instinctively know which ones would create the most impact." Bockris also mounts a defense, claiming that it is at this point in 1963 that he "begins to paint the history of America." As the camera begins to linger on *Pink Race Riot* [*Red Race Riot*] and *Mustard Race Riot*, Barefield-Pendleton asserts that "Sometimes images that are taken don't need to be doctored or modified. [Warhol] sees the world in pink. We did not." With her measured and authoritative tone, she offers a persuasive indictment:

> I don't actually understand what [Warhol's] purpose was when he did those paintings, and I'm not certain he even knew what his intentions were to be. My impression is that his intentions were strictly to generate money for him and so he decided to employ the struggles of Black Americans into his artwork—very nice.

Barefield-Pendleton's impression is an inevitable compression of historical intricacies, but it also needs to be read against the art-historical contextualizing of Warhol's Race Riot canvases in terms of how Warhol's intentions are translated and what might be missed or distorted. As we are once again shown the Moore photographs, it is left to Deitch to defend Warhol, to state that if he had not executed the paintings, Moore's images would have remained on the pages of *Life* magazine (a debatable point), and that by taking them out of context and suffusing them with color, they are able to enter into "our cultural history." A modern-day shot of *Pink Race Riot* [*Red Race Riot*] on the

and police departments. He directed fire hoses and police attack dogs at civil rights activists, including children, documented in footage that was broadcast to the world. The publicity served as a catalyst for social and legal change in the southern United States and contributed to the passing of the Civil Rights Act of 1964. This history, in connection to Warhol, is discussed by Johnathan Flatley, in "Skin Problems."

wall of a museum (contextualized by the COVID masks) provides a visual affirmation. As the sequence draws to a conclusion we hear from Warhol's former assistant, Joseph Freeman, that Warhol was "very authentic," and that he would "never say we live in a violent culture." This point is driven home by footage from 1966 of Warhol responding with a characteristically evasive reply to the question, "Are you saying you are involved in this idea of making people more conscious of their lives, but you don't really want to get into their lives deeply?" with a succinct "Yes, [I] don't want to get too involved."

An unpicking of what we see on the screen and its historical compression needs to be read against the source material of Moore's photographs and how they are presented—from archival live action film to Moore's "freeze frame" photographs to Warhol's paintings. The sequencing involved weeks of production discussions on how to represent the sensitivities inherent in the images, both from Warhol's viewpoint and in light of recent history and the Black Lives Matter movement. As Cairney explains: "Doing so without overwriting the events, because Moore's photographs were of an event, so you are already several times removed from the actual people involved. How do you really deal with Warhol's ethical position?"[42] Ultimately both Cairney and Whately decided that, on balance, they would have to "jettison" that idea and give people who were part of the story their voice,

> Because ... ultimately, things become confused in television when they raise more questions, or any questions really, apart from what's being said, and the implications of what's been said. It just doesn't work; it's got to be a clean line unfortunately."[43]

This explanation goes some way to justify the decision for the program not to have the contextualizing voice of art historians explaining in detail the intricacies of Warhol's work and also serves as a way to keep the audience engaged, with its pace of rapid-fire imagery and music.

So what then are we not seeing and what is implied? Warhol had clearly been affected by the coverage of the Birmingham peaceful protests and the aggressive actions by the police. In his book, *Like Andy Warhol*, Jonathan Flatley observes that "one can discern [in Warhol's work] a preoccupation with the color line."[44] Warhol selected Moore's double-page spread from *Life*

[42] Cairney, interview with Jean Wainwright, December 30, 2021.
[43] Cairney, interview with Jean Wainwright, December 30, 2021.
[44] Flatley, *Like Andy Warhol*, 180. Flatley draws attention to the fact that in Warhol's 1963 film *Kiss* he features an interracial kiss between Rufus Collins, an African American man, and Naomi Levine, an early Warhol "superstar," before such imagery appeared on television.

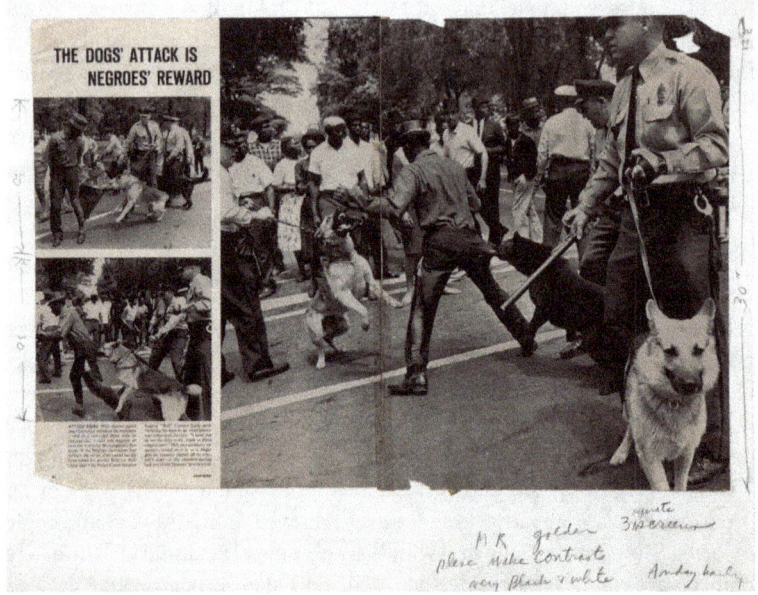

Figure 7.3 Andy Warhol, Mechanical ("The Dogs' Attack is Negroes' Reward," *Life* Magazine, May 17, 1963), 1963, newsprint clipping, graphite, tape, and gouache on heavyweight paper, 20 × 22½ in. (50.8 × 57.2 cm). The Andy Warhol Museum, Pittsburgh; Founding Collection, Contribution The Andy Warhol Foundation for the Visual Arts, Inc. Accession Number: 1998.3.4438.

and sent it to his silkscreen maker with instructions to make the contrasts "very black + white" (Figure 7.3). He also cropped the images in the same way as Moore, but rather than following the layout of the *Life* spread, in which one image is larger, with the police dog handler central frame, baton ready and the German Shepherd dog looking directly at the viewer, Warhol asked that all the images be the same size.[45] Warhol's focus may also have been due to the offensive and incendiary caption accompanying the *Life* spread under the heading "The Dogs' Attack Is Negroes' Reward" (which he did not include in his final silkscreen although clearly he had read it):

> With vicious guard dogs the police attacked the marchers—and thus rewarded them with an outrage that would win support all over the

[45] See Georg Frei and Neil Printz, eds., *The Andy Warhol Catalogue Raisonné*, vol. 2: *Paintings and Sculptures 1964–1969* (London: Phaidon, 2004), cat. nos. 1417–22.

world for Birmingham's Negroes … This extraordinary sequence—
brutal as it is as a Negro gets his trousers ripped off by Connor's dogs—is
the attention-getting jack pot of the Negroes' provocation.[46]

This caption, however important to the contextualizing of the *Race Riot*
paintings, is not explored in the television program, the language being
inappropriate for a contemporary TV audience. Curator and art critic
Okwui Enwezor also makes the case that "the recursive registers of the
imagery make the frame-by-frame display [Warhol] uses in the painting feel
almost prosecutorial, as if he were putting America on trial,"[47] yet we only
observe this aspect of Warhol's composition fleetingly on the screen as the
camera moves from the photographs to the canvas, highlighting Warhol's
appropriation.

Crow, writing in 1987, stated that he believed Warhol was attracted to "the
open sores in American political life, the issues that were most problematic
for liberal Democratic politicians such as [John F.] Kennedy and Edmund
Brown."[48] Enwezor argued that Warhol was engaged with an anguished
reflection on his country's condition, and that his deployment of Moore's
photographs "becomes an act of participation as a citizen," arguing that
Warhol worked with the "objectionable images, not as mere photojournalistic
spectacle … but to assert his own capacity to see the nature of a brutal
sovereign force arrayed against citizens like himself."[49] Borrowing from the
philosopher Georges Didi-Huberman, Enwezor proposed that Warhol's *Race
Riots* don't say the truth but rather are a fragment of it, its "lacunary remains."
He concluded that the *Race Riot* paintings seek to make visible the image of "an
American catastrophe" and that ultimately, they tell of the violence against the
Black body, "its constant violent desecration by apparatus of state violence."
For Enwezor, Warhol's *Race Riots* display "the wound in its resplendent and
sickening colors."[50] If we examine this interpretation against what we see on
the screen then we do see the "American catastrophe" highlighted for us with
Warhol's response, but due to constraints of time and because the narrative

[46] On Warhol and this May 17, 1963 *Life* magazine story, "They Fight the Fire that Won't Go Out: The Spectacle of Racial Turbulence in Birmingham," also see Enwezor, "Andy Warhol and the Painting of Catastrophe," 37, and Flatley, *Like Andy Warhol*, 186 (his footnote on dogs and the history of white supremacy gives some excellent references on the subject).
[47] Enwezor, "Andy Warhol and the Painting of Catastrophe," 39.
[48] Crow, "Saturday Disasters," 143.
[49] Enwezor, "Andy Warhol and the Painting of Catastrophe," 39.
[50] Enwezor, "Andy Warhol and the Painting of Catastrophe," 40.

has to move swiftly on to other stories, we do not see Warhol making decisions about the work. There is, however, inserted footage that shows Warhol and his assistant Gerard Malanga, who also appears as an interviewee in the program, screen-printing together, which becomes a televisual cipher for Warhol's making process, something used as a device in a number of different sections. As (present-day) Malanga comments in the program: "Well the whole image is pretty shocking, but Andy always felt that color diminished rather than intensified the violence of what the image was projecting."

Warhol purported "not to care"[51] and that is the impression given by the archival footage of him on screen, yet he vividly responds to Moore's photographs with a number of canvases, screen-printing them in black on different color grounds: red or pink, mustard (a diptych), mauve, and white.[52] In her article "Warhol Paints History, or Race in America" of 1996, the art historian Anne Wagner argues that the reason Warhol chose the Moore images was that the Black protests in 1963 were "emphatically topical" as Black activism gathered a new urgency and visibility under the John F. Kennedy administration and the leadership of the Reverend Martin Luther King Jr.[53] Birmingham was the most segregated city in America, and *Life* magazine was the mainstay of "photojournalism and prime source for white middle-class impressions of the week's *actualities*."[54]

Moore's black-and-white images are shown in close-up five times on the screen with zoom, as specific archival footage is focused on and then frozen into images of his photographs, which gives the viewer the impression of literally being there with Moore as he is framing his shots in camera. With pan shots to Warhol's canvases, we then see fleetingly, from the contrast between the photograph and canvas, how Warhol has used repetition of Moore's images and the pink and mustard paint washes to translate the source material. Cairney admitted that he and Whately wondered what the canvases implied:

> What does it do to the image when you just repeat it over and over again? Does it reiterate it? Does it make you think about it more? Or

[51] Warhol made this statement in one of his most often quoted and influential interviews, with Gene Swenson, "What is Pop Art? Answers from 8 Painters, Part 1," *ARTnews* 62, no. 7 (November 1963); citation from the reprint in *I'll Be Your Mirror: The Selected Andy Warhol Interviews*, ed. Kenneth Goldsmith (New York: Carroll and Graf, 2004), 16.

[52] See Frei and Printz, *Andy Warhol Catalogue Raisonné*, vol. 1, cat. nos. 421–4, and *Andy Warhol Catalogue Raisonné*, vol. 2, cat. nos. 1417–22.

[53] Anne M. Wagner, "Warhol Paints History, or Race in America," *Representations* 55 (Summer 1996): 104.

[54] Wagner, "Warhol Paints History," 105.

does it make you think about it less? Does it do both things at the same time, which is probably what I think … ? That's what makes them such amazing paintings.

He suggested that the entire TV series and the opinions by interviewees on the marches in Birmingham in relation to Warhol's paintings conformed to the Rashomon effect, the device of telling stories from different points of view: "You get these kind of fractured, very specific perspectives on America and Andy … all the people and voices that are there are some sort of polyphony in the end, everybody comes from a very specific angle."[55]

Regarding the *Race Riots*, Anne Wagner asks:

> The images may have been familiar, but are they quite empty enough? The question is relevant because one main requisite of Warhol's tested painterly strategy—that sensation of attention sapped or exhausted in confrontation with a repeated visual form—no longer prevails in quite the same way. Though now suffused with color, the photographs survive within Warhol's paintings: a bit grittier, more like newsprint, they still seem pretty much intact.[56]

Wagner sees them as history paintings with multiple protagonists of the "drama of race." It could be argued that the translation to the screen implies both Warhol's distancing from the action and yet a perpetuating of it, which is in line with much art-historical writing on the series.

What then is gained or lost by bringing the riots alive through interviews, archival footage, freeze frames, the quick edits from Moore's photographs to the paintings and back again in translating the sequence of events onto the screen as a context for Warhol's art? This condensing of the intricacies of Warhol's work is now translated through a particular historical contextualization within the framework of a documentary overview. The question arises of whether we need an art-historical reading of the Race Riot canvases and their "nightmare coloring" that Crow refers to, or his sense that what Warhol's series of paintings add up to is a:

> kind of *peinture noire* in the sense that we apply the term *film noir* … a stark, disabused, pessimistic view of American life, produced from the

[55] Cairney, interview with Jean Wainwright, December 30, 2021.
[56] Wagner, "Warhol Paints History," 106.

knowing re-arrangement of pulp materials of an artist who did not opt for the easier pathos of irony or condescension.[57]

In the *Race Riot* sequence there is no expert discussion on the placement of Moore's images and the significant differences between the two paintings. Instead, we are shown the canvases in zooms and tracking shots and significantly we are placed as if viewers at the actual scene. We can visually access the fact that *Mustard Race Riot* is a diptych, with a mustard monochrome canvas on the right-hand side (see Figure 7.2). (This is a device that Warhol first deployed in his *Death and Disaster* series.) We see a repetition of four rows of three of Moore's photographs with the cropping of each image on the far right-hand side.

In contrast, *Pink Race Riot* [*Red Race Riot*] has four rows of images in a three, two, one, and two configuration (see Figure 7.1). This time only the top right-hand image is cropped. The uneven distribution of the reddish pink ground is obvious with the marks giving the impression of the color being "mopped" across the canvas. There are irregular patterns of repetition and cropping that were not in the original source material and that interrupt their narrative coherence. We are left to follow the camera as it zooms in on the unevenly screened photographs, with a repetitive visual scrolling back and forth from Moore's photographs to the canvas, and to draw our own visual conclusions, guided by Bockris's comment that, "He saw death and disaster in America, that's what he saw." The on-screen political comments are, for expediency, curtailed to short contextualizing soundbites.

In his review of *Andy Warhol's America* for the *Financial Times*, Peter Aspden points to the absence of an "intellectual counterweight" to the "frothier claims made on Warhol's behalf."[58] Instead, the platform is given to people who were part of the story, who screened the works (Gerard Malanga) and otherwise were part of Warhol's life. It is their voices that create the links and provide the pulse of the dramatic tension.

Television is, by definition, a medium with a different set of rules from the writing of a book or academic paper. The mission is to reach both general audience and specialist. Although a documentary, *Andy Warhol's America* does not aspire to be an in-depth look at each body of work that is featured; its remit is different, its focus evident. Whately believes that Warhol chose subjects that were important to him. He conceded though that there are

[57] Crow, "Saturday Disasters," 143. Crow was speaking more generally about the *Death and Disaster* images here and not specifically of the *Race Riot* paintings.

[58] Peter Aspden, "Andy Warhol's America—Are We Still in the Thick of It?" *Financial Times*, January 6, 2022, https://www.ft.com/content/baf30220-f919-4124-a4eb-c6323bffc7ac.

dangers in any interpretation of Warhol's work when making a television program, given the sensitive issues he explored through his subject matter. One key reason the series was "green lit" was the "really interesting points of articulation, where [Warhol] comes into contact with an image that resonates at some level."[59] For Cairney, Warhol is an observer, his "raison d' être was to look intently at people, images and objects." The visual era that he was, and we are still, living in is saturated with images, and it was those images that were source material for his work.[60] For Whately, "Warhol was able to distill the images down to the ones that matter most."[61]

Ultimately by showing the Moore images so insistently intercut with archival footage and then the zoom cut to Warhol's artworks, we are being reattached to the referent. We are perhaps now firmly in Hal Foster's territory with the repetitions of Moore's images, the tearing at the peaceful protesters' clothes, the experience of a "warding away of traumatic significance and an opening out to it: a defending against traumatic effect and a producing of it,"[62] but from a different perspective. The *Race Riot* paintings are "seeking to make visible the image of an American catastrophe.... Rather than distance history and consciousness, these images continue to carry a metonymic charge."[63] The strength of this translation is that it leads us back to the crucial site of the event, itself a powerful contextualizing tool but, to reiterate, there is also inevitably an absence lurking in the analysis of Warhol's very particular screen-printing aesthetic and his complex personality traits of presence and absence which by 1963 he had crafted into a transformative act.

The decisions that are made for each segment of the documentary by necessity have a consistency of emphasis and tone of voice, through which the translation is guided. Thirteen years after creating his *Race Riot* paintings, Warhol appeared to highlight another political cause through his series of portraits of Russell Means, an Oglala Lakota American Indian who had become known for his role as a spokesperson and activist for the American Indian Movement (AIM).[64] Warhol produced this series, entitled

[59] Whately, interview with Jean Wainwright, December 20, 2021.
[60] Cairney, interview with Jean Wainwright, December 30, 2021.
[61] Whately, interview with Jean Wainwright, December 20, 2021.
[62] Hal Foster, "Death in America," *October* 75 (Winter 1996): 36–59, as reprinted in *Andy Warhol* (October Files 2), ed. Annette Michelson (Cambridge, MA: MIT Press, 2001), 72.
[63] Enwezor, "Andy Warhol and the Painting of Catastrophe," 40.
[64] The Oglala are one of the seven subtribes of the Lakota people who, along with the Dakota, make up the Očhéthi Šakówiŋ. A majority of the Oglala live on the Pine Ridge Indian Reservation in South Dakota, the eighth-largest Native American reservation in the United States. The American Indian Movement was founded July 1968 in Minneapolis, Minnesota. It was initially located in urban areas to address systemic issues of poverty, discrimination, and police brutality against Native Americans.

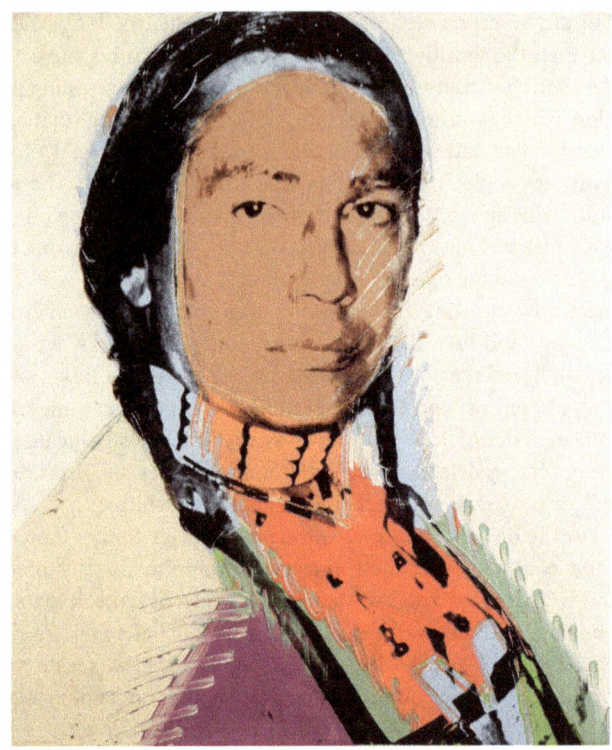

Figure 7.4 Andy Warhol, *The American Indian (Russell Means)*, 1977, acrylic and silkscreen ink on linen, 50 × 42 in. (127 × 106.7 cm). The Andy Warhol Museum, Pittsburgh. Image and Artwork © The Andy Warhol Foundation for the Visual Arts, Inc./Licensed by ARS.

The American Indian (Russell Means), between August 1976 and early 1977 (Figure 7.4). Rather than appropriated photographs, this time his canvases and drawings were based on a Polaroid photograph by Warhol, selected from around forty images taken by him during a single sitting with Means.[65] The six-minute segment in episode three of the documentary that features the

[65] In his autobiography, Means described the sitting and recounted that "they flew me to New York and Warhol took more than one hundred Polaroids of me"; Russell Means with Marvin J. Wolf, *Where White Men Fear to Tread: The Autobiography of Russell Means* (New York: St. Martin's Press, 1995), 361–2. For a comprehensive description of the sitting, see Neil Printz and Sally King-Nero, eds., *The Andy Warhol Catalogue Raisonné*, vol. 4: *Paintings and Sculptures Late 1974–1976* (London: Phaidon, 2014), 494–6.

Russell Means story and Warhol's series of portraits follows a similar format and narrative sequencing to that of the *Race Riot* segment in episode two. Once again it is Penny Arcade who guides us into the narrative: Warhol, she explains, understood that this period of the 1970s was a quest for "liberation and equality" and that "he was not immune to the individuality and power of certain people." In 1976, Means had been arrested for his role in the seventy-one-day protest in 1973, covered extensively in the news, at the site of the Wounded Knee Massacre of 1890 in South Dakota.[66] The inclusion of archival BBC footage of the protest in the program bears comparison with the Birmingham protests through the way in which the editing prepares us to view Warhol's art. In the *Race Riot* sequence, we are repeatedly visually reminded of news and photographic footage of the violent atrocities that Warhol transposed onto his canvas; in the *American Indian* footage we are constantly drawn in by the edit to Means's face. He is shown close-up in archival footage, the camera zooming in and with a slow tracking shot across a black-and-white photograph of his upper chest and face in a similar framing that Warhol uses for his portrait. This imagery is intercut with contemporary interview footage of his son, the activist, actor, boxer, comedian, and entrepreneur Tatanka Means, reinforcing that his father had been the "stand out" leader of AIM and used "everything he could to bring awareness of the Native Americans at the time." Echoing Martin Luther King's impassioned speech at the start of the *Race Riot* segment in the previous episode, there are then three clips of Means making powerful speeches on the oppressions of Native Americans to a background soundtrack of John Kangos's "He's Gonna Step on You Again" (1971). Each segment was edited from archival film footage and again focuses on a close-up of his face. Building up dramatic effect, the first is intercut with drumming and then the screen is filled with Means's face in profile as he says, "Hopefully within the next few years we will see the birth, the rebirth, of total Indian sovereignty in this country." With his second statement, "The White Man can't afford to face the truth about what he has done in this country. We have no rights as human beings," we see him positioned against the site of the Wounded Knee Massacre and a black-and-white photographic still of him having "war paint" applied.[67] The third

[66] The American Indian Movement armed occupation of Wounded Knee, on the site of the massacre of Native Americans by US soldiers in the late nineteenth century, lasted seventy-one days and began on February 27, 1973, when 200 AIM-led Sioux seized control of Wounded Knee.

[67] "Crow Dog mixed a special red paint made from grinding certain rocks and offered to mark every man among us who was willing to fight to the death … Each … accepted a single line daubed across the cheeks and the bridge of the nose, just below the eyes"; Russell Means with Marvin J. Wolf, *Where White Men Fear to Tread*, 274.

statement from Means gives more visual context with cuts to federal agents and Native Americans bearing arms while acknowledging, as he addresses the camera, "We knew that when we came here, we would probably be massacred, and we are preparing to die. Whether we get massacred or not we will still win." Means's son then provides us with the context, as he reads directly to camera the key points of the siege: "Thousands of shots were fired, two Indians were killed, and an agent was paralyzed. Russell Means and his fellow protest leaders were charged with assault, larceny and conspiracy." As he finishes reading with the background track of "India" by the Psychedelic Furs (1980), the camera provides a slow zoom to a black-and-white archival photograph of Means looking down with a contemplative expression on his face.

One of the challenges with television documentary is in the choices made about continuity, how the narrative flows from shot to shot. The aim of *Andy Warhol's America* was to have Warhol center stage and for this to be a translation to screen of Warhol's intentions. Thus, there needed to be a clear pathway from the highly emotive protest highlighting the plight of Native Americans to an explanation of why Warhol felt driven to embark on his Means portraits, and the editing of the interviews, footage of a historic event and Warhol's art all needed to be condensed to a few minutes.[68]

We are first introduced to a 1977 version of Warhol's painting *The American Indian (Russell Means)* with a tracking shot that moves slowly from his torso up to his face while we hear Penny Arcade saying, "It's irrefutable dignity, but I mean it's fierce, it's also raw, it's also very stripped away. I mean I think Andy always sought simplicity. His work was kind of like an X-ray." We are focused by the camera on Means's face. The camera then cuts to another painting of Means, from 1976, where the face is almost portrayed in negative—it is dark, against a bright yellow background as if he is standing against the sun. This is the image we see when Arcade says the word "X-ray." In the final portrait of Means that we see on the screen, this time from 1977, the painting is much more colorful (Figure 7.4), and a comment by Gopnik begins to hint at the very complexity of the portrait-sitting and Warhol's often subversive use of color. Gopnik tells us that one of the things that interested him in particular,

[68] Although much of the coverage was of the Wounded Knee standoff, the journalist Kevin McKiernan commented that the real experience was the religious ceremonies: "The real center of that experience for me was a spiritual one because of the daily sweat lodges and the other ceremonies that took place there. People really understood that their religion was under attack"; https://listen.sdpb.org/arts-life/2023-01-18/wounded-knee-standoff-50th-anniversary.

is that in a lot of the pictures of Russell Means, the color that's supposed to represent his face slips off the actual image of his face. It's as though his race, his coloring, his status, as what would have still been called in those days a "Red Indian," slips off. It's not something true, it's not something melded to his persona and that I think is interesting.[69]

When we look closely at the images, it is the face of Means and his expression that lures us in, both on the television and in front of the paintings themselves. In each one there are brushstrokes of paint on his face on the right-hand side that Gopnik is alluding to. Neil Printz observes that Means's style of dress and adornment was "Not strictly traditional nor particularly identified with the Lakota ancestry but rather had come into fashion in the 1970s as an expression of American Indian pride."[70] Means's face in his portraits is treated differently from the preceding footage of the *Mao* series; it is more subdued, yet the perimeters of his head are marked by crescents and stripes rather than, as Printz describes, the "psychoactive center."[71] Bands of color emphasize his braids, his neck, and leather braid ties, with the front part of his clothes almost becoming like a breastplate.

There is, however, in the short sequence no other discussion or pursuit of the implications of Gopnik's statement, of Means's background, or of his own relationship to his identity. Rather, what we hear is a particular strategic television shorthand, each word and image selected to alert our curiosity. Douglas Chrismas of the controversial ACE Gallery in Los Angeles tells us that Warhol had wanted to do a portrait "that would hold up in time, historically, about this man who was a very powerful communicator for the North American Indian cause." According to Chrismas,

> I remember I asked Andy, what is your biggest desire to paint? ... He said, "I wanna do an American Indian series." Then when [Andy] saw the images of Russell ... [he] responded big time ... and wanted to do it immediately, so I shot from the hip and I said: "Twelve big paintings,

[69] This comment hints at Means's background. Although he was born on the Pine Ridge (Native American Reservation), when he was three, in 1942, the family moved to Vallejo, California. Means later commented: "So thanks to my mother's courage and foresight, I didn't have to grow up as a reservation Indian cruelly trapped and systematically abused. Instead I would grow up with many of the opportunities available to white Americans—and I would learn firsthand about American racism"; Means and Wolf, *Where White Men Fear to Tread*, 22.
[70] See Printz and King-Nero, *Andy Warhol Catalogue Raisonné*, vol. 4, 495.
[71] See Printz and King-Nero, *Andy Warhol Catalogue Raisonné*, vol. 4, 504.

twenty-four medium-size paintings, and with that we can select out and do multiple exhibitions."[72]

By 1976, Means would have been an obvious choice for Warhol for a number of reasons, and not least because he was the "face" of the modern Indigenous resistance movement. Warhol's enthusiasm to create portraits of Means led to a business arrangement with Chrismas, resulting in several exhibitions. The *American Indian (Russell Means)* series eventually consisted of twenty-six 50 × 42 inch and twelve 84 × 70 inch portraits as well as twenty-three drawings.

The segment plays out with Tatanka Means suggesting that although his father was not impressed by the portrait, "he did like Andy as a businessman and thought he was a better businessman than an artist," a point supported within the documentary by the references to exhibitions of the portraits and the circumstances of the arrangements with Chrismas. This information, and a quote from the *Philosophy of Andy Warhol* that making money is art and working is art and "good business is the best art" to the music of "King in a Catholic Style" by China Crisis (1985) leads us to the next storyline.

We are as viewers given a finely tuned synopsis of the translation of both the story of Means's activism in the moving imagery and examples of his artworks. In 1976 Warhol was not emotionally, physically, or financially in the same position as in 1963. In 1968 he had been shot by Valerie Solanas and nearly died.[73] The optimism of the 1960s had dissipated and Warhol was reinventing himself as a "business artist," with a manager and an entourage charged with getting him portrait commissions.

In his essay on Warhol's portraits of Means, Gregg Deal argues that they are on the one hand symbolic of America's need to "see, recognize and hopefully reconcile a modern indigenous person's place in America," while on the other they represent "the consumption of the indigenous image."[74] Warhol's canvases of Means provided a point of intersection between American culture, history, politics, and society and the challenge for the producers was how to convey

[72] Chrismas entered into an exclusive option with Warhol to exhibit and sell the paintings over a ten-year period. Chrismas organized three exhibitions: at FIAC, Paris, October 1976; Ace Vancouver, November–December 1976; and Ace Los Angeles, February–March 1977. He also lent and consigned paintings to museum and gallery exhibitions, including at the Musée d'art et d'histoire, Geneva, October–January 1976-7, the Kunsthaus, Zurich, May–July 1978, and the Louisiana Museum, Humlebæk, October–November 1978.

[73] Episodes two and three of *Andy Warhol's America* cover Warhol's shooting, including archival footage. The shooting and its impact on Warhol has been discussed extensively, including in Bockris, *Warhol*, 296–312, and Gopnik, *Warhol*, especially 614–32.

[74] Gregg Deal, "The American Indian (Russell Means)," in *Warhol and the West*, ed. heather ahtone, Faith Brower, and Seth Hopkins (Berkeley: University of California Press, 2019), 71, 68.

the moral complexities "without the program becoming congested."[75] How are we introduced to Warhol's portraits of Means on screen and what might have been missed in the multifarious edited components that expose gaps in the translation? When Chrismas contacted Means to ask him to pose for Warhol, Means was in prison.[76] With this information as a dramatic lead into the context, we are then shown a series of the portraits. The only indication that the work originated with Warhol taking Polaroids is the sound of a camera shutter click. Do we need to see how Warhol transformed the image in his process of screening and adding paint and interpretive color from the selected image that he eventually chose out of the numerous photographs he took?[77] On the screen we are not shown any of these Polaroids, in which Means strikes a variety of poses, looking straight into the camera and to the left and right, composed and clearly someone who is comfortable being photographed.[78] Gregg Deal, whose mother was a Native American, claims that the portraits were important not only because they were created during the struggle of American Indians for equal rights but also because "America was seeing our faces for the first time, and the idea of Natives" as "modern living" beings.[79]

There is a compelling backstory that does not make the translation onto the screen due to the constraints of time and flow of the narrative. For Warhol, Native American art was a subject in which he had some investment. He amassed an extensive collection of Navajo Indian blankets, rugs, jewelry, baskets, beadwork, and other artifacts. This collection contained 650 items.[80]

[75] Cairney, interview with Jean Wainwright, January 10, 2022.
[76] Means and his friend Dick Marshall had been charged with the murder of Martin Montileaux on March 7, 1975, in a saloon just inside the Pine Ridge Reservation. In *Where White Men Fear to Tread*, Means notes, "For weeks I had been dickering with Doug Chrismas and Andy Warhol about when to do my portrait. Just before testimony began on the trial, I told them 'I might be put away for the rest of my life, or I might be dead. Better to do it now'"; see Printz and King-Nero, *Andy Warhol Catalogue Raisonné*, vol. 4, 494.
[77] Printz suggests that the photographs of Russell Means were also part of an ongoing chronicle spurred by his acquisition of his Minox camera. Warhol marked one exposure and had a 10 × 8 inch enlargement made for inclusion in his *Exposures* book although it was not used in the end. See Printz and King-Nero, *Andy Warhol Catalogue Raisonné*, vol. 4, 485.
[78] See Printz and King-Nero, *Andy Warhol Catalogue Raisonné*, vol. 4, 494–6.
[79] Deal, "*The American Indian (Russell Means)*," 68.
[80] Ellen Napiura Taubman, who was the organizer of major American Indian art sales for Sotheby's, remembers Warhol as an "amateur, whose spread was greater than his power of analysis"; Ralph T. Coe, "American Indian Art," in *Possession Obsession: Andy Warhol and Collecting*, ed. John W. Smith (Pittsburgh: The Andy Warhol Museum, 2002), 115–16. Bob Ashton, the founder of *American Indian Magazine*, recalls that around 1972 or 1973, "one afternoon Andy Warhol and his entourage ... came to my shop. They asked to look at Navajo textiles. Andy was particularly interested in what is called a Moki (Hopi) blanket, in which a series of brown and blue stripes alternate with bands of red ravelled wool called bayeta running through the center"; Coe, "American Indian Art," 119.

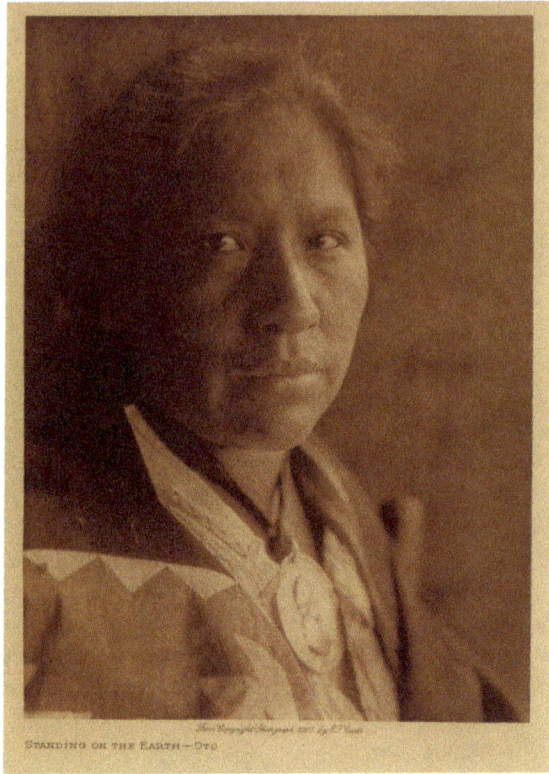

Figure 7.5 Edward S. Curtis (American 1868–1952), *Standing on the Earth–Oto*, 1927, photogravure, 9 × 6½ in. (22.86 × 16.51 cm). Courtesy Charles Deering McCormick Library of Special Collections and University Archives, Northwestern University Libraries.

Among them were a number of photogravures of Indigenous peoples of the United States by Edward S. Curtis. One, entitled *Standing on the Earth—Oto* (1927) (Figure 7.5), bears a remarkable similarity to the Means portraits.[81]

In her essay of 2019, "The American Indian and Warhol's Fantasy of an Indigenous Presence," heather ahtone provides a lengthy examination of

[81] The Sotheby's New York catalog, *Andy Warhol: American and European American Paintings, Drawings and Prints*, for the sales of April 29 and 30, 1988, includes, in item 2907, *The North American Indian*, volume 19, including thirty-four photogravures of Pacific Northwest Indians on vellum, one of which is this image.

the construction of Warhol's images of American Indians with particular reference to the photographs of Curtis, whose images were, she observes, "THE images of the West." She notes that Curtis's desire for his images to be recognized as American Indians was more important to him than for the image to represent "the truth of the subject," and that the American Indian community remained antagonized by Curtis and his project.[82] Neil Printz suggests that Warhol, similarly, was not interested in Means as a personality but as a regional type.[83] Warhol did, however, engage with him during the sitting. Means related in his autobiography that he had taken Warhol to a Puerto Rican club and later that evening Warhol had taken him to a "ritzy nightclub."[84] Warhol had invested time and energy producing a substantive number of portraits of Means. Although there is some loss of translation contributing to the entire backstory, once more it is the archival footage and clever editing with close-up shots of Means's face that makes a persuasive human link to the brightly colored portrait paintings. The fact that we have seen Warhol working on other bodies of work in the program, notably his *Mao* series where his technique is explained to camera, gives the viewer a comparison to see how different portrait series elicited different painterly responses. While the Russell Means portraits are presented with a more mask-like visage with only a few having any obvious brushstrokes on the skin of the face, the Mao portraits in contrast appear to have far more brushwork in that area, in bright colors.[85] However, although Means appeared with Warhol at the exhibitions put on by Douglas Chrismas in various cities, he does not describe his portrait-sitting in any detail in his autobiography, reducing it to a few lines.[86]

Andy Warhol's America is a translation of Warhol as a "bellwether" of American culture, as someone who, in the remit of the program, as emphasized by Jerry Hall in the repeated title sequences to each episode, would, if everything were destroyed except Warhol's work, "give you a very

[82] heather ahtone, "The American Indian and Warhol's Fantasy of an Indigenous Presence," in *Warhol and the West*, 33.
[83] Printz and King-Nero, *The Andy Warhol Catalogue Raisonné*, vol. 4, 493.
[84] Means and Wolf, *Where White Men Fear to Tread*, 362.
[85] In 1972 and 1973 Warhol produced five series of paintings, a portfolio of prints, and a series of drawings all based on the same image of Mao Zedong. "Warhol's early Mao series decisively breaches the hard-edged mechanical modality of his Pop style with a new series of paintings" that highlight the "actions of the hand, the marks of the brush, the material properties of the medium, and the optical effects of color"; Neil Printz and Sally King-Nero, eds., *The Andy Warhol Catalogue Raisonné*, vol. 3: *Paintings and Sculptures 1970–1974* (London: Phaidon, 2010), 167.
[86] See Means and Wolf, *Where White Men Fear to Tread*, 356, 361–2.

good idea of America." A number of storylines in the program comprise the translation: one is the context of American history and certain key events that the producers emphasize; a second is how the work of Warhol is encapsulated and brought to life through footage and eyewitness accounts and interviews; and a third is the artworks that are translated on screen.

When you watch television programs, there is an imposed linear format. *Andy Warhol's America*, with its three distinct but interlocking episodes, is connecting with an audience who may have seen Warhol's artworks garnering record saleroom prices, or who know him from an art-historical viewpoint, or who have seen his work in museums, galleries, private collections, or through their circulation within popular culture. We are, in *Andy Warhol's America*, propelled along with the producers' preconceived narrative, seeing Warhol's translation of American history into his art as packaged through a number of filmic stratagems. Television can be, as Cairney acknowledges, "extraordinarily manipulative," and what it should be doing is "forcing [us] to think about what [people] are saying in the different way … it reframes everything and makes Warhol feel more contemporary."[87]

Reflecting this statement was the handling in *Andy Warhol's America* of the *Race Riots* and the portraits of *The American Indian (Russell Means)*. Significantly, as already noted here, these works had not featured in previous television documentaries on Warhol. A television documentary translation does of course contain bias, based on such choices. It is selective, with a dominant narrative, to which interviewees' opinions and counter-opinions contribute. The soundtracks and choice of music lift the narrative or suggest a mood. The material is manipulated and condensed and transformed by the vision of the director and producers. It is a "semantic and iconographic coherence."[88] This cohesion encompasses all the visual and aural effects, including short quotes from Warhol's books, both narrated and shown on the screen (see Figure 1.4). There are essential differences in the translation from one medium to another. Written biographies and texts on Warhol are not set to a musical score. There are not the numerous nuanced visual devices that add subtle narratives. Part of the translation process is the embedding of narrative clues in the cold open sequence, such as that "Warhol was like a reporter" (Robert Heide), that there is "something essential about Andy Warhol, it is this very American story" (Jeffrey Deitch), that "he was blowing up everything so we could see it" (Eve Ensler, also known as V). These ideas

[87] Cairney, interview with Jean Wainwright, January 10, 2022.
[88] Cristina Valdés and Adrián Fuentes Luque, "Coherence in Translated Television Commercials," *European Journal of English Studies* 12, no. 2 (August 2008): 133–48.

then are stored in our memory bank and when we come to the segment of the story they relate to, we recognize the thread and make links.

The aim of *Andy Warhol's America* is to persuade us that Warhol was an interpreter, a "history painter," someone who Whately believed was a "cypher" who appropriated, translated, and repositioned our focus and dissipated our traumatic responses through his art. Whately translates him for us, but like Warhol's early canvas *Crossword*, of 1961, we do not have access to all the clues.

The biggest translation challenge is the edit. How much can be cut while still retaining the essence of the story? When we see the *Race Riot* or *Russell Means* paintings as they appear on our screens, we are being guided by editorial decisions and the fact that, unlike in a book where we are able to navigate backwards and forwards through the text, moving, reading, and evaluating at our own pace, in television (unless we stop and rewind) we move swiftly through the carefully selected filmic constructions, often at a relentless pace. Nothing is incidental; everything has been pared down to be essential to the storyline. While we absorb one story, we are swiftly led into the next, the editing "heartbeat." Interviewees, who may have been filmed from forty-five minutes to over two days, are reduced to the essential components of what they are saying, a form of brutal synopsis. What the filmmakers consider to be the most powerful statements make the edit to screen, and these ultimately create a bias, their statements having inevitable gravitas. There is, as Whately describes, the need to balance different voices, different points of view. These are televised counterpoints: "It's the grammar of film," he suggests, "what words fit together and what sentences fit together … the musicality of it, the light and shade of the entire filmic score."[89] The pace of the episodes, the highs and lows—for example we move from the *Race Riots* to a Kennedy sequence with Bockris intoning that "at that point the American Dream still exists." The use of links, whether spoken or visual, are an essential component in the translation, as is the real-time making of the program. As he moved through the process from scripting to filming to directing and editing the programs, Whately found revelations that surprised him, that went against the impression that he had when he first began researching. He had no idea that Warhol worked in a soup kitchen in New York serving food to the poor, and he was not aware of his interest in Russell Means. He initially thought Warhol was "more of a sensationalist, more of an opportunist, probably not as nice as I think he is now … he's such a deeply complex character. There are as many views on him as there are books on

[89] Whately, interview with Jean Wainwright, December 20, 2021.

him."⁹⁰ Ultimately that is one of the biggest challenges of translating him for the screen.

For Cairney there was nobody better than Warhol as a lens onto American culture, and he suggests that the sequences for both the *Race Riots* and *Russell Means* portraits illustrate that he:

> ... always has one foot inside and one foot outside culture ... he manages to shape-shift in that way. He has an eye for people who are disenfranchised, or who are outliers. I think that's why, for the purposes of our series, you have so many great stories, because he's drawn over and over again to people who are hard done by, whose plight may be well known, but the balance hasn't been redressed.⁹¹

Cairney's words underscore how *Andy Warhol's America* reflects our particular contemporary vantage point. Cairney agrees that while you are breathing life into the images, you are not "talking about paint and its handling, you are not talking about framing or impasto or gestural brushwork and because you're not, all that goes out of the window."⁹² The artmaking process, then, perhaps is one aspect of Warhol's work lost in this translation. However, in its translation, *Andy Warhol's America* gives us a focus on the significance of the actual events Warhol was responding to, and we reconnect with the "real." As Cairney emphasizes, the program answers the questions, what happened on that day when those protesters were viciously attacked? Who was involved in the *Russell Means* commission and what impression did the portrait make? Cairney believes that

> coming at the program through an historical rather than through an art-historical lens, it does so much more heavy lifting for you. The film becomes a kind of re-populated landscape, you feel as if you are there. The program has to somehow relate to the lives of the viewers. They need to find a contextual and contemporary resting place, whether to do with gender or race or violence, celebrity or identity.⁹³

Medium specificity is something that Warhol embraced his entire working life. There are losses or omissions in the translation that lie somewhere "on the cutting room floor": the hundreds of versions of the script, numerous

⁹⁰ Whately, interview with Jean Wainwright, December 20, 2021.
⁹¹ Cairney, interview with Jean Wainwright, January 10, 2022.
⁹² Cairney, interview with Jean Wainwright, January 10, 2022.
⁹³ Cairney, interview with Jean Wainwright, January 10, 2022.

hours of interview footage, the huge task of trawling through archival footage, picture libraries, museums, books, and biographies on Warhol—all reduced to three hours of television viewing. Yet when you watch the three episodes, you are reminded of the vibrancy of the medium, the viewing sensation it can provide, the crafted presentation, the way that the images are brought to life—a reminder that translations, particularly from one medium to another, can provide a different narrative and emphasis, and in this case a discourse using a distinct visual and aural vocabulary. What is gained by the particular translation in *Andy Warhol's America* is that we are propelled back to Birmingham, Alabama, and then see Warhol's resulting images; we see Russell Means protesting and the context of how his portrait came to be made. What is lost is that we are not shown Warhol's decisions, the crops and layout of the *Pink Race Riot* [*Red Race Riot*] or *Mustard Race Riot*; we do not have an art historian giving an in-depth critique of the work—but then that would have been a different program. Nor are we shown that Warhol took numerous Polaroid photographs of Russell Means, or the commentary that he produced on sitting for the portrait. But I would argue there is a balance, and what may be lost is balanced by a translation that gives us a different, multifaceted viewpoint on Warhol's work.

8

Translating Warhol to India

Deven M. Patel

I address this collection's thematic thread from the point of view of a translator of premodern Indian literature and as a student of theories on translation. Andy Warhol's writings have currently not been translated from American English into *another* Indian language, English being firmly counted as an Indian language at this point in history. Unlike bringing Warhol's words to a Chinese setting, about which Reva Wolf and Kou Huaiyu have cogently written,[1] the challenges of translating them to Indian contexts are complicated by several facts of language and culture in Indian metropoles—dating as far back as the 1970s—where Indians could and can ably receive Warhol, more or less, through the original American idiom. However, even the experience of urban Indians five decades ago is a far cry from that of contemporary citizens in Western, Central, or Eastern Europe, where Warhol's writings were translated into a local language. In this regard, Wolf addresses the situation that explicitly marks the alterity of Chinese in Warhol translations: "Translations of Warhol's writings appeared at an earlier date in countries where, due to historical circumstances, the cultural gaps with the U.S. are smaller than in China, and the language less radically distinct."[2] The fact that English is more widely understood (if not with active competence, at least passively) in India obviates the need to "translate" Warhol for cosmopolitan Indians who want to read his writings. However, from an "intercultural communication" point of view, Warhol's reception in India four or five decades ago would certainly diverge from the one in Europe during the same era, where the culture of Pop, while not squarely consonant with America's, certainly resonates deeper than the experience of 1970s and 1980s India.

[1] Reva Wolf and Kou Huaiyu, "Cosmic Jokes and Tangerine Flake: Translating Andy Warhol's *POPism*," in *Complementary Modernisms in China and the United States: Art as Life/Art as Idea*, ed. Zhang Jian and Bruce Robertson (Goleta, CA: Punctum Books, 2020), 82–98.

[2] Wolf and Kou, "Cosmic Jokes," 96.

While Wolf and Kou's collaborative essay compellingly underlines the need for and the challenges of translating Warhol (himself) and writing about Warhol into Mandarin, what can be said for would-be translations into modern Indian languages for modern Indians who could respond to Warhol—however approximately—in the original American English itself? In beginning to reflect on how one might take on the formidable challenge of translating Andy Warhol's writings into an indigenous Indian language, I am reminded of an experience-laden adage of A. K. Ramanujan, a well-known scholar-translator of premodern Indian literature, who strategically explains that "only a poem can translate a poem."[3] Ramanujan's point speaks to both theory and practice—as he simultaneously recognizes the incommensurability of translation *in theory* while actually composing numerous translations of Tamil and Kannada poems that can stand as English poems in their own right. In the context of translating Warhol's writings (or writings about Warhol) into an Indian language that is not English, however, one may unironically suggest that only an Andy Warhol can translate an Andy Warhol. While wholly conjectural, as no translation has been attempted to the best of my knowledge, one plausible reason to do a translation may lie in the fact that access or interest in American-English competency is not universal. A more persuasive argument for a translation would be that, as Wolf and Kou point out, the complications that Warhol translations manifest are themselves fascinating in their own right as they reveal the enormous cultural gaps that still need to be surmounted if global cultures are to translate themselves to each other.

Distilling the difficulties inherent in translating Warhol's *POPism* into Mandarin, Wolf writes:

> Four types of language featured in this book caused some of the most fascinating translation difficulties and will be the focus of my discussion: a.) time-bound terms; b.) inventive uses of colloquialisms; c.) unusual names of places and people; and d.) historically specific descriptions and allusions.[4]

These four features that obstruct the translator's task are magnified by the cultural differences that need to be negotiated in order to bring the Pop modernist culture of 1960s New York to twenty-first-century China. The examples Wolf gives from *POPism* to highlight Warhol's inflections on what

[3] A. K. Ramanujan, *Poems of Love and War: From the Eight Anthologies and the Ten Long Poems of Classical Tamil* (New York: Columbia University Press, 1985), 296.
[4] Wolf and Kou, "Cosmic Jokes," 86.

are already knotty time-bound colloquialisms and idioms ("cosmic joke," "tangerine flake," and "wrong side of the limousine," for example) demonstrate the gulf that translators must cross to make it happen. Even when a translator finds a way to transume Warhol's words on the most surface level, they still have to sensibly translate them for the target culture.[5]

From Andy Warhol's *Diaries*—a collaboration of Warhol and his assistant, diarist, and editor Pat Hackett—one identifies numerous examples where the prospect of rendering the literal, figurative, and even stylistic sense would make most translators throw up their hands in frustration. For instance, in an entry for Monday, January 16, 1978, Warhol writes: "Went home, glued, and then walked over to Quo Vadis to meet ... "[6] According to Hackett, "glued" or "gluing" was Warhol's term for "washing his face, adjusting the silver 'hair' that was his trademark, and maybe, *maybe*, changing his clothes."[7] For the translator, this neologism constitutes a.) and b.) of the above list given by Wolf: it is both time-bound and an inventive use of a colloquialism. As Hackett notes, the aim in the *Diaries* was not to "translate" these kinds of words for the reader, nor to explain the names of places and people that ubiquitously pop up in its pages:

> The Diary does not include a glossary because explanations of who people were in relation to Andy would go against—if not actually betray—the sensibility of what he was about and the unstructured world he generated around him. Andy was about not putting people into categories—he was about letting them cross in and out of categories. The people in his sixties "underground" movies were called "superstars," but what exactly did that mean? It could refer to the most beautiful model in New York or the delivery boy who brought her a pack of cigarettes during filming and wound up in front of the rolling camera.[8]

Peripheral to finding the rather easy equivalence for "superstar" (perhaps by not translating it at all) is the requirement to somehow bring Warhol's

[5] Wolf explicates the inherent difficulties in and strategies for translating Warhol's idioms: "An idiomatic expression can have multiple meanings, as well may the altered idiom 'wrong side of the limousine.' To translate an idiom is hard; to translate one that has been transformed, as this one has, is that much more difficult. Translation theorists have proposed three principles for translating idioms: 1.) do not treat idioms too literally; 2.) look for equivalencies in the target language that will convey the meaning to your audience; and 3.) maintain the 'artistic' or 'original rhetorical effect' as much as possible"; Wolf and Kou, "Cosmic Jokes," 91.
[6] Pat Hackett, ed., *The Andy Warhol Diaries* (New York: Warner Books, 1989), 99.
[7] Hackett, *The Andy Warhol Diaries*, xvi.
[8] Hackett, *The Andy Warhol Diaries*, xviii.

inflection of this usage—which Hackett herself wonders about—into the translation. However, the lack of editorial explanation in the *Diaries*—philosophically, not practically, determined—makes the translator's job doubly arduous, especially if they strive to be faithful to the format and spirit of the work so that, as Hackett explains, "the flow of Andy's own voice with its peculiar locutions could be preserved uninterrupted ... [to avoid] the jarring effect [annotations] would have on Andy's personal tone and the needlessly distancing effect they would have on the reader."[9]

Naturally, this outlook clashes with the scholarly translator's impulses, which are to supplement an otherwise literal translation with prefaces, textual and interpretive notes, and scholarly commentary to frame foreign elements. Hackett justifies the lack of annotation in the *Diaries* as follows: "To Andy, putting things in a format that made sense was enough of a compromise."[10] Inverting this tactic, Ramanujan, as one scholar explains, conceived of translation "as a multi-dimensional process in which the translator has to deal with his or her material, means, resources and objectives at several levels simultaneously."[11] His translations accordingly demonstrate a sensitivity to balancing literal representations with transpositions of the source language's syntax, design, structure, shaping principle, poetic core, surface, and deep structure of discourse. Reading Ramanujan's translations reveals that he was especially gifted with the ability to attentively reform the visual presentation of the original source text—usually linear in the manuscript—into a graphically shaped English translation, executing the act of translation as simultaneously a form of creative image-making. For example, here is the shape Ramanujan gives to a Tamil poem numbered 113 of the Aiṅkuṟunūṟu collection and attributed to a poet named Ammūvaṉār:

Yesterday,
some people of this town
said about me,
she is the woman
of that man from the seashore

 where great waves break
 on the white sands.

[9] Hackett, *The Andy Warhol Diaries*, xix.
[10] Hackett, *The Andy Warhol Diaries*, xix.
[11] Vinay Dharwadker, "A.K. Ramanujan's Theory and Practice of Translation," in *Postcolonial Translation: Theory and Practice*, ed. Susan Bassnett and Harish Trivedi (London and New York: Routledge, 1999), 115.

Mother heard it
and asked me,
>"Is that true?"

I said, under my breath,
"I'm burning."[12]

In translations such as these from the Tamil (or Kannada elsewhere), Ramanujan aptly negotiated the communicative intersection and tension between representing and appropriating the original source. The first- and second-level indentations invariably carry a hermeneutic logic to best facilitate appreciation for an English-language reader. As Ramanujan aims as close as he can toward a pure language that does not prioritize particular features of language or ideas but rather remains as transparent as possible, he explicates a higher logic that underwrites his translation procedure in the following manner:

> The originals would not speak freely through the translations to present-day readers if the renderings were not in modern English, and if they were not poems themselves in some sense. By the same token, the translations had to be close, as close as my sense of English and Tamil would allow.[13]

As a translator drawing together the nonverbal systems implied in the Tamil with the given verbal system, Ramanujan strives to deliver connotations and culture-specific aesthetics and semiotics to the modern reader. Recognizing the ultimately unsatisfying results of cross-cultural translation, however, he also offers this world-weary realization: "Translations are never finished, only abandoned."[14]

The difficulties that Ramanujan faced to transparently translate premodern India to the American reader would only intensify were a would-be translator to follow Ramanujan's approach and attempt to translate Warhol's writings into an Indian language. A glaring reason for this lies in Warhol's own desire to *not* be transparent in his verbal expressions but rather to inflect the literal to such a degree as to necessitate the framing addenda, prefaces, footnotes, and paratextual commentary that Ramanujan also had to grudgingly include in order to make things sensible. For Warhol's *Diaries*, the "what you see

[12] Ramanujan, *Poems of Love and War*, 38.
[13] This passage occurs in Ramanujan's *The Interior Landscape* (1967), and is quoted in Dharwadker, "A.K. Ramanujan's Theory and Practice of Translation," 119.
[14] Ramanujan, *Poems of Love and War*, xv.

is what you get" effect, unmediated by context, was indispensable to its effectiveness. Ramanujan, on the other hand, despite his urge to give as little mediation as necessary and make the Indian poem an American one, was forced into scholarly commentary. Faced with the inability to transparently merge a premodern Indian language into an expressive American English, his recourse is to translate both a text and a reader: "A translator hopes not only to translate a text, but hopes (against all odds) to translate a non-native reader into a native one."[15] One presumes that translating Warhol in another language without profuse annotation would thrust a translator into a similar predicament, especially if even an editor-scribe like Hackett found it a subject worthy of serious debate.

A further complication arises when one considers the translation of Warhol's visual language and persona, absolutely necessary for any kind of cross-cultural communication of his writings.[16] Here, it becomes not only about translating the visual language into a verbal language but the visual language that reflects the artist as persona into a verbal language that is resisted at every turn by the discursive elusiveness of art, artist, artist's meta-reflection, and ultimately critical nourishment to that artist's meta-reflections. Beyond the words, connotations, and embedded historical contexts lie planted confusions, quasi-rational ambiguities, far-flung allusions, and, of course, Warhol's own iconicity. On the face of it, then, translating Warhol's writings into an Indian language feels like a ridiculously impossible (and unnecessary) task that, nevertheless, could potentially yield a rich field for understanding the possibilities for cross-cultural translation. Optimistically, however, if we return to Ramanujan's precept (only a poem can translate a poem), perhaps the case of Indian artists associated with Warhol's Pop art can offer insight to the translator.

The contemporary Indian artist Durga Kainthola, whose 2005 exhibition entitled *The Art Factory 2* was a tribute to Andy Warhol, addressed a *Times of India* newspaper reporter's question about Warhol's inspiration to her work as follows:

> It was in 1982 that I first saw a Marilyn Monroe diptych by Warhol in a book at the JJ library. However, understanding the spirit of Warhol's

[15] This passage occurs in Ramanujan's Translator Notes to *Samkskāra*, quoted in Dharwadker, "A.K. Ramanujan's Theory and Practice of Translation," 121–2.

[16] A recent essay on Warhol's persona makes this point explicitly: "the apparently intractable relation between the verbal and material aspects of Warhol's oeuvre ... are bound up in the artist's persona—it is as if, thanks to the Warhol persona, it were quite impossible or unthinkable to put Warhol's words aside, even just for a moment, so one could look first"; Carmen Merport Quiñones, "Reading Color: Looking Through Language in Warhol," *Criticism* 59, no. 4 (Fall 2017): 513.

work and letting it seep into my work was a 20-year journey. My present collection is a culmination of that journey.[17]

A generation earlier, another artist, named Bhupen Khakhar, famously introduced (along with others) Pop to the then-Bombay art world. Khakhar's case is terrifically fecund for exploring cross-cultural translations of Warhol, and I draw upon the work of the curator and art historian Beth Citron on Khakhar and Warhol to draw out some relevant observations about translation. Khakhar has been called India's first Pop artist, sharing with Warhol and other Pop artists explorations of mass reproduction as well as experimenting with live art and performance along with a carefully cultivated persona (Figure 8.1). According to Citron, Khakhar's sartorial choices in photographs, along with his performative poses and allusions, palpably educe Warhol's image:

> Though Khakhar's conceptual and visual reference to Warhol is hardly altered, except for the clothing, the allusion went unspoken by Khakhar's peers and audience. He certainly would not have drawn attention to it

Figure 8.1 Bhupen Khakhar, *Truth Is Beauty and Beauty Is God*, exhibition catalog/artist book, offset printing on paper, 1972, 7–8. Image courtesy: Chemould Archives, Mumbai, India.

[17] Quoted in Binal Zaveri, "India's answer to Warhol," *The Times of India*, June 16, 2005, A9.

himself, as the subtlety of his self-fashioning lay in his projection of simplicity belied by the casual ease with which he appropriated his sources ... While these gestures may appear subtle and conservative in comparison to many antics of Warhol and others, it must be reminded that they would have seemed forward in the Indian public context of the 1970s.[18]

While Khakhar's meta-performative mimicry of Warhol may suggest a layer of cross-cultural translational remove that, on the one hand, indicates an inability for Pop to be sensible in an Indian context, it may otherwise demonstrate the quality of reproducing celebrity in strikingly affecting ways that quintessentially characterizes a Warhol aesthetic. Khakhar's "artistic quotation" of Warhol, as Citron aptly puts it, constitutes a translation of sorts. From a literary-critical and translational perspective, Citron's phrase-invoking quotation reminds one of Ramanujan's "long-lasting principles as a writer and scholar," as Vinay Dharwadker notes to explain Ramanujan's inheritance from Walter Benjamin: "the idea that the ideal critical essay would consist entirely of quotations."[19] Perhaps Khakhar translates Warhol in the only possible way one can: not in a literary sense, where only a poem can translate another poem, but rather, in a multimodal sense, in which only a persona could translate another persona (Figure 8.2).[20]

The need to translate a persona only underscores the information that is drained from the transaction, in Khakhar's case articulated in the ironic reversal of actual circumstances while strategically maintaining the form. This is a constant struggle in the visual and linguistic forms of translation where

[18] Beth Citron, "Bhupen Khakhar's 'Pop' in India, 1970–1972," *Art Journal* 71, no. 2 (Summer 2012): 55.

[19] See Dharwadker, "A.K. Ramanujan's Theory and Practice of Translation," 126–7, where he enlarges the point that "Ramanujan's major essays ... are all structured explicitly as Benjaminian 'anthologies of quotations.'"

[20] Citron elaborates on this point as follows: "As an exercise in artistic quotation, Khakhar's simulations of Warhol's self-portrayal, affect, and relationship with Sedgwick indicate control over the sources of his choosing. They showed that he could appropriate ideas from Pop just as casually as he could from Indian and historical sources. Yet his engagement with Warhol has a more pointed significance: Khakhar is not quoting Warhol's artwork, but Warhol's persona. In one sense, this directly follows the dictates of Pop: use of Warhol in these photos has a priori freed Khakhar from the constraints of originality. At the same time, paradoxically, Khakhar's gesture is wholly at odds with the pretense of one-dimensionality that Pop demanded. Unlike the quotation of an iconographic element or painting style, which could seem flat and superficial, Khakhar's mimicking of Warhol required his own—three-dimensional and unique—body and image, even though the product was a series of photos printed in a flat, mass-produced catalogue"; Citron, "Bhupen Khakhar's 'Pop' in India," 57.

Figure 8.2 Bhupen Khakhar, *Truth Is Beauty and Beauty Is God*, exhibition catalog/artist book, offset printing on paper, 1972, 15–16. Image courtesy: Chemould Archives, Mumbai, India.

contexts are never quite commensurable. Ostensibly, Khakhar's channeling of Warhol and other Pop artists signals a direct sort of explicit translation of the self-posturing manipulation of the sources, of the underlying politics of the act, and of the final product or reproduction of the image. In this regard, the surface itself gestures toward the depth of any implied message. Without the double work of a commentarial act whereby Warhol the artist is read into Warhol embodied in writing, the translation of the words probably remains without any semblance of translation with meaning.

The differences, however, between the conditions under which Warhol and Khakhar worked speak to how context also disrupts or, at least, interrupts any translational process. Citron details how the two artists came from different backgrounds, worked in different circumstances, and shaped or responded to a different set of social and political conditions. For instance, in commenting on Khakhar's photography and comparing his openness about his sexuality (Figure 8.3) and the facts of his livelihood with Warhol's, Citron writes:

> Revealing his homosexuality would have been even more fraught in the middle-class Gujarati society in which he also lived. In that sense, these photographs speak to Khakhar's desire to be like Warhol the person, more than just Warhol the artist. As Warhol had done, Khakhar manipulated the fact that he did not have a fine-art degree by posing

Figure 8.3 Bhupen Khakhar, *Truth Is Beauty and Beauty Is God*, exhibition catalog/artist book, offset printing on paper, 1972, 5–6. Image courtesy: Chemould Archives, Mumbai, India.

in ways other than as a "serious painter." Within the artwork Warhol presented himself as a businessman who ran a factory with workers. This indicates another ironic dimension in Khakhar's simulation because, unlike Warhol, he actually was involved in business through his accountancy. He considered issues of work and labor in his art, notably in the painting titled *Factory Strike* [see Figure 8.5].[21]

While Khakhar was able to translate into his own art world and cultural milieu some of the social and economic conditions that Pop artists in America operated under—breaking down "certain modernist barriers between the elite culture of high art and the democracy of the public arena"[22]—the significant divergences in their social and material experiences essentially made even this kind of translation virtually untenable. Some

[21] Citron, "Bhupen Khakhar's 'Pop' in India," 57.
[22] Citron elaborates on this point in the following way: "Through Pop, Khakhar was instrumental in creating a framework for artists in India to develop imagery and artistic languages from their local and everyday experiences, which could be contextualized and meaningful in Bombay's growing cosmopolitan art world. ... Khakhar's experimentations between 1970 and 1972 also enabled him to examine the interface between the elite art world and popular lower-and-middle-class urban cultures, critically informing his 'trade series' paintings begun in 1972"; Citron, "Bhupen Khakhar's 'Pop' in India," 61.

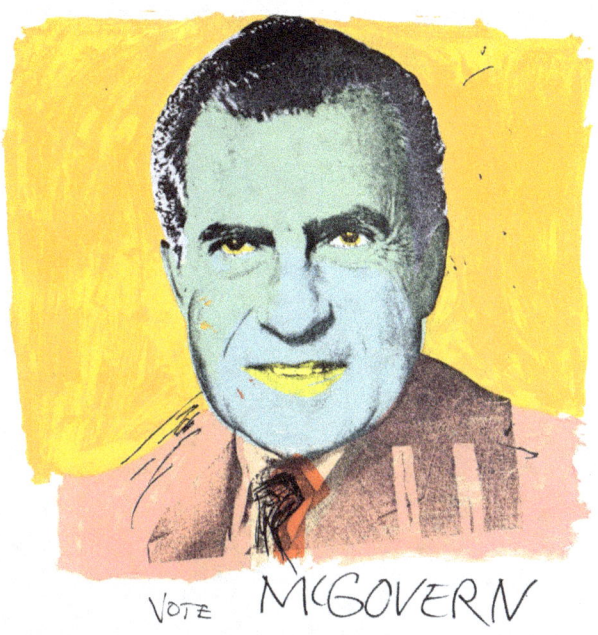

Figure 8.4 Andy Warhol, *Vote McGovern*, 1972, color screenprint, printed by Jeff Wasserman and published by Gemini G.E.L., 41$^{15}/_{16}$ × 41$^{15}/_{16}$ in. (106.5 × 106.5 cm), image. Whitney Museum of American Art, New York, 78.98, gift of Fred Mueller.

have also observed differences in the manner in which Warhol and Khakhar wove political critiques into their work. Both were sometimes thought to be apolitical but, it seems, neither, in fact, were; how to account for their oblique political gestures becomes an obvious translational difficulty, especially when moving across languages and cultures. How to speak, for instance, of Warhol's undivulged opinion of George McGovern's candidacy, even though he made a poster for his campaign (Figure 8.4), which Hackett evokes in her preface to the *Diaries*,[23] and Khakhar's perspective on India's conflict with Pakistan over Bangladesh, about which Citron speculates, in her analysis of one of Khakhar's paintings.[24] Or of Khakhar's *Factory Strike* (Figure 8.5)?

[23] Hackett, *The Andy Warhol Diaries*, xii.
[24] For an analysis of Khakhar's *My Mother and Father Going to Yatra*, in which the action of the painting is interpreted in light of "the tumultuous national politics of the time," see Citron, "Bhupen Khakhar's 'Pop' in India," 58.

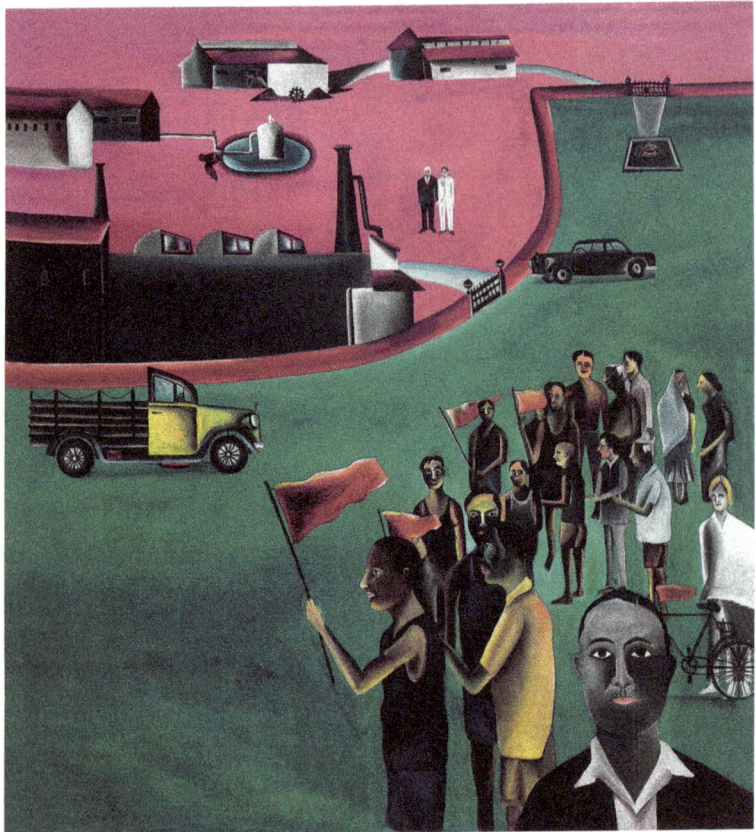

Figure 8.5 Bhupen Khakhar, *Factory Strike*, 1972, oil on canvas, 36 × 36 in. (91.4 × 91.4 cm). Collection Mala Marwah, New Delhi. Image courtesy: Chemould Archives, Mumbai, India.

According to Citron, Khakhar was part of a cultural milieu where artists were more "committed to creating and representing collective cultural identities for their new nation"; this commitment then extends beyond a binary lens of high brow and popular to include Indian "local imagery and ideas through the popular and everyday."[25] The classical/vernacular tension—both creative and fracturing, at turns—runs deep in premodern and contemporary Indian society, driven by the linguistic reality of India's stunning variety of dialects and regionally inflected speech worlds. Ramanujan, for instance, learned in multiple Indian languages, struggles in his formulation

[25] Citron, "Bhupen Khakhar's 'Pop' in India," 45.

of a translation strategy to account for this heterogeneity in translations of premodern cosmopolitan classical- and regional-language Indian texts into a modern American English, as each language *within* India also requires some measure of interlingual translation. Given the difficulties of locating points of translational intersection between the Pop world of Warhol and the Indian art culture of the time, the prospects for linguistic translation remain even more uncertain. An obvious obstacle of linguistic translation between cultures lies in the lack of a critical language to conceptually draw or interpret the two together. For example, even though the Indian artist's Pop activities were occurring along the lines of Warhol's Factory activities,[26] there was little in the way of interpreting them as such outside of the "art world," which Citron attributes

> partially to a lack of a critical language in India to interpret such interventions as art [as well as] little recognition of performance art (and the long traditions of street and other manner of popular performance informing it) in India's art discourses until recently."[27]

In light of specific Warhol language, such as a term like "gluing," for instance, which would be very difficult to translate intralingually into English without elaborate annotation, much less in a foreign language, Citron explains the ways in which "without critical definition, Khakhar's 'interventions' continued sporadically to be labeled 'happenings.'"[28]

Another set of decisions that a translator of Warhol must take, which Wolf highlights in her observations on delivering Warhol's writing in Mandarin, concerns "unusual names of places and people" and "historically specific descriptions and allusions."[29] Once again, Warhol's *Diaries* is replete with these entities. In the course of scanning strategies in Chinese to translate proper names, Wolf offers an interesting historical perspective of how translators nearly 1,500 years ago chose to transliterate, rather than translate, Indic names and places into Chinese: "It is noteworthy that in China, there is a long and interesting history of transliteration, or what is called 'not-translation' (*bùfān*), going back to sixth- and seventh-century translations of Buddhist scriptures."[30] While a modern practice of translation

[26] Geeta Kapur has described how Khakhar posed for photographs in absurd roles, wrote mischievous texts, donned fancy dress, and held fake salon parties; see Citron, "Bhupen Khakhar's 'Pop' in India," 50.
[27] Citron, "Bhupen Khakhar's 'Pop' in India," 50.
[28] Citron, "Bhupen Khakhar's 'Pop' in India," 53.
[29] Wolf and Kou, "Cosmic Jokes," 86.
[30] Wolf and Kou, "Cosmic Jokes," 91.

into widely used Indian languages resembles what Wolf suggests about historically premodern translation practices in China, interestingly, the case in premodern India had been to transliterate *and* translate into Sanskrit (or other such "classical" languages) people and places in culture-specific ways that retain phonetic and/or semantic properties of the original names being rendered. This habit also manifests in modern Sanskrit literary translations, many of which daringly attempt to modernize a premodern Sanskrit idiom. For example, the title of a 2009 Sanskrit translation of Shakespeare's *Hamlet* (by Sukhmay Mukhopadhyaya) is given as *Dinārka-rājakumāra-hema-lekha*, which literally translates to *The Golden Ray (hemalekha) that is the Prince (rājakumāra) of the Day's Sun (dinārka)*. A closer look reveals what the translator aims at: Hamlet (*hemalekha*), Prince (*rājakumāra*) of Denmark (*dinarka*). By consciously replicating, or at least subtly echoing, phonemes that reproduce "Hamlet, Prince of Denmark" in a syntactically and lexically syntonic form cognizable to the Sanskrit ear, the translator has both translated and not-translated, a sophisticated silliness that both Warhol and Khakhar might appreciate.

In addition to names, there is the problem of certain historically specific usages that are unstable even in the source language. For instance, in the preface to the *Diaries*, Hackett relates a peculiar anecdote about the use of the epithet "drag queen" in Warhol's *Interview* magazine:

> In the first issue, an interviewee had referred to a well-known movie critic who had just appeared in a Hollywood movie about a transsexual as a "drag queen." It was only after the issue was already off the presses that a lawyer advised that "drag queen" was libelous but that just plain "queen" would be fine. So ... [we] spent about six hours sitting in the front of the loft going through bundle after bundle of *inter/VIEW*s and crossing out the word "drag" with black felt-tip pens.[31]

In self-editing the very source that they created, Hackett and Warhol's team debated the legal propriety of a particular designation that is largely sensible only in the source language. To translate the alteration "drag queen" to "queen" across cultural boundaries further exacerbates what is already a translational quandary were one or the other word being singularly employed. As vexed as the editors of the magazine were in late 1960s America, one can conjecture what the stakes for mislabeling sexual or gender identities would

[31] Hackett, *The Andy Warhol Diaries*, xii.

be in today's global society, especially when cross-cultural translations of concepts-in-motion intervene in the non-West.[32]

It seems clear that translating Warhol into an Indian language other than English is—to a great extent—burdened by a host of tangled compromises and negotiations. When translating Warhol's implicit discourse or persona often overwhelms the translation of basic subjects, objects, and verbs of his writings, fluency of expression in the target language hangs by a thread. In recommending that a copy of the *Mona Lisa* be shown since it is as good as the original to those who lack the competency to recognize the original, or that his movies are "better talked about than seen," Warhol plays with the concept that the idea is more important than the authentic object. Under such conditions, without the illusion of an original text, the translator assumes the mantle of an artist and remains visible throughout the process, unafraid of allegations of misrepresentation and appropriation. The translation itself inescapably becomes as much a work of art as the original. Not giving up the enterprise of translation, however alienating, Ramanujan heroically sought to translate the *experience* of the Indian text (with profuse notes) over and above the visible signs and structures of it, and thereby translate the reader rather than the text. Even then, he could hardly account for the vast information contained in the intonation or metrical flow of the original, at least partially sensible to a native reader. One suspects that translating Warhol's writings into an Indian language would require the same effort, even if the end result would helplessly fall short to capture anything substantial of the original energy. How would one capture, after all, Warhol's playful and half-serious intonation to his assistant, "Sweetheart, you're fired!"[33] into an Indian language without losing almost all of it in translation?

[32] For a detailed treatment of translating queer terms into Indian languages and cultural contexts, see Shalmalee Palekar, "Re-mapping Translation: Queerying the Crossroads," in *Queer in Translation*, ed. B. J. Epstein and Robert Gillett (Abingdon and New York: Routledge, 2017), 8–24.
[33] Hackett, *The Andy Warhol Diaries*, xvii.

Selected Bibliography

This bibliography is divided into four parts: (I.) translations of Warhol's books and interviews discussed in *Translating Warhol*; (II.) publications and films about Warhol and his work; (III.) publications of and about the pertinent cultures and histories; and (IV.) writings about translation. The aim of this structure is to provide the reader with a useful resource for pursuing further research on the subjects covered in this book and on contiguous topics. This is a selected bibliography: publications highly specific to a particular chapter's focus are generally omitted; footnotes to individual chapters should be consulted for this type of resource.

I. Translations of Warhol's Books and Interviews

This material is organized by publication and is arranged chronologically within each listing. The English original is listed first, in bold type, followed by the translation(s). Only works discussed in *Translating Warhol* are included. Their compilation here provides a useful snapshot of the history discussed within the separate chapters of the book.

Swenson, Gene. "What Is Pop Art? Answers from 8 Painters, Part I."
ARTnews 62, no. 7 (November 1963): 26, 60–1.
"Uttalande av Andy Warhol." *Bonniers Litterära Magasin* 3, no. 33 (1964): 171–3.
"Andy Warhol." Translated by Marguerite Schlüter. In *Pop-Art. Eine kritische Information*, edited by Rolf-Gunter Dienst, 126–30. Wiesbaden: Limes, 1965.
"Andy Warhol." In Alberto Boatto, *Pop Art in U.S.A.*, 275–6. Milan: Lerici, 1967.
"Andy Warhol." Translated by Dieter Abel and Ellen Jones. In *Bildnerische Ausdrucksformen 1960–1970. Sammlung Karl Ströher im Hessischen Landesmuseum Darmstadt*, edited by Gerhard Bott, 437–9. Darmstadt: Roether, 1970.
"Andy Warhol." Translator unknown. In Bernhard Kerber, *Amerikanische Kunst seit 1945. Ihre theoretischen Grundlagen*, 213. Stuttgart: Reclam, 1971.
Glaser, Bruce. "Oldenburg, Lichtenstein, Warhol: A Discussion." *Artforum* 4, no. 6 (February 1966): 20–4.
"Andy Warhol." Translator unknown. In Bernhard Kerber, *Amerikanische Kunst seit 1945. Ihre theoretischen Grundlagen*, 214–15. Stuttgart: Reclam, 1971.
Berg, Gretchen. "Andy Warhol: My True Story." *The East Village Other* 1, no. 23 (November 1–15, 1966): 9–10.
Berg, Gretchen. "Andy, My True Story." *Los Angeles Free Press*, March 17, 1967, 3.

Selected Bibliography 213

Berg, Gretchen. "Nothing to Lose, Interview by Gretchen Berg." *Cahiers du Cinema in English* **10** (May 1967): 38–43.
"Rien à perdre." Translator unknown. *Cahiers du cinéma* 205 (October 1968): 40–7.
Italian translation, in Adriano Aprà and Enzo Ungari, *Il cinema di Andy Warhol*, 21–6. Rome: Arcana Editrice, 1971.
"Andy Warhol." Translator unknown. In Bernhard Kerber, *Amerikanische Kunst seit 1945. Ihre theoretischen Grundlagen*, 214. Stuttgart: Reclam, 1971.
***a: A Novel*. New York: Grove Press, 1968.**
"Comment devenir un homosexuel professionnel." Translated by S. T.-M. *VH 101* 1 (Spring 1970): 34–59. Excerpt.
a. Ein Roman. Translated by Carl Weissner. Cologne: Kiepenheuer & Witsch, 1971.
"Quelque part dans la 8e rue." Translated by Zéno Bianu. *L'Énergumène* 6–7 (June 1975): 45–59. Excerpt.
A: roman. Translated by David Zálesky. Prague: Volvox Globator, 2001.
***Blue Movie: The Complete Dialogue with Over 100 Photos*. New York: Grove Press, 1968.**
Blue Movie. Der ungekürzte Dialog mit über 100 Photos (*pocket*, 21). Translated by Hans Hermann. Cologne: Kiepenheuer & Witsch, 1971.
"Andy Warhol." In Joseph Gelmis, *The Film Director as Superstar*, 65–73. Garden City: Doubleday & Company, 1970.
Gelmis, Joseph. "I veri film li fanno a Hollywood: Andy Warhol si confessa." *Sipario* 299 (March–April 1971): 24–8.
***The Philosophy of Andy Warhol (From A to B and Back Again)*. New York and London: Harcourt Brace Jovanovich, 1975.**
"DIE Philosophie des Andy Warhol." Translated by Christa von Goßler. In Rainer Crone, *Andy Warhol. Das zeichnerische Werk 1942–1975*, 13–14. Stuttgart: Württembergischer Kunstverein, 1976. Excerpt.
Ma philosophie de A à B et vice-versa. Translated by Marianne Véron. Paris: Flammarion, 1977.
Mi filosofía de A a B y de B a A. Translated by Marcelo Covián. Barcelona: Tusquets, 1981.
La Filosofia di Andy Warhol. Translated by Rino Ponte and Fernando Ferretti. Genoa: Costa & Nolan, 1983.
Od A k B a zase zpět (Filozofie Andyho Warhola). Translated by Jan Lamper. Zlín: Archa, 1990.
Die Philosophie des Andy Warhol von A nach B und zurück. Translated by Regine Reimers. Munich: Droemer Knaur, 1991.
ぼくの哲学. Translated by Augustmoon Ochiishi. Tokyo: Shinchosha, 1998.
Философия Энди Уорхола (от А к Б и наоборот). Translated by G. Severskoy. Moscow: Aronov, 2001.
מאי לב' ובהזרה: הפילוסופיה של אנדי וורהול. Translated by Daphna Raz. Tel Aviv: Babel, 2005.

POPism: The Warhol '60s, with Pat Hackett. New York: Harcourt Brace Jovanovich, 1980.
"Amo New York, cioè Napoli." *Il Mattino* 84 (April 1, 1980): 5. Excerpts.
Popisme: Les années 1960 de Warhol. Translated by Alain Cueff. Paris: Flammarion, 2007.
POPism. Meine 60er Jahre. Translated by Nikolaus G. Schneider. Munich: Schirmer/Mosel, 2008.
波普主义: 沃霍尔的六十年代. Translated by Kou Huaiyu. Kaifeng: Henan University Press, 2014.
The Andy Warhol Diaries. Edited by Pat Hackett. New York: Warner Books, 1989.
Das Tagebuch. Translated by Judith Barkfelt. Munich: Droemer Knaur, 1989.
Journal. Translated by Jérôme Jacobs and Jean-Sébastien Stelhi. Paris: Grasset, 1990.
Дневники Энди Уорхола. Translated by V. Bolotnikova. Moscow: Ad Marginem, 2015.
I'll Be Your Mirror: The Selected Andy Warhol Interviews. Edited by Kenneth Goldsmith. New York: Carroll and Graf, 2004.
Entretiens: 1962–1987. Translated by Alain Cueff. Paris: Grasset, 2005.

II. Publications and Films about Warhol and His Work

ahtone, heather, Faith Brower, and Seth Hopkins. *Warhol and the West*. Berkeley: University of California Press, 2019.
Andre, Michael. "Andy Warhol's Interview." *Unmuzzled OX* 4, no. 2 (1976): 40–7.
Andy Warhol. Stockholm: Moderna Museet, 1968.
Andy Warhol: American and European American Paintings, Drawings and Prints. New York: Sotheby's, 1988.
Andy Warhol. Ausstellung der Deutschen Gesellschaft für Bildende Kunst e. V. (Kunstverein Berlin) und der Nationalgalerie der Staatlichen Museen Preussischer Kulturbesitz in der Neuen Nationalgalerie Berlin, 1. März–14. April 1969. Berlin: Deutsche Gesellschaft für Bildende Kunst e. V., in association with the Nationalgalerie Berlin, 1969.
Andy Warhol: The Complete Picture. Directed by Sarah Mortimer and Chris Rodney. Channel 4, UK, 2001.
Andy Warhol: A Documentary Film. Directed by Ric Burns. Steeplechase Films, WNET New York, 2006.
Andy Warhol—Modern Masters. Directed by Sarah Aspinall. BBC, 2010.
Andy Warhol Museum Archives (AWMA).
Andy Warhol's America. Directed by Francis Whately and Phil Cairney. BBC Two, 2022.
Andy Warhol's Exposures. New York: Andy Warhol Books/Grosset & Dunlap, 1979.

Selected Bibliography 215

Angell, Callie. *Andy Warhol Screen Tests*. New York: Abrams, in association with the Whitney Museum of American Art, 2006.
Angell, Callie. *The Films of Andy Warhol: Part II*. New York: Whitney Museum of American Art, 1994.
Aprà, Adriano, and Enzo Ungari. *Il cinema di Andy Warhol*. Rome: Arcana Editrice, 1971.
Baj, Enrico. "Un bidone chiamato Warhol." *MicroMega*. Le ragioni della sinistra 2 (1990): 65–76.
Battcock, Gregory. "Warhol: un libro. À la recherche du temps trivial, the philosophy of Andy Warhol." *Domus* 553 (December 1975): 52.
Bernasconi, Silvana. "Andy Warhol il grande replicante." *Vogue Italia* 406 (January 1984): 338.
Bockris, Victor. *Andy Warhol*. Translated by Pascale de Mezamat. Paris: Plon, 1990.
Bockris, Victor. *The Life and Death of Andy Warhol*. New York: Bantam Books, 1989.
Bockris, Victor. *Warhol*. London: F. Muller, 1989.
Bockris, Victor. *Warhol*. 1st Da Capo Press ed. New York: Da Capo Press, 1997.
Bockris, Victor. *Warhol: la biographie*. Translated by Emmanuelle and Philippe Aronson. Paris: Globe, 2015.
Bockris, Victor. *Warhol: The Biography*. 2nd ed. New York: Da Capo Press, 2003.
Bonuomo, Michele, ed. *Warhol, Beuys: Omaggio a Lucio Amelio*. Milan: Mazzotta, 2007.
Bourdon, David. "Warhol as a Filmmaker." *Art in America* 59, no. 3 (May–June 1971): 48–53.
Buchloh, Benjamin. "Andy Warhol's One-Dimensional Art: 1956–1966." In *Andy Warhol: A Retrospective*, edited by Kynaston McShine, 39–61. New York: Museum of Modern Art, 1989.
Bycko, Michal. *Nočné dialógy s Andym* [Nocturnal Dialogues with Andy]. Prešov [Slovakia]: CUPER, 1996.
Caroli, Flavio. "Il cinico Andy Warhol da Marilyn ai travestiti. Dollari come arte." *Corriere della sera*, October 26, 1975, 16.
Celant, Germano. "Il congelatore pop, memento mori dell'avanguardia." In *Pop Art: evoluzione di una generazione*, edited by Attilio Codognato, 11–30. Milan: Electa Editrice, 1980.
Ciardi, Nives. Review of *La Filosofia di Andy Warhol*, in "Libri e dischi." *Domus* 641 (July 1983): 81.
Coe, Ralph T. "American Indian Art." In *Possession Obsession: Andy Warhol and Collecting*, edited by John W. Smith, 112–25. Pittsburgh: The Andy Warhol Museum, 2002.
Colacello, Bob. *Holy Terror: Andy Warhol Close Up*. New York: HarperCollins, 1990.
Comenas, Gary. WarholStars.org.
Crimp, Douglas. *"Our Kind of Movie": The Films of Andy Warhol*. Cambridge, MA: MIT Press, 2012.

Crone, Rainer. *Andy Warhol. Das zeichnerische Werk 1942–1975*. Stuttgart: Württembergischer Kunstverein, 1976.
Crone, Rainer. *Das bildnerische Werk Andy Warhols*. Berlin: Wasmuth, 1976.
Crone, Rainer. *Warhol*. Stuttgart: Hatje, 1970.
Crone, Rainer, and Wilfried Wiegand. *Die revolutionäre Ästhetik Andy Warhol's*. Darmstadt: Melzer, 1972.
Crow, Thomas. "Saturday Disasters: Trace and Reference in Early Warhol." *Art in America* 75, no. 5 (May 1987): 128–36.
Cueff, Alain. *Warhol à son image*. Paris: Flammarion, 2009.
Danto, Arthur. "The Philosopher as Andy Warhol." In Danto, *Philosophizing Art: Selected Essays*, 61–83. Berkeley: University of California Press, 1999.
Delany, Max, and Eric C. Shiner, eds. *Andy Warhol/Ai Weiwei*. Melbourne: National Gallery of Victoria; Pittsburgh: Andy Warhol Museum; New Haven, CT: Yale University Press, 2015.
dell'Arco, Maurizio Fagiolo. "Warhol: The American Way of Dying." *Metro* 8, no. 14 (June 1968): 72–9.
Del Puppo, Alessandro. *Pasolini Warhol 1975*. Milan and Udine: Mimesis Edizioni, 2019.
de Rooij, Willem. "Willem de Rooij on Andy Warhol." In *Andy Warhol: A Guide to 706 items in 2 Hours 56 Minutes, Other Voices, Other Rooms*, edited by Eva Meyer-Hermann, 02:30:00–02:31:00. Rotterdam: NAi Publishers, 2007.
De Salvo, Donna, ed. *Andy Warhol: From A to B and Back Again*. New York: Whitney Museum of American Art, 2018.
Dessau, Ory. "מא׳ עד ז׳, מז׳ עד ע׳" ["From Aleph to Zein, from Zein to Ein"]. סטודיו [*Studio: Israeli Art Magazine*] 152 (May–June 2004): 38–40 [English summary, 63].
Dobner, Marianne. *Andy Warhol Exhibits. A Glittering Alternative*. Cologne: Walther König; Vienna: mumok, Museum moderner Kunst Stiftung Ludwig, 2020.
Enwezor, Okwui. "Andy Warhol and the Painting of Catastrophe." In *Andy Warhol: From A to B and Back Again*, edited by Donna De Salvo, 34–41. New York: Whitney Museum of American Art, 2018.
Fahlström, Öyvind. "Andy Warhol: Popkonstnär utan hämningar." *Dagens Nyheter*, February 4, 1968.
Fairbrother, Trevor J. *Beuys and Warhol: The Artist as Shaman and Star*. Boston: Museum of Fine Arts, 1991.
Flatley, Jonathan. *Like Andy Warhol*. Chicago and London: University of Chicago Press, 2017.
Foster, Hal. "Death in America." *October* 75 (Winter 1996): 36–59.
Franco, Francesca. "Diario napoletano e altro." In *Andy Warhol Vetrine*, edited by Achille Bonito Oliva, 17–20. Cinisello Balsamo: Silvana Editoriale, 2014.
Frei, Georg, and Neil Printz, eds. *The Andy Warhol Catalogue Raisonné*, vol. 1: *Paintings and Sculpture 1961–1963*. London: Phaidon Press, 2002.
Frei, Georg, and Neil Printz, eds. *The Andy Warhol Catalogue Raisonné*, vol. 2: *Paintings and Sculpture 1964–1969*. London: Phaidon Press, 2004.

Gangewere, R. Jay. "Ten Years Later—What Would Andy Say?" *Carnegie Magazine* 63, no. 9 (May/June 1997), https://carnegiemuseums.org/magazine-archive/1997/mayjun/feat4.htm.
Geldzahler, Henry. "Andy Warhol: A Memoir." In Geldzahler, *Making It New: Essays, Interviews, and Talks*, 42–4. New York: Turtle Point Press, 1994.
Gopnik, Blake. *Warhol*. London: Penguin/Random House, 2020.
Gopnik, Blake. *Warhol*. New York: Ecco/HarperCollins, 2020.
Granath, Olle. "With Andy Warhol 1968." In *Andy Warhol: A Guide to 706 Items in 2 Hours 56 Minutes, Other Voices, Other Rooms*, edited by Eva Meyer-Hermann, 00:10:00–00:13:00. Rotterdam: NAi Publishers, 2007.
Holtmann, Heinz. *Andy Warhol. Bilder, Grafik, Filme*. Braunschweig: Kunstverein Braunschweig, 1973.
Huxley, Geralyn, and Greg Pierce, eds. *Andy Warhol's The Chelsea Girls*. Pittsburgh: The Andy Warhol Museum, 2018.
James, David. "The Producer as Author." In *Andy Warhol: Film Factory*, edited by Michael O'Pray, 136–45. London: British Film Institute, 1989.
Janus, ed. *Andy Warhol. Ladies and Gentlemen*. Milan: Mazzotta, 1975.
Koch, Stephen. *Stargazer: Andy Warhol's World and Films*. New York and Washington, DC: Praeger, 1973.
Lebensztejn, Jean-Claude. "Zennish (Peel Slowly)." *Les Cahiers du Musée National d'Art Moderne* 97 (Autumn 2006): 21–35.
Leonard, John. "The Return of Andy Warhol." *New York Times Magazine*, November 10, 1968, 32–3, 142–51.
Mekas, Jonas. "Revoir les films d'Andy Warhol." In *Andy Warhol, cinema*, 41–53. Paris: Carré, in association with Centre Pompidou, 1990.
Michelson, Annette, ed. *Andy Warhol* (October Files 2). Cambridge, MA: MIT Press, 2001.
Morera, Daniela. "Andy Beauty." *Vogue Italia* 385 (February 1982): 316–19, 372.
Morera, Daniela. "Andy Warhol." *Vogue Italia* 356 (March 15, 1980): 538–41.
Morphet, Richard. *Andy Warhol*. London: Tate Publishing, 1971.
Mulroney, Lucy. *Andy Warhol, Publisher*. Chicago and London: University of Chicago Press, 2018.
Mulroney, Lucy. "'I'd Recognize Your Voice Anywhere: THE Philosophy of Andy Warhol (From A to B and Back Again)'." In *Reading Andy Warhol*, edited by Nina Schleif, 272–87. Ostfildern: Hatje Cantz, in association with Museum Brandhorst, Munich, 2013.
Murphy, J. J. *The Black Hole of the Camera: The Films of Andy Warhol*. Berkeley: University of California Press, 2012.
Mussman, Toby. "The Chelsea Girls." *Film Culture* 45 (1967): 41–5.
Musteata, Natalie. "Odd Walls, Even Pages: Andy Warhol as Curator and Editor." In *Andy Warhol Exhibits. A Glittering Alternative*, edited by Marianne Dobner, 109–40. Cologne: Walther König; Vienna: mumok, Museum moderner Kunst Stiftung Ludwig, 2020.
Nilsson, John Peter. "Essay by John Peter Nilsson, Curator." *Warhol 1968*. Stockholm: Moderna Museet, 2018, https://www.modernamuseet.se/malmo/en/exhibitions/warhol-1968/essa-av-curator-john-peter-nilsson/.

Osterweil, Ara. "Sons, Mothers, and Lovers: Ara Osterweil on Andy Warhol's and Rainer Werner Fassbinder's Queer Home Movies." *Artforum* 55, no. 9 (May 2017): 307–15.

Pacelli, Maria Luisa. "*Ladies and Gentlemen* at the Palazzo dei Diamanti in Ferrara, October 1975: An Interview with Franco Farina," translated by Ulrich Birkmaier. In *Warhol & Mapplethorpe: Guise & Dolls*, edited by Patricia Hickson, 43–7. Hartford, CT: Wadsworth Atheneum, in association with Yale University Press, 2015.

"The Painting on the Dress Said 'Fragile.'" *The New York Times*, November 11, 1966.

Pasolini, Pier Paolo. *Andy Warhol. Ladies and Gentlemen*. Milan: Luciano Anselmino, 1976.

Patella, Luca, and Rosa Patella. "Films e disattenzione selettiva di Warhol." *Data* 2, no. 4 (May 1972): 69.

Powers, Edward D. "Attention Must Be Paid: Andy Warhol, John Cage and Gertrude Stein." *European Journal of American Culture* 33, no. 1 (March 2014): 5–31.

Prekop, Rudo, and Mihal Cihlář. *Andy Warhol a Československo* [Andy Warhol and Czechoslovakia]. Řevnice [Czechia]: Arbor Vitae, 2011.

Printz, Neil, and Sally King-Nero, eds. *The Andy Warhol Catalogue Raisonné*, vol. 3: *Paintings and Sculptures 1970–1974*. London: Phaidon, 2010.

Printz, Neil, and Sally King-Nero, eds. *The Andy Warhol Catalogue Raisonné*, vol. 4: *Paintings and Sculpture Late 1974–1976*. London: Phaidon, 2014.

Quadri, Franco. "Warhol la maschera di cera." *Sipario* 313 (June 1972): 14–16.

Quiñones, Carmen Merport. "Reading Color: Looking Through Language in Warhol." *Criticism* 59, no. 4 (2017): 511–38.

Rossi-Wilcox, Susan M. "Social Satire in the Guise of a Cookbook: Warhol's *Wild Raspberries*." In *Reading Andy Warhol*, edited by Nina Schleif, 156–65. Ostfildern: Hatje Cantz, in association with Museum Brandhorst, Munich, 2013.

Rostagno, Aldo, and Nuccio Lodato. "Collage per Andy Warhol." *Sipario* 274 (February 1969): 65–6.

Rusinko, Elaine. "'We Are All Warhol's Children': Andy and the Rusyns." *The Carl Beck Papers in Russian and East European Studies* 2204 (2012): 9–21; http://carlbeckpapers.pitt.edu/ojs/index.php/cbp/article/view/190.

Sager, Peter. "Pop-Art oder wie tot muß eine Kunst sein, um Kunstgeschichte zu warden." *Das Kunstwerk* 23, nos. 9–10 (June–July 1970): 37–8.

Salzmann, Siegfried. *Kultstar – Warhol – Starkult*. Duisburg: Museumsverein Duisburg, 1972.

Sarkany-Perret, Juditte. "U.S.A.—Cinema a New York: Andy Warhol." *Marcatrè* 4, nos. 19–22 (April 1966): 89–91.

Schleif, Nina. *Reading Andy Warhol. Author, Illustrator, Publisher*. Ostfildern: Hatje Cantz, in association with Museum Brandhorst, Munich, 2013.

Schmidt, Christopher. "From A to B and Back Again: Warhol, Recycling, Writing." *Interval(le)s* 2, no. 2–3, no. 1 (Fall 2008–Winter 2009): 794–809.

Sichel, Jennifer. "'What is Pop Art?' A Revised Transcript of Gene Swenson's 1963 Interview with Andy Warhol." *Oxford Art Journal* 41, no. 1 (March 2018): 85–100.

Smith, John W., ed. *Possession Obsession: Andy Warhol and Collecting*. Pittsburgh: The Andy Warhol Museum, 2002.

Smith, Patrick S. *Andy Warhol's Art and Films*. Ann Arbor, MI: UMI Research Press, 1986.

Smith, Patrick S. *Warhol: Conversations about the Artist*. Ann Arbor, MI: UMI Research Press, 1988.

Stadtrucker, Ivan. "Andy Warhol a Júlia." *Literárny týždenník* [Bratislava: Literary Weekly] 23, nos. 39–40 (November 18, 2010): 16.

Swenson, Gene Robert. "The Darker Ariel: Random Notes on Andy Warhol/ annotazioni casuali su Andy Warhol." *Collage* 3–4 (December 1964): 102–6.

Tecce, Angela. "Warhol e Napoli." In *Andy Warhol. Viaggio in Italia*, edited by Gianni Mercurio and Mirella Panepinto, 21–6. Milan: Mazzotta, 1997.

Tomkins, Calvin. "Raggedy Andy." In *Andy Warhol*, edited by John Coplans, 8–14. Greenwich: New York Graphic Society, 1970.

Trimarco, Angelo. "Warhol e Beuys." *Domus* 607 (June 1980): 56.

Trini, Tommaso. "Deus ex recording" [Review of *a: A Novel*]. *Domus* 476 (July 1969): 49–50.

Wagner, Anne M. "Warhol Paints History, or Race in America." *Representations* 55 (Summer 1996): 98–119.

Warhol verso de Chirico. New York: Marisa Del Rey Gallery, 1985.

Weingart, Brigitte. "*Carrots/carats*: Die doppelte Erscheinung der 'Mother of Pop Art' in *Mrs. Warhol*." Lecture. Frankfurt: German Film Institute and Museum, January 16, 2014, https://www.youtube.com/watch?v=tKMUO1KF8ao.

Wolf, Reva. *Andy Warhol, Poetry, and Gossip in the 1960s*. Chicago and London: University of Chicago Press, 1997.

Wolf, Reva. "Introduction: Through the Looking-Glass." In *I'll Be Your Mirror: The Selected Andy Warhol Interviews, 1962–1987*, edited by Kenneth Goldsmith, xi–xxxi, 403–9. New York: Carroll & Graf Publishers, 2004.

Wolf, Reva, and Kou Huaiyu. "Cosmic Jokes and Tangerine Flake: Translating Andy Warhol's *POPism*/ 宇宙的玩笑与橙色亮片漆 译介安迪·沃霍尔《波普注意》." In *Complementary Modernisms in China and the United States: Art as Life/Art as Idea*, edited by Zhang Jian and Bruce Robertson, 82–98. Goleta, CA: Punctum Books, 2020.

Wrbican, Matt. *A Is for Archive: Warhol's World from A to Z*. New Haven, CT: Yale University Press, 2019.

Wrbican, Matt. "The True Story of 'My True Story.'" In *Andy Warhol: A Guide to 706 Items in 2 Hours 56 Minutes, Other Voices, Other Rooms*, edited by Eva Meyer-Hermann, 00:56:00–00:57:00. Rotterdam: NAi Publishers, 2007.

Zamir, Einav. "Lucio Amelio and Two Unidentified Men." In *Andy Warhol: Private and Public in 151 Photographs*, edited by Reva Wolf, 98–101. New Paltz, NY: The Samuel Dorsky Museum of Art, 2010.

Zwirner, Rudolf. "Wie Warhol in Europa und Beuys in den USA reüssierten. Ein Beitrag zur händlerischen Rezeptionsgeschichte. Ein Vortrag." *Sediment* 3 (1998): 30–44.

III. Publications of and about the Culture of the Time

Arbasino, Alberto. *Off-off*. Milan: Feltrinelli, 1968.

Boatto, Alberto. *Pop Art in U.S.A.* Milan: Lerici, 1967.

Britton, Claes. *Pontus Hultén. Den moderna konstens anförare. En biografi*. Stockholm: Albert Bonniers förlag, 2022.

Calvesi, Maurizio. "Un pensiero concreto (1°)." *Collage* 3–4 (December 1964): 65–70.

Calvesi, Maurizio. "Un pensiero concreto II." *Marcatrè* 3, nos. 16–18 (July 1965): 241–51.

Calvesi, Maurizio. "Un pensiero concreto parte terza." *Marcatrè* 4, nos. 23–25 (June 1966): 92–100.

Citron, Beth. "Bhupen Khakhar's 'Pop' in India, 1970–1972." *Art Journal* 71, no. 2 (Summer 2012): 44–61.

Corà, Bruno, ed. *Incontri 1972. Quaderni del Centro di Informazione Alternativa*, vol. 3. Rome: Incontri internazionali d'arte, 1979.

Dossin, Catherine. "Pop begeistert: American Pop Art and the German People." *American Art* 25, no. 3 (Fall 2011): 100–11.

Dossin, Catherine. *The Rise and Fall of American Art, 1940s–1980s: A Geopolitics of Western Art Worlds*. New York: Ashgate, 2015.

Edenman, Ragnar, et al., eds. *Multikonst: En bok om 66 konstverk, 100 utställningar, 350 000 besökare*. Stockholm: Sveriges radios förlag, Statens försöksverksamhet med riksutställningar, 1967.

Gilardi, Piero. "Lettera da New York." *Ombre elettriche* [without vol. no.] (December 1967): 23–5.

Guilbaut, Serge. *How New York Stole the Idea of Modern Art: Abstract Expressionism, Freedom, and the Cold War*. Translated by Arthur Goldhammer. Chicago and London: University of Chicago Press, 1983.

Guinn, Jeff, and Douglas Perry. *The Sixteenth Minute: Life in the Aftermath of Fame*. New York: Jeremy F. Tarcher/Penguin, 2005.

Guzzetti, Francesco, ed. *Facing America: Mario Schifano 1960–1965*. New York: Center for Italian Modern Art, 2021.

Hedges, Inez. *World Cinema and Cultural Memory*. London: Palgrave Macmillan, 2015.

Hopkins, Claudia, and Iain Boyd Whyte, eds. *Hot Art, Cold War—Southern and Eastern European Writing on American Art 1940–1990*. New York and London: Routledge, 2020.

Hopkins, Claudia, and Iain Boyd Whyte, eds. *Hot Art, Cold War—Western and Northern European Writing on American Art 1945–1990*. New York and London: Routledge, 2020.

Huyssen, Andreas. "The Cultural Politics of Pop: Reception and Critique of US Pop Art in the Federal Republic of Germany." *New German Critique* 4 (Winter 1975): 77–97.

Kvinnan. Stockholm: Riksutställningar, 1967.

Lapa, Pedro, and Sofia Nunes. "A Difficult Gap: The Reception of American Art in Portugal 1945–1990." In *Hot Art, Cold War—Southern and Eastern European Writing on American Art 1940–1990*, edited by Claudia Hopkins and Iain Boyd Whyte, 3–11. New York and London: Routledge, 2020.

Link, Jochen. "Pop Art in Deutschland. Die Rezeption der amerikanischen und englischen Pop Art durch deutsche Museen, Galerien, Sammler und ausgewählte Zeitungen in der Zeit von 1959 bis 1972." PhD diss., Stuttgart University, 2000.

Lippard, Lucy, ed. *Pop Art*. New York: Praeger Publishers, 1966.

Lippard, Lucy. *Pop Art*. Translated by Roberto Sanesi. Milan: Mazzotta, 1967.

Marchán Fiz, Simón. *Del arte objetual al arte de concepto: Las artes plásticas desde 1960*. Madrid: Alberto Corazón, 1972.

Marchán Fiz, Simón. *Del arte objetual al arte de concepto (1960–1974): Epílogo sobre la sensibilidad "postmoderna"; Antología de escritos y manifiestos*. 6th ed., corrected and augmented. Madrid: Akal, 1994.

Molinari, Renata M., ed. *Franco Quadri (Panta 31)*. Milan: Bompiani, 2014.

Moravia, Alberto. *Al cinema. Centoquarantotto film d'autore*. Milan: Bompiani, 1975.

Mulas, Ugo, and Alan Solomon. *New York: arte e persone*. Milan: Longanesi, 1967.

Mulas, Ugo, and Alan Solomon. *New York: The New Art Scene*. New York: Holt, Rinehart and Winston, 1967.

Öhrner, Annika. *Barbro Östlihn och New York. Konstens rum och möjligheter*. PhD diss., Uppsala University, 2010; Gothenburg and Stockholm: Makadam, 2010.

Öhrner, Annika. "Hillersberg i tiden." In *Lars Hillersberg. Entreprenör och provokaatör*, edited by Andreas Berg, 104–24. Stockholm: Ordfront, 2013.

Öhrner, Annika. "On the Construction of Pop Art. When American Pop Arrived in Stockholm in 1964." In *Art in Transfer in the Era of Pop*, edited by Annika Öhrner, 127–61. Stockholm: Södertörn Academic Studies, 2017.

Öhrner, Annika, ed. *Art in Transfer in the Era of Pop*. Stockholm: Södertörn Academic Studies, 2017.

Ortiz-Echagüe, Javier. "'A Truly Extraordinary Experience of an Unknown World': From American Pop to Neo-Expressionism in Spain 1963–1989," translated by Antonio Romero Limón. In *Hot Art, Cold War—Southern and Eastern European Writing on American Art 1940–1990*, edited by Claudia Hopkins and Iain Boyd Whyte, 69–76. New York and London: Routledge, 2020.

Pivano, Fernanda. "Manovelle fuori canale: i filmatori italiani da underground a indipendenti a collettivi." *Domus* 477 (August 1969): 42–9.

Pivano, Fernanda. "Obiettivo nell'occhio/coscienza: i filmatori USA dal cinema sperimentale all'underground." *Domus* 490 (September 1970): 51–8.

Rogers, Holly. *Music and Sound in Documentary Film*. New York: Routledge, 2014.

Rynell Åhlén, David. *Samtida konst på bästa sändningstid: Konst i svensk television 1956–1969*. PhD diss., Stockholm University, 2016; Lund: Mediehistoriskt arkiv, 2016.

Sitney, P. Adams. *Visionary Film: The American Avant-Garde*, 2nd ed. New York: Oxford University Press, 1979.

Sundberg, Martin. "Between Experiment and Everyday Life: The Exhibition Catalogues of Moderna Museet." In *The History Book: On Moderna Museet 1958–2008*, edited by Anna Tellgren, 297–328. Stockholm: Moderna Museet; Göttingen: Steidl, 2008.

Tellgren, Anna, ed. *The History Book: On Moderna Museet 1958–2008*. Stockholm: Moderna Museet; Göttingen: Steidl, 2008.

Tellgren, Anna. *Pontus Hultén and Moderna Museet. The Formative Years*. Stockholm: Moderna Museet; London: Koenig Books, 2017.

Tomkins, Calvin. *The Scene: Reports on Post-Modern Art*. New York: Viking Press, 1976.

Tomkins, Calvin. *Vite d'avanguardia: John Cage, Leo Castelli, Christo, Merce Cunningham, Philip Johnson, Andy Warhol*. Genoa: Costa & Nolan, 1983.

Vischer, Theodora. *Joseph Beuys. Die Einheit des Werkes. Zeichnungen, Aktionen, plastische Arbeiten, soziale Skulptur*. Cologne: Walther König, 1991.

Weinraub, Bernard. "Mothers." *Esquire*, November 1966, 96–101, 155–8.

Wissmann, Jürgen. "Pop Art oder die Realität als Kunstwerk." In *Die nicht mehr schönen Künste. Grenzphänomene des Ästhetischen*, edited by Hans Robert Jauß, 507–30. Munich: W. Fink, 1968.

Wolf, Reva. "The Artist Interview: An Elusive History." *Journal of Art Historiography* 23 (December 2020): 1–25.

Yacowar, Maurice. *The Films of Paul Morrissey*. Cambridge: Cambridge University Press, 1993.

IV. Works about or Relevant to Translation

Appiah, Kwame Anthony. "Thick Translation." *Callaloo* 16, no. 4 (Autumn 1993): 808–19.

Baer, Brian James, and Klaus Kaindl, eds. *Queering Translation, Translating the Queer: Theory, Practice, Activism*. New York and Abingdon: Routledge, 2018.

Benjamin, Walter. "The Task of the Translator" ("Die Aufgabe des Übersetzers," 1923). In *Walter Benjamin, Selected Writings*, vol. 1, *1913–1926*, edited by

Marcus Bullock and Michael W. Jennings, 253–63. Cambridge, MA: The Belknap Press of Harvard University Press, 1996.

Bistué, Belén. "On the Incorrect Way to Translate: The Absence of Collaborative Translation from Leonardo Bruni's *De interpretatione recta*." In *Collaborative Translation: From the Renaissance to the Digital Age*, edited by Anthony Cordingley and Céline Frigau Manning, 33–48. London and New York: Bloomsbury Academic, 2017.

Carrera Suárez, Isabel, Aurora García Fernández, and M. S. Suárez Lafuente, eds. *Translating Cultures*. Oviedo: KRK; Hebden Bridge, UK: Dangaroo Press, 1999.

Cheung, Martha P. Y. "Translation as Intercultural Communication: Views from the Chinese Discourse on Translation." In *A Companion to Translation Studies*, edited by Sandra Bermann and Catherine Porter, 179–90. Chichester: Wiley-Blackwell, 2014.

Cordingley, Anthony, and Céline Frigau Manning, eds. *Collaborative Translation: From the Renaissance to the Digital Age*. London and New York: Bloomsbury Academic, 2017.

Dharwadker, Vinay. "A.K. Ramanujan's Theory and Practice of Translation." In *Postcolonial Translation: Theory and Practice*, edited by Susan Bassnett and Harish Trivedi, 114–40. London and New York: Routledge, 1999.

Espagne, Michel. *Les transferts culturels franco-allemands*. Paris: Presses Universitaires de France, 1999.

Feng Youlan [Fung Yu Lan]. *A Short History of Chinese Philosophy* (1948). Edited by Derk Bodde. New York: The Macmillan Company, 1958.

Foucault, Michel. "Les mots qui saignent." *L'Express*, August 29, 1964. Reprinted in *Dits et écrits I, 1954–1975*, edited by Daniel Defert, François Ewald, and Jacques Lagrange, 452–54. Paris: Quarto Gallimard, 2001.

Gibbels, Elisabeth. "Translators, the Tacit Censors." In *Translation and Censorship: Patterns of Communication and Interference*, edited by Eiléan Ní Chuilleanáin, Cormac Ó Cuilleanáin, and David Parris, 57–75. Dublin: Four Courts Press, 2009.

Kramer, Max. "The Problem of Translating Queer Sexual Identity." *Neophilologus* 98, no. 4 (October 2014): 527–44.

Lacayo, Aarón. "A Queer and Embedded Translation: Ethics of Difference and Erotics of Distance." *Comparative Literature Studies* 51, no. 2 (July 2014): 215–30.

Lebensztejn, Jean-Claude. "Laozi à la lettre." *Ironie: interrogation critique et ludique* 157 (June 2011): 1–12.

Marivaux, Pierre de. "Réflexions sur Thucydide" (1744). *Mercure de France*, June 1755, II, 47. Reprinted in Marivaux, *Journaux et Œuvres diverses*, edited by Frédéric Deloffre and Michel Gilot, 457–64. Paris: Garnier, 1969.

Palekar, Shalmalee. "Re-mapping Translation: Queerying the Crossroads." In *Queer in Translation*, edited by B. J. Epstein and Robert Gillett, 8–24. Abingdon and New York: Routledge, 2017.

Ramanujan, A. K. *Poems of Love and War: From the Eight Anthologies and the Ten Long Poems of Classical Tamil*. New York: Columbia University Press, 1985.

Spivak, Gayatri Chakravorty. *An Aesthetic Education in the Era of Globalization*. Cambridge, MA, and London: Harvard University Press, 2012.

Valdés, Cristina, and Adrián Fuentes Luque. "Coherence in Translated Television Commercials." *European Journal of English Studies* 12, no. 2 (August 2008): 133–48.

Wang, Lan-chun, and Shuo Wang. "A Study of Idiom Translation Strategies between English and Chinese." *Theory and Practice in Language Studies* 3 (September 2013): 1691–7.

Woods, Michelle. *Censoring Translation: Censorship, Theatre, and the Politics of Translation*. London: Continuum, 2012.

Notes on Contributors

Francesco Guzzetti is Assistant Professor of Modern and Contemporary Art at the University of Florence. He holds a PhD in art history from Scuola Normale Superiore, Pisa. He has received fellowships from: Center for Italian Modern Art (CIMA); Harvard University; Magazzino Italian Art Foundation; and The Morgan Library & Museum. He recently curated the exhibition *Facing America: Mario Schifano 1960–1965* (2021). An expert on the art of the second half of the twentieth century, with special focus on the international connections of Italian art, he is currently writing a book about the relationships between Arte Povera and American art.

Jean-Claude Lebensztejn is a Paris-based art historian and critic. He is an Honorary Professor at the University of Paris I—Panthéon-Sorbonne. His numerous publications range in subject and time period from Jacopo Pontormo to Malcolm Morley and Paul Sharits. His book *Figures pissantes, 1280–2014* was published in English in 2017 as *Pissing Figures 1280–2014*. Recent publications include *Propos filmiques* (2021) and *Rafistolages (James, Burroughs, Kafka, Proust, Platon, Marivaux, Donne, Autophagie, Palmarès)* (2023).

Annika Öhrner is Associate Professor, Director of Doctoral Studies, Department of Art History, Södertörn University, Stockholm, and a curator. Öhrner edited the anthology *Art in Transfer in the Era of Pop* (2017), which was supported by a Terra Foundation for American Art International Publication Grant. Among recent publications: "Exploring the Territories of the Avant-Garde: Ivan Aguéli and the Institutions of His Time," in *Anarchist, Artist, Sufi: The Politics, Painting, and Esotericism of Ivan Aguéli*, ed. Mark Sedgwick (2021), and "Niki de Saint Phalle Playing with the Feminine in the Male Factory: 'Hon—en katedral,'" *Stedelijk Studies* 7 (2018).

Deven M. Patel is Professor at the University of Pennsylvania in the Department of South Asia Studies. His research focuses on classical Indian humanities, especially Sanskrit literature, Indian philosophy, aesthetics, and translation theory and practice. He is the author of *Text to Tradition: The Naisadhiyacarita and Literary Community in South Asia* (2014).

Elaine Rusinko, Emerita Associate Professor of Russian at the University of Maryland, Baltimore County, is a scholar of Russian and Carpatho-Rusyn culture. Her book, *Straddling Borders: Literature and Identity in Subcarpathian Rus'* (2003), is the first English-language history of Carpatho-Rusyn literature. "'We Are All Warhol's Children': Andy and the Rusyns" (2012) examines Warhol's ethnic background and the reception in his homeland of the most famous American of Carpatho-Rusyn ancestry. Her biography of Julia Warhola, *Andy Warhol's Mother: Julia Warhola and the Carpatho-Rusyn Immigrant Experience*, is forthcoming.

Nina Schleif holds degrees in art history and American studies. She is a curator of prints and drawings at Staatliche Graphische Sammlung München. In 2013 she curated the exhibition and edited the catalog *Reading Andy Warhol* at Museum Brandhorst, Munich, the first international consideration of Warhol's book oeuvre. In 2016 she published the monograph *Drag & Draw. Andy Warhol. The Unknown Fifties*.

Jean Wainwright is an art historian, critic, and curator living in London. She is director of the Fine Art and Photography Research Centre at the University for the Creative Arts. She has published extensively on contemporary art, contributing to numerous catalogs and books, and appearing on television and radio programs (including *Woman's Hour*, *Today Programme*, Channel Four, and the BBC). Her *Audio Arts* archive, begun in 1996, continues to expand, and to date she has interviewed over 2,000 artists, makers, photographers, filmmakers, and curators; 177 of her published interviews conducted for *Audio Arts* went online at the Tate in 2014.

Reva Wolf is Professor of Art History at the State University of New York at New Paltz. She teaches and writes on art of the eighteenth century to the present and on the historiography of art. She is the author of *Andy Warhol, Poetry, and Gossip in the 1960s* (1997), *Goya and the Satirical Print* (1991), and numerous articles and essays, and is co-editor of *Freemasonry and the Visual Arts from the Eighteenth Century Forward: Historical and Global Perspectives* (2020), which was selected as a 2020 Choice Outstanding Academic Title.

Index

a: A Novel 13 n. 29, 14, 18, 78
 Italian reviews of 98–9
 French translation, excerpts 16,
 23–4, 25 Fig. 2.2
 German translation 14, 55, 56–61,
 61 Fig. 3.1
ACE Gallery, Los Angeles
 and *American Indian (Russell Means)* pictures by Warhol 187–8
 and Chrismas, Douglas 187–8
Adelman, Bob, photograph of Warhol and German translation of *POPism* 11, 67, 68 Fig. 3.4
Adorno, Theodor W. 44, 46 n. 10, 52, 63, 69, 118
 Dialectic of Enlightenment co-author 46–7, 52
 reception of Warhol in Germany, and 47
Aftonbladet (newspaper), review of *Andy Warhol*, Stockholm 117
ahtone, heather, on Warhol's indigenous American paintings 190–1
Ai Weiwei, "easy," Warhol's *Philosophy* book as 1, 13, 14, 20
Albers, Josef 120
Amelio, Lucio
 art dealer, Naples 82
 relationship with Warhol 82–3, 100 n. 96
 Warhol portrait of 83 Fig. 4.4
America 55
Andy Warhol, Moderna Museet, Stockholm book 50, 54, 59, 103, 109–13, 109 Fig. 5.2
 exhibition 20, 21, 50, 103–8, 104 Fig. 5.1, 110, 113–18, 114 Fig. 5.3, 115 Fig. 5.4, 123–4
 German translations taken from 59
 German version 54
 Swedish translations of Warhol interviews in 110–13
 see also under Moderna Museet, Stockholm, exhibitions
The Andy Warhol Diaries 3, 86, 99, 199–200, 202, 207, 209, 210, 211
 French translation 3, 24
 German translation 3, 55
 Russian translation 3 n. 6
 see also Hackett, Pat
Andy Warhol's America, BBC Two 11, 12 Fig. 1.4, 15, 161–95
 see also Cairney, Phil; Whately, Francis
Andy Warhol's Exposures 55, 175 n. 39, 189 n. 77
Andy Warhol's Index (Book) 29, 55, 60 n. 54
Andy Warhol's Party Book 55
Andy Warhol's T.V. 88, 91 Fig. 4.7
Anger, Kenneth 28
 Fireworks (1947), shown on German television 59
Anselmino, Luciano
 art dealer, Turin 80
 promoter of Warhol, 80–2, 96
 see also under Warhol, Andy, paintings, *Ladies and Gentlemen*

Appiah, Kwame Anthony, on "thick" translation 2, 3
Aprà, Adriano, Italian catalog of Warhol's films, co-editor 78–9
Arbasino, Alberto 77
Arcade, Penny 174, 185, 186
Arte Povera 77
Aspden, Peter 182
Augustmoon Ochiishi, Japanese translator of *The Philosophy of Andy Warhol* 3–5, 4 Fig. 1.1

Baj, Enrico, negative view of *The Philosophy of Andy Warhol* 100–1
Banham, Reyner 93
Barefield-Pendleton, Denise 175–6
Battcock, Gregory, review in Italian of *The Philosophy of Andy Warhol* 99
Beaton, Cecil, photograph of Warhol in *Vogue Italia* 85
Benjamin, Walter 48, 172, 204
 translation, on 41
Bergengren, Kurt, Swedish review of *Andy Warhol* (Moderna Museet) and *Chelsea Girls* 117
Berg, Gretchen, published interviews with Warhol 23, 24, 50, 79, 111, 118
 French translation 23
 German translation 53
 Italian translation 79
 see also Warhol, Andy, interviews
Beuys, Joseph
 "everyone is an artist" 21, 60
 Warhol and 60 n. 53, 83–4
 Bonuomo, Michele, story on 84
Birmingham, Alabama
 Civil Rights Movement and 173–81, 185, 195

Björk, Karl-Olov 124
Blue Movie (book)
 German translation 15, 18, 55–6, 61–4, 62 Fig. 3.2, 69
 see also under Warhol, Andy, films, *Blue Movie*
Boatto, Alberto, *Pop Art in U.S.A.* 73, 74–5
 Swenson, "What Is Pop Art?" Italian translation 74–5 (*see also under* Warhol, Andy, interviews)
Bockris, Victor 175, 176, 182, 193
 Warhol biography 142
 French translations of 24–7
Bonniers Litterära Magasin (BLM) 112
 Swenson, "What Is Pop Art?" Swedish translation 14, 15 Fig. 1.5, 112 (*see also under* Warhol, Andy, interviews)
Bonuomo, Michele *see* Beuys, Joseph; *POPism: The Warhol '60s*
Bourdon, David 26, 138
Brakhage, Stan 34 n. 42, 75, 116
Braunschweig Kunstverein 60
Brecht, Bertolt 48, 52–3
Breer, Robert 116
British Broadcasting Corporation (BBC) 11, 12 Fig. 1.4, 162, 164, 165 n. 5, 170–1, 185
Buchloh, Benjamin 118

Cage, John 93 n.58
 "Lecture on Nothing" 6
Cairney, Phil
 producer, *Andy Warhol's America*, BBC Two 164–8, 170–2, 174 n. 35, 177, 180–1, 183, 189, 192, 194
Calder, Alexander 120
Calvesi, Maurizio 73

Index 229

camp
 theatricalization and 134 n. 22
 translation of "campy" 57
Campidoglio, Rome 94–5
Carey, Ted, Julia Warhola, Ruth Carey and 157–8
Carpatho-Rusyn 126–9, 128 Fig. 6.1, 160
 folk theater 134, 138–9
 immigrants to the United States 128–9
 Warhola family 126–7, 130
 Warhola, Julia 151, 158, 160
 peasant culture 134
Castelli, Leo 27, 93 n. 58, 107
Celant, Germano 93–4, 100
 The Philosophy of Andy Warhol, Italian translation and 71, 89, 92, 101
 writing about Warhol by 21, 77, 89–93
censorship *see under* translation
Cerri, Pierluigi 71
Chrismas, Douglas 187–9, 191
 see also under Ace Gallery, Los Angeles; Warhol, Andy, paintings, *American Indian (Russell Means)*
cinema *see* film
Cinema Rendezvous, New York 37
Citron, Beth 203–9
Civil Rights Movement 175–6
Clarke, Shirley 116
Codognato, Attilio 89
Colacello, Bob 12, 81, 167
Connor, Eugene (Bull) 175–6, 179
 see also Birmingham, Alabama
Costa & Nolan
 I turbamenti dell'arte book series 71, 92–3 (*see also* Celant, Germano)
 The Philosophy of Andy Warhol, Italian translation publisher 10 Fig. 1.3, 71, 72 Fig. 4.1, 91 Fig. 4.7
Crone, Rainer
 Marxist interpretation of Warhol 48–9
 The Philosophy of Andy Warhol, German translation, excerpts published by 14, 49
Crowther, Bosley 37
Crow, Thomas 173, 179, 181–2
Cueff, Alain
 POPism: The Warhol '60s, French translation 27–8, 29, 39–40
 The Selected Andy Warhol Interviews, French translation 28–30
 Warhol à son image 27, 30–32
Curtis, Edward S. 190–1
 Standing on the Earth—Oto 190 Fig. 7.5
Czechoslovakia 151
Czechoslovakian, Warhol's self-misidentification as 127, 130–1

d'Ablancourt, Nicolas Perrot, and translation 38, 39
Dagens Nyheter (newspaper) 116, 117 n. 34, 123 n. 47 *see also* Fahlström, Öyvind; Linde, Ulf
Darling, Candy 85
Deal, Gregg 188, 189
de Antonio, Emile 48
de Chirico, Giorgio, and Warhol 94–5, 95 Fig. 4.8
Deitch, Jeffrey 176, 192
dell'Arco, Maurizio Fagiolo 76
Derkert, Siri 119
De Salvo, Donna 171, 172 n. 27
Dessau, Ory, regarding *The Philosophy of Andy*

Warhol, Hebrew
 translation 2
Dharwadker, Vinay, regarding A.
 K. Ramanujan on
 translation 200, 204
 n. 19 *see also under*
 translation
*Diaries, The Andy Warhol see The
 Andy Warhol Diaries*
Dienst, Rolf-Gunter, German
 translation of Swenson,
 "What Is Pop Art" 50–1
Domus (magazine)
 POPism: The Warhol '60s, Italian
 translation, excerpts
 published in 84
 Warhol featured in 84, 98, 99–100
Dossin, Catherine 46 n. 9, 107
Drew, Jefferson 173, 175
The Driver's Seat (*Identikit*), Warhol
 cameo in 96
Dunér, Sten 124

Ensler, Eve 192
Enwezor, Okwui 179, 183
Erixson, Sven X:et 119
Espagne, Michel, on "cultural
 transfer" and
 translation 20, 105,
 114, 124 *see also under*
 translation
Esquire (magazine) 125–7, 141, 142
 see also Warhola, Julia
Experiments in Art and Technology
 (E.A.T.) 107
Exploding Plastic Inevitable 141

Factory, the (Warhol's studio) 29, 30,
 36, 76, 77, 78, 118, 131,
 141, 142, 158, 171, 209
 film screenings at 37
 photographs of
 Mulas, Ugo 75
 Name, Billy 108
 Schifano, Mario 74

Shore, Stephen 108
 in *Vogue Italia* 87
Factory Diaries *see under* Warhol,
 Andy, video work
Fahlström, Öyvind 16, 107
 review of *Andy Warhol* (Moderna
 Museet) 116–17
Farina, Franco 80–1
Feng Youlan 40–1 *see also* under
 translation
Ferretti, Fernando, *The Philosophy
 of Andy Warhol*, co-
 translator into Italian 96
film *see* Warhol, Andy, films, *for
 individual titles*
 dubbing 15, 63
 medium transfer 15–16, 35–6, 39,
 161, 164, 182–3, 192,
 194–5
 as mistranslation 16
 subtitling 15, 34
Film-Makers' Cinematheque, New
 York 37 *see also* Mekas,
 Jonas
Flatley, Jonathan 175 n. 40, 175–6
 n. 41, 177, 179 n. 46
Foster, Hal 183
Foucault, Michel
 "author-function" and Warhol's
 writings 2 n. 3
 see also under translation
Frankfurt School 21, 43–4, 46–7, 52,
 63, 69, 70
Freeman, Joseph ("Little Joey") 29,
 30, 177
Fremont, Vincent 132

Galleria Anselmino, Milan 82
Galleria Lucio Amelio, Naples 83–4
Galleria Il Punto, Turin 73
Galleria Rizzardi, Milan 100
Geldzahler, Henry 141
Gelmis, Joseph, interview with
 Warhol, Italian
 translation of 79 *see also*

under Warhol, Andy, interviews
Genet, Jean 14–15, 15 Fig. 1.5, 18 *see also under* translation, censorship and
Gibbels, Elisabeth 17
Gilardi, Piero 76
Glaser, Bruce
 "Oldenburg, Lichtenstein, Warhol: A Discussion," translations 26, 53
 see also Warhol, Andy, interviews
Goldsmith, Kenneth xv
I'll Be Your Mirror, French translation 23, 30 *(see also* Cueff, Alain)
Gopnik, Blake 134 n. 21, 169, 171, 186–7
Granath, Olle 107–8, 110–13
Grand Palais, Paris 27
Gruskin, George 135, 136

Haas, Patrick de 34, 35–6
Hackett, Pat 23
 The Andy Warhol Diaries and 3, 199–200, 202, 210
 Interview magazine and 210
 The Philosophy of Andy Warhol and 2, 3
 POPism: The Warhol '60s and xiv, 3, 8 Fig. 1.2, 39, 55–6, 67, 84
 see also Warhol, Andy, publications with Pat Hackett
Hall, Jerry 167, 191–2
Halsman, Philippe, photograph by, *The Philosophy of Andy Warhol* dust jacket 88, 90 Fig. 4.6
Hamilton, George 157
 Anne Stevens and 157–8
 see also under Warhol, Andy, films, *The George Hamilton Story*
Haslam, Nicky 28

Havaj, confusion with Hawaii 144–7, 150, 153
Hebdige, Dick 93
Heide, Robert 192
Hermann, Hans, translator of *Blue Movie* 56, 63–4
homosexuality 32, 82, 105, 117, 139 n. 37, 153, 174 n. 35, 205–6
 translation and xiii, 3, 16–17, 29, 30, 38–9, 211 n. 32
Horkheimer, Max 44, 63, 69
 Dialectic of Enlightenment co-author 46–7, 52
Höste, Einar 119, 120
Hultén, Pontus 107, 110, 112–13, 114 Fig. 5.3, 115
Huyssen, Andreas 47, 48 n. 16

Identikit see The Driver's Seat
Interview magazine 86, 87, 167 n. 10, 175 n. 39, 210
interviews *see* Warhol, Andy, interviews

Jagger, Bianca 173–4
Jähn, Hannes
 a. Ein Roman, dust jacket design 60, 61 Fig. 3.1
 Blue Movie, German edition, cover design 61, 62 Fig. 3.2
James, David 149
Janus, interpretation of *Ladies and Gentlemen* 81–2, 87
Jireš, Jaromil 131
Johansson, Albert 119, 120, 122 Fig. 5.7, 123 *see also Multikonst*
Johns, Jasper 29
Johnson, Jay 85
Johnson, Jed 137, 174 n. 34

Kainthola, Durga, *The Art Factory 2* exhibition 202–3

Kerber, Bernhard
　Berg interview with Warhol,
　　German translation,
　　excerpts 53
　Glaser, "Oldenburg, Lichtenstein,
　　Warhol: A Discussion,"
　　German translation,
　　excerpts 53
　Swenson, "What Is Pop Art?"
　　German translation,
　　excerpts 52–3
　see also Warhol, Andy, interviews
Khakhar, Bhupen
　Factory Strike 206, 207, 208
　　Fig. 8.5
　and performance as translation
　　16–17, 203–4
　Truth Is Beauty and Beauty Is
　　God 203 Fig. 8.1, 205
　　Fig. 8.2, 206 Fig. 8.3
　Warhol and 203–10
Kiepenheuer & Witsch (KiWi)
　avant-garde titles and 56, 57
　publisher of Warhol in German
　　56–63, 61 Fig. 3.1,
　　62 Fig. 3.2
Klüver, Billy 107, 108 n. 12
Koch, Stephen 29, 34 n. 42
König, Kasper 107
Kou Huaiyu
　The Philosophy of Andy Warhol,
　　translator into Chinese
　　1–2, 6, 7, 11–12
　POPism: The Warhol '60s,
　　translator into Chinese
　　xiv, xvii, 7–8, 8 Fig. 1.2,
　　197–8
Kramer, Max 17
Kunsthalle zu Kiel 45

Lamarr, Hedy
　arrest for shoplifting, 147–8
　Ecstasy, role in 147
　Hedy and 147

Warhola, Julia, and 147–8
　White Cargo, role in 148
Landesmuseum Darmstadt 51 see
　also Ströher, Karl
Laozi 3, 41 see also under translation
Lawder, Standish D. 93
Leonard, John 78
Leth, Jørgen, 66 Scenes from America
　169
　Warhol eating a burger, scene of 169
Lichtenstein, Roy 26, 36 n. 45, 53, 73,
　106, 110, 123
Life magazine, Birmingham,
　Alabama protest photos
　175–80, 178 Fig. 7.3
Lindblom, Sivert 119
Linde, Ulf, review of Andy Warhol
　(Moderna Museet) 117
Link, Jochen 44 n. 3, 45
Lippard, Lucy, Pop Art, Italian
　translation 73, 74
　Fig. 4.2
Lodato, Nuccio 78
Ludwig, Peter, Warhol collection 45,
　162 Fig. 7.1

Makos, Christopher, The Philosophy
　of Andy Warhol Italian
　translation cover photo
　9, 72 Fig. 4.1, 88
Malanga, Gerard 56, 75, 118, 142,
　180, 182
Man Ray 96, 120
Marchán Fiz, Simón 18
Marcuse, Herbert 44, 47 n. 12
　Eros and Civilization 63
　concept of sexual and political
　　liberation 62–3
Marisa Del Rey Gallery, New York
　94–5, 95 Fig. 4.8
Marivaux, Pierre de 38 see also under
　translation
Markopoulos, Gregory 75, 116
Marxist 44

interpretations of art 48–9, 52, 53, 69, 117 (*see also* Crone, Rainer)
Max's Kansas City 27, 131
McShine, Kynaston 100
Means, Russell
 American Indian Movement (AIM), and 183
 Oglala Lakota 183
 Warhol's portraits of 161, 164, 165, 173, 183–91, 184 Fig. 7.4, 192, 193, 194, 195 (*see also under* Chrismas, Douglas; Warhol, Andy, paintings)
 Wounded Knee Massacre site, and 185
Means, Tatanka 185, 186, 188
Mekas, Jonas 37, 75, 76–7, 115, 116
Melin, John 109–10, 119, 120
Meyerson, Åke 120
Miková 127–8, 131, 135, 139, 140, 144, 146, 152
 Warhola, Julia, ancestral village of 127
Moderna Museet, Stockholm 106–8
 exhibitions
 American Pop Art 106, 112, 118
 Andy Warhol 21, 54, 103–8, 104 Fig. 5.1, 109 Fig. 5.2, 113–16, 114 Fig. 5.3, 115 Fig. 5.4, 119, 123–4
 book 54, 59, 108–13
 Berlin version 54
 reviews of 116–17, 123–4
 Claes Oldenburg 106
 Movement in Art 106, 107
 see also Hultén, Pontus
Monroe, Marilyn, Warhol depictions of 18, 19 Fig. 1.6, 100 n. 92, 103, 113, 117, 203

Montez, Mario 33, 148 *see also under* Warhol, Andy, films, *Harlot*; *Hedy*
Moore, Charles 175, 176, 177–9, 178 Fig. 7.3, 180–3
 photographs of 1963 Birmingham, Alabama protests 175–83
Moravia, Alberto, review of *Chelsea Girls* 77
Morera, Daniela 86
 Interview magazine, European editor 86
 Polaroid portrait by Warhol 86 Fig. 4.5
 Vogue Italia, articles on Warhol by 87
Morrissey, Paul 36, 80, 139, 157, 174 n. 34 *see also under* Warhol, Andy, films, with Paul Morrissey
Mulas, Ugo 75–6
Mulroney, Lucy xv, 2, 64, 85, 88
Multikonst 21, 105–6, 119–24, 121 Figs. 5.5, 5.6, 122 Fig. 5.7 *see also* repetition
Murphy, J. J. 139, 153
Museum of Modern Art, New York 39

Name, Billy 108
Nationalgalerie Berlin 45
Nedziel'skii, Evgenii 134
Neo-Dada 73
neo-Marxist *see* Marxist
Netter, Michael 132
Neue Nationalgalerie, Berlin 54
New Realists exhibition 107

Oldenburg, Claes 26, 53, 106, 107
 see also Glaser, Bruce; Moderna Museet
Oliva, Achille Bonito 80, 94 *see also* Swenson, Gene

and Warhol, Andy, interviews
Ondine (Robert Olivo) 57, 59, 99
Österlin, Anders 119, 120
Osterweil, Ara 139 n. 37, 147, 152, 153
Östlihn, Barbro 107

Palazzo dei Diamanti, Ferrara 80–2, 81 Fig. 4.3
Palazzo Grassi, Venice 89
Pasolini, Pier Paolo 82, 87 *see also under* Warhol, Andy, paintings, *Ladies and Gentlemen*
Patroni Griffi, Giuseppe 96
Pedriali, Dino, photographs by of Warhol in Italy 80–1
performative
 Khakhar, Bhupen as xiv, 203–4
 Warhol as 21
 Warhola, Julia, as 135
Perreault, John 56
Pettersson, Berndt 106 n. 6, 119
The Philosophy of Andy Warhol (From A to B and Back Again) 1, 16, 90 Fig. 4.6, 92, 98, 99, 100–1, 127, 138, 146, 188
 Chinese translation 1, 6, 11–12 (*see also* Kou Huaiyu)
 collaboration and 2, 3
 Czech translation 13 n. 30
 "easy" (*see* Ai Weiwei)
 French translation 14, 23, 27 (*see also* Véron, Marianne)
 German translation 13, 14, 49, 55, 64–6, 65 Fig. 3.3 (*see also* Reimers, Regine)
 Hebrew translation 2
 Italian translation 9, 17, 71, 72 Fig. 4.1, 79, 85–101 (*see also* Celant, Germano; Ferretti, Fernando; Ponte, Rino)
 Italy, references to 95–7
 Japanese translation 3–5, 4 Fig. 1.1 (*see also* Augustmoon Ochiishi)
 "nothing," and 6–7, 94, 97 (*see also* Sartre, Jean-Paul)
 Russian translation 13 n. 30
 Spanish translation 18, 19 Fig. 1.6
Pierce, Greg 154
Pile, Susan 127, 139, 148, 155
Piotrowski, Piotr 105
Pivano, Fernanda 76
Polk, Brigid (Brigid Berlin) 12, 25, 64
Pompidou, Centre 34
Ponte, Rino, *The Philosophy of Andy Warhol*, co-translator into Italian 96
Pop art 26, 43–4, 67, 69, 77, 84, 118, 172, 198
 capitalism, and 18, 21, 52–3 (*see also* Marxism)
 France, reception in xv
 Germany, reception in 14, 45–50, 51, 59
 poppen and 44, 70
 India, reception in 197, 202–6, 209
 Italy, reception in 14, 73–5, 89–92, 101
 Spain and 18–19
 Sweden, reception in 104–7, 109–10, 112, 117, 120–3
POPism: The Warhol '60s 88, 152
 Chinese translation 7–8, 8 Fig. 1.2, 11, 198–9 (*see also* Kou Huaiyu)
 collaboration, and 3
 French translation 7, 11, 17, 23, 27–9, 33, 39–40 (*see also* Cueff, Alain)
 German translation 7, 11, 17, 55–6, 67–9, 68 Fig. 3.4 (*see also* Schneider, Nikolaus G.)

Italian translation, excerpts 84–5 (*see also* Bonuomo, Michele)
see also Hackett, Pat
Porizkova, Paulina 131
Printz, Neil 82 n. 34, 95 n. 64, 174 n.36, 187, 189 n. 77, 191

queer *see* homosexuality

Ramanujan, A. K., translation theories of 17, 20, 198, 200–2, 204, 208–9, 211 *see also under* translation
Rauschenberg, Robert 29, 30, 73, 107
Reimers, Regine, *The Philosophy of Andy Warhol*, German translation of 55, 64–6, 67
repetition
 Multikonst exhibition and 21, 106, 120–3
 Warhol's work and 46, 47, 94, 103, 104–5, 107–8, 114, 117, 118, 123, 124, 172, 180, 182, 183
Rheem, Richard 16, 139, 140–53, 155–6, 158–9 *see also The George Hamilton Story*
Rimbaud, Arthur, "Voyelles," translation of 17
Rodhe, Lennart 119
Rosenquist, James 106, 107
Rostagno, Aldo 78
Rusyn 13, 16, 127–41, 144–6, 148–50, 155, 159–60
 Church Slavonic, and 131
 see also under Warhol, Andy, films, *The George Hamilton Story*; Warhol, Andy, video work, *Factory Diaries*; Warhola, Julia

Salzmann, Siegfried, *Kultstar—Warhol—Starkult* 48 n. 16, 49, 54
Sarkany-Perret, Juditte, interview with Warhol 75
Sartre, Jean-Paul, and *The Philosophy of Andy Warhol* 6–7
Schifano, Mario 74 *see also under* Factory, the
Schiff, Brian 152
Schlüter, Marguerite
 publisher of experimental writing 50–1
 translator of Swenson, "What Is Pop Art?" into German 50–1 (*see also under* Warhol, Andy, interviews)
Schneider, Nikolaus G., *POPism*, German translator 55–6, 67–9 (*see also under POPism: The Warhol '60s*)
Segal, George 106
Shore, Stephen 108
Sidney Janis Gallery, New York 107
Sipario (magazine)
 Joseph Gelmis interview with Warhol, Italian translation in 79 (*see also under* Warhol, Andy, interviews)
 writings on experimental film in the United States in 76, 78, 80 n. 29
66 Scenes from America see Leth, Jørgen
Slovakia 127–9, 128 Fig. 6.1, 130, 145 Fig. 6.4 *see also* Carpatho-Rusyn; Czechoslovakia; Havaj
Smith, Jack 116
Smith, Patrick S. 64
Solanas, Valerie 40, 188
Solomon, Alan 75–6

Sperone, Gian Enzo 73
Spivak, Gayatri Chakravorty,
 translation as "intimate"
 reading 7–8
Stable Gallery, New York 27, 74
Stadtrucker, Ivan 139–40
Ströher, Karl
 and Swenson "What Is Pop Art?"
 German translation
 51–2 (*see also* Warhol,
 Andy, interviews)
 Warhol collection 45, 51–2, 54
Svensson, Gösta 109
Swenson, Gene 74, 117, 180
 "What Is Pop Art?" (interview
 with Andy Warhol),
 translations 14
 German 14, 50–3
 Italian 14, 74–5
 omissions in 14–15, 18
 Spanish, quotations from 18
 Swedish 14, 15 Fig. 1.5,
 111–12, 116
 see also Warhol, Andy,
 interviews
Sydsvenska Dagbladet (newspaper) 109

Tate Gallery, London 171–2
Taubin, Amy 171
Taylor, Paul 26, 29, 30
Tinguely, Jean 107, 120
Tomkins, Calvin 93–4
translation
 accessibility and 37–8, 159
 Benjamin, Walter, on 41
 censorship and 15, 17–18
 code-switching and 135
 errors of 37, 55, 101
 as projections of the translator
 30
 Feng Youlan on 40–1
 Foucault, Michel, on 41–2
 homosexuality and (*see*
 homosexuality)

ignorance and 30
interpretation and 3, 11, 20, 41,
 101
intimate reading as xiv, 7–8
Laozi and 3, 41
Marivaux, Pierre de, and 38
misinterpretation and 97–8
Ramanujan, A. K., theories of 17,
 20, 198, 200–2, 204,
 208–9, 211
Sanskrit, from English into,
 approaches to 210
Spivak, Gayatri Chakravorty, on
 7–8
thick translation 2, 3
traduire 20, 33
transfer, as 20, 33, 39, 104–5
 (*see also* Espagne,
 Michel)
transference, and 16, 20
transliteration and 128 n. 8, 129,
 209
Trimarco, Angelo 83–4
Trini, Tommaso, review of *a: A Novel*
 98–9

Ukrainian 128
Ultvedt, P. O. 107
Ungari, Enzo, Italian catalog of
 Warhol's films, co-
 editor 78–9

Vasari, Giorgio 93–4, 164 n. 2
Vasulka, Woody 131
Velvet Underground 59, 141
Véron, Marianne, French translation
 of *The Philosophy of
 Andy Warhol* 23 n. 2
video 16, 35, 36, 86, 125, 131,
 132–8, 159, 160 *see also*
 Warhol, Andy, video
 work
Vogue Italia, stories about Warhol in
 85–7, 100

Wagner, Anne 180–1
Wallowitch, Ed 25
Warhol, Andy, films
 Blow Job 30–2, 31 Fig. 2.3, 35, 36 n. 47
 Blue Movie 15, 62, 63 see also *Blue Movie* (book)
 Chelsea Girls 27, 33, 37, 77, 103, 117
 French subtitles, with 34
 Italian subtitles, with 34
 Eat 35, 116
 Eating Too Fast (Blow Job #2) 35
 Empire 33, 36 n. 47
 The George Hamilton Story 16, 127, 137, 139–59, 140 Fig. 6.3, 149 Fig. 6.5
 "Mrs. Warhol," also known as 127, 154, 154 Fig. 6.6, 155 Fig. 6.7
 see also Rheem, Richard; Warhola, Julia
 Harlot 33
 Hedy 147–8
 Lupe 28, 147
 Mario Banana, shown on German TV 59
 More Milk, Yvette 147
 Screen Tests 31 n. 32, 35, 39, 40 Fig. 2.5, 142, 166 n. 7, 171
 subtitle translations and dubbing of (*see under* film)
Warhol, Andy, films, with Paul Morrissey
 Flesh 62
 L'Amour 80
 Trash 62, 167 n. 10
 Women in Revolt 80, 174
Warhol, Andy, interviews 40, 75, 79–80, 94, 117
 French translations 23, 26, 28–30 (see also Berg, Gretchen; Cueff, Alain; Glaser, Bruce; Goldsmith, Kenneth)
 German translations 14, 50–3 (see also Berg, Gretchen; Glaser, Bruce; Swenson, Gene)
 Italian translations 14–15, 74–5, 79, 94 (see also Berg, Gretchen; Boatto, Alberto; Gelmis, Joseph; Oliva, Achille Bonito; Swenson, Gene; Tomkins, Calvin)
 Spanish translation 18 (see also Swenson, Gene)
 Swedish translations 14, 15 Fig. 1.5, 111–12, 116 (see also Berg, Gretchen; *Bonniers Litterära Magasin* [*BLM*]; Swenson, Gene)
Warhol, Andy, paintings
 The American Indian (Russell Means) 161, 162, 164, 165, 173, 183–91, 184 Fig. 7.4, 192, 193, 194, 195 (see also Means, Russell)
 Atomic Bomb 174
 Crossword 193
 Death and Disaster series 182
 Dollar Sign 10–11
 Electric Chair 103, 113, 114 Fig. 5.3, 168, 170, 173
 Flowers 103, 113
 Jackie 74 Fig. 4.2
 Ladies and Gentlemen 9, 80–2, 81 Fig. 4.3, 85, 87, 96, 100
 Last Supper 32
 Little Race Riots 173
 Mao 187, 191
 Marilyn Diptych 203
 Mustard Race Riot 161, 163 Fig. 7.2, 173, 175–6, 182, 195

Pink Race Riot [Red Race Riot]
 161, 162 Fig. 7.1, 173,
 175–6, 182, 195
Skulls 32
Thirteen Most Wanted Men 173
Warhol, Andy, Polaroid photographs
 Amelio, Lucio 83 Fig. 4.4
 Hall, Jerry 167 n. 11
 Means, Russell 184, 189, 195
 Morera, Daniela 86 Fig. 4.5
Warhol, Andy, prints
 Cow Wallpaper 103, 108, 113
 Jacqueline Kennedy 123
 Marilyn 103, 113 (see also
 Monroe, Marilyn,
 Warhol depictions of)
 Vote McGovern 207 Fig. 8.4
Warhol, Andy, publications see under
 a: A Novel; America;
 Andy Warhol's Index
 (Book); Andy Warhol's
 Party Book; Blue Movie;
 Interview magazine;
 The Philosophy of Andy
 Warhol
Warhol, Andy, publications with
 Suzie Frankfurt, Wild Raspberries
 129–30
 Pat Hackett see under The Andy
 Warhol Diaries;
 POPism: The Warhol
 '60s
 Julia Warhola, 25 Cats Name Sam
 and One Blue Pussy 129
Warhol, Andy, sculptures
 Brillo Boxes 55, 67, 74, 75, 103,
 104 Fig. 5.1, 113–14,
 115 Fig. 5.4, 172 n. 27
 clouds 55

Warhol, Andy, video work
 Factory Diaries 16, 22, 132, 139,
 159
 "Julia Warhola in Bed,
 Talking" 132
 "Julia Warhola in Bed, Talking,
 Sleeping" 132, 137, 138
 Fig. 6.2
 "Julia Warhola in T-shirt, Sick"
 132, 136
 Sony Portapak, use of 132
 Tape Recording magazine and 132
Warhola, Andrii 129
Warhola, James 167
Warhola, Julia 125–60
 comedic talent of 139
 cows and 151–2
 Esquire magazine interview
 125–7, 141, 142
 mother-son relationship 153
 narrative, use of 152
 performativity, and 135
Warhola, Paul 137 n. 27
Weingart, Brigitte 144, 146 n. 48,
 153, 158
Weinraub, Bernard 125–6
Weissner, Carl, a: A Novel, German
 translation of 55–9,
 62 see also under a: A
 Novel
Wesselmann, Tom 106, 123
Whately, Francis, director and
 producer, Andy Warhol's
 America, BBC Two
 164–8, 170–2, 174, 177,
 180–1, 182–3, 193–4
Whitehall, Richard 147
Wibom, Anna-Lena 115
Wissmann, Jürgen 47

www.ingramcontent.com/pod-product-compliance
Lightning Source LLC
Chambersburg PA
CBHW070030010526
44117CB00011B/1773